Y0-BXJ-749

3 0050 01188 2395

The Published Diaries and Letters of American Women

an annotated bibliography

G. K. Hall
WOMEN'S
STUDIES
Publications

The Published Diaries and Letters of American Women

an annotated bibliography

JOYCE D. GOODFRIEND

G.K.HALL &CO.

70 LINCOLN STREET, BOSTON, MASS.

Library of Congress Cataloging-in-Publication Data

Goodfriend, Joyce. D.
 The published diaries and letters of American women :
an annotated bibliography/Joyce D. Goodfriend.
 p. cm.—(A Reference publication in women's studies)
 Includes index.
 ISBN 0-8161-8778-9
 1. Women—United States—Biography—Bibliograpy.
2. American diaries—Bibliography. 3. United States—
Biography—Bibliography.
I. Title. II. Series.
Z5305.U5G66 1987
[CT3260]
016.920′073—dc19 87-17908

This publication is printed on permanent/durable acid-free paper
MANUFACTURED IN THE UNITED STATES OF AMERICA

To my mother and father

Contents

The Author

Joyce D. Goodfriend studied at Brown University and the University of California, Los Angeles, where she received her Ph.D. in history in 1975. She is currently associate professor of history at the University of Denver. She is the coauthor of <u>Lives of American Women: A History with Documents</u> (Boston: Little, Brown, 1981) and "Women in Colorado before the First World War" in the <u>Colorado Magazine</u> (1976), and the author of "The Struggle for Survival: Widows in Denver, 1880-1912" in <u>On Their Own: Widows and Widowhood in the American Southwest, 1848-1939</u>, edited by Arlene Scadron (Urbana and Chicago: University of Illinois Press, 1987). In 1982 she received a Radcliffe Research Support Grant for work at the Arthur and Elizabeth Schlesinger Library on the History of Women in America.

Preface

 The purpose of this bibliography is to acquaint readers, re-
searchers, students, and teachers with the many women's diaries and
letters that are available in printed form. Certain limitations on
the scope of the bibliography have had to be imposed for pragmatic
reasons, but I believe that these limitations are also intellectually
justifiable. It is hoped that others will see fit to examine the
categories of material that have, of necessity, been excluded from
this book. First, the bibliography treats only the diaries and
letters of American females who were writing in the United States.
Therefore, the documents of foreign women who toured the United States
are not included nor are those of American women visiting or living
abroad. In cases where American women were writing from here as well
as from other countries, I have focused my annotations on the American
context.

 The key criterion for inclusion apart from those already men-
tioned relates to genre. Only personal, not public documents were
considered. These personal documents were required to be immediate
rather than retrospective in nature, composed at the time the events
discussed were taking place, not many years later. In other words,
what I was looking for were diaries, journals, or letters, not auto-
biographies. Again, there are gray areas, since diaries not
uncommonly contain retrospective entries. I have used my best
judgment in making this distinction between firsthand and retrospec-
tive materials. As a rule, I have excluded undated journals, fic-
tional works in journal form, and diaries or letters that do not
appear to me to be authentic. One other type of material has gener-
ally been excluded--biographical works in which the amount of edi-
torial intrusion has negated the value of the excerpts from the
diaries or letters.

 The arrangement of the bibliography is chronological, with the
initial date of composition of the diary or letter determining its
placement in the book. Each annotation notes the years covered in the
document and the birth and death dates of the author, when known, as
well as the location in which the author was writing. The annotation

also indicates whether the item in question is a diary or letter, or both.

 Within each year annotations are arranged alphabetically by title. The author's name is included only if her name appears on the title page. When a name other than the author's appears on the title page, I have specified the role played by the person to the best of my determination; brackets have been inserted around the terms "Edited by" or "Introduction by" to convey this information. Brackets are also used when I have supplied names not found on the title page.

 When I began this bibliography, I cherished the illusion that I would be able to track down every fugitive publication that met my specifications. Reluctantly, and yet in a way happily, I have reached the conclusion that this effort to assemble a master list--with annotations--of all published American women's diaries and letters is but the initial step in a much larger process of recovery. Simply put, there are still an unknown number of sources waiting to be rediscovered. Defined as insignificant, many books and pamphlets, frequently issued privately or by obscure publishers, are found only inadvertently by someone browsing in libraries, bookstores, or personal collections. Other female documents are obscured by the titles of the volumes in which they are printed. From a cursory examination, it is clear that many sets of family papers and papers of famous American men contain letters by females. Thus, as I end my search (for the moment?), I am glad to report that further riches await those of us who are committed to teaching and writing the history of American women. For the present, I offer this bibliography as a basic tool for identifying diaries and letters that might be useful for research on female Americans.

 I would like to express my appreciation for a Radcliffe Research Support Grant that permitted me to make use of the unparalleled resources of the Schlesinger Library during the summer of 1982. I am also indebted to the staff of the Interlibrary Loan department of Penrose Library at the University of Denver for assistance in obtaining materials over the years. Without the support and encouragement of my mother, Irvine Slater Goodfriend, this book never would have been completed.

Introduction

My pen is always freer than my tongue. I have written many
things to you that I suppose I never could have talked.
 Abigail Adams, 1775

American women's diaries and letters are filled with the excep-
tional and the commonplace, the intimate and the impersonal, the
particular and the general. They range in concern from domestic
minutiae to issues of global significance. They are, by turns,
passionate in tone and unemotional. They furnish compelling evidence
of the sufferings of women as well as their fortitude and endurance.
Composed at different points in time in a variety of settings by
females of diverse backgrounds and talents and interests, the diaries
and letters of female Americans constitute a cornucopia of source
material for historical, sociological, psychological, and literary
analysis.

Personal writings convey the experiential dimension of history in
ways that no other sources can. They offer evidence of the all-
important reactions of women to the events, ideas, and advice so
frequently put forth as the substance of historical knowledge. They
allow us to know what women thought about social issues and social
groups. They enable us to recover what women felt at crucial junc-
tures in their lives--the birth of a child, the death of a parent,
separation from loved ones.

Diaries (or journals as they are sometimes called) and letters
add to our understanding of American women's lives in another way, one
their authors never intended. They supply us with facts about the
conditions under which women labored--the technology, health care,
education, and welfare that were available to them. From reading
these documents we can learn what women wore, what they ate, what they
read, and how they amused themselves. We can reconstruct their
routines--their household chores, their visiting patterns, their
holiday celebrations. We can learn how frequently they went to
church, how they spent the Sabbath, how they prayed. We can gain a
sense of the texture of relationships within the family--with parents

and siblings and husbands and children--and piece together friendship networks.

Furthermore, long series of diaries and letters permit us to study individual lives over time in a variety of historical contexts. They provide us with uniquely valuable evidence for assessing individual development through successive life stages.

With all these advantages for documenting the American female past, the diaries and letters of our nations's women deserve to be widely known to researchers, teachers, and students. In recent years, several publications have furthered this goal by publicizing the personal writings of women. Among these works are Lynn Lifshin, ed., Ariadne's Thread: A Collection of Contemporary Women's Journals (New York: Harper & Row, 1982); Karen Payne, ed., Between Ourselves: Letters Between Mothers and Daughters, 1750-1982 (Boston: Houghton Mifflin Company, 1983); Nancy Caldwell Sorel, Ever Since Eve: Personal Reflections on Childbirth (New York: Oxford University Press, 1984); Margo Culley, ed., A Day at a Time: The Diary Literature of American Women from 1764 to the Present (New York: The Feminist Press at the City University of New York, 1985); and Penelope Franklin, ed., Private Pages: Diaries of American Women 1830s-1970s (New York: Ballantine Books, 1986). Yet there is no comprehensive guide to the most readily accessible diaries and letters--those that have been printed. This book is designed to remedy that problem.

In the past few years, I have tracked down and read hundreds of printed diaries and letters written by female Americans from the seventeenth century to the 1980s. After overcoming my initial astonishment that so many diaries and letters written by American women had been published in spite of the persistence of patriarchal attitudes among publishers and educators, I set about understanding why these particular women's documents and no others had been printed. Although ascertaining whether these printed diaries and letters constitute a representative sample of all diaries and letters is not possible, one can suggest the reasons certain types of items were selected for publication and in so doing uncover the motives of those responsible for their publication.

Interestingly, the majority of these documents were not composed by exceptional women, although clearly such women's writings are found in significant numbers here. Celebrity, then, is not a sufficient explanation for publication. We can account for the issuance of women's diaries and letters in a few readily understood ways. Filiopietism is one. Prominent and affluent families have under-written the publication of the personal writings of their female ancestors as a token of pride or at times snobbery. Association with a famous male personage, be he a national leader or a local figure, has frequently led to publication. The inordinate amount of attention paid to the writings of the wives of the presidents aptly illustrates this point.

The didactic value of the writings of women whose saintly lives merited remembrance (and imitation) has been another, major reason for their publication. Religious groups--be they families or denominations--were especially susceptible to this line of reasoning. Female missionaries were prime candidates for memorialization in this way. Participation in a great event such as the Civil War or the westward migration was often enough reason to turn a manuscript into print. The fact that a woman's diary cast light on an event or personage deemed important in local history also might explain its publication.

The impact of recent scholarship in women's history and women's literature on the publication process has been substantial. Personal or chauvinistic reasons for publication have been superseded by criteria premised on historical or literary significance. The intrinsic merit of a document or its value in illuminating the hidden corners of female lives now determines whether or not it is published.

The appearance in print of a host of female diaries and letters in the last decade or so and the serious treatment of these documents by editors are cause for jubilation. In the past, women's personal documents have suffered from injudicious editing whether caused by male bias or plain ignorance. Elimination of personal comments by prudish or embarrassed compilers no longer is the case. Editorial guideposts are framed with reference to pressing scholarly questions rather than considerations of respectability or reputation.

The printed diaries and correspondence of American women are not randomly distributed. For the reasons suggested above, there is a preponderance of writings by privileged women of English background and Protestant faith, women whose families had the means and access to the press. The same reasons, in part, explain why there is a paucity of published works by female members of ethnic and religious minorities. This bibliography does include diaries or letters written by Roman Catholics and Jews, blacks, and Japanese, Irish, German, Norwegian, Swedish, and Czechoslovakian women, but they are far fewer in number than their proportionate size in the American female population would warrant. The explanation lies in the fact that the production of personal documents by immigrant and black women was sharply curtailed by illiteracy, the language barrier, little leisure time in which to write, and the lack of a cultural tradition of diary keeping. Extant personal writings of immigrant and black women tend to come from members of these groups who enjoyed advantages over their peers.

With respect to other differentiating characteristics of their authors, printed diaries and letters encompass the full spectrum of female experience. All age groups and life stages are represented among the writers--children, adolescents, brides, young mothers, middle-aged and older women. The diarists and correspondents also include persons of every marital status--single women, married women, widows, and divorcées.

The occupations and regional identities of the authors of these documents are diverse. Urban housewives, farm women, professional women, and factory workers are all included as are women from New England, the South, the Midwest, and the Far West. Female travelers produced a sizable number of diaries, often on the pretext of describing their journeys for the loved ones at home. Some of the trips described were vacation rambles, whereas others were permanent migrations with family and friends.

The time distribution of these materials is clearly not random. Seventeenth-century diaries are rare; nineteenth-century diaries are plentiful. The cultural determinants of these patterns are familiar to students of women's history. Specific historical phenomena occasioned an outburst of diary and letter writing, most notably the American Revolution, the westward movement, and the Civil War. Notwithstanding the ebbs and flows of female personal writing, however, diaries and correspondence exist for virtually every decade from the mid-seventeenth century to the 1980s.

The Published Diaries and Letters of American Women

1669

1 Correspondence of Maria van Rensselaer 1669-1689. Translated
 and edited by A.J.F. van Laer. Albany: University of the
 State of New York, 1935, 206 pp.
 Maria van Cortlandt van Rensselaer (1645-89), the daughter
 of Oloff Stevensen van Cortlandt, a prominent New Amsterdam
 brewer and merchant, married Jeremias van Rensselaer, heir to the
 estate of Rensselaerswyck, near Albany, when she was seventeen.
 Widowed at the age of twenty-nine and left with six children,
 Maria found herself enmeshed in a complex web of family and
 political intrigue that prevented her from settling the estate of
 her husband. The bulk of the correspondence in this volume deals
 with her unceasing efforts to resolve her financial difficulties.
 Interspersed among lengthy discussions of business and politics,
 however, are references to her children, her illnesses, and her
 religious beliefs. These letters of Maria van Rensselaer,
 written primarily to her husband's kinfolk in the Netherlands,
 are among the few extant personal documents of Dutch women in the
 colony of New York.

1680

1 "Business Letters of Alida Schuyler Livingston, 1680-1726."
 Edited by Linda Biemer. New York History 63 (1982):183-207.
 The vital role played by Dutch wives in family economic
 enterprises in colonial New York is illustrated by this sampling
 of the letters of **Alida Schuyler** (Van Rensselaer) **Livingston**
 (1656-1727) to her husband between 1680 and 1726. Alida, who
 functioned essentially as the business partner of her prominent
 husband, Robert Livingston, managed the family's interests in
 Albany and later at Livingston Manor. Her communications to him
 contain little personal news but instead focus on the availabil-
 ity and prices of commodities, orders for goods, shipping
 arrangements, and financial matters. These letters are trans-
 lated from Dutch.

1688

1 Mehetabel Chandler Coit, Her Book, 1714. Norwich, Conn.:
 Privately Printed, 1895, 19 pp.
 Not strictly a diary, this book kept by **Mehitable Chandler
 Coit** (1673-1758) of New London, Connecticut, contains brief
 entries made sporadically between 1688 and 1749, or perhaps
 later. Coit reported events of significance to family members,
 such as births, marriages, and deaths, noted her reading, and
 declared her fatigue. Appended to the text are two of Coit's
 letters, dated 1724 and 1726, which reveal the distress of a
 middle-aged mother over her daughter's questionable behavior.

1704

1 The Journal of Madam Knight. With an introductory note by
 Malcolm Freiberg. Wood engravings by Michael McCurdy.
 Boston: David R. Godine, 1972, 39 pp.
 First published in 1825, the journal kept by **Sarah Kemble
 Knight** (1666-1727) of Boston on a journey to New York City in
 1704-5 has attained the status of a classic in early American
 literature. Knight, who was married and the mother of a
 daughter, proved herself to be an acute observer of local mores
 as she recounted her adventures while traveling through a series
 of towns in Massachusetts, Rhode Island, Connecticut, and New
 York. Road conditions, lodgings, and meals all came under her
 scrutiny, but it is her striking delineations of character that
 distinguish her writing. She portrayed the diverse array of
 colonists she encountered along the way with perceptiveness and a
 piercing wit. Her journal also includes several poems of her own
 composition.

1711

1 "A Letter Written in 1711 by Mary Stafford to her Kinswoman in
 England." [Contributed by St. Julien R. Childs.] South
 Carolina Historical Magazine 81 (1980):1-7.
 Deeply indebted and facing destitution in England, **Mary
 Stafford**, her husband, and two of her children sailed to the
 colony of South Carolina in hopes of improving their condition
 and ultimately returning home. In this 1711 letter to a female
 cousin in England, Stafford movingly recounts her embarrassment
 about her family's plight, enumerates their reasons for moving to
 America, and chronicles the success they have had so far in
 obtaining work. She also sketches some of the distinctive
 features of life in South Carolina.

1715

1 "Broughton Letters." [Copied and annotated by D.E. Huger
 Smith.] South Carolina Historical and Genealogical Magazine
 15 (1914):171-96.
 This collection of eighteenth-century correspondence of the
 Broughtons of South Carolina includes five letters written to
 Nathaniel Broughton by female members of his family. His
 mother, **Anne Broughton**, wrote him in 1715 and 1716, expressing
 her concern for his soul and urging him to fulfill his religious
 obligations. Two letters of Nathaniel's wife, **Henrietta
 Charlotte Broughton**, dated 1732 and 1733-34, and one of his
 widowed sister, **Anne Broughton Gibbes**, dated 1753, contain family
 and local news.

1725

1 "An Account of Charles Town in 1725." South Carolina Histori-
 cal Magazine 61 (1960):13-18.
 Margaret Brett Kennett had recently migrated to South
 Carolina with her husband when she wrote this letter to her
 mother in England in January 1725 describing Charles Town's
 (Charleston's) natural features and the character of its in-
 habitants. She also discussed her financial condition and her
 work in the shop the couple ran.

1739

1 The Letterbook of Eliza Lucas Pinckney 1739-1762. Edited by
 Elise Pinckney with the editorial assistance of Marvin R.
 Zahniser. Introduction by Walter Muir Whitehill. Chapel
 Hill: University of North Carolina Press, 1972, 195 pp.
 While still in her teens, **Eliza Lucas Pinckney** (1722-93),
 who had been born in the West Indies and educated in England,
 assumed the responsibility for running her father's plantations
 near Charleston, South Carolina, and experimented successfully
 with growing indigo, which subsequently became a staple crop of
 the colony. Pinckney's letterbook, which includes copies of some
 of her letters and memoranda on the contents of others, documents
 three distinct periods of her life from 1739 to 1762--her early
 years on her father's plantation, a time of domestic happiness in
 England after marriage and the birth of her children, and the
 initial stage of her widowhood, again in South Carolina. What
 emerges from these writings is a portrait of a woman whose
 intellect and mastery of business affairs set her apart from her
 contemporaries. As a young girl and then as a widow, Pinckney
 was compelled by circumstances to shoulder burdens usually
 reserved for men, and her letters deal with financial matters and
 public issues as a matter of course. Yet, even in her youth, she

was a person who thought deeply about religion and morality, and her advice to her brothers and later her sons distilled the ideas on Christian virtue that formed the underpinning of her own life. Severely tested by the death of the husband she loved and admired, Pinckney discoursed at length on her bereavement and avowed her determination to ensure the welfare of her children. Letters written during a later period in Pinckney's life are found in Elise Pinckney, ed., "Letters of Eliza Lucas Pinckney, 1768-1782," South Carolina Historical Magazine 76 (1975):143-70.

1740

1 Familiar Letters Written by Mrs. Sarah Osborn, and Miss Susan Anthony, late of Newport, Rhode-Island. Newport, [R.I.]: Printed at the office of the Newport Mercury, 1807, 170 pp.
 The friendship between **Sarah Haggar Wheaten Osborn** (1714-96) who played a key role in the religious revival of 1766-67 in Newport, Rhode Island, and **Susanna Anthony** was founded on their mutual concern over spiritual matters. The letters between Osborn and Anthony, which compose the majority of the 74 letters printed in this volume, are not dated individually but are known to have been written between 1740 and 1779. Religion was the major focus of the correspondence, as the two pious women reviewed the events of their lives and exchanged the insights they had gained from examining their souls. A recurrent theme was the necessity for submitting to God's will. Osborn and Anthony also commented on local church affairs and the British occupation of Newport during the revolutionary war. A 1767 letter from Osborn to the Reverend Joseph Fish is published in Mary Beth Norton, "'My Resting Reaping Times': Sarah Osborn's Defense of 'Unfeminine' Activities, 1767," Signs: Journal of Women in Culture and Society 2 (1976):515-29. See also 1744.1.

1742

1 The Cary Letters. Edited by C[aroline] G. C[urtis]. Cambridge, Mass.: Printed at the Riverside Press, 1891, 335 pp.
 Female writers predominate in this compendium of Cary family letters, diaries, and recollections spanning the years 1742 to 1843. The correspondence of **Sarah Cary** (?-1824) between 1779 and 1824, first from Grenada in the West Indies and later from Chelsea, Massachusetts, forms the centerpiece of the volume. In letters written in a formal literary style, Mrs. Cary imparted moralistic advice to her sons, reaffirmed her religious beliefs, communicated news of her children, and discussed the crisis in family finances caused by the Negro insurrection in Grenada. Two of Sarah Cary's daughters are well represented here. **Margaret G. Cary** wrote frequently from New York, and **Anne M. Cary** gave an

account of her 1818 trip to Canada in letters. The volume also includes a brief diary of **Margaret Graves Cary** (1719-62), the mother of Sarah Cary's husband, Samuel, for the years 1742-59, and a journal kept by **Harriet Otis**, a close friend of the Cary family in Chelsea, on a visit to Saratoga in 1819.

1744

1 Memoirs of the Life of Mrs. Sarah Osborn, who died at Newport, Rhode Island on the second day of August, 1796. In the eighty third year of her age, by Samuel Hopkins. Worcester, Mass.: Leonard Worcester, 1799, 380 pp.
 Sarah Haggar Wheaten Osborn (1714-96) gained prominence as the leader of a religious revival in Newport, Rhode Island, in 1766-67. This autobiographical volume contains lengthy extracts from the diary Osborn kept between 1744 and 1767. A woman of exemplary piety, Osborn used her diary primarily as a repository for her spiritual meditations. Illnesses, family affairs, and community events, when noted at all, are discussed in terms of their religious significance. See also 1740.1.

1745

1 "Vermont Letters: A Series II." Proceedings of the Vermont Historical Society, n.s. 6 (1938):362-67.
 Ruth Starbuck Wentworth, a young single woman, remained on Nantucket Island with relatives when her parents migrated to Vermont. In this letter written in 1745, she told her mother that a ship captain, who was a friend of a cousin recently returned from China, had asked her to marry him.

1754

1 "Extracts from the Journal of Mrs. Ann Manigault 1754-1781." [With notes by Mabel L. Webber.] South Carolina Historical and Genealogical Magazine 20 (1919): 57-63, 128-41, 204-12, 256-59; 21 (1920):10-23, 59-72, 112-20.
 A surprising amount of information on the life of an older upper-class woman in colonial America can be gleaned from the brief factual entries in the journal of **Ann Ashby Manigault** (1703-82) of Charleston, South Carolina, which spans the years 1754 to 1781. This precise record of guests at dinner, callers, attendance at church, plays, balls, and races, and the movements of family members makes it possible to reconstruct Mrs. Manigault's customary activities. Her regular notations of marriages, childbirths, and deaths in the community establish the parameters of her social world. Illness was of vital interest to Mrs. Manigault, and her journal abounds in references to her own ailments and those of her husband, children, and grandchildren.

Though she rarely mentioned public affairs in the journal, she did allude to the events of the American Revolution in South Carolina.

2 The Journal of Esther Edwards Burr 1754-1757. Edited, with an introduction by Carol F. Karlsen and Laurie Crumpacker. New Haven and London: Yale University Press, 1984, 318 pp.
 The journal that **Esther Edwards Burr** (1732-58) kept between 1754 and 1757 was sent in the form of letters to her closest friend, Sarah Prince, in Boston. For Esther, who lived in Newark and then Princeton, New Jersey, where her husband, a Presbyterian minister, was president of the college, having a trusted confidante like Sarah to share her worldly discontents and spiritual yearnings was of immeasurable importance. Being a good wife and mother presented a formidable challenge to Esther, the devout daughter of famed minister Jonathan Edwards. Taught by her religion to submit to the will of God and man, Esther nonetheless chafed at social arrangements that severely circumscribed her opportunities to exercise her intellect. Her journal contains ample evidence of her mood swings, as she tried to cope with illnesses, the demands of her babies, the frequent absences of her husband, entertaining visiting clergymen, and anxiety about her parents living on the frontier of western Massachusetts during the French and Indian War. Deprived of the company of her dear friend, Esther relied on her faith to sustain her.

1755

1 Benjamin Franklin and Catharine Ray Greene: Their Correspondence 1755-1790. Edited and annotated by William Greene Roelker. Philadelphia: American Philosophical Society, 1949, 147 pp.
 For many decades, **Catharine Ray Greene** (1731?-94) of Warwick, Rhode Island, was a valued friend of Benjamin Franklin and his sister, Jane Franklin Mecom (1712-94). A letter written in 1755, before she was married, makes clear that Catharine trusted Franklin with her confidences and sought his advice on personal matters. In letters penned to Franklin and Mecom between 1775 and 1789, Catharine reported on her husband's political career and his economic fortunes, communicated news of her children's and grandchildren's accomplishments, inquired about Franklin's welfare, and occasionally requested his aid. Catharine was deeply involved in the American Revolution and held strong anti-British and pro-French views. Her account of the distress caused Rhode Islanders by the revolutionary war is compelling. This volume also contains a number of letters written by **Jane Mecom**. See 1758.2 for letters of Jane Mecom.

1757

1 "Extracts from the Diary of Hannah Callender." [Edited by]
 George Vaux. Pennsylvania Magazine of History and Biography
 12 (1888):432-56.
 These selections from the diary kept by **Hannah Callender**
 (1737-1801) between 1757 and 1762 consist primarily of notes made
 during the young single Quaker woman's travels with her friends.
 Callender's polished descriptions of homes and gardens near her
 Philadelphia home and the scenery, buildings, and people en-
 countered on a trip through New Jersey and New York mark her as a
 well-educated person of refined sensibility. The most fascinat-
 ing passages in the diary deal with a visit to the Moravian
 community at Bethlehem, Pennsylvania.

1758

1 Extracts from the Journal of Elizabeth Drinker, from 1759 to
 1807, A.D. Edited by Henry D. Biddle. Philadelphia: J.B.
 Lippincott Co., 1889, 423 pp.
 A few years before her marriage, **Elizabeth Sandwith Drinker**
 (1734-1807), a Quaker from Philadelphia, commenced a journal
 which she kept regularly until shortly before her death, almost
 half a century later. The longevity of this record, which covers
 the years 1758 to 1807, as well as its profusion of detail, makes
 it an unparalleled source for documenting the life of an upper-
 class wife, mother, grandmother, and mistress of a large house-
 hold. Although filled with information on childbirth and child
 rearing, medical treatments, religious practices, social ac-
 tivities, and relations with servants, it nevertheless reveals
 little of Drinker's inner life. Though centered on the minutiae
 of the domestic world, the journal conveys Drinker's perspective
 on the public events of the Revolutionary Era. A portion of the
 journal was published in "Extracts from the Journal of Mrs. Henry
 Drinker, of Philadelphia, from September 25, 1777, to July 4,
 1778," Pennsylvania Magazine of History and Biography 13
 (1889):298-308.

2 The Letters of Benjamin Franklin & Jane Mecom. Edited with an
 introduction by Carl Van Doren. [Princeton, N.J.]: Published
 for the American Philosophical Society by Princeton University
 Press, 1950, 380 pp.
 The special relationship that **Jane Franklin Mecom** (1712-94)
 enjoyed with her brother Benjamin Franklin is amply demonstrated
 in her correspondence spanning the years 1758-93. Mecom's pride
 in her brother's accomplishments, her concern for his welfare and
 reputation, and her gratitude for his counsel and financial
 assistance are evident in these letters to Franklin and other
 members of the family circle. The correspondence also sheds

light on the repeated family tragedies that Mecom, a poor Boston
widow, endured. Her responses to the problems of her children
and grandchildren reveal not only her perdurable religious faith
but her realistic approach to life's travails. That Mecom
possessed a lively mind is clear from her comments on her reading
and current political issues as well as her reports on the
American Revolution. The correspondence also is useful for
delineating Mecom's attitude toward old age. See also 1755.1.

1760

1 The Holyoke Diaries, 1709-1856: Rev. Edward Holyoke, Marble-
 head and Cambridge, 1709-1768. Edward Augustus Holyoke, M.D.,
 Cambridge, 1742-1747, John Holyoke, Cambridge, 1748, Mrs. Mary
 (Vial) Holyoke, Salem, 1760-1800, Margaret Holyoke, Salem,
 1801-1823, Mrs. Susanna (Holyoke) Ward, Salem, 1793-1856.
 With an introduction and annotations by George Francis Dow.
 Salem, Mass.: Essex Institute, 1911, 215 pp.
 The diary that **Mary Vial Holyoke** (1737-1802), an upper-
 class woman from Salem, Massachusetts, kept between 1760 and 1799
 records the salient facts of her existence in concise form.
 Despite the brevity of her entries, a good deal can be gleaned
 from them about her household work, her social engagements, and
 news of the family and community. Most striking are Holyoke's
 dispassionate references to the births, illnesses, and deaths of
 her own children. This volume also contains the diaries of two
 other Salem women, **Margaret Holyoke** (1763-1825) and **Susanna
 Holyoke Ward** (1779-1860).

2 "Letters of Martha Logan to John Bartram, 1760-1763." Edited
 by Mary Barbot Prior. South Carolina Historical Magazine 59
 (1958):38-46.
 Between 1760 and 1763, **Martha Daniell Logan** (1704-?), a
 widow from Charleston, South Carolina, corresponded and exchanged
 samples of seeds with the eminent botanist John Bartram in
 Philadelphia. These seven letters are confined to the subject of
 gardening.

1761

1 The Huntington Letters in the Possession of Julia Chester
 Wells. Edited by W.D. McCrackan. New York: Appleton Press,
 1905, 220 pp.
 The correspondence of two female members of the Huntington
 family of Norwich, Connecticut--**Anne Huntington Huntington**
 (1740?-1790) and her daughter, **Rachel Huntington** (Tracy)
 (1779-?)--comprises most of this volume. With the exception of a
 1761 letter to her sister, all of Anne's letters were written to
 her husband between 1774 and 1790 while he was serving in the

government. She communicated news of family members and neigh-
bors, provided her husband with details of her management of the
household, and requested his aid in matters concerning their
children. Anne suffered from poor health, but she always coupled
reports of her condition with expressions of her faith in God.
Between 1796 and 1798, young Rachel Huntington wrote a series of
letters to her sisters recounting her experiences while visiting
relatives in New York City, Stamford, Connecticut, and Rome, New
York. Her animated accounts of the affairs of the well-to-do
young men and women with whom she socialized were accompanied by
lengthy descriptions of the latest fashions.

1762

1 The Book of Abigail and John: Selected Letters of the Adams
 Family 1762-1784. Edited and with an introduction by L.H.
 Butterfield, Marc Friedlaender, and Mary-Jo Kline. Cambridge,
 Mass., and London: Harvard University Press, 1975, 411 pp.
 During the course of their courtship and married life,
 Abigail Smith Adams (1744-1818) and her husband, John Adams,
 wrote each other hundreds of letters that deservedly rank among
 the best of the genre. The editors of this volume have culled
 absorbing examples of this correspondence for the years 1762 to
 1784, a time of momentous personal and public change for the
 Adamses. Caught up in the tide of events of the Revolutionary
 Era and yet dismayed at her husband's prolonged absences, Abigail
 wrote with equal facility of public affairs and happenings on the
 domestic scene. She transmitted reports of battles in
 Massachusetts, ventured her opinions on the great issues of the
 day, and continued to hope that the American cause would triumph
 against the odds. In her letters to John, Abigail shared her
 concerns over their children and other family members and also
 expressed her feelings about her pregnancy and the birth of a
 stillborn child. Through it all, she expressed her abiding
 affection for her husband and her longing to be with him. This
 book supplants two nineteenth-century collections of Abigail
 Adams's letters: Charles Francis Adams, Letters of Mrs. Adams,
 The Wife of John Adams, 2 vols. (Boston: C.C. Little and J.
 Brown, 1841), and Charles Francis Adams, Familiar Letters of John
 Adams and His Wife Abigail Adams, during the Revolution: With a
 Memoir of Mrs. Adams (New York, Hurd and Houghton, 1875). See
 also Lyman H. Butterfield et al., eds., The Adams Family Cor-
 respondence, 4 vols. (Cambridge, Mass.: Harvard University
 Press, Belknap Press, 1963, 1973). See also 1785.1; 1788.2;
 1808.1.

1765

1 "Selections from the Diary of Christiana Leach, of
 Kingsessing, 1765-1796." <u>Pennsylvania Magazine of History and
 Biography</u> 35 (1911):343-49.
 Most of these brief entries from the diary **Christiana Leach**
 of Kingsessing, Pennsylvania, kept in German between 1765 and
 1796 concern the vital events of her family: births, marriages,
 deaths, and the apprenticeships of her sons. A few references to
 the privations her family suffered during the revolutionary war
 make clear that Leach supported the American side in the con-
 flict. Leach's notations also show that she was a woman of deep
 religious faith.

1768

1 The Diary of Mary Cooper: Life on a Long Island Farm 1768-
 1773. Edited by Field Horne. [Oyster Bay, N.Y.]: Oyster Bay
 Historical Society, 1981, 84 pp.
 The power of religion to transform the outlook of a woman
 whose endless labors and troubled family relationships caused her
 untold distress is shown in moving fashion in the diary kept by
 Mary Wright Cooper (1714-78) of Oyster Bay, Long Island, New
 York, between 1768 and 1773. The brief but illuminating entries
 in Cooper's diary record the details of her work as a farmer's
 wife, convey her bitter feelings about her situation, and most
 significant, trace the progress of her spiritual search. During
 this period, Cooper continuously examined her own soul, listened
 to a number of preachers in her community, and found meaning in a
 New Light Baptist church, which welcomed the participation of
 women and blacks.

1770

1 "Diary of M. Ambler, 1770." <u>Virginia Magazine of History and
 Biography</u> 45 (1937):152-70.
 In 1770, **Mary Cary Ambler**, a widow from Virginia, took her
 two young children to Baltimore to be inoculated against small-
 pox. Her diary of the trip, written in the third person, traces
 the tortuous course of the inoculation procedure. Appended to
 the diary is a record of the expenses Ambler incurred on the
 journey as well as a description of Baltimore.

2 "Letters of Phillis Wheatley and Susanna Wheatley." [Edited
 by] Sara Dunlap Jackson. <u>Journal of Negro History</u> 57
 (1972):211-15.
 These letters written to the countess of Huntingdon in
 England between 1770 and 1773, three by the celebrated black poet

Phillis Wheatley (Peters) (1753?-84) and two by her mistress, **Susanna Wheatley** (?-1774?), make clear the primacy of religion in their lives. Phillis, who had sent the countess a poem commemorating the death of the Reverend George Whitefield, expressed her gratitude for the countess's patronage. Susanna Wheatley praised the work of the countess of Huntingdon in sponsoring ministers to spread the gospel in America and offered her appreciation for the countess's interest in Phillis and her willingness to allow Phillis to dedicate her book of poems to her. See also 1772.2, 4.

1771

1 "Diary of a Little Colonial Girl." Virginia Magazine of History and Biography 11 (1903-4):212-14.
 This brief fragment of a diary kept by **Sally Cary Fairfax**, the young daughter of a prominent Fairfax County, Virginia, family, between December 1771 and February 1772 consists of miscellaneous household news that the child deemed important. Appended to the diary is a 1778 letter Sally wrote to her father in New York reporting on her mother's feelings at the prospect of a lengthy separation from her husband.

2 Diary of Anna Green Winslow: A Boston School Girl of 1771. Edited by Alice Morse Earle. Boston and New York: Houghton, Mifflin & Co., 1894, 121 pp.
 A young girl's education for a life of gentility is recounted in the diary kept by **Anna Green Winslow** (1759-79) between 1771 and 1773. Anna, who resided with her aunt in Boston after her British-sympathizing parents moved to Nova Scotia, assisted in the domestic duties of the household, practiced her sewing, and attended school. In addition to her academic studies, she also took dancing lessons and spent a good deal of time in well-regulated social activities that brought her into contact with similarly situated young females as well as older relatives and friends. Inculcated with the importance of religious and moral truths, Anna monitored her own behavior carefully, read the Bible, and went to church regularly, entering notes on the sermons in her diary. Her concern for virtue and matters of the spirit did not, however, preclude a lively interest in things of this world, especially fashions.

1772

1 "Extracts from the Journal of Miss Sarah Eve: Written While Living near the City of Philadelphia in 1772-73." Pennsylvania Magazine of History and Biography 5 (1881):19-36, 191-205.

Between December 1772 and December 1773, **Sarah Eve**
(1750-74), a young single woman living on the outskirts of
Philadelphia, kept this journal for her father, who was in the
West Indies attempting to recoup the family's fortunes. Sarah's
journal comprises much more than a record of her routine calls
and visits, for it contains the measured reflections of one whose
brush with poverty has jeopardized her social status. Sarah's
thoughtful comments on her precarious position as well as her
acute observations on contemporary manners and fashions paint her
as a person who stands out for her independence of mind.

2 "Four New Letters by Phillis Wheatley." [Edited by] Kenneth
 Silverman. Early American Literature 8 (1974):257-71.
 Between April 1772 and October 1774, **Phillis Wheatley**
 (Peters) (1753?-84), the young African slave who was acclaimed
 for her poetry, wrote four letters to John Thornton, a prominent
 English supporter of missionary activity to blacks and Indians.
 Phillis noted her indebtedness to Thornton for the religious
 advice he had given her and discoursed on her own spiritual
 condition and beliefs. Her sorrow was evident as she depicted
 the deathbed scene of her mistress, Susanna Wheatley, and
 extolled the virtues of this woman who had been like a mother to
 her. Phillis affirmed her gratitude to her master for freeing
 her in conformity with her mistress's wishes but rejected John
 Thornton's suggestion that she travel to Africa with two black
 male missionaries. See also 1770.2; 1772.4.

3 Jemima Condict Her Book: Being a Transcript of the Diary of
 an Essex County Maid during the Revolutionary War. Newark,
 N.J.: Cartaret Book Club, 1930, 73 pp.
 Thoughts of her own sinfulness flooded in on **Jemima Condict**
 (Harrison) (1754-79), the daughter of an Essex County, New
 Jersey, farmer, as she wrote in her diary from 1772 to 1779. For
 Jemima, a devout Presbyterian, religion provided an absolute
 standard of conduct, and not surprisingly for a girl on the brink
 of adulthood, she consistently found herself unworthy of the good
 things her family had given her. The inner turmoil that Jemima
 experienced during this period of her life was undoubtedly linked
 to the pressure she felt to marry, and her hesitation about
 taking this big step is reflected in her comments on marriage in
 general and on the choice of a mate. Jemima's copious notes on
 illnesses and deaths in her neighborhood, coupled with her
 references to the events of the revolutionary war, provide
 striking evidence of her consciousness of her own mortality.

4 Poems and Letters: First Collected Edition, by Phillis
 Wheatley (Phillis Peters). Edited by Chas. Fred. Heartman.
 New York: Privately printed, 1915, 111 pp.

Phillis Wheatley (Peters) (1753?-84), the young African slave whose intellect and poetical talents made her an object of admiration in Boston society, penned seven letters to Obour Tanner, a black female friend, between 1772 and 1779. A devout Christian, Phillis filled her letters with expressions of her religious faith and exhortations to behave in a pious manner. After the death of her beloved mistress, Susanna Wheatley, she praised her for the kind treatment and affection she had bestowed on her as well as for the example of her life. These letters were originally published in the <u>Proceedings</u> (of the Massachusetts Historical Society) 7 (1863-64):267-79, and were reprinted in <u>Letters of Phillis Wheatley, the Negro-slave poet of Boston</u> (Boston: Privately printed, 1864). See also 1770.2; 1772.2.

1774

1 "Letters of Eliza Farmar to Her Nephew." <u>Pennsylvania Magazine of History and Biography</u> 40 (1916):199-207.
 News of the revolutionary crisis in America dominated the correspondence of **Eliza Farmar** with her nephew in England. A recent British immigrant to Philadelphia, Mrs. Farmar identified her interests with her new home, but retained sympathies for her birthplace. Her acute analysis of economic and political developments in 1774 and 1775 reflects this ambivalent perspective. A letter penned in 1783 recounts the hardships encountered by the Farmar family during the British occupation of Philadelphia.

1775

1 "From the Letters of Josiah and Mary Bartlett of Kingston, New Hampshire, 1775-1778." In <u>The Old Revolutionaries: Political Lives in the Age of Samuel Adams</u>, by Pauline Maier. New York: Alfred A. Knopf, 1980, pp. 139-63.
 Printed here are sixteen letters by **Mary Bartlett** to her husband, Josiah, written while he was a member of the Continental Congress in Philadelphia. Mary's correspondence, for the most part, is confined to news of family members, farm conditions, and illness and death among the townspeople. Nevertheless, her letters include, on occasion, accounts of local developments related to the Revolution as well as her own thoughts on the unfolding crisis.

2 "The Hodgkins Letters, May 7, 1775, to January 1, 1779." In <u>This Glorious Cause . . . The Adventures of Two Company Officers in Washington's Army</u>, by Herbert T. Wade and Robert A. Lively. Princeton, N.J.: Princeton University Press, 1958, pp. 165-245.

13

Twenty letters included in an appendix to this book were written by **Sarah Perkins Hodgkins** (1750?-1803) of Ipswich, Massachusetts, to her husband, Joseph, a shoemaker who was serving as an officer in the American revolutionary army. In addition to providing information on the activities of women on the home front during the war, the letters reveal a great deal about the emotional texture of late eighteenth-century marital relationships. The depth of Sarah's feeling for her husband comes through clearly in her frequently expressed longing for his return as well as her ever-present concern for his safety and health. Evidence of Sarah's abiding faith in Divine Providence pervades these letters.

1776

1 "'A Diary of Trifling Occurrences,' Philadelphia, 1776-1778." [Introduction by Nicholas B. Wainwright.] <u>Pennsylvania Magazine of History and Biography</u> 82 (1958):411-65.
 The political turmoil of the American Revolution was uppermost in the mind of **Sarah Logan Fisher** (1751-96), a young wife and mother from a prominent Philadelphia Quaker family, as she wrote in her diary from November 1776 to June 1778. Her pronounced Loyalist sympathies colored her reports of war news, and her denunciations of the leaders of the new revolutionary government were filled with emotion. Fisher's suffering became intensely personal in September 1777 when her husband was taken prisoner by the revolutionaries and exiled to Virginia while she was in the latter stages of a pregnancy. Following the British occupation of Philadelphia, she was forced to cope with a scarcity of provisions and hard money. Throughout the crisis, Fisher attended Quaker meeting regularly and maintained her faith that Providence would deliver her brethren from their plight.

2 <u>Personal Recollections of the American Revolution: A Private Journal. Prepared from Authentic Domestic Records by Lydia Minturn Post</u>. Edited by Sidney Barclay [pseud.]. Port Washington, N.Y. and London: Kennikat Press, 1970, 251 pp. [Originally published in 1859.]
 During the revolutionary war, **Lydia Minturn Post** endured both separation from her husband, an officer in the American army, and the privations associated with the British occupation of Long Island. The journal she kept for her absent husband between 1776 and 1783 details the stressful conditions under which she, her father--an Anglican clergyman--and her three children lived and traces the evolution of her views on the war. Deeply moved by the victimization of neighboring farmers, particularly those of the Quaker faith, and herself forced to quarter Hessian troops, Lydia was steadfast in her patriotism. She offered informed comments on political and military

developments and continually underscored the righteousness of the American position. Nevertheless, her prolonged exposure to the cruelties and uncertainties of war, coupled with the experience of nursing a dying British officer in her home, tempered her commitment to the revolutionary cause while strengthening her religious faith and humanitarian sensibilities.

3 Private Journal Kept during the Revolutionary War, by Margaret Morris. [New York]: New York Times, Arno Press, 1969, 36 pp. [Originally published in 1836.]
 Margaret Hill Morris (1737-1816), a devout Quaker widow of Burlington, New Jersey, had no doubt that it was Providence that preserved her and her children when her town became the scene of conflict between Americans and Hessian troops during the revolutionary war. Morris noted the events of the period from December 1776 to June 1777 in copious detail in a diary she kept for her sister, freqently expressing her sympathy for the victims of the war. In addition, she willingly answered calls to render medical and humanitarian aid to needy persons, whatever their politics.

1777

1 "The Cornelia (Bell) Paterson Letters." [Edited by] J. Lawrence Boggs. Proceedings of the New Jersey Historical Society, n.s. 15 (1930):508-17; n.s. 16 (1931):56-67, 186-201.
 Separated from her brother throughout the American Revolution because of his Loyalist views, **Cornelia Bell Paterson** (1755-83), of Raritan, New Jersey, corresponded with him regularly between 1777 and 1783. Carefully avoiding political debate, Paterson assured him of her continuing affection and expressed her concern for his welfare. Following her marriage in 1779, she wrote him of her happiness and later joyfully conveyed the news of the birth of her daughter. Paterson also communicated important information to her brother about the distribution of family property according to their father's will.

2 Sally Wister's Journal: A True Narrative Being a Quaker Maiden's Account of Her Experiences with Officers of the Continental Army, 1777-1778. Edited by Albert Cook Myers. Philadelphia: Ferris & Leach Publishers, 1902, 224 pp.
 When her family moved from Philadelphia to a Montgomery County, Pennsylvania, farmhouse to escape the dangers of the American Revolution, **Sarah (Sally) Wister** (1761-1804), a teenaged Quaker girl, decided to chronicle her experiences for her closest friend, Deborah Norris. The British and American armies were both situated near the Wisters' temporary residence and Sally's journal, which covers the period from September 1777 to June 1778, periodically mentioned her anxiety over being caught in the middle of a battle. But, for the most part, Sally focused her

attention on her encounters with the American officers who
stopped at her house. Clearly fascinated with the appearance and
manners of these military men, Sally fashioned elaborate accounts
of her conversations with them and speculated endlessly on their
attributes. Caught up in her own romantic musings, Sally rarely
commented on the progress of the war. Another published version
of this journal is "Journal of Miss Sally Wister," Pennsylvania
Magazine of History and Biography 9 (1885):318-33, 463-78; 10
(1886):51-60.

1778

1 "'A dear dear friend': Six Letters from Deborah Norris to
 Sarah Wister, 1778-1779." [Edited by] Kathryn Zabelle
 Derounian. Pennsylvania Magazine of History and Biography 108
 (1984):487-516.
 The letters **Deborah Norris** (Logan) (1761-1839), a
 Philadelphia Quaker, wrote to her best friend Sarah (Sally)
 Wister in 1778 and 1779 help us understand the meaning attached
 to friendship by upper-class adolescent girls. As Deborah's
 closest friend, Sally was the repository not only of her trust
 and affection but of her confidences and self-doubts. Deborah's
 letters abounded in intimate references as she discoursed on the
 character and behavior of the young men and women in their social
 circle. In her writings, Deborah took scant note of the revolu-
 tionary drama that enveloped Philadelphians, preferring to
 concentrate on the gossip and musings that fascinated female
 adolescents. See 1779.1 for other letters by Deborah Norris.
 See 1777.2 for the journal kept by Sally Wister.

2 "Diary of Grace Growden Galloway." With an introduction and
 notes by Raymond C. Werner. Pennsylvania Magazine of History
 and Biography 55 (1931):32-94; 58 (1934):152-89. Reprinted as
 Diary of Grace Growden Galloway: Journal Kept June 17, 1778
 through September 30, 1779. New York: Arno Press, 1971.
 The troubles that engulfed **Grace Growden Galloway** (?-1782)
 of Philadelphia after her Loyalist husband fled to England with
 the couple's only daughter during the revolutionary war are
 brought vividly to life in the diary Galloway kept from June 1778
 to September 1779. As she struggled in vain to prevent the
 confiscation of her husband's estate and the sequestration of her
 own inherited property, Galloway became embittered against the
 former friends of her family who tried to help her. Her suf-
 ferings in body and spirit multiplied with the realization that
 she had been relegated from the pinnacle of wealth and prestige
 to a position of near-poverty. Tormented by the prolonged
 separation from her daughter and increasingly suspicious of her
 Philadelphia circle, Galloway found a release for her feelings of
 sorrow and anger in her diary. As she publicly blamed her plight

on the conduct of the British army, Galloway, in her private diary, vilified her husband for his failure to protect her interests.

3 "Mrs. Almy's Journal: Siege of Newport, R.I., August 1778." <u>Newport Historical Magazine</u> 1 (1880-81):17-36.
 In July and August 1778, Americans and their French allies attacked Newport, Rhode Island, which had been occupied by the British since early in the revolutionary war. During the siege, **Mary Gould Almy** (1735-1808), an ardent Loyalist, kept this journal for her husband, who was fighting on the American side. Mrs. Almy painted a graphic picture of the battle, detailed her own suffering and her efforts to protect herself and her children, and voiced her political views in no uncertain terms.

<u>1779</u>

1 "The Norris-Fisher Correspondence: A Circle of Friends, 1779-82." Edited by John A.H. Sweeney. <u>Delaware History</u> 6 (1954-55):187-232.
 The importance of correspondence in sustaining the ties of friendship between upper-class females in the late eighteenth century is made clear in this collection of letters written by three young single Philadelphia Quakers--**Sarah (Sally) Fisher** (Dawes) (1759-89), **Deborah Norris** (Logan) (1761-1839), and **Sally Zane** (1754-1807)--between 1779 and 1782. The recipient of the letters with their affectionate sentiments was **Sally Fisher** (Corbit) (1758-89) of Kent County, Delaware, only one of whose letters has survived. The essence of the correspondence was the confidential exchange of information and opinions on the characters and romantic relationships of eligible young men and women but the letter writers also transmitted news of family and acquaintances and expressed pious thoughts at appropriate junctures. Their employment of the literary language of the period attests to their education and reading habits. The absence of direct references to the ongoing American Revolution by these young Quaker correspondents is suggestive. See 1778.1 for other letters by Deborah Norris.

2 "A Woman's Letters in 1779 and 1782." <u>South Carolina Histori-cal and Genealogical Magazine</u> 10 (1909):125-28.
 The close relationship between two well-to-do young South Carolina women, **Mary Lucia Bull** (Guerard) and Susanna (Sukey) Stoll Garvey, was tested during the revolutionary war. Lucia's two letters to Sukey in 1779 reported the disruption and uncer-tainty in her life and asserted her strong desire to be with her friend. In a letter written in 1782, after both women had married, Lucia pleaded with Sukey not to let her (Lucia's) marriage alter the feelings between them.

1781

1 "A Loyalist's Account of Certain Occurrences in Philadelphia
 after Cornwallis's Surrender at Yorktown: Extracted from the
 Diary of Miss Anna Rawle." <u>Pennsylvania Magazine of History
 and Biography</u> 16 (1892):103-7.
 In these entries from her diary for October 1781, **Anna
 Rawle** (Clifford) (1758-1828), a young single Quaker woman of
 Loyalist sympathies, described the damage that Whig crowds in-
 flicted on the homes of Loyalists in Philadelphia after receiving
 the news of the surrender of Lord Cornwallis in the revolutionary
 war.

1782

1 <u>Letters of Eliza Wilkinson, during the Invasion and Possession
 of Charlestown, S.C., by the British in the Revolutionary War</u>.
 Arranged from the original manuscripts by Caroline Gilman.
 New York: New York Times, Arno Press, 1969, 108 pp. [Orig-
 inally published in 1839.]
 Eliza Wilkinson, a young widow from an upper-class family
 living on Yonge's Island, near Charleston, South Carolina, wrote
 these twelve letters to an unnamed female friend in 1782.
 Strongly sympathetic to the cause of the American rebels in the
 revolutionary war, she paints a vivid picture of the dislocation
 and suffering caused by the invasion of the British. These
 letters, which describe in detail the plundering of her home by
 British soldiers and local Tories and the forced migration of her
 family around the countryside, convey forcefully the emotional
 toll exacted by these deprivations. Eliza's comments on the key
 issues of the crisis, interspersed with her narrative of events,
 attest to her familiarity with the political philosophy of the
 American revolutionaries.

2 "Letters of Molly and Hetty Tilghman: Eighteenth Century
 Gossip of Two Maryland Girls." Edited by J. Hall Pleasants.
 <u>Maryland Historical Magazine</u> 21 (1926):20-39, 123-49, 219-41.
 The courtship customs of the upper class in post-
 revolutionary Maryland emerge in sharp relief in the seventeen
 letters **Mary (Molly) Tilghman** and her sister **Henrietta Maria
 (Hetty) Tilghman** (Tilghman) (1763-96) wrote to a female cousin
 between 1782 and 1789. The character traits, wardrobe, and
 behavior of the belles and beaux of the sisters' social circle
 form the major topic of interest in these letters, all but two of
 which were penned by Molly, a young single woman who lived at
 her family home in Chestertown on the Eastern Shore of Maryland.
 In addition to speculating on the marriage prospects of various
 members of the elite, Molly frequently discussed her own family
 obligations. Her comments on the experiences of her sister,

Hetty, and other young married women of her acquaintance
illuminate contemporary attitudes toward pregnancy and child-
birth.

1783

1 Nancy Shippen Her Journal Book: The International Romance of
 a Young Lady of Fashion of Colonial Philadelphia with Letters
 to Her and about Her. Compiled and edited by Ethel Armes.
 Philadelphia: J.B. Lippincott Co., 1935, 349 pp.
 Despite her love for a French diplomat, **Anne (Nancy) Home
 Shippen Livingston** (1763-1841) was persuaded by family financial
 considerations to wed Henry Beekman Livingston, a wealthy New
 Yorker, only to have his abusive behavior drive her to return to
 her parents' home in Philadelphia with her baby daughter.
 Nancy's journal, embellished by an array of correspondence
 including numerous letters from her mother-in-law, **Margaret
 Beekman Livingston**, chronicles the unhappy course of her life
 between 1783 and 1791 as she attempted to cope with her predica-
 ment. She participated listlessly in the social rituals of the
 upper class, renewed her friendship with the French diplomat, and
 spent a good deal of time tending to her emotionally disturbed
 mother. Accustomed to lavishing her attention on her baby, the
 sole object of her affection, she was dismayed by her parents'
 insistence that she give up custody to her mother-in-law.
 Assigning imaginary names to the central figures in her world,
 Nancy was able to vent her anger toward her husband who spurned
 reconciliation, cast aspersions on her reputation, and threatened
 to deprive her of access to her child. Opposed by her parents in
 her futile attempts to obtain a divorce, she ironically found an
 ally in Margaret Livingston, who allowed her frequent visits from
 her daughter.

1785

1 The Adams-Jefferson Letters The Complete Correspondence
 beween Thomas Jefferson and Abigail and John Adams. Edited by
 Lester J. Cappon. 2 vols. Chapel Hill: University of North
 Carolina Press, 1959, 638 pp.
 Although the preponderance of the correspondence published
 in these volumes is that of Thomas Jefferson and John Adams, the
 collection includes twenty-seven letters from **Abigail Smith Adams**
 (1744-1818) to Thomas Jefferson. Of these letters, twenty were
 written from London between 1785 and 1788, and the remaining
 seven from Quincy, Massachusetts, four in 1804 and the others
 between 1813 and 1817. Abigail Adams's letters are always
 compelling, and even though this compilation contains only a
 small sampling of them, they again demonstrate the nature of her
 intellectual powers. These letters are of particular interest

for their analysis of Jefferson's presidency and the record of her feelings on the death of her daughter. See also 1762.1; 1788.2; 1808.1.

2 The History of Augusta First Settlements and Early Days as a Town Including the Diary of Mrs. Martha Moore Ballard (1785-1812), by Charles Elventon Nash. Augusta, Maine: Charles E. Nash & Son, 1904, pp. 229-464.

In the area surrounding what is now Augusta, Maine, **Martha Moore Ballard** (1735-1812) was highly regarded for her skills as a midwife and medical practitioner. The succinct entries in the diary Ballard kept from 1785 to 1812 document her work delivering babies and doctoring sick neighbors and, in addition, furnish a detailed picture of the manifold duties of an early American housewife. A religious woman active in church affairs, Ballard placed her trust in God as she approached old age.

3 "The Journal of Elizabeth Cranch." With an introductory note by Lizzie Norton Mason and James Duncan Phillips. Essex Institute Historical Collections 80 (1944):1-36.

An enlightening picture of the social rituals and amusements of young upper-class single women and men in post-revolutionary Massachusetts emerges from the journal kept by **Elizabeth Cranch** (Norton) (1763-?), a niece of Abigail Adams, during an extended visit to a close female friend in Haverhill in the fall and winter of 1785-86. Though absorbed in an unceasing round of visiting, going to meeting, lessons on the pianoforte, sleigh riding, and dancing assemblies, Cranch regularly paused to take stock of herself and her companions. Her reflections shed light on the character traits she prized as well as the nature of her religious beliefs.

4 "Letters of Hannah Thomson, 1785-1788." Pennsylvania Magazine of History and Biography 14 (1890):28-40.

Hannah Thomson, who moved to New York City with her husband, Charles Thomson, the Secretary of Congress, penned these letters to a male correspondent in her Philadelphia home between 1785 and 1788. The letters are mostly taken up with gossip concerning New York's fashionable society and particularly with the matches of eligible men and women. Mrs. Thomson also commented on some distinctive New York customs.

1787

1 Journal of a Young Lady of Virginia 1782. Edited by Emily V. Mason. Baltimore: John Murphy & Co., 1871, 56 pp.

The social world of youthful members of the late-eighteenth-century Virginia gentry is brought to life in the journal **Lucinda Lee** (Orr) kept for her sorely missed friend,

Polly Brent. During the course of making a round of visits to relatives in the Virginia countryside, Lucinda reported on her activities, which included calling on nearby families, attending parties, and dancing, and offered characterizations of beaux as well as female companions. Occasional comments on matrimony, novel reading and fashion afford some insight into Lucinda's mind. Although the date of this journal is given as 1782, it has been established that it was actually written in 1787.

2 "A Portion of a Journal of Cornelia, Daughter of Governor George Clinton." New York Genealogical and Biographical Record 20 (1889):40-41.

 This fragment from the 1787 journal of **Cornelia Clinton** (Genet), the daughter of New York governor George Clinton, describes last-minute social activities prior to her departure from New York City.

1788

1 "Mrs. Mary Dewees's Journal from Philadelphia to Kentucky." Edited by John L. Blair. Register of the Kentucky Historical Society 63 (1965):195-217.

 In 1788, **Mary Coburn Dewees** traveled with her husband and children from Philadelphia to the family's new home near Lexington, Kentucky. Dewees chronicled their adventurous journey across the mountains by wagon and down the Ohio River by boat in her journal. She marveled at the beautiful country abundantly filled with wildlife and praised the hospitality of the families that entertained them during their stay in Pittsburgh. Previously published editions of this journal are "Mrs. Mary Dewees's Journal from Philadelphia to Kentucky, 1787-1788," Pennsylvania Magazine of History and Biography 28 (1904):182-98, and R.E. Banta, ed., Journal of a Trip from Philadelphia to Lexington in Kentucky (Crawfordsville, Ind., 1936).

2 New Letters of Abigail Adams 1788-1801. Edited, with an introduction by Stewart Mitchell. Boston: Houghton Mifflin Co., 1947, 281 pp.

 The gift that **Abigail Smith Adams** (1744-1818) had for letter writing is displayed in exemplary fashion in this collection of her correspondence to her elder sister, Mary Cranch, covering the years 1788 to 1801. All but a few of these letters were penned while her husband, John Adams, was vice president and then president of the United States, and they offer her trenchant observations on society and politics in the successive capitals of the new republic--New York City, Philadelphia, and Washington. Unusually knowledgeable about the public issues of the day, Abigail was also highly partisan, and her letters constitute a valuable source for studying Federalist views. Abigail's private

concerns as a middle-aged wife, mother, and grandmother are also
well documented in this volume. Particularly enlightening are
her comments on her daughter's experiences of childbirth, the
illnesses of family members and friends, and the difficulties of
managing household servants. See also 1762.1; 1785.1; 1808.1.

1790

1 "Diary kept by Elizabeth Fuller, Daughter of Rev. Timothy
 Fuller of Princeton." In History of the Town of Princeton in
 the County of Worcester and Commonwealth of Massachusetts
 1759-1915, by Francis Everett Blake. 2 vols. Princeton,
 Mass.: Published by the town, 1915, 1:302-23.
 Although the entries in this diary of **Elizabeth Fuller**
 (1775-1856) of Princeton, Massachusetts, are exceedingly brief,
 they convey vividly the essence of the daily life of a teenaged
 girl in a New England town from 1790 to 1792. Elizabeth's
 household duties feature prominently in the diary, in particular,
 her major occupations of spinning and weaving. The diary also
 records family and community activities, including a quilting.
 Elizabeth notes her attendance at meeting and supplies an account
 of various preachers and their sermons. Occasionally, Elizabeth
 expresses her feelings in this otherwise matter-of-fact diary.

1791

1 Memoirs of the Life of Martha Laurens Ramsay, who Died in
 Charleston, S.C. on the 10th of June, 1811, in the 52nd year
 of her Age. With an appendix containing extracts from her
 diary, letters, and other private papers, and also from
 letters written to her, by her father, Henry Laurens, 1771-
 1776, by David Ramsay. 3d ed. Boston: Samuel T. Armstrong,
 1812, 280 pp.
 Included in this memorial to the pious life of **Martha
 Laurens Ramsay** (1759-1811) of Charleston, South Carolina, are
 extracts from her diary between 1791 and 1808 and a selection of
 her letters, some undated and the remainder from the years 1792
 to 1811. Spiritual matters were uppermost in Ramsay's mind,
 prompting her to fill her diary with prayers, condemnations of
 her own sins, notes on sermons, and instances of God's provi-
 dence. Family events such as the weaning of her daughter and the
 death of her sister are presented in a religious context. In her
 letters, Ramsay expressed her solicitude for the spiritual
 condition of her children and her friends, offering them counsel
 and recommending appropriate reading. Of particular interest is
 the series of letters written to her son at Princeton, urging him
 to improve in virtue and to take advantage of the opportunities
 afforded by a college education.

1794

1 "From Concord, Massachusetts, to the Wilderness: The Brown
 Family Letters, 1792-1852." [Edited by] Mary-Agnes Brown-
 Groover. New England Historical and Genealogical Register 131
 (1977):28-39, 113-20, 200-06.
 Several letters written by female members of the Brown
 family between 1794 and 1813 are included in this collection of
 correspondence documenting the migrations of an extended kinship
 network. **Elizabeth Brown Brown** (1753-1812) of Concord,
 Massachusetts, and her sisters, **Rebecca Brown French** (1763-1813)
 and **Anna Brown Spaulding** (1761-1825), both of Cavendish, Vermont,
 filled their letters with religious reflections and exhortations,
 leaving little space for family news. Of greatest interest is
 Anna's description of Rebecca's exemplary behavior on her
 deathbed.

1795

1 The Intimate Letters of John Cleves Symmes and His Family
 including Those of His Daughter Mrs. William Henry Harrison,
 Wife of the Ninth President of the United States. Edited by
 Beverley W. Bond, Jr. Cincinnati: Historical and Philosophi-
 cal Society of Ohio, 1956, 174 pp.
 Being the widow of a president of the United States did not
 shield **Anna Symmes Harrison** (1775-1864) from financial uncer-
 tainty in old age. That the protracted settlement of William
 Henry Harrison's estate compelled Mrs. Harrison to repeatedly
 request assistance from relatives is made clear in the twenty-
 three letters of hers printed in this volume, the majority of
 which date from the years 1845 to 1862. Apart from economic
 concerns, family news absorbed most of the attention of the aged
 widow, who lived on a farm in North Bend, Ohio. Nevertheless,
 her correspondence is a rich source for tracing an elderly
 woman's feelings on aging and ill health. In her calm prepara-
 tion for impending death, Mrs. Harrison was sustained by her
 strong religious faith. Also included in this book are a few
 letters of **Susan (Susanna) Livingston Symmes**, the third wife of
 Judge John Cleves Symmes, Anna Symmes Harrison's father. These
 letters, spanning the years 1795-1815, are of interest primarily
 for their detailed discussion of the problems arising from the
 monetary arrangements for Susanna Livingston Symmes's marriage.

1796

1 Chronicles of a Pioneer School from 1792 to 1833, Being the
 History of Miss Sarah Pierce and Her Litchfield School.
 Compiled by Emily Noyes Vanderpoel. Edited by Elizabeth C.
 Barney Buel. Cambridge, Mass.: Printed at the University
 Press, 1903, 465 pp.
 This large book is a compilation of chronologically
 organized documents relating to the history of Litchfield Female
 Academy in Connecticut. Among the students excerpts from whose
 diaries and letters are included in this volume are (dates of
 document given in parentheses) **Charlotte Sheldon** (1796), **Julia
 Cowles** (1797), **Lucy Sheldon** (1801), **Mary Ann Bacon** (1802),
 Catherine Cebra Webb (1816), **Caroline Chester** (1815-16), **Eliza
 Ogden** (1816-18), **Mary Chester** (1819), **Jane Lewis** (1820), and **Mary
 L. Wilbor** (1822). Most of these writings recount activities at
 school, friendships, and family events. This documentary
 collection also contains a selection of "Letters of Miss Sarah
 Pierce from 1802-1842." **Sarah Pierce** (1767-1852), the founder of
 Litchfield Academy, was a pioneer in female education. This cor-
 respondence, addressed to her brother, nephew, and other family
 members, deals with both school matters and personal affairs.
 See 1797.1 for the diary of Julia Cowles. See 1816.2 for the
 journal of Caroline Chester.

2 Memoir, Letters and Journal, of Elizabeth Seton, Convert to
 the Catholic Faith, and Sister of Charity. Edited by Robert
 Seton. 2 vols. New York: P. O'Shea Publisher, 1869,
 322 pp., 311 pp.
 Among the diverse materials assembled here to chronicle the
 life of **Elizabeth Ann Bayley Seton** (1774-1821), the first
 American saint and the founder of the Sisters of Charity--the
 first religious order composed of American women--are selections
 from her letters and journal spanning the years 1796 to 1820.
 Arranged chronologically, with connecting text and related
 documents supplied by the editor, Mother Seton's writings touch
 on her family difficulties, her decision to leave the Episcopal
 church and convert to Catholicism, her efforts to support
 herself, and her establishment of a religious community in
 Emmitsburg, Maryland. The documents shed light on the evolution
 of Mother Seton's religious faith and make clear her deep love
 for her children and friends. See also 1798.1.

1797

1 The Diaries of Julia Cowles: A Connecticut Record, 1797-1803.
 Edited by Laura Hadley Moseley. New Haven: Yale University
 Press, 1931, 94 pp.
 The intellectual and emotional development of a young girl
 raised in genteel society can be traced in the series of diaries

kept by **Julia Cowles** (1785-1803) of Farmington, Connecticut, between 1797 and 1803. The earliest diary, dating from 1797 when Julia was a student at Sally Pierce's school in Litchfield, Connecticut, consists of summaries of history lessons and sermons, along with notes on reading, sewing, and good behavior. Julia's 1799-1800 diary concentrates on her social activities among a circle of female and male friends in Farmington, but also covers a stint at school in Middletown, Connecticut. By the time she commenced her final diary in 1802, religion had assumed a prominent place in Julia's life, and her entries exhibited an introspective dimension previously lacking. She criticized herself for pursuing worldly pleasures instead of following God's way. As her health deteriorated, Julia increasingly reflected on her own mortality and focused her thoughts on preparing for death. See also 1796.1.

2 "The Diary of Frances Baylor Hill." [Introduction by William K. Bottorff and Roy C. Flannagan.] <u>Early American Literature Newsletter</u> 2 (1967):4-53.
 In the diary she kept in 1797, **Frances Baylor Hill**, the single daughter of an upper-class family of King and Queen County, Virginia, preserved a detailed record of her everyday activities. Rarely hinting at her feelings, Frances dutifully noted her daily stint of sewing or knitting various articles of apparel, commented on the books that she read, and listed the names of the company who arrived at her house and the people she encountered in her frequent rounds of visiting. Immersed in an extensive social network, Frances spent much of her time with young men and women her own age playing games, singing, dancing, and conversing. She also attended church regularly and occasionally went to weddings and funerals.

3 <u>A Girl's Life Eighty Years Ago: Selections from the Letters of Eliza Southgate Bowne</u>. With an introduction by Clarence Cook. New York: Charles Scribner's Sons, 1887, 239 pp.
 The path that young girls of the upper class traversed on their way to marriage and motherhood is aptly illustrated in the polished letters **Eliza Southgate Bowne** (1783-1809), the daughter of a well-to-do Scarborough, Maine, family, penned between 1797 and 1809. Recipient of a superior education, Eliza demonstrated her intellectual prowess in a spirited exchange with a male cousin in which she debated the characteristics and proper roles of females and males. Traveling in the company of a prominent family afforded Eliza the opportunity to refine her social skills as well as to meet eligible young men. She furnished her parents not only with an account of her initiation into the elite social world but with the news of her courtship. In her letters following her marriage to Walter Bowne, she exuded happiness in her new life in New York City. She related her enjoyment in

sightseeing, the theater, fashion, and visiting with friends and noted with pleasure the birth of two children. Her final letters prior to her early death recount her trip to Charleston, South Carolina, for her health.

1798

1 Letters of Mother Seton to Mrs. Julianna Scott. [Edited by] Joseph B. Code. 2d ed. New York: Father Salvator M. Burgio Memorial Foundation in Honor of Mother Seton, 1960, 294 pp.

 Julianna Scott was a close friend of **Elizabeth Ann Bayley Seton** (1774-1821), both before and after Seton's conversion to Catholicism in 1805. Mother Seton, the first American saint and the founder of the Sisters of Charity, corresponded with Scott between 1798 and 1820, and her letters, printed here in their entirety, increase our understanding of her life and thought. Her early letters, written from New York City, center on her family and contain absorbing accounts of the birth of her children and their development. Seton experienced many personal sorrows, and she wrote movingly of the deterioration of her husband's business affairs, his declining health, his death in Italy, and her widowhood. The letters are most valuable for the perspective they give on Seton's spiritual odyssey--her initial loyalty to the Episcopal church, her religious questioning, her conversion to Catholicism in 1805, and her founding of a religious community. See also 1796.2.

1799

1 Memoranda and Correspondence of Mildred Ratcliff. Philadelphia: Friends Book Store, 1890, 210 pp.

 Believing herself to be an instrument of God, **Mildred Morris Ratcliff** (1773-1847) traveled extensively as a Quaker minister to promulgate the message of her faith. Her memoranda (journal entries) and letters spanning the years 1799 to 1838 provide valuable insight into her conception of her work and also illuminate her personal beliefs. Ratcliff, who lived successively in Virginia, Ohio, and Pennsylvania, periodically felt compelled to leave her husband in order to speak to Quakers and non-Quakers in communities throughout the United States. As she made her way across the landscape, Ratcliff customarily recorded the precise nature of her participation in each meeting, often noting how God had empowered her to preach. She assessed the spiritual condition of the members of her audiences and offered strictures on the worldliness of many self-styled professors of the faith. Uncompromising in her adherence to the Quaker verities, Ratcliff issued dire warnings on the conflicts that were then rending the Quaker sect. A tender counselor of other Friends, Ratcliff subjected her own soul to intense scrutiny,

prayed fervently, and expressed her gratitude for God's assistance in her trials.

1800

1 "Diary of Mrs. William Thornton, 1800-1863." In <u>Records of the Columbia Historical Society Washington, D.C.</u> Vol. 10. Washington, D.C.: Published by the Society, 1907, pp. 88-226.
 The kaleidoscopic picture of life in the new federal city of Washington, D.C., captured in the 1800 diary of **Anna Maria Brodeau Thornton** (m. 1790), the wife of Dr. William Thornton, an architect and commissioner of the city, immerses the reader in the everyday world of a privileged young woman who was present during the establishment of the national government in Washington. Because of her husband's position, Mrs. Thornton was a witness to historic events and a participant in the social life of the Washington elite. Her brief but telling accounts of visits with the recently widowed Martha Washington and Abigail Adams embellish a daily record replete with details of entertaining famous personages and attending plays and assemblies. Mrs. Thornton's diary also sheds light on a variety of other matters ranging from household affairs and family finances to the role of blacks in Washington's economy. Despite its title, the diary printed here covers only the year 1800.

2 <u>The First Forty Years of Washington Society in the Family Letters of Margaret Bayard Smith.</u> Edited by Gaillard Hunt. 1906. Reprint. New York: Frederick Ungar Publishing Co., 1965, 424 pp.
 The voluminous correspondence and notebooks of **Margaret Bayard Smith** (1778-1844) from 1800 to 1841 were gleaned by the editor of this volume for selections that would cast light on the political and social life of Washington, D.C. Smith, who came to the new capital as a young bride and remained there for the rest of her life, moved in the top echelons of society and frequently met with leading government figures. An observant woman whose demonstrated talent for writing was displayed in a number of publications, Smith regaled her relatives with pen portraits of such luminaries as Thomas Jefferson, James Madison, and Dolley Madison. She also produced lavishly detailed accounts of ceremonial occasions, private parties, and visits to Monticello and Montpelier. Politics, fashions, and manners all came under her scrutiny, as she chronicled Washington's evolution over four pivotal decades in the nation's history. Although Smith's personal and domestic concerns are touched on only peripherally in these selections, her remarks suffice to provide a sense of her experiences as a wife, mother, and mistress of a household.

3 Life and Letters of Catharine M. Sedgwick. Edited by Mary E.
 Dewey. New York: Harper & Brothers, 1871, 446 pp.
 Although **Catharine Maria Sedgwick** (1789-1867) attained con-
 spicuous success as the author of novels and moralistic tracts
 for children, she prized her ties with members of her family
 above everything. These selections from Sedgwick's letters and
 journal spanning the years 1800 to 1867 show the deep affection
 she had for her nieces, nephews, sisters, and especially two of
 her brothers, with whom she shared residences in Lenox,
 Massachusetts, and New York City. Notwithstanding the closeness
 she felt for her kin, Sedgwick was troubled by being single and
 admitted the sense of incompleteness she felt. Interspersed
 among her lengthy accounts of family affairs and her comments on
 her writing, her reading, her contemporary literary figures,
 current politics, social engagements, and sightseeing trips are
 revelations of her need for affection. Religion occupied a
 prominent place in Sedgwick's mind, and her letters offer insight
 into the questioning that led her to abandon orthodox Calvinism
 and join the Unitarian church.

4 A Season in New York 1801: Letters of Harriet and Maria
 Trumbull. Edited by Helen M. Morgan. [Pittsburgh]: Univer-
 sity of Pittsburgh Press, 1969, 189 pp.
 To acquire the social skills befitting their station in
 life, **Harriet Trumbull** (Silliman) (1783-1850) and her sister
 Maria Trumbull (Hudson) (1785-1805), the teenaged daughters of
 the governor of Connecticut, spent the winter and spring of
 1800-1 in New York City. The letters each sister wrote to
 their parents in Lebanon and Hartford, Connecticut, during this
 time chronicle their initiation into upper-class New York
 society. Though primarily taken up with notes on visiting,
 parties, plays, shopping, churchgoing, and drawing, dancing, and
 music lessons, the letters do impart a sense of the girls' con-
 servative social values.

 1801

1 "Eleanor Parke Lewis to Mrs. C.C. Pinckney." Edited by Alston
 Deas. South Carolina Historical Magazine 63 (1962):12-17.
 As the granddaughter of George Washington's widow, **Eleanor
 Parke Lewis** not surprisingly was a vigorous champion of the Fed-
 eralist cause. In two letters written from Mount Vernon in 1801
 and 1802 to Mary Pinckney, wife of Charles Cotesworth Pinckney,
 the defeated Federalist nominee for president in the election of
 1800, Lewis voiced her political sympathies and elaborated on her
 antipathy for Democrats with a scathing denunciation of Joseph
 Alston, the husband of Vice President Aaron Burr's daughter
 Theodosia. Lewis's letters to Mrs. Pinckney also contain news of

her husband, two young daughters, Martha Washington, and other
family members.

2 "A New England Woman's Perspective on Norfolk, Virginia,
 1801-1802: Excerpts from the Diary of Ruth Henshaw Bascom."
 [Edited by] A.G. Roeber. Proceedings of the American Anti-
 quarian Society 88, pt. 2 (1978):277-325.
 Between November 1801 and June 1802, **Ruth Henshaw** (Miles)
 (Bascom) (1772-1848), a single woman from Leicester, Massachu-
 setts, made an extended visit to the family of a baker who had
 recently moved from New England to Norfolk, Virginia. From the
 brief factual entries in her diary, it is possible to reconstruct
 Ruth's active everyday life while in Norfolk. A working member
 of the household, Ruth sewed, ironed, and kept business accounts
 for her host. In her leisure time, she enjoyed churchgoing,
 shopping, reading books from the library, and playing cards,
 checkers, and backgammon. Ruth's diary also contains her obser-
 vations on Norfolk society and news of a rumored insurrection of
 blacks.

3 "Susan Assheton's Book." Edited by Joseph M. Beatty, Jr.
 Pennsylvania Magazine of History and Biography 55 (1931):
 174-86.
 The book kept by **Susan Assheton** (1767-?) between 1801 and
 1832 is less a diary than a compendium of information deemed
 important by Assheton, a single woman from a prominent
 Philadelphia family. The heart of the little book is a listing
 of the births, marriages, and deaths of family members, friends,
 and famous persons in the United States and Europe. A sense of
 Assheton's strong religious convictions as a Universal Baptist
 can be gleaned from her praise for the pious lives of some of
 the departed.

1802

1 "Diary of Mary Orne Tucker, 1802." Essex Institute Histori-
 cal Collections 77 (1941):306-38.
 The seriousness with which **Mary Orne Tucker** (1775-1806), a
 young married woman of Haverhill, Massachusetts, took religion is
 evident in the diary she kept in April and May 1802. Tucker
 endeavored to conduct her life according to Christian precepts,
 and her diary is largely taken up with notes on sermons, the
 merits of her preacher, the admission of new church members,
 religious meetings in her home, and thumbnail sketches of the
 virtues and faults of her acquaintances. A person of firm
 convictions, she ventured her opinions on a variety of topics--
 poverty, novel reading, celibacy, Quakers, and the Sabbath. The
 diary is also instructive in elucidating Tucker's conception of

the role of wife and the nature of her relationships with female friends.

1803

1 Corresondence of Aaron Burr and His Daughter Theodosia.
 Edited, with a preface by Mark Van Doren. New York:
 Covici-Friede, 1929, 349 pp.
 Theodosia Burr Alston (1783-1813) idolized her father,
 Aaron Burr, notwithstanding his tarnished reputation in American
 political circles. Her letters to him, dating from 1803 and from
 1808 to 1812, reveal the unusual intimacy and trust that existed
 between them. Regarding her father as an equal, Theodosia
 analyzed his problems and went on to speculate on her own charac-
 ter. Married to a South Carolina planter, she wrote in great
 detail about her husband and her child as well as her health and
 social life. She also discoursed freely on political affairs and
 financial matters. Theodosia was exceptionally well educated,
 and her letters testify to her intelligence and sophistication.

1804

1 Henry and Mary Lee Letters and Journals: With Other Family
 Letters 1802-1860. Edited by Francis Rollins Morse. Boston:
 Privately printed, 1926, 423 pp.
 The personal writings of **Mary Jackson Lee** (1783-1860)
 included in this compilation of family correspondence allow us to
 follow an upper-class Boston woman through the stages of her
 adult life. A journal kept for her merchant husband between 1813
 and 1816, when he was in India, and over 50 letters, spanning the
 years 1804 to 1859, supply ample documentation for studying Mrs.
 Lee's relationships with her husband, children, and grand-
 children, her conception of the role of mother, her religious
 beliefs, and her notion of aging. Analysis of the changes in
 Mrs. Lee's self-image over the decades is facilitated by the
 numerous introspective passages in her journal and letters.

2 Life and Letters of Dolly [sic] Madison, by Allen C. Clark.
 Washington, D.C.: Press of W.F. Roberts Co., 1914, 517 pp.
 This compendium of documents relating to the life of **Dolley
 Payne Todd Madison** (1768-1849), the wife of President James
 Madison, contains numerous letters written by Mrs. Madison
 between 1804 and 1849. Mrs. Madison's letters, many of which are
 reprinted from Memoirs and Letters of Dolly [sic] Madison, are
 supplemented by the writings of other people who knew her, and
 all are organized chronologically, with a connecting narrative
 supplied by the author. See also 1804.3.

3 <u>Memoirs and Letters of Dolly [sic] Madison, Wife of James</u>
 <u>Madison, President of the United States</u>. Edited by her
 grandniece [Lucia B. Cutts]. Boston and New York: Houghton,
 Mifflin & Co., 1886, 210 pp.
 This biographical memoir contains a sampling of letters
 written by **Dolley Payne Todd Madison** (1768-1849), the wife of
 President James Madison, between 1804 and 1837 from Philadelphia,
 Washington, D.C., and Montpelier, the Madison plantation in
 Orange County, Virginia. Though rarely introspective, the let-
 ters make plain the deep love Mrs. Madison felt for her husband,
 her disappointment in her son by her first marriage, her close-
 ness to her younger sister, and her abiding concern for her
 nieces. Also of interest are Mrs. Madison's observations on
 Washington politics and society and her personal account of the
 evacuation of the White House during the War of 1812. Several
 letters of other women are also included in this volume. See
 also 1804.2.

1805

1 <u>Blacks in Bondage: Letters of American Slaves</u>. Edited by
 Robert S. Starobin. New York: New Viewpoints, 1974, 196 pp.
 Letters composed by black Americans under slavery are
 extremely rare. This invaluable collection of slave correspon-
 dence, culled from a variety of sources, contains letters writ-
 ten by fifteen female slaves in different locales between 1805
 and 1864. Ranging from brief fragments to complete letters,
 some dictated and others penned by the women themselves, these
 remarkable documents offer a tantalizing glimpse of the lives of
 female slaves. The most extensive sampling of female correspon-
 dence in the volume comes from **Hannah Valentine**, an elderly
 house servant on a plantation in Abingdon, Virginia. When
 Hannah's master became the governor of Virginia, he took some of
 his slaves--among them Hannah's husband and a few of her
 children--to Richmond with his family. In separate letters
 written to her mistress, husband, and daughter in 1837 and 1838,
 Hannah conveyed news of the plantation and the neighborhood and
 expressed her strong feelings for both her own and her master's
 family. These three letters also reveal the depth of Hannah's
 religious convictions and her approbation of genteel conduct.

2 <u>Diary of Sarah Connell Ayer: Andover and Newburyport,</u>
 <u>Massachusetts, Concord and Bow, New Hampshire, Portland and</u>
 <u>Eastport, Maine</u>. Portland, Maine: Lefavor-Tower Co., 1910,
 404 pp.
 The everyday life of a genteel New England woman from
 adolescence to middle age is traced in painstaking detail in the
 diary kept by **Sarah Newman Connell Ayer** (1791-1835) between 1805
 and 1835. Ayer spent her teen years in a warm family circle in

1805

Newburyport, Massachusetts, and Concord and Bow, New Hampshire. Her diary records the pleasure she derived from making visits to relatives in Andover, attending school, reading, shopping, sharing confidences with close female friends, and dancing at assemblies. The tone of Ayer's diary altered perceptibly fol- lowing her marriage and the loss of her first four children, as religious values moved to the forefront of her consciousness. Conversations on spiritual matters, participating in church affairs and female prayer meetings, and recording the sermons of orthodox ministers took the place of the amusements of her youth. Ayer now applied a spiritual yardstick to distinguish her Christian friends from other people with whom she came into con- tact. Disappointed by her husband's lack of concern for the state of his soul, she concentrated her attention on the reli- gious instruction of her offspring. She wrote feelingly of her continuing hopes for her children despite their failure to live up to her uncompromising standards.

3 Tryphena Ely White's Journal: Being a Record, Written One
 Hundred Years Ago, of the Daily Life of a Young Lady of
 Puritan Heritage. New York: Privately printed, 1904, 43 pp.
 In 1805, **Tryphena Ely White** (1784-1816), a young single
 woman, moved with her parents and brothers from West
 Springfield, Massachusetts, to Onondaga County, New York. Her
 diary recounts her household labors, her attendance at Methodist
 preaching, and the social life in her new neighborhood. Of par-
 ticular interest is the rapidity with which Tryphena and her
 stepmother were incorporated into the local female network.

 1807

1 "Correspondence Between John Adams and Mercy Warren Relating
 to Her 'History of the American Revolution,' July-August
 1807." [Edited by Charles Francis Adams.] Collections (of
 the Massachusetts Historical Society), 5th ser., 4 (1878):
 317-511. Reprinted as Correspondence between John Adams and
 Mercy Warren Relating to Her "History of the American Revolu-
 tion," July-August 1807. With a new appendix of specimen
 pages from the History, 1805. New York: Arno Press, 1972,
 various pagings.
 The publication of her History of the Rise, Progress and
 Termination of the American Revolution in 1805 led to a bitter
 exchange of letters in 1807 between author and revolutionary
 patriot **Mercy Otis Warren** (1728-1814) and her old friend, John
 Adams. Warren, whose political sympathies lay with the
 Jeffersonian Republicans, endeavored to defend her work against
 the criticisms leveled by Adams, who was disturbed by the un-
 flattering way in which he was portrayed in the book. Her

spirited letters attest not only to her intellect but to her
acute political sense.

2 Journey to the Promised Land: The Journal of Elizabeth
 Van Horne 1807. [Edited by] Elizabeth Collette.
 [Pittsburgh]: The Historical Society of Western
 Pennsylvania, December 1939, 23 pp.
 In 1807, **Elizabeth (Eliza) Van Horne** (Collette) (1776–
 1846), a thirty-year-old single woman, set out from Scotch
 Plains, New Jersey, with her parents, sisters, and brother for
 Lebanon, Ohio, to settle on land granted to her father, a
 Baptist minister, in return for his services as a chaplain
 during the revolutionary war. Eliza's account of the family's
 journey, composed for friends in New Jersey, comments on the
 conditions of travel, accommodations, towns visited, and her own
 activities. The central preoccupation of her journal, however,
 is her father's illness and death when the family reaches
 Pittsburgh. Eliza expressed strong feelings at this calamity,
 and in fact, the journal breaks off at this point and is con-
 tinued in retrospect a few months later after the remaining
 travelers have arrived in Ohio. This latter portion of the
 journal contains a description of the death and funeral of the
 Reverend Van Horne as well as observations on the town and
 people of Lebanon, Ohio.

1808

1 "Abigail Adams, Commentator." Edited by Allyn B. Forbes.
 Proceedings (Massachusetts Historical Society) 66 (1936-41):
 126-53.
 In these letters to her married daughter, all but one
 penned in 1808, **Abigail Smith Adams** (1744-1818) focused her
 attention on public affairs. She discoursed on current politi-
 cal issues at great length while defending the reputation of her
 son John Quincy Adams. The letters also contain comments on her
 grandchildren and news of other family members. See also
 1762.1; 1785.1; 1788.2.

2 "The Diary of Frances Few, 1808-1809." Edited by Noble E.
 Cunningham, Jr. Journal of Southern History 29 (1963):
 345-61.
 As the niece of Mrs. Albert Gallatin, the wife of the
 secretary of the treasury, **Frances Few** (Chrystie) (1789-1885)
 was in a unique position to meet the luminaries of the federal
 government when she visited Washington, D.C., in the winter of
 1808-9. The diary that nineteen-year-old Frances kept during her
 stay attests to her keen powers of observation, with its vivid
 descriptions of President Thomas Jefferson, President-elect James
 Madison and his wife Dolley, several congressmen, and a number of

other prominent figures. Frances was privileged to attend
congressional debates, receptions at the White House, and
Madison's inauguration. Surprisingly, however, much of her time
was occupied with reading and personal reflection, and her diary
contains a valuable record of the books and magazines she read.

3 Letters of Rebecca Gratz. Edited, with an introduction and
 notes by David Philipson. Philadelphia: Jewish Publication
 Society of America, 1929, 454 pp.
 An unusually extensive picture of the life of a well-to-do
single Jewish woman from Philadelphia is presented in the letters
of **Rebecca Gratz** (1781-1869) to her brother and his first and
second wives between 1808 and 1866. Gratz's deep-seated affec-
tion for her family, her devotion to the Jewish faith, and her
unstinting efforts in behalf of charitable and educational
enterprises such as the Philadelphia Orphan Society and the
Hebrew Sunday School Society are all well documented in the cor-
respondence. A discerning observer of the social scene, Gratz
furnished her Lexington, Kentucky, relatives with detailed
descriptions of events and personalities and supplemented them
with her own reflections on the human condition. Her letters
also contain her views on social and political issues, current
literature, and the experience of growing old.

4 Memoirs of the Late Mrs. Susan Huntington, of Boston, Mass.
 Consisting Principally of Extracts from her Journal and
 Letters: with the Sermon occasioned by her Death, by
 Benjamin B. Wisner. 2d ed. Boston: Crocker & Brewster,
 1826, 392 pp.
 Conscious of her influence as the wife of a Boston minis-
ter, **Susan Mansfield Huntington** (1791-1823) had a well-
articulated set of beliefs about the proper behavior of women.
In these chronologically arranged excerpts from her letters and
journal between 1808 and 1823, the rules by which she conducted
her life and the precepts she endorsed come into sharp focus. A
firm advocate of the value of domesticity, Huntington concen-
trated her energies on running her household and caring for her
children. She took her responsibilities as a mother very
seriously and frequently discoursed on the education and
discipline of children. The emphasis she placed on personal
religion is evident in the host of introspective passages in
which she assessed her own spiritual condition and established
goals for improvement. Her husband's sudden death in 1819 cast
Huntington in a new role, that of widow, and her subsequent
writings shed considerable light on the magnitude of her adjust-
ment. She commented on the financial provisions made for her by
the congregation, noted her identification with other widows of
clergymen, and, most interesting, expressed her sense of dis-
placement when she was required to move from the parsonage.

1809

1 "Diary and Letters of Caira Robbins, 1794-1881." [Edited by]
 Ellen A. Stone. Proceedings of the Lexington Historical
 Society 4 (1905-10):61-81.
 This compilation of selections from the personal writings
 of **Caira Robbins** (1794-1881), a single woman of East Lexington,
 Massachusetts, includes examples of the terse factual entries in
 her diary over the years 1809-23 as well as a few letters dating
 from 1828 and 1829. Robbins noted her routine activities and her
 visits to a sister in Montpelier, Vermont, and penned a lengthy
 description of a trip to Niagara Falls.

2 Fifteen Letters of Nathalie Sumter. [Introduction and
 Notations by Mary Virginia Saunders White.] Columbia, S.C.:
 Printed for Gittman's Book shop by the R.L. Bryan Company,
 1942, 124 pp.
 Of French birth, Roman Catholic faith, superior education,
 and upper-class status, **Nathalie de Delage Sumter** (1782-1841)
 stood out from her contemporaries in early nineteenth-century
 America. Her correspondence, spanning the years 1809-25, is of
 unusual interest for this reason as well as because she was a
 talented writer. Five letters penned in 1809, while she and her
 young children were traveling from their home in South Carolina
 to Washington, D.C., reveal her as an acute observer of planta-
 tion society and a perceptive commentator on childrearing. But
 it is Sumter's forthright discussion of health matters, including
 her own pregnancy, that distinguishes these letters. Another
 letter written in 1823 from Charleston describes preparations for
 a trip to Paris. Sumter's remaining correspondence in this col-
 lection emanated from Rio de Janeiro, where her husband was min-
 ister to Portugal, and Paris.

1810

1 A Journey to Ohio in 1810 as Recorded in the Journal of
 Margaret Van Horn Dwight. Edited by Max Farrand. New Haven:
 Yale University Press, 1912, 64 pp.
 The perils of long-distance travel by wagon in 1810 are
 amusingly related in the journal of **Margaret Van Horn Dwight**
 (Bell) (1790-1834), a young single woman from New Haven,
 Connecticut, who was joining her cousins in Warren, Ohio. Dread-
 ful road conditions in the Pennsylvania mountains, deplorable
 accommodations, and strange customs all figure prominently in
 Margaret's account, which is distinguished for its pithy descrip-
 tions of her traveling companions and the assortment of unsavory
 characters she encountered along the way. Margaret's harshest
 criticisms were reserved for Pennsylvania "Dutchmen" and

waggoners, both of whom departed egregiously from the New England standards of propriety that guided Margaret's life.

1811

1 Life of Abby Hopper Gibbons: Told Chiefly through Her Corresponence. 2 vols. Edited by Sarah Hopper Emerson. New York: G.P. Putnam's Sons, 1896-97, 395 pp., 372 pp.
The humanitarian values that **Abigail Hopper Gibbons** (1801-93) imbibed from her widely revered Quaker father and espoused throughout her long life underlay her involvement in the antislavery movement, her work as a nurse during the Civil War, and her unceasing efforts in behalf of women prisoners and poor children in New York City. Gibbons's correspondence from 1811 to 1893, which includes numerous letters from relatives and friends and is supplemented by a journal kept between 1861 and 1865, amply documents her varied career in reform and charitable endeavors and, additionally, furnishes detailed evidence of the manner in which she reared her children. The advice Gibbons proffered to her daughters, and to the son whose tragic death while a student at college distressed her immensely, emphasizes the simple virtues she esteemed. Always placing service to the less fortunate above personal gratification, Gibbons embraced humility and scorned extravagance.

2 "Mrs. Lydia B. Bacon's Journal, 1811-1812." Edited by Mary M. Crawford. Indiana Magazine of History 40 (1944):367-86; 41 (1945):59-79.
Lydia B. Stetson Bacon (1786-1853) thought her place was beside her husband, an officer in the United States Army, when his regiment was ordered from Boston to the West. Her eventful tour of duty with him in Kentucky, Vincennes (Indiana Territory), and Detroit between May 1811 and August 1812 is chronicled in this journal, which combines letters and diary entries with some retrospective commentary. The journal is noteworthy for its graphic account of her boat trip down the Ohio River, her anxious wait to learn her husband's fate in the Battle of Tippecanoe, and her unnerving experiences during the siege of Detroit and as a prisoner of war of the English during the War of 1812. It holds equal interest for its revelation of the values that informed Mrs. Bacon's life--her orthodox religious beliefs, her stern sense of morality, her love for New England, her fervent patriotism, and her hatred for Indians.

<u>1814</u>

1 <u>The Articulate Sisters: Passages from Journals and Letters</u>
 <u>of the Daughters of President Josiah Quincy of Harvard</u>
 <u>University</u>. Edited by M.A. DeWolfe Howe. Cambridge, Mass.:
 Harvard University Press, 1946, 249 pp.
 This volume consists of selections from the journals and
 letters of **Eliza Susan Quincy** (1798-?), **Margaret Morton Quincy**
 Greene (1806-?), **Maria Sophia Quincy** (1805-?), and **Anna Cabot**
 Lowell Quincy (Waterston) (1812-?), four of the daughters of
 Harvard University president Josiah Quincy. The journal of
 "Sister Susan" from 1814 to 1821 contains notes on her encounters
 with a number of celebrated people, including Abigail Adams.
 Detailed observations on the social life of the vacationing
 Boston elite are found in the journal "Sister Margaret" kept
 during the summer of 1824. Margaret's letters of 1827-28
 describe the wedding journey that took her to Charleston, South
 Carolina, Havana, Cuba, and New Orleans. "Sister Sophia's" 1829
 journal chornicles a trip to Malta, New York, and offers a vivid
 picture of commencement exercises at Harvard. Witnessing the
 performances of actress Fanny Kemble in Boston and meeting
 President Andrew Jackson and Vice President Martin Van Buren in
 her home constituted the highlights of the journal "Sister Ann"
 kept in 1833.

2 "Letter of Mrs. Margaret Manigault to Mrs. Alice Izard, 1814."
 Edited by Bernard C. Weber and Brooks Thompson. <u>South</u>
 <u>Carolina Historical Magazine</u> 54 (1953):156-58.
 In June 1814, **Margaret Izard Manigault** (1768-1824), who was
 living in Philadelphia, penned this letter to her mother, Alice
 deLancey Izard, in South Carolina. Manigault, who had spent much
 time abroad, discoursed on European affairs, reporting the latest
 news regarding the restoration of the Bourbons in France.

3 <u>Letters and Journals of Samuel and Laura Sherwood (1813-1823)</u>.
 Edited by J.D. Crocker. Delhi, N.Y.: Privately printed,
 1967, 23 pp.
 Immediately following her marriage **Laura Bostwick Sherwood**
 moved to Washington, D.C., with her new husband, a Federalist
 congressman from Delhi, New York. Sherwood's letters to her
 sister during 1814 and 1815 give her impressions of social life
 in the capital, Dolley Madison's manner of entertaining, the
 latest fashions, and a visit to the House of Representatives. An
 incomplete journal of 1823 is Sherwood's record of a family tour
 of New York State that included the state prison at Auburn,
 Niagara Falls, and the opening of the Erie Canal aqueduct at
 Rochester.

1814

4 "Some Letters of Mary Boardman Crowninshield." Prepared and
 notated by Margaret Pardee Bates. Essex Institute Historical
 Collections 83 (1947):112-42.
 Mary Boardman Crowninshield (1778-?) was pregnant with her
 sixth child when her husband, Benjamin, a leading Salem,
 Massachusetts, merchant assumed the job of secretary of the navy
 under President James Madison. Mary's letters to Benjamin in
 Washington, D.C., dated between March 1814 and June 1815, offer a
 glimpse of the life-style of a privileged young matron in the
 early Republic. Maritime commerce dominated the lives of the
 Crowninshields, and Mary's correspondence is filled with comments
 on trade and politics. Mary provided her husband with a detailed
 account of Salem shipping and noted, in particular, the fine
 goods taken as a prize by one of the family's ships. One of the
 continuing themes of these letters is Mary's desire to possess
 furniture, books, and other objects of the highest quality. She
 evinced a strong interest in the latest fashions and queried her
 husband on the way in which women in Washington were dressed.
 Mary's correspondence also includes news of children and other
 family members as well as expressions of longing for her husband.
 See also 1815.3.

 1815

1 "The Diary of Salome Paddock Enos." [Introduction by Louisa
 I. Enos.] Journal of the Illinois State Historical Society
 13 (1920):370-77.
 Immediately following her marriage on September 4, 1815,
 Salome Paddock Enos (?-1877) set out for the West from Woodstock,
 Vermont, with her husband, parents, brothers, and sisters. She
 made daily entries in her "Itinerary Diary" until October 22,
 1815, resumed the diary on September 14, 1816, after a winter's
 residence in Cincinnati, and kept it until October 5, 1816, when
 the family had reached the outskirts of St. Louis. Salome's
 diary consists of little more than notations of weather, places
 passed, miles covered, and the vagaries of wagon and boat travel.
 Occasional acerbic comments on the character of the country's
 inhabitants enliven an otherwise prosaic account of a westward
 journey.

2 The Education of the Heart: The Correspondence of Rachel
 Mordecai Lazarus and Maria Edgeworth. Edited by Edgar E.
 MacDonald. Chapel Hill: University of North Carolina Press,
 1977, 341 pp.
 Although a devoted admirer of the educational writings of
 Maria Edgeworth, **Rachel Mordecai Lazarus** (1788-1838), a young
 Jewish woman from North Carolina, objected strongly to the noted
 Anglo-Irish author's stereotypic portrayal of a Jewish character
 in one of her novels. Lazarus voiced her feelings and issued a

spirited brief for American Jews in an 1815 letter to Edgeworth, which initiated a transatlantic correspondence that lasted until Lazarus's death in 1838. Literature and education at first dominated the exchange, with Lazarus inditing laudatory commentaries on Edgeworth's latest publications and offering her own opinions on the works of contemporary authors such as Scott, Cooper, Irving, and Trollope. But as the epistolary friendship unfolded, the range of topics broadened to include botany, entymology, and ornithology, as well as domestic affairs and the American character and customs. Lazarus, who had married a widower in 1821, lovingly told of her children and other members of her family and expressed solicitude for Edgeworth's kin. Aware of the harsh charges of the Abolitionists, Lazarus acknowledged the evils of slavery but defended its perpetuation by southerners.

3 Letters of Mary Boardman Crowninshield 1815-1816. Edited by Francis Boardman Crowninshield. Cambridge, Mass.: Privately printed, 1905, 82 pp.
 One year after her husband was appointed secretary of the navy by President James Madison, **Mary Boardman Crowninshield** (1778-?) of Salem, Massachusetts, went with him to Washington, D.C., accompanied by her two eldest daughters. These twenty letters, dating from November 1815 to June 1816, most of which were written to her mother who was caring for the couple's four other children in Salem, chronicle Mrs. Crowninshield's journey to and from Washington and her experiences during her stay there. Because of her husband's position, Mrs. Crowninshield moved in the top circles of Washington society, spending much of her time with the wives of prominent public figures, including Dolley Madison. She recorded her impressions of these women, being careful to furnish detailed descriptions of their attire, and also reported on the various social events of the season. Although these letters disclose little about Mrs. Crowninshield's marital relationship, they do document her enjoyment of the role of mother. See also 1814.4.

1816

1 "Aunt Ebe: Some Letters of Elizabeth M. Hawthorne." [Edited by] Manning Hawthorne. New England Quarterly 20 (1947): 209-31.
 These excerpts from letters written by **Elizabeth M. Hawthorne** (1802-83) between 1816 and 1882 are not arranged chronologically, but they nevertheless paint a compelling portrait of the elder sister of Nathaniel Hawthorne. Though she led a solitary existence in Montserrat in Beverly, Massachusetts, Elizabeth, who never married, was extremely well read and her singular opinions on politics and literature attest to her

independence of mind. Her letters also disclose her continuing interest in the lives of her brother's three children.

2 More Chronicles of a Pioneer School from 1792 to 1833 Being Added History on the Litchfield Female Academy kept by Miss Sarah Pierce and Her Nephew, John Pierce Brace. Compiled by Emily Noyes Vanderpoel. New York: Cadmus Book Shop, 1927, 376 pp.

This book contains the second part of the journal of **Caroline Chester** (1801-70), a student at Litchfield Female Academy in Connecticut. The first part was published in Chronicles of a Pioneer School from 1792 to 1833 Being the History of Miss Sarah Pierce and Her Litchfield School. This section of Chester's journal covers the period between May and September 1816. It comprises a detailed account of her life at school in Litchfield, describing the content of her instruction and giving comments on her own performance. Religious meditations form an important part of the journal. See 1796.1 for the first part of the journal of Caroline Chester.

<div align="center">1817</div>

1 The Letters of Margaret Fuller. Edited by Robert N. Hudspeth. Vol. 1, 1817-38; vol. 2, 1839-41; vol. 3, 1842-44. Ithaca and London: Cornell University Press, 1 (1983):374 pp.; 2 (1983): 264 pp.; 3 (1984):269 pp.

One of the nineteenth century's foremost women of intellect, **Sarah Margaret Fuller** (Ossoli) (1810-50) pursued a distinctive multifaceted career as a teacher, translator, convener of "conversations," literary critic, editor, and journalist. This comprehensive edition of Fuller's correspondence, three volumes of which have been published to date covering the years 1817 to 1844, illuminates her professional endeavors, family and personal relationships, and, most fundamental, her private feelings. Through her letters to a variety of people, famous and obscure, one can trace the development of this brilliant and complex woman from her early years in Cambridge, her role as founder and editor of the Dial magazine, and the publication of her feminist work Woman in the Nineteenth Century to her work as a writer for Horace Greeley's New York Tribune and the awakening of her social conscience. In the process, one shares the human and intellectual concerns of a single, self-supporting woman immersed in the world of letters. Some of Fuller's letters may also be found in Bell Gale Chevigny, The Woman and the Myth: Margaret Fuller's Life and Writings (Old Westbury, N.Y.: Feminist Press, 1976) and Love-letters of Margaret Fuller, 1845-1846. With an Introduction by Julia Ward Howe. To Which Is Added the Reminiscences of Ralph Waldo Emerson, Horace Greeley and Charles T. Congdon. New York: D. Appleton, 1903).

2 Lydia Maria Child: Selected Letters, 1817-1880. Edited by
 Milton Meltzer and Patricia G. Holland; associate editor,
 Francine Krasno. Amherst: University of Massachusetts Press,
 1982, 583 pp.
 Through her writings and editorial work, **Lydia Maria
Francis Child** (1802-80) exerted a notable influence on public
opinion in nineteenth-century America. A wealth of information
on Child's publications, her views on contemporary issues, and
her personal life is found in this extensive selection from her
correspondence encompassing the years 1817 to 1880, most of it
from Massachusetts and New York. Best known for her denuncia-
tions of slavery and racial prejudice, Child was an articulate
witness to her times and wrote with clarity as well as passion of
the events that divided the nation in the decades surrounding the
Civil War. Politics, reform, and women's rights captured the
lion's share of her attention, but she also wrote with facility
of literature, music, art, and religion. Financial insecurity
was a recurring theme in Child's correspondence. Her husband's
ineptness forced her to live frugally and to protect her own
earnings; as a consequence she experienced considerable strain in
her marital relationship. This edition of Child's correspondence
supplants Letters of Lydia Maria Child (Boston: Houghton
Mifflin, 1882). See also Nancy Slocum Hornick, ed., "The Last
Appeal: Lydia Maria Child's Antislavery Letters to John G.
Underwood," Virginia Magazine of History and Biography 79
(1971):45-54.

1818

1 "A Journey through New England and New York in 1818."
 Magazine of History 2 (1905):14-27, 90-95.
 In the summer of 1818, **Eliza Williams Bridgham** (Patten)
(1799-1882), a young single woman from Providence, Rhode Island,
accompanied her father on a tour of Massachusetts, New Hampshire,
Vermont, New York, and Connecticut. An observant traveler, Eliza
filled her diary with vivid thumbnail sketches of the towns she
visited, including a fascinating account of worship in the Shaker
community near Lebanon Springs, New York.

2 Mary Lyon through Her Letters. As edited by Marion Lansing.
 Boston: Books, Inc., 1937, 317 pp.
 Letters and fragments of letters by **Mary Lyon** (1797-1849),
the founder of Mount Holyoke Female Seminary, compose the core of
this biographical volume, which also includes documents of Lyon's
contemporaries. Arranged in essentially chronological form, the
correspondence, which spans the years 1818 to 1849, traces the
noted educator's early experiences as a student and as a teacher
in Massachusetts and New Hampshire, her association with Zilpah
Grant in operating female academies--most notably Ipswich

Seminary--and her decision to sever her connection with Grant in order to establish a school based on a permanent endowment, with fees low enough to enable girls from families with modest means to attend. Lyon worked tirelessly to garner support from influential men and to raise funds for Mount Holyoke Female Seminary, which opened in 1837 in South Hadley, Massachusetts. In her letters, Lyon elucidated her educational philosophy and spiritual beliefs and emphasized her conception of the underlying religious purpose of the institution. She also discussed the domestic system she implemented at the seminary, the rigorous academic program, and her efforts to comply with requests for qualified teachers. The correspondence contains relatively little on the personal life of this single woman who devoted her life to the cause of women's education.

3 Memoir, Diary, and Letters, of Miss Hannah Syng Bunting, of
 Philadelphia, Who Departed This Life May 25, 1832 in the
 Thirty-First Year of Her Age. Compiled by Rev. T. Merritt.
 2 vols. New York: Published by T. Mason and G. Lane for the
 Sunday School Union of the Methodist Episcopal Church, 1837,
 199 pp., 144 pp.
 The spiritual development of an exemplary Methodist can be
 traced in the diary and letters of **Hannah Syng Bunting** (1801-32),
 a single woman from Philadelphia. Bunting's diary, begun on the
 day she joined the Methodist church in 1818, extends to 1832 and
 is supplemented by a volume of her letters to five female
 correspondents between 1824 and 1832. The quest for holiness
 dominated Bunting's life, and her writings constitute, in
 essence, a continuous exploration of her religious faith.
 Prayers and exhortations abound in her meditations, and outward
 chronology is inevitably subordinated to inner reflections.
 Initially concerned with conquering her sins and resisting the
 temptations of the world, Bunting turned to extending herself in
 grace after receiving the blessing of sanctification in 1824.
 She participated in all the activities of the Methodist church
 and wrote with feeling of her reactions to sermons, prayer
 meetings, love feasts, and camp meetings. She labored
 unselfishly in behalf of her faith, teaching Sabbath school,
 visiting the sick and needy, and traveling to spread the word of
 God. Increasingly burdened by illness in her final years, she
 directed her thoughts toward preparing for death.

4 "The Original Diary of Mrs. Laura (Downs) Clark, of Wakeman,
 Ohio, from June 21, to October 26, 1818." Firelands Pioneer
 21 (1920):2308-26.
 The pain of separation from her mother was almost too much
 for **Laura Downs Clark** (1798-1863) to bear. Her diary, begun
 shortly after she and her husband, a doctor, had moved from
 Connecticut to Wakeman, Ohio, in 1818, is filled with sorrowful

passages in which Laura articulates her longing to see her mother and her despair at being so far from family and friends. Laura discovered that the most efficacious remedy for her homesickness was continuous activity, and her diary attests to the numerous tasks she performed. In addition to customary household chores, Laura sewed for others and taught a school for the children in the pioneer community. The remainder of her time was spent in visiting among a small circle of neighborhood women and in occasional churchgoing.

1819

1 James and Lucretia Mott: Life and Letters. Edited by Anna Davis Hallowell. Boston: Houghton, Mifflin & Co., 1884, 566 pp.
 This biographical volume consists largely of selections from the correspondence of **Lucretia Coffin Mott** (1793-1880), the Philadelphia Quaker minister who played a prominent role in the antislavery and women's rights movements. Mott's opinions on a variety of issues concerning religious thought and practice are well documented in the letters, which span the years 1819 to 1877, as are her reasons for aligning herself with the more liberal side in the internal disputes among Quakers. Mott's equalitarianism, rooted in her Quaker beliefs, led her to speak out against slavery and to join with people outside her faith in working for Abolition. Her letters not only give a sense of her place in the reform network but show how she responded to criticism of her antislavery activities by influential Friends. A diary she kept on her trip to the World Antislavery Convention in England in 1840 is included here. The correspondence also traces Mott's efforts in behalf of women and presents information on her marriage and family life.

1820

1 Familiar Letters of Ann Willson. Philadelphia: Wm. D. Parrish & Co., 1850, 270 pp.
 One way in which **Ann Willson** (1797-1843), a single Quaker woman from New Jersey, found purpose in her life was in being of service to her sister's family. Ann's letters spanning the years 1820 to 1843 show that filling the role of aunt was a rich source of satisfaction to her. But there were other roots of meaning in Ann's life--her religion and her female friends. As the numerous passages devoted to self-examination and exhortation of friends make clear, her faith was of utmost importance to her. She regularly took herself to task for placing too high a value on worldly interests and continually urged all to prepare for death. Ann's social life was contained within the Quaker orbit and visits to kin and friends were frequently combined with

attendance at meetings of the Society of Friends. In the latter
years of her life, Ann's social and spiritual needs converged
when she found a female companion who shared her passion for
proclaiming religious truths.

2 "Letters of Ann Gillam Storrow to Jared Sparks." Edited by
 Frances Bradshaw Blanshard. <u>Smith College Studies in History</u>
 (Northampton, Mass.: Department of History and Government of
 Smith College) 6, no. 3 (April 1921):189-252.
 Corresponding with Jared Sparks, a noted historian and
 editor, meant a great deal to **Ann Gillam Storrow** (1784-1856). As
 a single woman living in the household of a married sister, Ann
 was expected to help with housekeeping and child care. Friend-
 ship with a man like Sparks relieved the tedium of her days and
 enabled her to make use of her considerable intellectual gifts.
 These letters, which span the years 1820 to 1846, focus on
 Sparks's accomplishments as well as his personal life. Ann
 clearly derived vicarious pleasure from the progress of Sparks's
 career, although her comments on his work were not always
 uncritical. The majority of the letters were written from
 Cambridge, Massachusetts, and many are filled with pungent
 observations on Harvard College and Cambridge society. Although
 this correspondence reveals little of Ann's emotional life, it
 documents her interests in literature and the Unitarian church
 and demonstrates her familiarity with the intellectual currents
 of the day.

3 <u>Letters of Elizabeth Palmer Peabody, American Renaissance</u>
 <u>Woman</u>. Edited, with an introduction by Bruce A. Ronda.
 Middletown, Conn.: Wesleyan University Press, 1984, 477 pp.
 In a lengthy career that bridged the Civil War, **Elizabeth**
 Palmer Peabody (1804-94) of Boston left her mark on American
 ideas and institutions. This selection of Peabody's letters
 dating from 1820 to 1890 charts her intellectual development,
 provides a fund of information on her connections with such
 luminaries as William Ellery Channing, Bronson Alcott, Ralph
 Waldo Emerson, and her two brothers-in-law, Horace Mann and
 Nathaniel Hawthorne, and documents her role in contemporary
 reform movements. A single, self-supporting woman, Peabody was
 best known for promoting the kindergarten in the United States,
 and much of her correspondence deals with the subject of educa-
 tion. Letters by Peabody may also be found in "Elizabeth
 Peabody's Letters to Maria Chase of Salem, Relating to
 Lafayette's Visit in 1824," <u>Essex Institute Historical Collec-</u>
 <u>tions</u> 85 (1949):360-68; Arlin Turner, "Elizabeth Peabody Visits
 Lincoln February, 1865," <u>New England Quarterly</u> 48 (1975):116-24;
 and Margaret Neussendorfer, "Elizabeth Palmer Peabody to William
 Wordsworth: Eight Letters, 1825-1845," in <u>Studies in the</u>

American Renaissance, 1984, ed. Joel Myerson (Charlottesville, Va.: University Press of Virginia, 1984), pp. 181-211.

1821

1 The Diary of Calvin Fletcher. Vol. 1, 1817-1838. Including Letters of Calvin Fletcher and Diaries and Letters of His Wife, Sarah Hill Fletcher. Edited by Gayle Thornbrough. Indianapolis: Indiana Historical Society, 1972, 516 pp.
 A young bride's feelings of inadequacy are vividly captured in the diary **Sarah Hill Fletcher** (1801?-1854) of Indianapolis kept at the instruction of her lawyer-husband from 1821 to 1824. Sarah's matter-of-fact record of household chores, churchgoing, and local visiting is punctuated by notes on her efforts to remedy her educational deficiencies and, more significant, expressions of the inferiority she felt in the presence of her husband and other accomplished people. Participation in a circle of female friends fostered a more positive outlook in Sarah and when it came time to give birth to her first child, her friends were there to assist her. This volume also includes several letters Sarah wrote between 1824 and 1827 as well as diary fragments from 1830 and 1837-38.

2 "Mary Tyler's Journal." [Edited by] George Floyd Newbrough. Vermont Quarterly, n.s. 20 (1952):19-31.
 The editorial arrangement of these selections from the journal of **Mary Palmer Tyler** (1775?-?) by topic rather than chronology reduces their usefulness. The years covered by the journal, 1821-26, were difficult ones for the Tylers of Brattleboro, Vermont, owing to the fatal illness of Mary's eminent husband, jurist and writer Royall Tyler, and the consequent economic distress of the family. Mary's strong religious faith sustained her during this time of trial.

3 "A Newburyport Wedding One Hundred Years Ago: The Bride, Elizabeth Margaret Carter." [Edited by James Duncan Phillips.] Essex Institute Historical Collections 87 (1951):309-32.
 An unusually vivid and detailed account of the wedding of an upper-class young woman in Newburyport, Massachusetts, in 1821 appears in this journal kept by the bride's older half-sister, **Anna Quincy Thaxter Parsons**, for her half-brother who was away at sea. Preparations for Elizabeth Margaret Carter's marriage to William Belcher Reynolds commenced in Boston with several days devoted to furnishing the couple's new house and completing the bride's wardrobe and continued in Newburyport with cooking and decoration of the parlor. The events of the wedding day, highlighted by the ceremony and a levee for local society, and the newlyweds' return to Boston are all chronicled in an

—

entertaining style. Although designed to focus on the bride's
experiences, Mrs. Parson's journal sheds light on her own unhappy
marriage.

1823

1 Mistress of Evergreen Plantation: Rachel O'Connor's Legacy of
 Letters 1823-1845. Edited by Allie Bayne Windham Webb.
 Albany: State University of New York Press, 1983, 304 pp.
 Twice widowed, and having lost both her sons, **Rachel Swayze
 Bell O'Connor** (1774-1846) centered her life around running her
 cotton plantation in West Feliciana Parish, Louisiana. These 157
 letters written between 1823 and 1845 to her beloved half-brother
 and other relatives offer a comprehensive view of O'Connor's work
 in planting and marketing crops, dealing with overseers, and
 managing slaves. A woman whose interest in her slaves
 transcended their economic value, she frequently spoke with
 compassion of the concerns and illnesses of individual blacks.
 O'Connor struggled against indebtedness for many years, and her
 correspondence makes clear the extent to which she, as a single
 woman, was dependent on the assistance of her male relatives in
 financial and legal matters. Her abiding love for members of her
 family is always palpable in her letters and nowhere more so than
 in the earnest medical and religious advice she offered them. As
 she grew older and more infirm, O'Connor increasingly reflected
 on the subject of death.

1824

1 Caleb and Mary Wilder Foote: Reminiscences and Letters.
 Edited by Mary Wilder Tileston. Boston and New York:
 Houghton Mifflin Co., 1918, 369 pp.
 The power of faith to sustain a woman through the deaths of
 three of her children is illustrated in moving fashion in these
 extensive extracts from the correspondence and journal of **Mary
 Wilder White Foote** (1810-57) of Salem, Massachusetts, over the
 years 1824 to 1857. A deeply religious woman who was committed
 to living in accordance with Christian principles, Foote wrote at
 length of how she was able to submit herself to God's will, even
 when it meant losing her three precious infants. Impressed with
 the gravity of her responsibility as a mother, she devoted
 herself to fostering the spiritual development of her remaining
 children, making every effort to curb their tendencies toward
 selfishness. Her letters to her son, Henry, while he was a
 student at Harvard College offer a revealing commentary on the
 type of relationship she desired with her children. Foote
 regularly contemplated the nature of the moral life and paid
 homage to the virtues of her husband and several of her female

friends. Her observations on her reading and on politics in the election of 1856 are also of interest.

2 "Diary of Mrs. Joseph Duncan (Elizabeth Caldwell Smith)."
 Edited by Elizabeth Duncan Putnam. Journal of the Illinois
 Historical Society 21 (1928):1-91.
 Two distinct periods in the life of **Elizabeth Caldwell
 Smith Duncan** (1808-76), the wife of an early governor of
 Illinois, are illuminated in this diary bridging the years
 1824-48. During the years 1824-25, Elizabeth, the adolescent
 daughter of a well-to-do New York City family, attended the
 Newark Institute in New Jersey. The picture that emerges from
 her diary is of a serious student, intent on attaining good marks
 in school, but not willing to forgo the pleasures of visiting and
 shopping in New York. Elizabeth's religious bent, which became
 more pronounced in later years, was already evident in her
 scrupulous account of services in the local Presbyterian church.
 The second major portion of the diary, covering the period
 1841-44 with some additional entries for the years up to 1848,
 depicts Elizabeth as a wife and mother in her thirties residing
 in Jacksonville, Illinois. By this time, evangelical
 Protestantism had become the dominant force in her life, defining
 her beliefs, thoughts, and actions. The record of her attendance
 at worship, lectures, prayer meetings, and other religious
 gatherings provides a counterpoint to the frequent exercises in
 self-examination that dot the diary. Elizabeth conceived of the
 roles of wife and mother in religious terms, and the diary makes
 clear how she attempted to influence members of the family by
 example as well as precept. Not one to take the awesome respon-
 sibilities of motherhood lightly, she went to the Maternal
 Meeting and read the Mothers' Magazine. Elizabeth's diary also
 supplies ample evidence to show how religion enabled her to cope
 with pregnancy and childbirth as well as the death of her husband
 and some of her children.

1825

1 "Journal of a Visit to Greenville from Charleston in the
 Summer of 1825, Caroline Olivia Laurens, May 1825." South
 Carolina Historical Magazine 72 (1971):164-73, 220-33.
 In the spring of 1825, **Caroline Olivia Laurens** set out from
 Charleston, South Carolina, with her husband and infant son on an
 extended vacation trip. Her record of their stay in the country
 at Greenville and Pendleton affords us a glimpse of the recrea-
 tional activities of well-to-do South Carolinians. The young
 Mrs. Laurens spent her time in touring important sights, horse-
 back riding, visiting among resident families--including that of
 Vice President John C. Calhoun--playing chess, and reading.

Throughout her visit to the region, she made notes on the manners of country people, rating them by how closely they approximated city ways.

2 Mrs. Longfellow: Selected Letters and Journals of Fanny
 Appleton Longfellow (1817-1861). Edited by Edward
 Wagenknecht. New York: Longmans Green & Co., 1956, 255 pp.
 Born into a prominent Boston family, **Frances (Fanny)**
Elizabeth Appleton Longfellow (1817-61) was well read and widely
traveled before she married poet and professor Henry Wadsworth
Longfellow in 1843. These selections from Fanny's letters and
journals between 1825 and 1861 document her abiding interest in
intellectual and cultural trends as well as in political devel-
opments in America and Europe. Fanny took great pleasure in her
domestic roles. Her relationship with her husband was idyllic,
and she never tired of praising Henry's poems or entertaining the
literary figures who were his friends. A devoted mother, Fanny
openly discussed pregnancy and childbirth--she was the first
woman to have a baby under the influence of ether--and lovingly
chronicled the behavior of her children. Fanny periodically
reflected on her spiritual condition and inscribed her thoughts
in a separate religious journal, excerpts from which are included
in this volume.

3 "Pamela Savage of Champlain, Health Seeker in Oxford." Edited
 by Helen Harriet Salls. North Carolina Historical Review 29
 (1952):540-68.
 Pamela Savage (Moore) (1801-75), a young single woman from
Champlain, New York, journeyed to Oxford, North Carolina, in
order to improve her health. The details of her travels as well
as her career as a teacher in the Oxford Female Seminary are
recorded in the journal she kept between 1825 and 1827. A devout
Presbyterian, Pamela distilled the religious meaning from her
experiences during this time. Her journal is also of interest
for its observations on the southern people and climate and its
descriptions of the public buildings in cities such as
Washington, D.C.

1826

1 "Correspondence of Anna Briggs Bentley from Columbiana County,
 1826." Edited by Bayly Ellen Marks. Ohio History 78 (1969):
 38-45, 71.
 This long letter written by **Anna Briggs Bentley** (1796-?), a
recent migrant to Ohio, to her family in Maryland provides a
glimpse of the daily life of a farm wife and mother in Columbiana
County, Ohio, in 1826. In addition to offering a detailed
description of her household work, Bentley, a member of the
Society of Friends, elaborated on the helpfulness of her new

Quaker neighbors and gave an account of the Quaker monthly
meeting. A considerable portion of Bentley's letter is devoted
to recording the progress of each of her six children.
Enthusiasm for her new life on the frontier mingles with
homesickness for relatives in Maryland in this informative letter
of a female pioneer in early-nineteenth-century Ohio.

2 "A Visit to Saratoga: 1826." [Edited by] Genevieve M.
 Darden. New York History 50 (1969):283-301.
 Poor health impelled **Almira Hathaway Read** (1797-1831) to
leave her home in Fairhaven, Massachusetts, in the summer of 1826
to seek the curative powers of the waters in Saratoga Springs,
New York. A deeply religious woman, who subjected her health as
well as her spiritual state to intense scrutiny, Read filled her
trip journal with reflections on the value of Protestant
Christianity in teaching one how to live and how to prepare for
death. Scrupulous summaries of sermons she heard preached are
interspersed with remarks on the condition of fellow health
seekers, the profanation of the Sabbath in Saratoga, and the
defects of the Catholic religion. A recurrent concern of Read's
was the hoped-for conversion of her husband, a New Bedford
whaling captain away on a voyage.

1827

1 "Cambridge Eighty Years Since." Cambridge Historical Society
 Publications 2 (1906):20-32.
 Louisa Higginson, wife of the steward of Harvard College
and mistress of a large household, kept this diary in the form of
letters to her son who was away on a business trip between
October 1827 and March 1828. Consisting primarily of reports of
Mrs. Higginson's activities--sewing, reading, visiting,
entertaining "college gentlemen", caring for her young children,
and celebrating New Year's Day--the diary also paints a revealing
picture of social life among the elite of early nineteenth-
century Cambridge, Massachusetts.

2 Life and Letters of Harriet Beecher Stowe. Edited by Annie
 Fields. Boston and New York: Houghton, Mifflin & Co., 1897,
 406 pp.
 Individual letters and fragments of letters composed by
author **Harriet Elizabeth Beecher Stowe** (1811-96) between 1827 and
1893 are incorporated here into a continuous biographical
narrative of Stowe's life. Though the materials assembled inade-
quately represent Stowe's correspondence, they do give a sense of
her views on religion, marriage, child rearing, slavery, and
writing. See also 1828.2.

<u>1828</u>

1 "Hard Cash; or a Salem Housewife in the Eighteen Twenties."
 Edited by Elma Loines. <u>Essex Historical Institute Collections</u>
 91 (1955):246-65.
 When economic conditions caused her husband to move his
 import business to New York City, **Mary Porter Low** (1785?-1872)
 was left at home in Salem, Massachusetts, with ten of the
 couple's children. How she managed household affairs on her own,
 with little cash at hand, and kept the family going is the main
 subject of these nine letters written to her husband in 1828 and
 1829. Low's gentle reproval of her husband for his laxity in
 correspondence sheds light on the nature of their marital
 relationship.

2 <u>Life of Harriet Beecher Stowe Compiled from Her Letters and</u>
 <u>Journals by Her Son Charles Edward Stowe</u>. Boston and New
 York: Houghton, Mifflin & Co., 1889, 530 pp.
 This laudatory biography of **Harriet Elizabeth Beecher Stowe**
 (1811-96) prepared by her son includes numerous selections from
 the correspondence of the celebrated author of <u>Uncle Tom's Cabin</u>.
 These letters, spanning the years 1828 to 1887, provide insight
 into Stowe's relationship with her husband and children, her
 writing career, and her role as a public figure. See also
 1827.2.

3 <u>One First Love: The Letters of Ellen Louisa Tucker to Ralph</u>
 <u>Waldo Emerson</u>. Edited by Edith W. Gregg. Cambridge, Mass.:
 Harvard University Press, Belknap Press, 1962, 208 pp.
 In December 1828, seventeen-year-old **Ellen Louisa Tucker**
 (Emerson) (1811?-31), of Concord, New Hampshire, became engaged
 to Ralph Waldo Emerson, then a young minster. The letters she
 wrote to her beloved Waldo from then until their marriage in
 September 1829 are printed here, along with a few subsequent
 pieces of her correspondence dating from 1829 to shortly before
 her death in February 1831. Ellen was quite eloquent in her
 expressions of love for Waldo, and her letters give evidence not
 only of the purity of her sentiments but of her literary skills.
 News of family and community were of peripheral importance in
 these romantic communications filled with the sort of intimate
 details that only those about to marry feel free to share.

4 "Pepper Wife." Edited by Helen O'Boyle Park. <u>Essex Institute</u>
 <u>Historical Collections</u> 94 (1958):151-55.
 Shortly after his marriage in September 1828, John Nichols,
 Jr., sailed on a lengthy voyage to Sumatra as first officer on a
 vessel in the pepper trade, leaving his new bride, **Elizabeth Day**
 Nichols (1806?-31) at home in Salem, Massachusetts. Five of
 Elizabeth's letters to her husband, written between 1828 and 1830

are published here. Although her mode of expression suggests
that she had only a rudimentary education, Elizabeth had no
difficulty in communicating important news--such as the birth of
their son--to her husband. Her brief but touching letters convey
her frustration at his prolonged absence and capture the mood of
expectancy of a proud young mother waiting to show off their baby
to his father.

<div align="center">1830</div>

1 "A Document of Michigan Pioneer Life." Edited by Robert M.
 Warner. Michigan History 40 (1956):215-24.
 Lucy Stow Morgan (1796-1887) had just been married when she
 arrived in Ann Arbor, Michigan, in 1830. In a lengthy letter to
 her family in Middletown, Connecticut, the former teacher
 sketched a portrait of her new life on the rapidly growing
 Michigan frontier, discussing her husband's law practice and her
 housekeeping duties and supplying a meticulous description of
 their home and its furnishings.

2 "Elizabeth Gilpin's Journal of 1830." Edited by Marjorie
 McNinch. Delaware History 20 (1983):223-55.
 Touring for pleasure had become an integral part of the
 upper-class life-style by 1830, the year that Elizabeth Gilpin
 (1804-92) journeyed from Wilmington, Delaware, to Johnstown, New
 York. Gilpin, a young single woman from a prominent family,
 traveled in the company of her friends Henry Bayard and his
 sister Mary, who were making a visit to their relatives in
 Johnstown. Conscientiously chronicling the events of the trip in
 her journal, she described excursions to natural wonders such as
 Trenton Falls, gave her impressions of New York City and other
 communities, and carefully noted social calls and horseback
 rides.

3 Farm to Factory: Women's Letters, 1830-1860. Edited by
 Thomas Dublin. New York: Columbia University Press, 1981,
 191 pp.
 The advent of industrial capitalism greatly increased the
 employment possibilities for northern New England's young women.
 This invaluable collection of letters written between 1830 and
 1862 by New Hampshire and Vermont young women who labored in the
 textile mills, and as teachers and seamstresses, and by their
 kinfolk on the farm enables us to recapture the world of these
 early female workers. Their attitudes toward the jobs they held,
 their families, and religion are illuminated in the rare personal
 documents published here. A number of correspondents are
 represented in the book, which is divided into four parts: "The
 Hogdon Letters," "Letters to Sabrina Bennett," "Mary Paul
 Letters," and "Delia Page Letters." Only one set of letters

allows us to follow the career of a single individual over an extended period of time. Spanning the years 1845 to 1862, the letters of **Mary Paul** (1829?-?) document the varying work experiences and ideas of a Vermont woman who worked in the Lowell, Massachusetts, textile mills, as a seamstress in Brattleboro, Vermont, and in a utopian agricultural community--the North American Phalanx in Redbank, New Jersey--before marrying and moving to Lynn, Massachusetts. Members of Delia Page's foster family, the Trussells of New London, New Hampshire--including her foster mother, **Eliza S.Trussell**, and two foster sisters, **Sarah E.Trussell** and **Mary Trussell**--regularly wrote her when she worked in the Amoskeag mills in Manchester, New Hampshire, between 1859 and 1861 and offered sober counsel when she became involved in a relationship with a married man. Portions of the correspondence contained in this volume were published previously in Thomas Dublin, "The Hogdon Family Letters: A View of Women in the Early Textile Mills, 1830-1840," Historical New Hampshire 33 (1978):283-95, and Thomas Dublin, ed., "The Letters of Mary Paul, 1845-1849," Vermont History 48 (1980):77-88.

1831

1 Matilda's Letters. Compiled and printed by Barbara Trueblood Abbott. N.p.: Privately printed, 1974, 136 pp.
 The family correspondence collected in this volume is centered on **Matilda Appleman Williams** (1815-?) of Mystic, Connecticut, a wife and mother of eleven children. Matilda's own letters, spanning the years 1831 to 1877, are down to earth in style and concerned primarily with the details of her everyday life as a housewife. A loving mother, Matilda enjoyed relaying news of her offspring. Her accounts of the illnesses and deaths of two daughters and a son are especially moving.

2 Memoir and Correspondence of Eliza P.Gurney. Edited by Richard F. Mott. Philadelphia: J.B. Lippincott, 1884, 377 pp.
 Philadelphia-born **Eliza Paul Kirkbride Gurney** (1801-81) was recognized as a Quaker minister in England in 1841, the same year she married Joseph John Gurney, an English Quaker. Spiritual concerns were of paramount importance in Gurney's life, and her career as a preacher for the Society of Friends was conducted on both sides of the Atlantic. Although the majority of these letters were written during her stays in England and Europe, a substantial selection of her American correspondence is included in this volume. Letters written to her mentor, English Quaker Hannah C. Backhouse, between 1831 and 1840 reveal Eliza's deepening religious commitment. A larger group of letters to friends and relatives, dating from 1851 to 1879 after she was widowed and had settled in New Jersey, provides a fuller picture

of Gurney's religious service. Of particular interest are two letters written during the Civil War to President Abraham Lincoln, whom she had met, expressing the inner conflict she felt between her antislavery views and her antiwar views. This volume also contains sporadic extracts from Gurney's journal.

1832

1 The Diaries of Sally and Pamela Brown, 1832-1838; Hyde Leslie,
 1887. Plymouth Notch, Vermont. Edited by Blanche Brown
 Bryant and Gertrude Elaine Baker. Springfield, Vt.: William
 L. Bryant Foundation, 1970, 176 pp.
 This book contains the diaries kept by two sisters of
 Plymouth Notch, Vermont, **Sally Experience Brown** (1807-?) and
 Pamela Brown (1816-?). Sally's diary, written in part while she
 was living in the household of an older sister in Cavendish,
 Vermont, covers a portion of the years 1832 and 1833 and includes
 one entry for 1834. Pamela's lengthier diary is continuous from
 December 1835 to March 1838. Both diaries are excellent sources
 for reconstructing the everyday life patterns of young single
 women in rural New England. The brief entries note routine
 female chores such as washing, spinning, knitting, and making
 garments for family members as well as stints as teachers of
 district schools. The diaries also chronicle other common
 activities of the Brown sisters--visiting, attending parties,
 reading, going to meeting, shopping, and caring for relatives and
 neighbors.

2 The Diary of Millie Gray, 1832-1840 (Née Mildred Richards
 Stone, Wife of Col. Wm. Fairfax Gray) Recording Her Family
 Life before, during and after Col. Wm. F. Gray's Journey to
 Texas in 1835, and the Small Journal Giving Particulars of All
 That Occurred during the Family's Voyage to Texas in 1838.
 Houston: Fletcher Young Publishing Co., 1967, 158 pp.
 The impact of her husband's sudden financial reversal on
 the life-style of **Mildred (Millie) Richards Stone Gray** (1800-
 1851) is graphically illustrated in the diary she kept between
 1832 and 1840. When Mrs.Gray commenced her journal, her accus-
 tomed activities resembled those of other genteel women in
 Fredericksburg, Virginia--visiting and entertaining among a wide
 circle of kinfolk and friends, attending services at the
 Episcopal church, shopping, caring for her children, and super-
 vising the work of a household staffed with slaves. When the
 family was forced to move and sell its furniture and slaves in
 1834, relatives stepped in to help them maintain a semblance of
 their former way of life. Nevertheless, Millie Gray's social
 life was sharply curtailed as she began to give music lessons, do
 dressmaking and copying, and take in boarders in order to produce
 needed income. After her husband decided to recoup his fortune

by migrating to Texas, Millie and the children moved to Houston where Mr. Gray initiated a law practice and she kept boarders. Millie's comments regarding her new acquaintances in Texas attest to her abiding concern for social status. A brief travel journal recording the events of Millie Gray's journey from Fredericksburg to Houston in 1838-39 is appended to the main diary.

3 "Phoebe George Bradford Diaries." Edited by W. Emerson Wilson. Delaware History 16 (1974):1-21, 132-51; (1975): 244-67, 337-57.
 Exempt from the toils of domestic labor by virtue of her upper-class status, **Phoebe George Bradford** (1794-1840), a middle-aged wife and mother of Wilmington, Delaware, was free to order her own life. These extensive selections from the diary she kept between 1832 and 1839 suggest the range of her interests and identify her deepest concerns. Apart from overseeing the education and moral training of her three sons, Bradford devoted the largest portion of her time and thought to the affairs of the Episcopal church. Her days were also occupied in serving local societies--the Female Colonization Society in particular--attending edifying lectures, and participating in the customary round of visiting, entertaining, and traveling. Bradford's comments on her relations with her servants shed light on her role as mistress of a privileged household.

1833

1 "Journal of Sarah Pierce Nichols of Salem, 1833." Essex Institute Historical Collections 82 (1946):211-27.
 A twelve-mile walk undertaken for health purposes formed an integral part of the daily routine of **Sarah Pierce Nichols** (1804-?), the twenty-nine-year-old woman of Salem, Massachusetts, who kept this journal in 1833. With this exception, Sarah's activities resembled those of other single women in genteel New England families. She assisted with the domestic labors of the household, participated in the customary round of visiting and entertaining callers, attended worship at the Unitarian church, and taught a class at Sabbath school. Apart from occasional expressions of religious faith, Sarah's journal comprises brief factual notations.

2 "Sentimental Journey: The Diary of Margaret Miller Davidson." Edited by Walter Harding. Journal of the Rutgers University Library 13 (1949):19-24.
 Margaret Miller Davidson (1823-38), a precocious ten-year-old girl who achieved fame as a poet before her premature death, kept this travel diary on a trip from upstate New York to New York City in the summer of 1833. Composed in a style reminiscent of the literature of the period, Margaret's diary includes

detailed descriptions of the places she visited, such as Saratoga Springs, Coney Island, and Hoboken, New Jersey, and the people she encountered, in particular, Black Hawk, the Indian chief, and author Washington Irving. The diary provides evidence of the lively imagination and romantic sensibility of a talented young girl.

1834

1 "A Southern Girl at Saratoga Springs, 1834." Edited by Barnes F. Lathrop. <u>North Carolina Historical Review</u> 15 (1938): 159-61.
 In contrast to those visitors whose aim was to improve their health, **Eliza Thompson**, the daughter of a wealthy North Carolina planter family, traveled to Saratoga Springs, New York, purely for pleasure. In this 1834 letter to her married sister, Eliza made clear her preference for balls rather than edifying lectures and supplied a roster of celebrated guests currently in town, including Vice President Martin Van Buren, for whom she had nothing but scorn.

2 <u>A Trip to Washington, 1834: Papers of Joanna Shipman</u> <u>Bosworth, Being the Diary of a Carriage Trip Made in 1834 by</u> <u>Charles Shipman and His Daughters, Joanna and Betsey, from</u> <u>Athens, Ohio, to Philadelphia, Baltimore and Washington; and a</u> <u>Family History</u>. N.p.: Privately published, 1914, 44 pp.
 This is the travel diary kept by **Joanna Shipman** (Bosworth) (1815-?), an educated young Ohio woman, on a trip to Washington, D.C., with her father and sister, Betsey, in 1834. Daily entries spanning the period October 6, 1834-November 19, 1834 record her observations of places visited and people encountered on the journey. Lengthy descriptions of the sights in Philadelphia and Washington, D.C., as well as an account of a visit to President Andrew Jackson are of particular interest.

1835

1 "Ann Allen of Ann Arbor." [Introduction by Florence Woolsey Hazzard.] <u>Michigan History</u> 40 (1956):405-18.
 Ann Isabella Barry McCue Allen (1797-1875) settled with her second husband and their daughter in the fledgling community of Ann Arbor, Michigan. Between 1835 and 1842, she penned six letters to Thomas W. McCue, her son by a first marriage, who lived in Virginia. Anxious to maintain her ties with Thomas and his brother, John, Mrs. Allen expressed her deep concern for the boys' welfare and urged them to stay in touch with her. Of particular interest is the account Mrs. Allen gives of the downturn in her family's economic fortunes following a brief move to New York City in 1837 and her resignation to a more frugal way

of life. Evidence of Mrs. Allen's strong religious faith runs through these letters.

2 The Letters of George Catlin and His Family: A Chronicle of the American West. [Edited by] Marjorie Catlin Roehm. Berkeley and Los Angeles: University of California Press, 1966, 463 pp.
 Although the life and work of artist George Catlin form the centerpiece of this absorbing volume of family correspondence, the forty-seven letters of various female members of the Catlin clan selected for inclusion constitute a rich source for researchers of mid-nineteenth-century American women. Religious concerns dominate the nine letters **Polly Sutton Catlin** (1770-1844), George's elderly mother, wrote to her son Francis between 1835 and 1844 from her home in Great Bend, Pennsylvania. Rudimentary literary skills did not prevent Polly from bombarding her son with advice on his health, behavior, and most important, his spiritual condition. **Eliza Catlin Dart** (1798-1866), George's sister, was more preoccupied with the affairs of this world. The distress that she felt at the loss of status caused by her husband's financial failure in the panic of 1837 and the family's consequent move from Utica, New York, to the Wisconsin frontier is poignantly captured in twenty-five letters spanning the years 1835-63. Saddened by the separation from relatives and friends, Eliza became increasingly embittered following further misfortunes and eventually was estranged from her husband. Additional letters by other women of the Catlin family add to the value of this collection.

3 "Letters Written by a Peoria Woman in 1835: By Boat, Wagon, Horse and Foot to Peoria in the Days of Pioneers," by Ellen Bigelow. Journal of the Illinois State Historical Society 22 (1929):335-53.
 Ellen Bigelow (1816[17?]-?), a young single woman, was overcome by homesickness for New England by the time she arrived in Peoria, Illinois, in 1835 to join her father who had resettled the family there. Ellen's long letter of June 1835 to her aunt describing the few highlights and many pitfalls of her journey from Petersham, Massachusetts, to Peoria dwells on the negative characteristics of the inhabitants of Illinois and makes clear her preference for her birthplace.

4 Mary Austin Holley: The Texas Diary, 1835-1838. Edited, with an introduction by J.P. Bryan. Austin: University of Texas Press, 1965, 120 pp.
 Noted for her writings publicizing Texas, **Mary Phelps Austin Holley** (1784-1846) kept this diary during her second and third trips there between 1835 and 1838. A relative of pioneer settler Stephen Austin, Holley, a widow, coupled discussion of

family activities with lengthy commentaries on the natural environment, public events, and personalities. Holley's classic work Texas: Observations, Historical, Geographical, and Descriptive, in a Series of Letters Written during a Visit to Austin's Colony with a View to Permanent Settlement in That County in the Autumn of 1831 (1833) has been reprinted in Mattie Austin Hatcher, Letters of an Early American Traveller: Mary Austin Holley, Her Life and Her Works 1784-1846 (Dallas: Southwest Press, 1933).

5 Memoirs of Anne C.L. Botta Written by Her Friends: With Selections from Her Correspondence and from Her Writings in Prose and Poetry. [Edited by Vincenzo Botta.] New York: J. Selwin Tait & Sons, 1893, 459 pp.
 Excerpts from her correspondence are included in this volume compiled to memorialize **Anne Charlotte Lynch Botta** (1815-91), a poet and nonfiction writer best known for hosting highly regarded literary salons in New York City. Penned in a self-conscious formal style, Botta's letters, written to a variety of people between 1835 and 1889, illustrate her views on literature, religion, and politics.

6 "A Trip to Niagara in 1835: Miss Caroline Spencer's Journal." Magazine of American History 22 (1889):331-42.
 Caroline Spencer (Benton), accompanied by her father and a female friend, traveled from New York City to Niagara in July 1835. In her journal, the young single woman recorded the sights she saw on the trip by canal boat and rhapsodized about the splendor of Niagara Falls.

7 "A Yankee School Teacher in Louisiana, 1835-1837: The Diary of Caroline B. Poole." Edited by James A. Padgett. Louisiana Historical Quarterly 20 (1937):651-79.
 The profound sense of dislocation New Englander **Caroline B. Poole** (1802-44) experienced when transplanted from Cambridge, Massachusetts, to Monroe, Louisiana, to teach school is apparent in the diary she kept from April 1835 to May 1837. A single woman with firm moral convictions, Poole registered her displeasure at the laxity of southern society, yet remained determined to persist in her educational mission. Religion was of primary importance to Caroline Poole, and discussion of preachers, Sabbath school work, and spiritual matters abounds. A considerable portion of Poole's diary is devoted to chronicling the events of a trip to Bardstown, Kentucky, in the summer of 1836.

1836

1 First White Women over the Rockies: Diaries, Letters, and
 Biographical Sketches of the Six Women of the Oregon Mission
 Who Made the Overland Journey in 1836 and 1838. With intro-
 ductions and editorial notes by Clifford Merrill Drury.
 2 vols. Vol. 1, Mrs. Marcus Whitman, Mrs. Henry H. Spalding,
 Mrs. William H. Gray, and Mrs. Asa B. Smith. Vol. 2, Mrs.
 Elkanah Walker and Mrs. Cushing Eells. Glendale, Calif.:
 Arthur H. Clark Co., 1963, 280 pp., 382 pp.

 First White Women over the Rockies: Diaries, Letters, and
 Biographical Sketches of the Six Women of the Oregon Mission
 Who Made the Overland Journey in 1836 and 1838. With intro-
 ductions and editorial notes by Clifford Merrill Drury.
 Vol. 3, Diary of Sarah White Smith (Mrs. Asa B. Smith),
 Letters of Asa B. Smith and Other Documents Relating to the
 1838 Reenforcement to the Oregon Mission. Glendale, Calif.:
 Arthur H. Clark Co., 1966, 332 pp.
 In 1836 and 1838, the American Board of Commissioners for
 Foreign Missions sent a small group of men and their wives to
 Oregon as missionaries to the Indians. This collection prints
 the diaries and letters of the six religious women who undertook
 this dangerous journey: **Narcissa Prentiss Whitman** (1808-47),
 Eliza Hart Spalding (1807-51), **Mary Richardson Walker** (1811-97),
 Myra Fairbanks Eells (1805-78), **Mary Augusta Dix Gray** (1810-81),
 and **Sarah Gilbert White Smith** (1813-55).

2 A Journey in 1836 from New Jersey to Ohio, Being the Diary of
 Elizabeth Lundy Willson. Edited by William C. Armstrong.
 Morrison, Ill.: Shawver Publishing Co., 1929, 43 pp.
 Elizabeth Lundy Willson (?-1838), a Quaker widow from
 Allamuchy, New Jersey, accompanied her eldest son to Wyandot
 County, Ohio, in 1836 when he decided to relocate his young
 family there. In her diary of the 1836 wagon trip to Ohio and
 the return journey in 1837, Mrs. Willson recorded her comments on
 topography, crops, roads, lodgings, and the variety of people en-
 countered along the route. These commonplace observations are
 punctuated by personal expressions of religious faith which
 convey with clarity the values that framed the life of this
 devout Quaker woman. The diary also provides evidence of Mrs.
 Willson's penchant for writing rhymed verses to suit various
 occasions.

3 Letters of Theodore Dwight Weld, Angelina Grimké Weld, and
 Sarah Grimké 1822-1844. Edited by Gilbert H. Barnes and
 Dwight L. Dumond. 2 vols. New York: Appleton-Century-
 Crofts, 1934, 1023 pp.

Their identity as daughters of a prominent Charleston, South Carolina, slaveholding family heightened public interest in **Sarah Moore Grimké** (1792-1873) and **Angelina Emily Grimké Weld** (1805-79) when they became vocal advocates of Abolition and women's rights. These selections from the correspondence of the Grimké sisters between 1836 and 1842 are invaluable for documenting their ideological position, their work in the antislavery movement, and their relations with others in the circle of reformers. Filled with detailed information on their travels, meetings, speaking engagements, and reception in various communities, the letters also contain lucid expositions of issues and strategies. Angelina's love letters to Theodore Weld, whom she married in 1838, are of unusual interest for their mixture of passion and reformist fervor. The sisters' removal from active participation in the movement following Angelina's marriage is hinted at by the introduction of domestic concerns into their letters. This voluminous collection of correspondence also includes letters by several other women reformers.

4 Life and Letters of Mrs. Jason Lee, First Wife of Rev. Jason Lee of the Oregon Mission, by Theressa Gay. Portland, Oreg.: Metropolitan Press, Publishers, 1936, 224 pp.
 Anna Maria Pittman Lee (1803-38) was one of the first female missionaries sent to the Oregon country. Married shortly after her arrival there to the Reverend Jason Lee, superintendent of the Methodist-sponsored Willamette Mission, she survived only a year before dying in childbirth. All but two of the eighteen letters of Anna printed here date from 1836 to 1838 and concern her missionary work with the Indians. In correspondence with members of her family, she related her state of mind at the commencement of her trip to Oregon, described the journey itself including a stopover in the Sandwich Islands (Hawaii), and reported on the condition of the Indians, her work at the Oregon mission, and her personal life. Three letters written to her husband following his departure for the eastern states reveal her deep affection for him and her trepidation at the impending birth of her child. Anna Lee's letters contain abundant evidence of her religious faith as well as her genuine concern for the salvation of others.

5 "A Missionary's Wife Looks at Missouri: Letters of Julia Barnard Strong, 1836-1839." Edited by Vivian K. McLarty. Missouri Historical Review 47 (1953):329-43.
 Julia Barnard Strong traveled to Missouri with her husband, a Presbyterian minister, so that he could fulfill his duties as a missionary for the Tract Society. In six letters written to family members in Minden, New York, between 1836 and 1839, Julia chronicled her husband's religious work and her own teaching at the Lindenwood Seminary. She expressed delight that the company

of civilized and neighborly people could be found in the West and furnished her eastern relatives with lengthy descriptions of the unfamiliar prairie landscape.

6 The Neglected Thread: A Journal from the Calhoun Community, 1836-1842, by Mary E. Moragne. Edited, with preface and backgrounds by Delle Mullen Craven. Columbia: University of South Carolina Press, 1951, 256 pp.
 The impact of religious conversion on the life of a rela-tively privileged young southern woman is vividly illustrated in this diary kept by **Mary Elisabeth Moragne** (1816-1903) of the Abbeville District in South Carolina from 1836 to 1842. Ini-tially preoccupied with her busy social life, her reading, and her budding career as a writer, Mary experienced the gift of God's grace following the death of a favorite uncle and her meeting with the Presbyterian minister who eventually became her husband. Already given to self-analysis, she reexamined her life in the light of Christian beliefs and ultimately decided to give up her literary ambitions. As it traces her troubled path toward marriage, this introspective diary documents Mary's inner conflicts regarding woman's proper role. The diary is also a useful source for analyzing the intellectual development of an intelligent and educated young woman, since it contains a com-prehensive record of Mary's reading and studies.

<u>1837</u>

1 Diary of Elizabeth Dick Lindsay, February 1, 1837-May 3, 1861. Salisbury, N.C.: Salisbury Printing Co., 1975, n.p.
 This difficult-to-decipher facsimile edition of the diary kept by **Elizabeth Dick Lindsay** (1792-1845) of Guilford County, North Carolina, between 1837 and 1845 offers a glimpse of the everyday life of the wife of a prosperous farmer and storekeeper. Valuable for its detailed record of Mrs. Lindsay's gardening and household work, the diary also sheds light on child care, reli-gious practices, and community activities. Mrs. Lindsay's matter-of-fact attitude toward mortality becomes evident in lengthy passages describing the deaths of family members and neighbors. Her daughter, **Mary Eliza Lindsay Bowman**, made scattered entries in her mother's diary until 1861.

2 The Diary of Lucy Ann Higbee, 1837. Edited by Mrs. Fanny Southard (Hay) Hall. Cleveland: Privately printed, 1924, 57 pp.
 In 1837, **Lucy Ann Higbee**, a single woman of about forty, undertook a journey from Trenton, New Jersey, to Ohio for the purpose of bringing her niece, who had been at school in Philadelphia, back to visit her father (Lucy's brother) in Ohio. This diary is a record of that trip made by railroad, steamboat,

and carriage. Higbee's descriptions of settlements, scenery,
fellow travelers, and accommodations are especially interesting
because of their matter-of-fact tone, although Higbee's genteel
values are reflected in her comments on accommodations.

3 Land of Their Choice: The Immigrants Write Home. Edited by
 Theodore C. Blegen. [Minneapolis]: University of Minnesota
 Press, 1955, 463 pp.
 Women are well represented in this useful collection of
Norwegian immigrant letters. Extensive selections from the
correspondence of **Gro Svendsen** (see 1861.13) and **Elise Amalie
Tvede Waerenskjold** (see 1851.3) provide ample evidence for
documenting the lives of these female pioneers in nineteenth-
century Iowa and Texas. Individual letters composed by **Martha
Larsen** (1837), **Jannicke Saehle** (1847), **Henrietta Jessen** (1850),
Ragnil Omland (1850), and **Guri Endressen** (1866) shed light on the
varied experiences of female immigrants from Norway in New York,
Wisconsin, and Minnesota. The letters by Saehle, Jessen, and
Endressen are also printed in Theodore C. Blegen, trans. and ed.,
"Immigrant Women and the American Frontier: Three Early 'America
Letters,'" Norwegian-American Studies and Records 5 (1930):14-29.

4 Log City Days, Two Narratives on the Settlement of Galesburg,
 Illinois: The Diary of Jerusha Loomis Farnham. Sketch of Log
 City by Samuel Holyoke. [Introduction by Earnest Elmo
 Calkins.] Galesburg, Ill.: Knox College Centenary Publica-
 tions, 1937, pp. 11-57.
 Memories of her family in Cazenovia, New York, flooded in
on **Jerusha Brewster Loomis Farnham** (1807-72) as she composed her
diary en route to the Gale Colony at Log City (Galesburg),
Illinois, and during her early months there in 1837 and 1838.
Mrs. Farnham, who was childless at the time, was particularly
devoted to a little niece whom she had cared for in New York, and
she periodically indulged in flights of imagination concerning
this child as she recorded the events of the day. The Galesburg
settlers were closely bonded by strong religious convictions, and
Mrs. Farnham's diary is filled with news of the church as well as
personal meditations of a spiritual nature. Her participation in
the embryonic female networks of the community is also well
documented.

 1838

1 "'I Can Never Be Happy There in Among So Many Mountains'--The
 Letters of Sally Rice." [Edited by] Nell W. Kull. Vermont
 History 38 (1970):49-57.
 Dissatisfaction with the limited opportunities in her home
town of Somerset, Vermont, impelled **Sarah (Sally) Rice** (1821?-?)
to seek employment beyond the borders of her state. These six

letters, written to her family between 1838 and 1845, document
Sally's work history and cast light on the options available to
New England women in the 1830s and 1840s. Forced to support
herself as well as to provide her own marriage portion, Sally
worked for a series of farm families in Union Village, New York,
Barre, Massachusetts, and Millbury, Massachusetts. The prospect
of higher wages enticed her to take a job as a weaver in a cotton
factory in Thompson, Connecticut, but a brief stint in the mills
affected her health adversely and reinforced her preferences for
housework and farm life. After undergoing a moral transforma-
tion, Sally emphasized the importance of attending the Methodist
meeting.

2 The Journal of Mary Peacock: Life, a Century Ago, as Seen in
 Buffalo and Chautauqua County by a Seventeen Year Old Girl in
 Boarding School and Elsewhere. Buffalo, N.Y.: Privately
 printed, 1938, [60 pp.].
 This brief journal of **Mary Peacock** (Evans) (1821-1912), a
 boarding school student in Buffalo, New York, covers the period
 from January 1, 1838 to January 1, 1839. The relatively routine
 entries focus on Peacock's social life: visiting, entertaining
 gentlemen callers, attending parties and balls. Other more
 mundane concerns, such as school and church and reading, also
 figure in this journal. A trip home to Mayville, New York, is
 recounted as well. For the most part, this journal presents a
 straightforward chronicle of Peacock's activities, enlivened only
 by occasional comments on public events.

3 Life and Letters of Mrs. Jeanette H. Platt. [Compiled by
 Cyrus Platt.] Philadelphia: E. Claxton & Co., 1882, 363 pp.
 The correspondence of **Jeanette Hulme Platt** (1816-77), span-
 ning the years 1838 to 1877, constitutes a rich source for docu-
 menting the life of a woman who exemplified the virtues of
 Victorian womanhood. Spiritual concerns were of paramount
 importance to Jeanette, a devout Episcopalian, and she viewed the
 course of her life through a religious lens. First, as a self-
 described "old maid" and later as a wife and mother of six
 children, she devoted herself to serving her family through both
 concrete deeds and religious instruction. Jeanette's letters to
 her husband, Cyrus, reveal her views on love and marriage in a
 Christian context, and her letters to her daughter and son con-
 tain ample evidence of the moral and spiritual guidance she
 offered her children.

1839

1 Elizabeth Cady Stanton As Revealed in Her Letters, Diary, and
 Reminiscences. Edited by Theodore Stanton and Harriot Stanton
 Blatch. 2 vols. New York and London: Harper & Brothers,
 1922, 362 pp., 369 pp.
 This compilation of the writings of women's suffrage leader
 Elizabeth Cady Stanton (1815-1902) includes selections from her
 correspondence between 1839 and 1880 and her diary for the years
 1880 to 1902. In her letters, Stanton expounded her feminist
 views, discussed her activities in behalf of the women's rights
 movement, and expressed her opinions on current political ques-
 tions. She also spoke freely of her private life, acknowledging
 frankly the conflict she felt between her family obligations and
 her career as a reformer. The letters also shed light on her
 unconventional experiences of childbirth and her relationships
 with her husband and children. Stanton's diary documents her
 undiminished enthusiasm for the cause of women's rights in her
 later years, noting her work on speeches, articles, and books,
 especially the multivolume History of Woman Suffrage. The diary
 also contains Stanton's record of her reading and her trips to
 England. See also 1852.2.

2 "Family Life on the Frontier: The Diary of Kitturah Penton
 Belknap." Edited by Glenda Riley. Annals of Iowa, 3d ser.
 44 (1977):31-51.
 The periodic entries **Kitturah Penton Belknap** (1820-1913)
 made in her diary between 1839 and 1848 give a good sense of the
 everyday work she performed on a frontier farm in Van Buren
 County, Iowa. They also document her feelings at the birth and
 death of her children and the pleasure she took in the religious
 meetings held in her home. The latter part of the diary chroni-
 cles Belknap's meticulous preparations for the family's journey
 to Oregon. See also 1845.1.

3 The First State Normal School in America: The Journals of
 Cyrus Peirce and Mary Swift. With an introduction by Arthur
 O. Norton. Cambridge, Mass.: Harvard University Press,
 1926, 299 pp.
 This book contains "The Journal of Mary Swift, August 1,
 1839-April 4, 1840," a lengthy record of the education of a
 seventeen-year-old girl preparing to be a teacher. **Mary Swift**
 (Lamson) (1822-1909) was one of the first young women to enroll
 at the State Normal School established in Lexington, Massachu-
 setts. Her journal, covering three terms, constitutes a
 detailed chronicle of school life and includes notes on lectures
 and other classroom work. Swift's observations of the town of
 Lexington and its people as well as her accounts of regional
 events such as the Harvard University commencement and the

Middlesex County school convention give the journal an added
dimension.

4 "Frontier Life: Loneliness and Hope." Edited by Donald F.
 Carmony. <u>Indiana Magazine of History</u> 61 (1965):53-57.
 In this long letter written to her mother-in-law in
Deerfield, Massachusetts, in 1839, **Sarah Ames Stebbins** described
the primitive living conditions in her new home of Richfield,
Illinois. She also dwelt on the poor health of settlers on the
Illinois frontier. The overriding theme of the letter, however,
is her homesickness. Depressed by the lack of civilized people
on the frontier, not to mention the accoutrements of a civilized
life-style, Sarah expressed her strong wish that people from the
East should migrate to Illinois. This letter conveys unmis-
takably the sense of loss experienced by women uprooted from
stable communities in order to move West with their husbands.

5 <u>Letters of Ada R. Parker</u>. Boston: Crosby & Nichols; New
 York: A.D.F. Randolph, 1863, 302 pp.
 Continual bouts of severe illness marked the adult life of
Adaline (Ada) Rice Parker (1819-60) of Nottingham, New Hampshire,
a single woman who enjoyed a brief career as a district school-
teacher before becoming incapacitated by tuberculosis. Ada's
correspondence with friends over the years 1839-60 shows clearly
how her unshakable religious faith sustained her during her
ordeal and enabled her to find meaning in her suffering. In-
creasingly confined to bed, Ada occupied her time in reading and
meditation. A member of the Congregational church from the age
of sixteen, she evolved her own religious philosophy through
study of the Bible and other devotional works and continuous
examination of her own soul. Compelled by her precarious condi-
tion to face wasting illness and the ever-present prospect of
death, Ada grappled with questions related to physical and
spiritual health and devised answers that brought her comfort
and aided her in counseling friends. Religious matters figure
most prominently in Ada's correspondence, but her intellectual
breadth is evident from her comments on a variety of publica-
tions and current issues.

1840

1 "Almira Raymond Letters 1840-1880." Edited by Olga Freeman.
 <u>Oregon Historical Quarterly</u> 85 (1984):291-303.
 As this sampling of letters written between 1840 and 1880
attests, **Almira David Raymond** (1813[14?]-1880) never swayed from
her convictions as a Christian during her long years in Oregon.
Almira and her husband embarked from New York for Oregon as
Methodist missionaries intent on bringing the Gospel to the
"heathen." Letters to her family dating from the 1840s are

primarily concerned with assessing the progress of religious work among the Indians. After the Raymonds settled on a farm, domestic labors consumed most of Almira's time, and she re- defined her purpose as educating her children in the way of God. An 1852 letter contains a frank discussion of the difficulties she had encountered in childbirth. In 1864, Almira and her husband were divorced.

2 "Diary of Anna R. Morrison, Wife of Isaac L. Morrison." [Introduction by Miriam Morrison Worthington.] <u>Journal of the Illinois Historical Society</u> 7 (1914):34-50.
 At the time she kept this diary during the winter of 1840-41, **Anna Tucker Rapalje** (Morrison) (1820-?) had separated from her husband, George Rapalje, whom she had married just before her fifteenth birthday, and was traveling from New York City to Illinois with her father to find a new family home. Distraught over her unfortunate marriage, the death of her baby, and her father's financial difficulties, Anna was engaged in an ongoing struggle to control her emotions, using religion as a means of solace. Although the diary contains the usual record of occurrences on the journey, its principal interest lies in those passages in which Anna examines her feelings and speculates on her future. Anna subsequently settled in Jacksonville, Illinois, with her parents and sister, was divorced, and married Isaac Morrison in 1853.

3 Elizabeth Lloyd and the Whittiers: A Budget of Letters. Edited by Thomas Franklin Currier. Cambridge, Mass.: Harvard University Press, 1939, 146 pp.
 The high esteem in which **Elizabeth Lloyd** (Howell) (1811-96), a Philadelphia Quaker, held poet John Greenleaf Whittier and his sister, Elizabeth, is evident in the letters she penned to them between 1840 and 1866. Lloyd did much more than transmit news of her Quaker social circle, which had welcomed the Whittiers warmly during their time in Philadelphia. Sharing the poet's humanitarian sensibility and love of literature, she dis- cussed social and intellectual issues freely. Her articulate letters contain her comments on developments in the antislavery movement and the Society of Friends as well as her observations on religion and poverty. Lloyd also expressed her opinions of books and authors, offered praise for Whittier's poetry, and occasionally included samples of her own poems. Intelligent and independent of mind, Lloyd remarked on the limitations that her gender and her orthodox upbringing imposed on her. Most of these letters were written while Lloyd was single, but a few date from the period of her widowhood.

1840

4 Journals and Letters of Mother Theodore Guerin, Foundress of
 the Sisters of Providence of Saint Mary-of-the-Woods, Indiana.
 Edited with notes by Sister Mary Theodosia Mug. Saint Mary-
 of-the-Woods, Ind.: Providence Press, 1937, 452 pp.
 In 1840, **Mother Theodore** (Anne-Therese) **Guerin** (1798-1856)
 was sent from France to establish a new mission of the Sisters
 of Providence in Indiana. Three travel journals and a series of
 letters spanning the years 1840 to 1856 document her journey to
 America and her educational and charitable work at St. Mary-of-
 the-Woods. The problems with which she had to grapple--
 financial difficulties, the ill health of Sisters, Protestant
 opposition to Catholic schools--emerge in her correspondence
 with church authorities in France and the United States. Her
 most serious problem was the protracted conflict with her bishop
 engendered by her determination to adhere to the principles of
 her order. Mother Guerin's personal side is revealed in her
 letters to Sisters who were away on missions as teachers in
 various Indiana communities. Her concern and affection for them
 is evident, as she offers them counsel and reminds them of the
 supremacy of religious values. Filled with illuminating details
 of the everyday life of the Sisters of Providence as well as
 critical comments on American mores, Mother Guerin's correspon-
 dence is an indispensable source for the study of Roman Catholic
 women in the mid-nineteenth century.

5 Mary Todd Lincoln: Her Life and Letters, by Justin G. Turner
 and Linda Levitt Turner. With an introduction by Fawn M.
 Brodie. New York: Alfred A. Knopf, 1972, 750 pp.
 The more than six hundred letters printed in this volume go
 a long way toward dispelling the myths that have grown up around
 Mary Ann Todd Lincoln (1818-82), the wife of President Abraham
 Lincoln. Although it spans the years 1840 to 1882, the corre-
 spondence centers on Mary's years in the White House and her
 lengthy widowhood. Mary welcomed the opportunity to be First
 Lady and soon immersed herself in Washington politics. Her let-
 ters reveal how she cultivated certain individuals, sought favors
 for friends as well as needy individuals, and supplied aid for
 ex-slaves. Deeply in debt because of her penchant for fashion-
 able clothing, Mary used her political connections to alleviate
 her plight. The assassination of her husband compounded her
 financial difficulties, and much of the correspondence during the
 years of her widowhood relates to her efforts to obtain a pension
 from Congress and pay off her debts. From her writings, it is
 evident that Mary dearly loved her husband and three younger sons
 and was inconsolable after their deaths. The tragedies that
 marred her life inflicted a heavy psychological toll, but the
 charges of mental illness leveled at her are not substantiated by
 her correspondence. Some of the letters included in this book
 were previously published in Charles V. Darrin, "Your Truly

Attached Friend, Mary Lincoln," <u>Journal of the Illinois State Historical Society</u> 44 (1951):7-25; Francis Whiting Hatch, "Mary Lincoln Writes to Noah Brooks," <u>Journal of the Illinois State Historical Society</u> 48 (1955):45-51; and Justin G. Turner, "The Mary Lincoln Letters to Mrs. Felician Slataper," <u>Journal of the Illinois State Historical Society</u> 49 (1956):7-33. See also 1852.8.

6 "A Trip to the White Mountains in 1840," by Mary A. Hale. <u>Essex Institute Historical Collections</u> 83 (1947):23-29.
 In August 1840, **Mary A. Hale** (1824-1910) of Haverhill, Massachusetts, traveled with her parents and sister to the White Mountains of New Hampshire. Her diary account of this journey through northern New England is written in a matter-of-fact tone, devoid of the romantic superlatives so common in travel narratives of the period. Hale carefully noted the major establishments in each town, including factories as well as churches, academies, and public houses. The trip was highlighted by a tour of the powder works in Lowell, Massachusetts, a visit to the Shaker community in Enfield, New Hampshire, and finally, walks in the White Mountains, where Mary was only the second woman to climb Mount Lafayette.

7 <u>Two Quaker Sisters: From the Original Diaries of Elizabeth Buffum Chace and Lucy Buffum Lovell</u>. With an introduction by Malcolm R. Lovell. New York: Liveright Publishing Corp., 1937, 183 pp.
 Despite its title, this book contains only one diary, that of **Lucy Buffum Lovell**, the wife of a Baptist minister in Bellingham, Massachusetts. Consisting of a handful of lengthy retrospective entries inscribed between October 1840 and June 1843, Lovell's poignant diary was intended to commemorate the lives and deaths of her two daughters and son. The young mother sketched the character and accomplishments of her children in loving detail, discussed her role in their discipline and religious education, and recalled the agonies of their final days. Sustained by her unshakable faith, Lovell was able to accept their deaths.

<u>1841</u>

1 "Charleston in the Summer of 1841: The Letters of Harriot Horry Rutledge." Edited by Harriet R. Holman. <u>South Carolina Historical and Genealogical Magazine</u> 46 (1945):1-14.
 A precocious nine-year-old girl's animated recital of daily occurrences is found in the letters **Harriott Horry Rutledge** (Ravenel) (1831[32?]-?) of Charleston, South Carolina, wrote to her mother in Boston in the summer of 1841. Harriott lived in a privileged world where she spent her time taking French lessons,

1841

entertaining her playmates, and visiting the family's country home. Her educational progress was charted by her aunt, **Harriott Pinckney Rutledge Holbrook**, some of whose letters to young Harriott's mother are included here.

2 The Life and Letters of Sister St. Francis Xavier (Irma LeFer de la Motte) of the Sisters of Providence of Saint Mary-of-the -Woods, Indiana, by Clementine de la Corbiniere. Rev. and enl. ed. Saint-Mary-of-the-Woods, Ind.: Providence Press, 1934, 459 pp.
Sister Saint Francis Xavier (Irma LeFer de la Motte) (1816-56) was eager to leave her native France to labor in America as one of the Sisters of Providence in Saint-Mary-of-the-Woods, Indiana. From the date of her arrival in the United States in 1841 until 1856, she corresponded with her family as well as religious men and women in France, recounting her missionary endeavors and commenting on the attitudes and behavior of Americans. Deeply committed to the religious life, Sister Saint Francis was put in charge of the novitiate and worked to shape the young women to fulfill their trust through her teaching and her example. She counseled novices and former pupils in letters that reflect her staunch faith and her abiding concern for other people's welfare.

1842

1 The Letters of Emily Dickinson. Edited by Thomas H. Johnson and associate editor Theodora Ward. 3 vols. Cambridge, Mass.: Harvard University Press, Belknap Press, 1958, 999 pp.
Over a thousand letters--all the known correspondence--of poet **Emily Dickinson** (1830-86) are published here. Dating from 1842 to 1886, they are of incalculable value for understanding the remarkable mind of the reclusive single woman of Amherst, Massachusetts, whose poetic genius was recognized only after her death. Dickinson's early letters, some quite lengthy, are informal in tone and focus on domestic and local happenings. Once she had determined to isolate herself from the world, her correspondence became more serious and more intense. Her concern for the universals of existence became paramount, and the later letters are often indistinguishable from her poems. This edition of Dickinson's letters supplants all previous compilations of the poet's correspondence. Earlier publications of Emily Dickinson's letters include Mabel Loomis Todd, ed., Letters of Emily Dickinson, 2 vols. (Boston: Roberts Brothers, 1894); Martha Dickinson Bianchi, The Life and Letters of Emily Dickinson (Boston and New York: Houghton Mifflin, 1924); Mabel Loomis Todd, ed., Letters of Emily Dickinson, enl. ed. (New York and London: Harper & Brothers, 1931); Martha Dickinson Bianchi, Emily Dickinson Face to Face: Unpublished Letters with Notes and Reminiscences

(Boston: Houghton Mifflin Co., 1932); Theodora Van Wagenen Ward, ed., Emily Dickinson's Letters to Dr. and Mrs. Josiah Gilbert Holland (Cambridge, Mass.: Harvard University Press, 1951). See also Thomas H. Johnson, ed., Emily Dickinson: Selected Letters (Cambridge, Mass.: Harvard University Press, Belknap Press, 1971). See also 1847.3.

2 "Two Letters from Pine Ridge Mission." [Edited by] Elizabeth H. Hunt. Chronicles of Oklahoma 50 (1972):219-25.
 Two letters of **Electa May Kingsbury**, the wife of Cyrus Kingsbury, missionary to the Choctaw Indians, are printed here. The letters were written in 1842 and 1844 from Pine Ridge Mission in the Indian Territory to an old friend from a former mission. The letters are largely taken up with reminiscences of and requests for information about a wide circle of old friends, now living in other parts of the country. Mrs. Kingsbury's paramount interest, however, was the missionary work in which she was involved. In addition to reporting on her own teaching activities among the Indians and her husband's work, she exhorted her friend to greater efforts in the cause of Christianity.

<u>1843</u>

1 "From 'The Crack Post of the Frontier': Letters of Thomas and Charlotte Swords." Edited by Harry C. Myers. Kansas History 5 (1982):184-213.
 Charlotte Cotheal Swords (?-1888?) willingly shared the hardships of army life on the western frontier with her husband, Captain Thomas Swords, the quartermaster of Fort Scott. Four of these letters to a friend and fellow officer of Thomas were written by Charlotte during the years 1843 to 1845. In them, she relates army gossip and tells of her life at Fort Scott, noting the time she has spent reading, collecting flowers, and consoling a grief-stricken widow.

2 Gifts of Power: The Writings of Rebecca Jackson, Black Visionary, Shaker Eldress. Edited, with an introduction by Jean McMahon Humez. [Amherst]: University of Massachusetts Press, 1981, 368 pp.
 Following her spiritual rebirth in her mid-thirties, **Rebecca Cox Jackson** (1795-1871), a free black woman of Philadelphia, separated from her husband, commenced preaching in public as a Holiness Methodist, entered upon a lifelong relationship with a female disciple and companion, joined the Shaker community at Watervliet, New York, and ultimately founded a Shaker sisterhood in Philadelphia comprised primarily of blacks. Believing herself an instrument of God's will, Jackson received knowledge of divine purpose through the medium of dreams and visions, the record of which is preserved in an autobiography

1843

and a journal running from 1843 to 1864. The journal focuses
exclusively on Jackson's inner experience and portrays the
images and symbolic landscapes that formed the basis of her
religious beliefs and activities.

3 "The Girl He Left Behind: The Letters of Harriet Hutchinson
 Salisbury." [Edited by] Allan F. Davis. Vermont History 33
 (1965):274-82.
 Between October 1843 and December 1846, **Harriet Hutchinson**
 (Salisbury) (1825?-?), a young single woman of East Braintree,
 Vermont, corresponded with her future husband, Lucius Salisbury,
 who had gone to Missouri to earn money. These excerpts from
 Harriet's letters reveal that she was disheartened at the lengthy
 separation from Lucius, yet at the same time reluctant to move to
 the West with him.

4 Louisa May Alcott: Her Life, Letters, and Journals. Edited
 by Ednah D. Cheney. Boston: Roberts Brothers, 1889, 404 pp.
 In her later years, author **Louisa May Alcott** (1832-88)
 reviewed her journals, excising personal material and adding com-
 ments. These revised journals, supplemented here with a small
 number of her letters and spanning the years 1843 to 1888,
 furnish a moving account of Alcott's devotion to her mother,
 father, and sisters and document her laborious efforts to earn
 money to support the impoverished family by sewing, teaching, and
 writing. The growing success of her stories and novels ulti-
 mately gave Alcott the financial security she craved, but she
 continued to work hard and to place her family's needs above her
 own. Although proud of her life as an independent single woman,
 Alcott was frequently lonely and depressed as she aged and rued
 the fact that she had never fulfilled her own desires. A person
 of broad humanitarian sympathies, Alcott nursed Union soldiers
 during the Civil War, read her stories to prisoners, and cham-
 pioned antislavery and woman's suffrage. See 1871.4 for letters
 of Abigail May Alcott, the mother of Louisa May Alcott.

1844

1 "Journal of a Trip from Illinois Back to Long Island in 1844,"
 by Elizabeth Howell Blanchard. Edited and contributed by
 William A. Robbins. Long Island Historical Society Quarterly
 3 (1941):3-13, 42-53, 77-83, 107-15; 4 (1942):3-15.
 In 1844, after an absence of more than a quarter of a cen-
 tury, **Elizabeth Howell Blanchard** (1800-46) returned to her child-
 hood home on Long Island for an extended visit with relatives and

friends. Homesick for her husband and children left behind on
the farm in Greenville, Illinois, yet eager to see the people and
places of her youth, Blanchard turned to her journal to unburden
herself of her feelings as well as to make notes on the events of
her busy days. The conditions women faced when traveling alone
are made clear in Blanchard's detailed account of her lengthy
journey by stage, boat, and railroad and her days in Philadelphia
and New York City. Blanchard's stay among her old acquaintances
on eastern Long Island brought her an infinite amount of pleasure
but also heightened her consciousness of aging and reminded her
of her deep ties to the East despite her long residence in the
West. Religion was the foundation stone of Elizabeth Blanchard's
life, and her journal provides a comprehensive record of her
spiritual exercises and her worship at various Protestant
churches.

2 Letters from Brook Farm 1844-1847, by Marianne Dwight.
 Edited by Amy L. Reed. With a note on Anna Q.T. Parsons by
 Helen Dwight Orvis. Poughkeepsie, N.Y.: Vassar College,
 1928, 191 pp.
 The idealism that pervaded the members of Brook Farm, a
communal society located on the outskirts of West Roxbury,
Massachusetts, is evident in the letters **Mary Ann** (or Marianne)
Dwight (Orvis) (1816-?) wrote to a close female friend and to her
brother between 1844 and 1847. Caught up in the spirit of
"Association," Dwight, a single woman who had been a teacher in
Boston, extolled the labor system, social activities, meetings,
and intellectual vitality of her new environment. Citing the
beneficial influence of life at Brook Farm on her personal
development, she urged others to give up the trappings of
civilization and join her in serving humanity. Dwight's letters
illuminate not only the functioning of the experimental society
but her own views on woman's equality, religious worship, and the
doctrines of Charles Fourier so dear to her comrades. The
despondency over the impending demise of Brook Farm expressed in
her final letters was offset by her joy in marrying John Orvis, a
fellow member of the community.

3 Letters of Elizabeth Cabot. 2 vols. Boston: Privately
 printed, 1905, 327 pp., 351 pp.
 The life of **Elizabeth Dwight Cabot** (1830-1901) from ado-
lescence to old age is amply documented in these copious selec-
tions from her correspondence spanning the years 1844 to 1901.
Born into Boston's world of wealth and privilege, Cabot was
devoted to her family and especially to her sister, Ellen. Her
numerous letters to Ellen, who had married and moved to England,
convey the keen pain of separation from a loved one and the sense
of self-doubt experienced in the process of establishing her own
identity. They also recount the typical occupations of a single

upper-class woman--parties, assemblies, lectures, shopping, read-
ing, French lessons, and playing the harp. Cabot's marriage in
1857 inaugurated a period of great happiness in her life, and her
correspondence is filled with glowing accounts of her husband,
her seven sons, and her in-laws. She also commented on social
life in Brookline and Beverly Farms and the responsibilities of
managing a large household and servants. The lingering illnesses
and deaths of her sister, Ellen, and of her son Ted deeply
affected Cabot, and her responses to these catastrophic events
give insight into her religious beliefs. Although Cabot wrote
primarily of family matters, she did air her feelings on the
Civil War crisis and frequently discussed her involvement in
women's clubs, school reform, and charitable work.

4 Old Days in Chapel Hill: Being the Life and Letters of
 Cornelia Phillips Spencer, by Hope Summerell Chamberlain.
 Chapel Hill: University of North Carolina Press, 1926,
 325 pp.
 Through her publications as well as the force of her
personality, **Cornelia Phillips Spencer** (1825-1908) left an in-
delible mark on higher education in North Carolina. Excerpts
from Spencer's journal and letters spanning the years 1844 to
1907 compose the bulk of this biographical volume. A widow with
one daughter, Spencer was instrumental in securing the contin-
uance of the University of North Carolina as well as establishing
a woman's college in the state. Her writings touch on her per-
sonal life, her family, the university, and the community of
Chapel Hill. She also discussed her books and articles on the
Civil War in North Carolina and on Presbyterianism.

<div align="center">1845</div>

1 Covered Wagon Women: Diaries & Letters from the Western
 Trails 1840-1890. Edited and compiled by Kenneth L. Holmes.
 5 vols. Vol. 1, 1840-1849. Vol. 2, 1850. Vol. 3, 1851.
 Vol. 4, 1852,The California Trail. Vol. 5, 1852, The Oregon
 Trail. Glendale, Calif.: Arthur H. Clark Co., 1983-86,
 272 pp., 294 pp., 283 pp., 295 pp., 312 pp.
 This ongoing series, five volumes of which have been pub-
lished to date, presents in chronological order a large selection
of the diaries and letters of women who traveled in covered
wagons on the overland trails to California and the Pacific
Northwest. The documents printed so far cover the years 1845 to
1852. The women represented in this collection are:
 Volume 1, 1840-1849: **Elizabeth (Betsey) Munson Bayley**
(1804-55); **Anna Maria Allen King** (1822-1905); **Tabitha Brown**
(1780-1858); **Tamsen Eustis Donner; Virginia Elizabeth B. Reed**
(1833?-?); **Phoebe Fail Stanton** (1815-86); **Rachel Joy Fisher
(Mills)** (1822-69); **Elizabeth Dixon Smith** (Geer) (1808[9?]-55);

Patty Bartlett Sessions (Parry) (1795-1892); Keturah Penton Belknap (1820-1913); Sallie Hester (1835-?); Louisiana Erwin Strenzel (1821-97).
Volume 2, 1850: Anna Maria De Camp Morris (1813-61); Mary M. Edwards Colby (1806?-89); Margaret Ann Alsip Frink (1818-93); Sarah Green Davis (1826-1906); Sophia Lois Goodridge (Hardy) (1826?-1903); Lucena Pfuffer Parsons (1821-1905).
Volume 3, 1851: Harriet Talcott Buckingham (Clarke) (1832-90); Amelia Hammond Hadley (1825-86); Susan Amelia Marsh Cranston (1829-57); Lucia Loraine Bigelow Williams (1816-74); Elizabeth Wood (Morse) (1838?-1913); Eugenia Zieber (Bush) (1833-63); Jean Rio Griffiths Baker (Pearce) (1810-83).
Volume 4, 1852, The California Trail: Elizabeth Keegan (Ketchum) (1840-1907); Eliza Ann McAuley (Egbert) (1835-1919); Francis Sawyer (1831-?); Mariett Foster Cummings (1827-?); Sarah Pratt (Miner) (1832?-?); Lucy Rutledge Cooke (1827-1915).
Volume 5, 1852, The Oregon Trail: Abigail Jane Scott (Duniway) (1834-1915); Polly Lavinia Crandall Coon (Price) (1825-98); Martha Stone Thompson Read (1811-91); Cecilia McMillen Adams (1829-67); Parthenia McMillen Blank (1829-1915).
See 1839.2 for the diary of Keturah (Kitturah) Penton Belknap. See 1847.2 for the diary of Elizabeth Dixon Smith (Geer). See 1851.2 for the journal of Elizabeth Wood (Morse).

2 Gail Hamilton's Life in Letters. Edited by H. Augusta Dodge. 2 vols. Boston: Lee & Shepard, 1901, 1090 pp.
The voluminous correspondence of Mary Abigail Dodge (1833-96), who wrote under the pen name Gail Hamilton, documents the life of a successful nineteenth-century career woman who mingled with the political and literary elite of Washington, D.C., and Boston. Presented here with a minimum of editorial intrusion, these entertaining and often witty letters, spanning the years 1845 to 1896, not only provide a detailed record of Dodge's professional and social activities but offer a sample of her views on a variety of issues--literary, political, social, metaphysical, and theological. They amply demonstrate her analytical powers as well as her familiarity with the intellectual currents of the day. As one who deliberately chose not to marry and who cherished independence, Dodge was keenly aware of her anomalous position in nineteenth-century society. Her reflections on her career path, when coupled with her comments on women, assume added interest in this context. Subscribing to the reigning truths regarding differences between the sexes yet rejecting the notion that fetters should be imposed on women's development, Dodge in a sense sought to make room for people like herself who did not fit into conventional social roles.

1845

3 Jefferson Davis: Private Letters 1823-1889. Edited by Hudson
 Strode. New York: Harcourt Brace & World, 1966, 580 pp.
 The title of this book does not indicate that it contains a
 sizable sample of letters written by **Varina Anne Howell Davis**
 (1826-1906), the wife of Confederate president Jefferson Davis,
 during the years of her marriage, 1845-89. Varina's acute obser-
 vations on political and financial issues are intermixed with
 news of the children and social activities in these engrossing
 letters penned, for the most part, from the family plantation in
 Mississippi and Washington, D.C. Varina's deep loyalty to her
 husband and his cause is evident throughout the correspondence
 and nowhere more so than in the emotional letters she wrote him
 when he was imprisoned at the end of the Civil War. Also
 included in this volume are a number of letters by the two Davis
 daughters, **Margaret Howell Davis** and **Varina Anne (Winnie) Davis**
 (1864-98), as well as other female family members. See 1886.3
 for other letters by Varina Anne Howell Davis and Varina Anne
 (Winnie) Davis.

4 "Letters from the Past: The Letters and Journal of Two
 Vermont Missionaries." Vermont Quarterly, n.s. 21 (1953):
 118-27, 200-210, 279-88; 22 (1954):42-51, 212-22.
 Charlotte Taylor Ranney (?-1874) and her husband Timothy
 traveled to the West as missionaries to the Indians under the
 auspices of the American Board of Commissioners of Foreign
 Missions, serving first among the Pawnees and then in the
 Cherokee Nation. Portions of Charlotte's journal from 1847 and
 1861 and letters of hers from 1845, 1847, and 1860 offer insight
 into her perspective on her work. Charlotte's elevated sense of
 purpose in bringing the Gospel to the Indians emerges clearly
 from her writings, but more striking is the consistent denigra-
 tion of Indian conduct and belief. The Ranneys lived by a rigid
 moral code shaped by their version of Christianity. The result-
 ing lack of receptivity to Indian culture is illustrated in
 Charlotte's comment that her two sons were absorbing too much of
 the Cherokee way of life and that she did not permit them to
 attend school with the Cherokees. Charlotte was also unyielding
 in her criticism of French and "halfbreed" traders for their
 greed, intemperance, and profanation of the Sabbath.

5 Linka's Diary on Land and Sea 1845-1864. Translated and
 edited by Johan Carl Keyser Preus and Diderikke Margrethe
 Preus (nee Brandt). Minneapolis: Augsburg Publishing
 House, 1952, 288 pp.
 Caroline Dorothea Margrethe Keyser Preus (1829-80),
 called "Linka," was a young bride when she emigrated from Norway
 to Spring Prairie, Wisconsin, in 1851 with her husband, a newly
 ordained Lutheran minister. Well educated and articulate, Linka
 kept a diary between 1845 and 1864 which spans her teen years,

betrothal, and marriage in Norway, her journey to America, and
her life as a minister's wife in Wisconsin. Linka recorded the
details of her outward life in vivid prose, effortlessly captur-
ing the essence of landscapes as well as family celebrations.
Her diary is most noteworthy, however, for its introspective
dimension. As a devout Lutheran and a woman of wide reading,
Linka continually subjected her behavior, thoughts, and feelings
to intensive scrutiny. Lengthy passages of religious self-
examination alternate with meditations on the duties of a wife
and the dangers and joys of childbearing. Linka's diary is
distinguished not only for its high literary quality but for its
insights into the mind of a Norwegian immigrant woman whose
desire to fulfill her domestic responsibilities frequently con-
flicted with her intellectual impulses.

1846

1 "From Virginia to Missouri in 1846: The Journal of Elizabeth
 Ann Cooley." Edited by Edward D. Jervey and James E. Moss.
 Missouri Historical Review 60 (1966):162-206.
 Soon after newly married **Elizabeth Ann Cooley McClure**
 (1825-48) set out for Texas with her husband, she began to have
 second thoughts about leaving her Virginia home. Feelings of
 regret at leaving her parents surfaced frequently in the journal
 she kept from March 1846 to March 1848, as she recorded her dis-
 like of Texas and her fear of the unhealthy climate in the
 couple's subsequent home near Independence, Missouri. Though
 Elizabeth derived considerable satisfaction from her work as a
 schoolteacher, she continued to struggle with moods of depression
 and eventually turned to membership in the Methodist church for
 comfort.

2 Invisible Immigrants: The Adaptation of English and Scottish
 Immigrants in Nineteenth-Century America, by Charlotte
 Erickson. Coral Gables, Fla.: University of Miami Press,
 1972, 531 pp.
 Although most of the letter writers represented in this
 volume of correspondence of nineteenth-century English and
 Scottish immigrants to the United States are male, the collection
 does contain a few valuable samples of women's letters. Included
 are letters by **Rebecca Butterworth**, from Outland Grove, Arkansas
 (1846); **Ann Whittaker**, from Monroe County, Illinois (1849-56);
 Emily Tongate, from Penn Yan, Yates County, New York (1874); and
 Hattie Reid, from Brooklyn, New York (1879-82). The most exten-
 sive and illuminating series of female-composed letters in the
 book is that written by **Catherine Bond**. Early letters, dating
 from 1870 to 1874, relate the experiences of Catherine and her
 husband as servants on a farm in Milford, Connecticut. The Bonds
 migrated to Bunker Hill, Kansas, in order to start their own

farm, and letters spanning the years 1879-99 describe the diffi-
culties they encountered in their efforts to be independent
farmers. News of the Bond children also fills these later let-
ters, and there are poignant passages recording Catherine's
feelings at the death of her daughter. This collection also
includes many letters signed jointly by husband and wife.

3 "An Irish Immigrant Housewife on the New York Frontier."
Edited by Philip L. White. New York History 48 (1967):
182-88.
 Reproduced here are three letters written in 1846 by
Minerva Padden Donovan, an Irish immigrant wife and mother, to
James W. Beekman, the son of her former employer, in New York
City. The letters provide a detailed description of the
desperate economic circumstances of the Donovans, a farm family
struggling to survive in Oswego County, New York. The letters
also express the family's heartfelt gratitude for the benevolence
of the Beekmans. As one of the few published examples of the
writings of Irish immigrant women in nineteenth-century America,
this correspondence possesses great value.

4 Journals of the Late Brevet Major Philip Norbourne Barbour,
Captain in the 3rd Regiment, United States Infantry, and His
Wife Martha Isabella Hopkins Barbour, Written during the War
with Mexico--1846. Edited, with a foreword by Rhoda van
Bibber Tanner Doubleday. New York and London: G.P. Putnam's
Sons, 1936, 187 pp.
 The anguish **Martha Isabella Hopkins Barbour** (Bunch)
(1824-88) felt at being separated from her husband, an officer in
the American army who was fighting in the war against Mexico, is
readily apparent in the journal she kept for him between July and
October 1846. Martha, a genteel young woman from Henderson,
Kentucky, was staying with relatives in Galveston, Texas, and
occupied her time with sewing, reading, churchgoing, visiting,
and bathing in the Gulf. But her journal entries reveal that her
thoughts were constantly focused on her absent mate, whom she
idolized. Fearful for his safety and despairing of ever being
reunited with him, she nevertheless dreamed of a life of domestic
happiness in the future. Martha's husband was killed in the war.

5 The Letters of Ellen Tucker Emerson. Edited by Edith E.W.
Gregg. 2 vols. [Kent, Ohio]: Kent State University Press,
1982, 702 pp., 681 pp.
 As the elder daughter of Ralph Waldo Emerson, **Ellen Tucker
Emerson** (1839-1909) was in a unique position to observe her
famous father and other family members, as well as the stream of
celebrated visitors that flocked to their Concord, Massachusetts,
home. Ellen's massive correspondence for the years 1846-92
constitutes an unparalleled source of information on Emerson and

the major cultural figures who moved in his orbit. Because she was both perceptive and articulate, her letters possess added significance as a chronicle of nineteenth-century New England domestic and social life. But these letters also serve to bring Ellen's own life into focus. A single woman who willingly assumed the burdens of running her parents' household and caring for them in their later years, Ellen was active in the Unitarian church and the Concord community. She enjoyed visiting and traveling and was a lively companion to her numerous relatives and friends.

6 Lucy Larcom: Life, Letters, and Diary. [Edited by] Daniel
 Dulany Addison. Boston and New York: Houghton, Mifflin &
 Co., 1894, 295 pp.
 Lucy Larcom (1824-93) achieved fame as the Lowell mill
 girl who rose to become a teacher, writer, and editor. This
 selective compilation of excerpts from Larcom's journal and
 correspondence between 1846 and 1893 documents her career and
 traces the evolution of her thought. As a single self-supporting
 woman, Larcom engaged in a continuing search for the means to
 maintain a genteel life-style. Initially compelled to derive
 her income from teaching, she gravitated toward the literary
 world, a world that, as her correspondence with authors and
 editors shows, she greatly preferred. The materials in this
 volume make it possible to delineate Larcom's intellectual inter-
 ests and political views and most important her religious be-
 liefs. The personal writings of her later years were dominated
 by religious questions and explain her eventual conversion from
 Congregationalism to the Episcopal church. Larcom's journals are
 noteworthy for their introspective dimension. See also 1849.8;
 1855.3.

7 "A Pioneer Trek from Ohio to Wisconsin: Sarah Foote's Journal
 of a Journey by Ox-Team from Wellington, Ohio, to Winnebago
 County, Wisconsin, April and May 1846." Journal of American
 History 15 (1921):25-36.
 In 1846, **Sarah Foote** moved with her family from Wellington,
 Ohio, to Winnebago County, Wisconsin. Young Sarah's journal of
 the uneventful trip by wagon describes the countryside, road
 conditions, and various stopping places.

8 Soul Mates: The Oberlin Correspondence of Lucy Stone and
 Antoinette Brown 1846-1850. Edited by Carol Lasser and
 Marlene Merrill. Oberlin, Ohio: Oberlin College, 1983,
 100 pp.
 Both destined to contribute significantly to the emancipa-
 tion of American women, **Lucy Stone** (1818-93) and **Antoinette Brown**
 (Blackwell) (1825-1921) commenced a lifelong friendship while
 students at Oberlin College in Ohio. Their letters to each

other from 1846 to 1850, a period when Stone had already embarked
on her career as a lecturer for antislavery and women's rights
and Brown was pursuing theological studies unofficially at
Oberlin, disclose the intensity of feeling that bound the two
women together as well as their often differing opinions.
Brown's ambition to be a Congregational minister sparked spirited
exchanges on religion, with Stone challenging the validity of
Brown's orthodox position. The young women also debated Aboli-
tionism and women's rights and spent a considerable amount of
time discussing the institution of marriage, which Stone de-
nounced in strong language. See 1853.9 for other letters by Lucy
Stone.

1847

1 The Diary of Dolly Lunt Burge. Edited by James I. Robertson,
 Jr. Athens: University of Georgia Press, 1962, 141 pp.
 Dolly Sumner Lunt Lewis Burge (Parks) (1817-91) of Newton
 County, Georgia, was widowed three times in the course of her
 life, but managed to persevere, sustained by her strong reli-
 gious faith. The different roles that Burge played over the
 years--teacher, mistress and then manager of a cotton plantation,
 and minister's wife--are well documented in the diary she kept
 from 1847 to 1879. She also wrote at length about her feelings
 for each of her husbands and for her only surviving daughter.
 A devout Methodist, Burge kept a record of her attendance at
 church services, camp meetings, and love feasts and at times
 subjected herself to rigorous self-examination. Although a
 native of Maine, Burge supported the Confederacy throughout the
 Civil War and experienced significant loss of property when
 General Sherman's troops arrived in her neighborhood. Her
 strongest wish, however, was for the restoration of peace. This
 diary was also published in serial form in James I. Robertson,
 Jr., ed., "The Diary of Dolly Lunt Burge," Georgia Historical
 Quarterly 44 (1960):202-19, 321-38, 434-55; 45 (1961):57-73,
 155-70, 257-75, 367-84; 46 (1962):59-78.

2 "Diary of Mrs. Elizabeth Dixon Smith Geer." Transactions of
 the 35th Annual Reunion of the Oregon Pioneer Association,
 Portland, June 19th, 1907 (1908):153-79.
 Initially a routine record of the everyday experiences of a
 large family on the Oregon Trail, this diary kept by **Elizabeth
 Dixon Smith** (Geer) (1808[9?]-55) of La Porte, Indiana, between
 April 1847 and February 1848 turned into a somber chronicle of
 hardship and suffering near the end of the journey, culminating
 in the illness and death of Elizabeth's husband in Portland,
 Oregon. An 1850 letter appended to the diary recounts the subse-
 quent history of the family and Elizabeth Dixon Smith's re-
 marriage to Joseph Geer. See also 1845.1.

3 <u>Emily Dickinson's Home: Letters of Edward Dickinson and His</u>
 <u>Family</u>. With documentation and comment by Millicent Todd
 Bingham. New York: Harper & Brothers, 1955, 600 pp.
 This collection of the correspondence of the Dickinson
family cf Amherst, Massachusetts, includes numerous letters by
poet **Emily Dickinson** (1830-86) and her sister **Lavinia Norcross
Dickinson** (1833-99), most of them written to their brother,
Austin, between 1847 and 1854. Since Emily's letters have been
published in an authoritative edition, it is Lavinia's letters
that constitute the major focus of interest of this volume. A
few early letters recount Lavinia's experiences as a student at
Ipswich Female Seminary and supply evidence of her religious
beliefs. Lavinia's correspondence for the most part, however, is
given over to a recital of current events in Amherst society.
See 1842.1 for the letters of Emily Dickinson.

<u>1848</u>

1 "The Letters of Calista Hall." Edited by Carol Kammen. <u>New</u>
 <u>York History</u> 63 (1982):208-34.
 When her husband accepted a job as a guard in Auburn Prison
in order to augment the family's income, **Calista Marsh** (Woodruff)
Hall (1816-99) remained in Lansing, New York, to run the farm and
care for the children. In her letters to her husband between
1848 and 1850, Calista reiterated how difficult it was for her to
be separated from the man she loved. She alluded more than once
to their sex life and the fact that she had not become pregnant.
Calista took the responsibility of parenting very seriously and
wrote at length about the behavior of each child. Her letters
also discuss the work she performed on the farm and her religious
practices.

2 <u>Letters of Susan Hale</u>. Edited by Caroline P. Atkinson.
 Boston: Marshall Jones Co., 1919, 483 pp.
 Susan Hale (1833-1910) of Boston was known to her contempo-
raries for her travel books, art work, and lectures to women's
groups on literary topics. From 1848 to 1910, Hale entertained
her family and friends with animated letters recounting her
adventures in places such as Egypt, Spain, Italy, France,
Mexico, and Jamaica. A single woman, Hale presided over her
brother's household in Matunuck, Rhode Island, for many years and
wrote perceptively of the social scene she observed.

1849

1 Apron Full of Gold: The Letters of Mary Jane Megquier from
 San Francisco, 1849-1856. Edited by Robert Glass Cleland.
 San Marino, Calif.: Huntington Library, 1949, 99 pp.
 Originally intending to remain in San Francisco only as
 long as it took her and her physician husband to amass sufficient
 wealth to guarantee the welfare of their children at home in
 Winthrop, Maine, **Mary Jane Megquier** eventually returned to San
 Francisco to live on her own. Megquier's unusual odyssey can be
 traced in letters written between 1849 and 1856 that tell of her
 three perilous voyages to California and her work and leisure-
 time activities there. A keen observer of social mores,
 Megquier produced fascinating vignettes of San Francisco's
 denizens, as she went about chronicling her own personal history.
 Upon arrival in the city, she plunged energetically into the
 frenetic stream of activity, toiling long hours in her boarding
 house and then spending carefree evenings at the theater, con-
 certs, and dances. Ever mindful of the needs of her children,
 Megquier nevertheless found it difficult to relinquish the
 financial opportunities and cosmopolitanism of San Francisco for
 the stifling atmosphere of provincial Maine, and she ultimately
 left her husband. Megquier's letters paint an intriguing self-
 portrait of a woman whose willingness to defy convention allowed
 her to carve out an independent life for herself.

2 "Dr. Elizabeth Blackwell's Graduation--An Eye-witness Account
 by Margaret Munro De Lancey." Edited by Wendell Tripp. New
 York History 43 (1962):182-85.
 Elizabeth Blackwell's graduation from the Medical Institu-
 tion of Geneva College in 1849 evoked intense interest both
 locally and nationally. In a letter to her sister-in-law,
 Margaret Munro De Lancey (Rochester) (1823[24?]-90), a single
 woman who resided in Geneva, New York, vividly described the
 commencement exercises and captured the drama of the moment when
 the degree of doctor of medicine was first conferred on a woman.

3 "From Tennessee to California in 1849: Letters of the Reeve
 Family of Medford, New Jersey." Edited by Oscar Osburn
 Winther. Journal of the Rutgers University Library 11
 (1948):33-84.
 Most of the correspondence printed here is that of **Rebecca
 Foster Reeve** (Scott) (?-1881), who journeyed to California from
 Tennessee in 1849 with her two brothers. The most illuminating
 of these five letters written to her cousin in New Jersey from
 various places in California between 1849 and 1878 is an
 extremely lengthy one composed shortly after her arrival in
 Sacramento. In it, she describes the death of her brother
 Clayton on the trail at the hands of the Modoc Indians and her
 subsequent antipathy toward all indians, recounts the hardships



and anxieties of the latter stage of the trip, and comments favorably on the people and sights of the new settlement of Sacramento. Subsequent letters written in 1862, 1870, 187?, and 1878, after Rebecca's marriage to Dr. John D. Scott, are of interest primarily for their observations on California communities in which the Scotts lived, such as San Francisco and San Jose.

4 Ho for California! Women's Overland Diaries from the Huntington Library. Edited and annotated by Sandra L. Myres. San Marino, Calif.: Huntington Library, 1980, 314 pp.
 Assembled in this volume are the diaries of five women who journeyed to and from California between 1849 and 1870. **Jane McDougal** (?-1862), a young wife and mother, chronicled her 1849 return ship voyage from San Francisco by the Panamanian route. In 1852, **Mary Stuart Bailey** (1830-99) of Sylvania, Ohio, traveled to California with her husband along the California trail, and **Helen McCowen Carpenter** (1838?-1917), a young bride from Kansas, also followed this route in 1857. The final two diarists traveled to California by means of southwestern trails. **Harriet Bunyard** (1850?-1900), a young single woman from Collin County, Texas, made the trip in 1869, and **Maria Hargrave Shrode**, a middle-aged wife and mother from Hopkins County, Texas, did so in 1870.

5 "I Am Doom to Disapointment [sic]: The Diaries of a Beverly, Massachusetts, Shoebinder, Sarah E. Trask, 1849-51." [Edited by] Mary H. Blewett. Essex Institute Historical Collections 117 (1981):192-212.
 Marriage dominated the thoughts of **Sarah E. Trask** (1828?-92), a young working woman of Beverly, Massachusetts, during the time her prospective husband, sailor Luther Woodberry, was absent on a long voyage. Speculations on Luther's whereabouts and his anticipated date of return filled Sarah's 1849 diary as she struggled to control her feelings of despair and frustration while continuing to work at binding shoes and assisting her mother in domestic tasks. Although bolstered by a group of female friends in similar circumstances, Sarah frequently succumbed to pessimism as she imagined her future. Sarah's reaction to Luther's death on a return trip from California is recorded in two final entries from her 1851 diary.

6 "The Letters of Roselle Putnam." Edited by Sheba Hargreaves. Oregon Historical Quarterly 29 (1928):242-64.
 Between 1849 and 1852, **Roselle (Rozelle) Applegate Putnam** (1832-61), a young wife and mother, penned six letters to members of her husband's family in Kentucky. Rozelle and Charles Putnam were in the process of carving out a farm in the Umpqua Valley of Oregon and were eager to convince the elder Putnams to join them

there. Rozelle, whose own family were early settlers in the
region, presented her new relatives with a favorable yet factual
account of the natural environment, the remnants of Indian cul-
ture, and the hardships of pioneer life.

7 A Life for Liberty: Anti-Slavery and Other Letters of Sallie
 Holley. Edited, with introductory chapters by John White
 Chadwick. New York and London: G.P. Putnam's Sons, 1899,
 292 pp.
 For most of her life, **Sallie Holley** (1818-93), a single
woman, worked to advance the cause of black people, first as an
agent of the American Anti-Slavery Society and then as a teacher
of freed slaves in the post-Civil War South. Holley's corre-
spondence, which spans the years 1849-92, traces her career. As
she traveled around the North lecturing in behalf of abolition-
ism, she chronicled her experiences, capturing the enthusiasm and
commitment of the circle of reformers. Beginning in 1870, Holley
ran a school in Lottsburgh, Virginia, with her companion,
Caroline Putnam. Her later letters document not only her work
teaching black pupils but her involvement in political disputes
with local whites.

8 "Lucy Larcom Letters: Extracts from the Collection in the
 Library of the Essex Institute." Essex Institute Historical
 Collections 68 (1932):257-79.
 These twenty-eight letters of **Lucy Larcom** (1824-93), most
of which were directed to Philena Fobes, the principal of the
Monticello Seminary in Godfrey, Illinois, where Larcom studied,
were written at different times between 1849 and 1892 and cover
a variety of subjects. The correspondence dating from the period
when Larcom was an instructor at Wheaton Seminary in Norton,
Massachusetts, offers insight into her dissatisfaction with a
teaching career. Larcom's preoccupation with spiritual matters
as she grew older is made clear in a cluster of letters in which
she articulated her beliefs and discussed her religious writings.
See also 1846.6; 1855.3.

9 "Selections from Achsa W. Sprague's Diary and Journal."
 Edited by Leonard Twynham. Proceedings of the Vermont His-
 torical Society, n.s. 9 (1941):131-84.
 Between the time she first kept her diary in 1849-50 and
the time she resumed it in 1855-57, **Achsa W. Sprague** (1827-62),
a single woman of Plymouth, Vermont, underwent a remarkable
transformation from a chronic invalid, overwhelmed by morbid
introspection, to a dedicated laborer in the cause of spiritual-
ism. Attributing her healing to the agency of spirits, Sprague
embraced the role of medium and commenced a career traveling
through the Northeast lecturing on aspects of the spirit world.
A prolific poet during her years of illness, Sprague began to

contribute articles on spiritualism to periodicals. Sprague's
humanitarian sympathies emerge distinctly from the comments in
her diary on poverty, women's equality, and prison reform.

10 Stuart Letters of Robert and Elizabeth Sullivan Stuart and
 Their Children 1819-1864: With an Undated Letter Prior to
 July 21, 1813. [Introduction by Helen Stuart Mackay-Smith
 Marlatt.] 2 vols. New York: Privately printed, 1961,
 1,058 pp.
 The figure of **Elizabeth Emma Sullivan Stuart** (1792-1866),
 a well-to-do Detroit widow, dominates this massive collection of
 Stuart family correspondence. Stuart's numerous letters to her
 children, nearly all of them dating from the years 1849 to 1864,
 illuminate the thinking of an aging woman whose strict Presby-
 terian values infused every aspect of her life. She expressed
 strong opinions on a variety of subjects, ranging from the merits
 of Irish domestic servants and local politics to morality and
 death. Her correspondence with her daughter Kate, filled with
 instructions on how to be a proper wife and mother and advice on
 housekeeping and health care, constitutes a rich source for prob-
 ing the relationship between a mother and her married daughter
 in the mid-nineteenth century. These volumes also contain let-
 ters by Stuart's two daughters, **Mary Elizabeth Stuart Turner
 Baker** (1814-78) and **Kate Stuart Baker** (1820-53), as well as
 other female members of the family.

<div align="center">1850</div>

1 The Diary of Ellen Birdseye Wheaton. With notes by Donald
 Gordon. Boston: Privately printed, 1923, 420 pp.
 Though **Ellen Douglas Birdseye Wheaton** (1816-58) of
 Syracuse, New York, conformed to the mid-nineteenth-century
 ideal of marriage and motherhood, the diary she kept from 1850
 to 1857 presents considerable evidence of her underlying dis-
 satisfaction with the restrictions it imposed on her. Wheaton
 willingly devoted her energies to rearing her large brood of
 children and spent her remaining time participating in the edify-
 ing activities of respectable middle-class society. Yet in her
 private diary, she unburdened herself of feelings of frustration
 at her imperfect marriage and registered disappointment at the
 course her life had taken. While acknowledging the primacy of
 the family claim, she nevertheless took seriously her affinity
 for the literary world and continued to pursue the writing that
 enabled her to maintain her individuality. This book also con-
 tains a few letters penned by Ellen Wheaton.

1850

2 The Journal of Ellen Whitmore. Edited by Lola Garrett Bowers
 and Kathleen Garrett. Tahlequah, Okla.: Northeastern State
 College, July 1953, 28 pp.
 Ellen Rebecca Whitmore (Goodale) (1828-61) traveled across
 the country in 1850 in order to teach at the Cherokee National
 Female Seminary in the Cherokee Nation of the Indian Territory.
 Imbued with a sense of high purpose, her mission was to bring
 advanced education to young Cherokee women on the model of Mount
 Holyoke Female Seminary, which she had attended. This journal,
 covering the period 1850-52, describes her trip to the Indian
 Territory and then provides an account of her experiences as a
 teacher at the Cherokee National Female Seminary and her ultimate
 decision to leave her position in order to marry.

3 The Lady and the President: The Letters of Dorothea Dix &
 Millard Fillmore. [Edited by] Charles M. Snyder. Lexington:
 University Press of Kentucky, 1975, 400 pp.
 Dorothea Lynde Dix (1802-87), an indefatigable advocate for
 better treatment of the insane in nineteenth-century America,
 carried on a correspondence with President Millard Fillmore,
 whose aid she had enlisted in her ultimately unsuccessful effort
 to channel funds from the sale of federal land to the support of
 the mentally ill. Between 1850 and 1862, Dix, a single woman,
 wrote Fillmore over one hundred letters detailing the progress of
 her cause as she traveled widely in the United States and
 England. Regarding Fillmore as a personal friend as well as an
 ally, she communicated her impressions of people she met as well
 as her political views on issues related to humanitarian reform.

4 Not by Bread Alone: The Journal of Martha Spence Haywood,
 1850-1856. Edited by Juanita Brooks. Salt Lake City: Utah
 State Historical Society, 1978, 141 pp.
 The journal **Martha Spence Haywood** (1811-73) kept from 1850
 to 1856 offers a rare firsthand perspective on the Mormon insti-
 tution of plural marriage. Haywood, who was born in Dublin and
 immigrated to the United States in 1834, converted to Mormonism
 in 1848. She traveled from Kanesville (Council Bluffs), Iowa,
 to Salt Lake City, where she became the third wife of a Mormon
 bishop, subsequently moving to the new settlement at Nephi,
 where she was frequently left alone by her husband. In addition
 to describing her work making caps and teaching school, detailing
 her health problems, and recounting her dreams, Haywood expressed
 her feelings on pregnancy, childbirth, weaning, and the death of
 her child. Her comments on family, religion, social life, and
 politics in Utah are of unusual interest as is her account of her
 conversion to the Mormon faith.

1851

1 "An Independent Voice: A Mill Girl from Vermont Speaks Her
 Mind." [Submitted by Loriman S. Brigham.] Vermont History 41
 (1973):142-46.
 A young Vermont woman, known to us only as **Lucy Ann**, penned
 this remarkable letter to a female cousin in 1851. Impatient of
 convention, Lucy Ann saw her job at a textile factory in Clinton,
 Massachusetts, not as a means of assisting her family but as a
 springboard to Oberlin College. Her comments on the tedium of
 mill work and her efforts at self-education bespeak a woman who
 aspired to a life far different from that she had known. Yet it
 is her iconoclastic views on New England's Protestant churches,
 expounded at length in this letter, that most clearly distinguish
 her from her contemporaries.

2 "Journal of a Trip to Oregon 1851 (Copied from the Peoria
 Weekly Republican of January 30, 1852, and February 13,
 1852)," by Elizabeth Wood. Oregon Historical Quarterly 27
 (1926):192-203.
 This portion of the journal kept by **Elizabeth Wood** (Morse)
 (1828?-1913) of Tazewell County, Illinois, during her trip to
 Oregon in the summer of 1851 was originally published in the
 Peoria Weekly Republican. Wood, a single woman, offered advice
 to prospective western migrants and described mountain scenery,
 mishaps with cattle, and encounters with Indians. See also
 1845.1.

3 The Lady with the Pen: Elise Waerenskjold in Texas. Edited
 by C.A. Clausen. Northfield, Minn.: Norwegian-American
 Historical Association, 1961, 183 pp.
 Elise Amalie Tvede Waerenskjold (1815-95), who immigrated
 to Texas from Norway in 1847, was an uncommon woman. A teacher,
 writer, and editor in Norway, she decided to join a group of
 migrants to Texas after the failure of her first marriage. Her
 articulate letters to friends and relatives in Norway from
 Prairieville, Texas, spanning the years 1851 to 1895, some of
 them subsequently published in Norwegian newspapers, treat both
 domestic matters and broader social issues. The three sons of
 her second marriage occupy a prominent place in the letters
 alongside discussions of her reading, social life, and the Nor-
 wegian Lutheran church. In addition, she set forth her views on
 agricultural conditions, economic problems, slavery, and the
 affairs of the Norwegian immigrant community. Waerenskjold
 spent the final three decades of her life as a widow and her
 letters constitute a rich source for documenting the personal and
 financial dimensions of growing old alone. A public letter writ-
 ten by Waerenskjold in 1851 to rebut a widely circulated but in-
 accurate portrayal of life in Texas is printed in Clarence A.

1851

Clausen, ed. and trans., "A Texas Manifesto: A Letter from Mrs. Elise Waerenskjold," <u>Norwegian-American Studies and Records</u> 20 (1959):32-45. A selection of Waerenskjold's correspondence is found in 1837.3.

4 <u>Letters from the Promised Land: Swedes in America, 1840-1914</u>. [Edited by] H. Arnold Barton. Minneapolis: University of Minnesota Press, 1975, 344 pp.
 This collection of letters written by Swedish immigrants in America contains a small number of letters composed by women. Most of the female correspondence included in the book is brief, but there are lengthier selections from the writings of three women: **Rosalie Roos**, who served as a governess in South Carolina from 1851 to 1855; **Mary Stephenson**, who lived in Iowa in the 1850s and 1860s; and **Ida Lindgren**, a resident of Manhattan, Kansas, in the 1870s.

5 <u>Letters of a Ticonderoga Farmer: Selections from the Correspondence of William H. Cook and His Wife with Their Son, Joseph Cook, 1851-1885</u>. Edited by Frederick G. Bascom. Ithaca, N.Y.: Cornell University Press, 1946, 134 pp.
 Over a dozen letters of **Merrette Lamb Cook** to her son, spanning the years 1851-77, appear in this volume of family correspondence. Isolated on a farm near Ticonderoga, New York, Mrs. Cook lived vicariously through her son and only child as he pursued his education and later his career. Her letters to him combine homely advice and sharp criticism. Repeatedly deploring her son's asceticism, Merrette Cook unwittingly disclosed her own hunger for material possessions. Mrs. Cook's letters also shed light on her less-than-satisfactory marital relationship. A spirited woman, well aware of the limitations imposed on her by nineteenth-century social norms, she chafed at her dependence on her husband but resigned herself to keeping her place.

6 <u>My Beloved Zebulon: The Correspondence of Zebulon Baird Vance and Harriett Newell Espy</u>. Edited by Elizabeth Roberts Cannon. Chapel Hill: University of North Carolina Press, 1971, 278 pp.
 This book contains the love letters written by Zebulon Vance, a lawyer who became governor and senator from North Carolina, and **Harriett Newell Espy** (Vance) (1832-78), during their courtship between 1851 and 1853. Harriett Espy, forty-six of whose letters appear in this collection, had been raised in genteel southern society. Since her parents were no longer living, she resided with relatives in Burke County, North Carolina. Having inherited a substantial estate from her mother, Espy lived a life of ease, spending much of her time enjoying the social life of the upper class. Her letters to Vance, who came from a poor but respectable family, are filled with the details

of her privileged life-style. Espy, however, was not a frivolous woman, and her correspondence reveals her strong commitment to the Presbyterian faith. The essence of these letters, however, is the self-revelation engaged in by people in love. Espy's statements of her beliefs and fears, her expressions of feeling for Vance, and her responses to his sentiments make these lengthy letters a valuable source for investigating Victorian courtship.

7 "'Rambles among the Virginia Mountains': The Journal of Mary Jane Boggs, June 1851." Edited by Andrew Buni. Virginia Magazine of History and Biography 77 (1969):78-111.
 In June 1851, **Mary Jane Boggs** (Holladay) (1833-61) of Spotsylvania County, Virginia, embarked on a long-anticipated tour of the Shenandoah Valley with her father and four young relatives. Boggs enjoyed the trip immensely and filled her journal with detailed comments on travel arrangements, hotel guests, and scenery.

8 Records of a California Family: Journals and Letters of Lewis C. Gunn and Elizabeth Le Breton Gunn. Edited by Anna Lee Marston. San Diego: Privately printed, 1928, 279 pp.
 In 1851, **Elizabeth Le Breton Stickney Gunn** (1811-1906) with her four children sailed around Cape Horn to San Francisco to rejoin her husband who was waiting to take them to the family's new home in Sonora, California. During the six-month voyage, Gunn kept a journal, written in the form of a letter to her mother and sisters in Philadelphia, in which she depicted life on shipboard, complete with notations of her own housekeeping chores. Once settled in Sonora, Gunn resumed her correspondence with her family, providing them with detailed reports of domestic affairs, the children's activities, and her own reading. The letters printed here, spanning the years 1851-59, also give an account of local personalities and events.

9 "South Carolina through New England Eyes: Almira Coffin's Visit to the Low Country in 1851." South Carolina Historical and Genealogical Magazine 45 (1944):127-36.
 In this long letter written to a female friend at home in Maine in 1851, **Almira Coffin**, a young single woman of Buxton, Maine, recounted her experiences while on a visit to her cousin in Charleston, South Carolina. Brief comments on social events in Charleston are followed by an extended narrative of her stay in the country. Of particular interest is Almira's detailed description of the rice plantations and the way of life of the planters' families and the Negro slaves. Despite the sectional tension of the time, Almira's impressions of South Carolina society were overwhelmingly favorable.

1851

10 To Raise Myself a Little: The Diaries and Letters of Jennie,
 a Georgia Teacher, 1851-1886, by Amelia Akehurst Lines.
 Edited by Thomas Dyer. Athens: University of Georgia
 Press, 1982, 284 pp.
 For **Amelia Jane (Jennie) Akehurst Lines** (1827?-86), being
 a teacher meant economic security, social respectability, and
 intellectual fulfillment. Yet the record of her experiences
 with students and parents in schools in upstate New York and
 Georgia in her diary and letters between 1851 and 1884 makes
 plain that her expectations were only partially realized. A
 woman imbued with strong religious and moral values, Lines
 frequently bemoaned the deficiencies of her pupils and the
 deadening routine of the classroom. Her courtship and subsequent
 marriage to a printer brought her emotional satisfaction but did
 not provide a reprieve from the genteel poverty to which she had
 grown accustomed. Plunged into despair by the death of her first
 child, she eventually drew comfort from the presence of her one
 surviving daughter. Lines's writings constitute a rich source
 for tracing the evolution of a northern woman's racial attitudes
 after migrating to the South.

 1852

1 "Diary of Colonel and Mrs. I.N. Ebey." Washington Historical
 Quarterly 7 (1916):239-46, 307-21; 8 (1917):40-62, 124-52.
 Internal evidence indicates that most of the entries in
 this diary for 1852-53 were made by **Rebecca Whitby Davis Ebey**
 (1822-53), the first wife of Isaac Neff Ebey, a pioneer settler
 on Whidbey Island in Puget Sound, Washington Territory. Though
 sensible of the advantages of her new home, Rebecca dwelt on the
 negative features of her existence in her writings. She noted
 her loneliness during prolonged separations from her husband,
 her ill health, annoying encounters with Indians, difficulties
 in educating her sons, and most important, the lack of religious
 services on the Sabbath. When she learned of the death of her
 mother, who was en route to Washington, Rebecca was grief
 stricken and was able to endure only by clinging to her faith in
 God. She died in September 1853, a few months after giving birth
 to a daughter. See 1856.3 for the diary of Emily Palmer Sconce
 Ebey, the second wife of Isaac Neff Ebey.

2 Elizabeth Cady Stanton/Susan B. Anthony: Correspondence,
 Writings, Speeches. Edited, and with a critical commentary by
 Ellen Carol DuBois. New York: Schocken Books, 1981, 272 pp.
 Most of the documents reproduced in this collection of
 materials relating to the lives of nineteenth-century America's
 leading feminists, **Elizabeth Cady Stanton** (1815-1902) and **Susan
 Brownell Anthony** (1820-1906), are public writings or speeches.
 The book, however, does include Anthony's diary of a lecture tour

with Ernestine Rose in 1854, some personal letters of Stanton and
Anthony dating from 1852-59, and a selection of women's letters
to Anthony in 1880 supporting women's suffrage. See 1839.1 for
the correspondence and diary of Elizabeth Cady Stanton.

3 "Ellen Parker's Journal." <u>New Hampshire Historical Society</u>
 <u>Collections</u> 11 (1915):131-62.
 With few exceptions, the entries in the journal **Ellen**
Augusta Parker (Cobb) (Showerman) (1833-1910) kept from 1852 to
1854 constitute capsule summaries of her work--in her parents'
household and as a district schoolteacher--and her social life
among the young single people of Muskego, Wisconsin. Occasion-
ally, Ellen did give vent to her sorrowful feelings at the
separation from close friends. In two final journal entries from
1856 and 1857, Ellen lamented the death of the man she had mar-
ried in 1854.

4 <u>Growing Up in the 1850s: The Journal of Agnes Lee</u>. Edited by
 Mary Custis Lee deButts. Chapel Hill and London: University
 of North Carolina Press, 1984, 151 pp.
 Between 1852 and 1858, **Eleanor Agnes Lee** (1841-73), the
young daughter of famed Virginian Robert E. Lee, kept a journal
in which she periodically recorded the events of her life and
explored her feelings. Agnes's deep attachment to her family
home at Arlington comes through in her emotion-laden descriptions
of the house and gardens, visitors, servants, and animals. The
deaths of her beloved grandparents, whose house it was, prompted
sober reflections on her spiritual and moral condition. At
first intimidated by the cadets at West Point, where her father
was superintendent of the United States Military Academy, Agnes
gradually came to relish not only her busy social life there but
her walks and French and music lessons as well. Less enamored of
the regime at the Virginia Female Institute at Staunton,
Virginia, Agnes nonetheless adapted quickly to her new environ-
ment and rambled on about her wardrobe, the other girls, the
teachers, and school activities. Conscious of the growing pres-
sure placed upon her to act as an adult, Agnes acknowledged that
she was reluctant to surrender the privileges of childhood.

5 "Letters from the Past." <u>Vermont Quarterly</u>, n.s. 20 (1952):
 45-50, 125-32, 208-14, 295-303; 21 (1953):38-46.
 When gold fever gripped her young husband, **Mathilda Theresa**
Roberts (1833-?) was left in Walden, Vermont, to await his return
from California. Her distress at their lengthy separation is
evident from the thirteen letters she wrote to him between July
1852 and May 1853 which are included in this correspondence.
Fearful for his health and safety, but primarily concerned with
the condition of his soul, she urged him to leave California as
soon as possible, cautioning that earthly riches were not as

important as spiritual treasures. Religion dominated Mathilda's life, and her letters to her husband are filled with exhortations to prayer and lectures on preparation for death. Mathilda also wrote of the birth of their son and supplied details of his early development.

6 Memoirs of Puget Sound, Early Seattle 1853-1856: The Letters of David & Catherine Blaine. Edited by Richard A. Seiber. Fairfield, Wash.: Ye Galleon Press, 1978, 220 pp.
 This volume includes over fifty letters of **Catherine Paine Blaine** (1829-1908), who accompanied her husband, a Methodist Episcopal minister, to the Pacific Northwest shortly after their marriage in 1853. Most of Catherine's letters, which span the years 1852-59, were written to members of her family in Seneca Falls, New York, from, successively, Seattle, Portland, and Oregon City. In them, she gave a full account of her domestic work, her schoolteaching, and her new baby, as well as news of her husband's efforts in behalf of the church. Although determined to do her duty, Catherine was manifestly ambivalent about her new life and her letters are noteworthy for their pointed criticisms of the region's primitive living conditions, irreligious inhabitants, and especially its Indians, as well as their frequent expressions of her homesickness. Catherine's correspondence also reveals her familiarity with national and local political issues as well as her strong antislavery convictions.

7 "Mrs. Butler's 1853 Diary of Rogue River Valley." [Edited by] Oscar Osburn Winther and Rose Dodge Galey. Oregon Historical Quarterly 41 (1940):337-66.
 America E. Rollins Butler (1826-1910) migrated with her husband from Illinois to Yreka, California, and then to the Rogue River valley of southern Oregon. Mrs. Butler's record of her life on the journey west, in Yreka, and finally in Oregon is preserved in the diary she kept intermittently from April 1852 to January 1854. Discouraged by the persistent hard times local farmers faced, ongoing troubles with Indians, and the monotony of her domestic labors, the young housewife drew comfort from her loving relationship with her mate.

8 "'Took Tea at Mrs. Lincoln's': The Diary of Mrs. William M. Black." Journal of the Illinois State Historical Society 48 (1955):59-64.
 Mary Ann Todd Lincoln figures prominently in the brief entries **Elizabeth Gundaker Dale Black** (Mrs. William M. Black) (1823-1902) made in her diary during her residence in Springfield, Illinois, in 1852. The two women traveled in the same social circle, and Mrs. Black recorded a number of visits to Mrs. Lincoln. When Elizabeth Black's infant son died, she

accepted the support of Mary Lincoln, but found that her grief
was assuaged only by religion. Her diary documents her con-
tinual attendance at prayer meetings and services at the
Presbyterian church as well as her own soul-searching. Appended
to the diary is a September 1853 letter from **Mary Ann Todd
Lincoln** (1818-82) to Mrs.Black, who by then had moved to St.
Louis, requesting assistance in purchasing a hat for her baby son
and a bonnet for herself. See 1840.5 for the letters of Mary Ann
Todd Lincoln.

9 Village Life in America 1852-1872 Including the Period of the
 American Civil War as Told in the Diary of a School-Girl, by
 Caroline Cowles Richards. Enl. ed. With an introduction by
 Margaret E. Sangster. New York: Henry Holt & Co., 1913,
 225 pp.
 Growing up in her grandparents' home in Canandaigua, New
 York, **Caroline Cowles Richards** (Clarke) (1842-1913) was
 patiently instructed in the religious and moral truths that would
 guide her life. The entries in the diary she kept from 1852 to
 1872--with a final note inscribed in 1880--show how Caroline and
 her younger sister attempted to behave in an acceptable fashion
 while still enjoying the many pleasures of childhood and youth.
 Games, shopping, and social activities were somehow fitted into a
 routine that centered around Bible reading, services, and prayer
 meetings at the Congregational church, and attendance at the
 local female academy. Occasional references to servants and
 blacks provide further evidence of the value system to which
 Caroline was exposed. Her observations on the local response to
 the Civil War give an idea of the impact of the crisis on a small
 upstate New York community. The diary sheds little light on
 Caroline's courtship but notes that she was married in 1866.

10 "'Vineland' in Tennessee, 1852: The Journal of Rosine
 Parmentier." Edited by Ben H. McClary and LeRoy P. Graf.
 East Tennessee Historical Society Publications 31 (1959):
 95-111.
 The Parmentiers, a well-to-do French Catholic family of
 Brooklyn, New York, were proprietors of Vineland, a small colony
 of European-born Catholic settlers located in the Sylco Mountains
 of East Tennessee. In October 1852, **Rosine Parmentier** (1829-?),
 a young single woman, accompanied her sister and brother-in-law
 on a visit to Vineland and recorded the highlights of the trip in
 her journal. Her strong interest in botany was reflected in her
 notes on the varieties of plants and flowers she detected in the
 mountain colony.

<u>1853</u>

1 <u>The Diary of Elisabeth Koren 1853-1855</u>. Translated and edited
 by David T. Nelson. Northfield, Minn.: Norwegian-American
 Historical Association, 1955, 381 pp.
 Shortly after her marriage **Else Elisabeth Hysing Koren**
 (1832-1918) left Norway for America with her husband, a Lutheran
 minister who had been called to preach to the immigrant communi-
 ties on the Iowa frontier. Koren's diary, supplemented by some
 letters to her father, covers the period from September 1853 to
 January 1855 and chronicles her journey to Washington Prairie,
 Iowa, and her adjustment to her new life there. An accomplished
 writer, Koren deftly sketched her impressions of the well-meaning
 but unsophisticated farm families who made up her husband's
 congregations. Although accustomed to living in a far more
 genteel fashion, Koren seems to have been less disturbed by the
 primitive setting than by her husband's prolonged absences. She
 struggled valiantly with feelings of loneliness and melancholy,
 as she recalled happy days in Norway and anticipated her hus-
 band's return from his pastoral work. Reading, knitting, and
 writing long letters home occupied Koren during her early months
 in Iowa, as she gradually made the acquaintance of neighbors and
 waited for a parsonage to be built. The yearning for her own
 home was finally satisfied just before the birth of her first
 baby.

2 "Diary of Maria Parsons Belshaw, 1853." [Edited by] Joseph W.
 Ellison. <u>Oregon Historical Quarterly</u> 33 (1932):318-33.
 This portion of the diary of **Maria Parsons Belshaw** covers
 the final stage of her family's 1853 journey from Lake County,
 Indiana, to Oregon and their search for a place to settle there.
 Though largely a record of the physical features of the land-
 scape, road conditions, and distances traveled, the diary does
 disclose Mrs. Belshaw's undisguised longing for her Indiana
 home. A highly religious person who sorely missed regular
 Sabbath worship on the trail, she mastered her melancholy feel-
 ings by reminding herself that in migrating to Oregon she was
 fulfilling God's will. En route, Mrs. Belshaw made it a habit to
 count the number of graves seen along the road.

3 "Diary of Mrs. Amelia Stewart Knight, an Oregon Pioneer of
 1853 Starting from Monroe County, Iowa, Saturday, April 9,
 1853, and Ending Near Millwaukie, Oregon Territory, Septem-
 ber 17, 1853." <u>Transactions of the Fifty-sixth Annual
 Reunion of the Oregon Pioneer Association for 1928</u> (1933):
 38-54.

Although she failed to disclose it until the end of her
diary, **Amelia Stewart Knight** was pregnant with her eighth child
during the entire time her family traveled from Iowa to the
Oregon Territory in 1853. Read in this light, the diary is of
more than usual interest since it reveals that, regardless of her
condition, Mrs. Knight was still expected to perform laborious
domestic chores as well as to care for her seven children. That
this was a burden to her is made clear by frequent references to
her illnesses and her emphasis on the difficulties of the
journey.

4 "Diary of Mrs. Cornelia A. Sharp: Crossing the Plains from
 Missouri to Oregon in 1852." <u>Transactions of the Thirty-First
 Annual Reunion of the Oregon Pioneer Association for 1903</u>
 (1904):171-88.
 The brief, prosaic entries in the diary **Cornelia A. Sharp**
 kept on her journey from Jackson County, Missouri, to the Oregon
 Territory in 1853 deal almost exclusively with the conditions of
 travel. Little of a personal nature is found here.

5 <u>A Divided Heart: Letters of Sally Baxter Hampton 1853-1862</u>.
 Edited, with an introduction by Ann Fripp Hampton. Spartan-
 burg, S.C.: Reprint Co., 1980, 146 pp.
 The polarization of North and South on the eve of the Civil
 War created an insoluble dilemma for **Sarah (Sally) Strong Baxter
 Hampton** (1833-62), the daughter of a well-to-do New York City
 family, who moved to South Carolina after her marriage in 1855.
 Hampton's letters, which span the years 1853 to 1862, give evi-
 dence of her gradual acclimation to the way of life on her
 husband's plantation near Columbia and supply valuable details of
 her household routine, the progress made by her four children,
 and the recreations of the upper class. An intelligent young
 woman who numbered English author William Makepeace Thackeray
 among her friends, Hampton followed contemporary events closely
 and rewarded her correspondents with thoughtful observations on
 the political questions of the day. Dispirited by the severing
 of the Union, she bravely faced an even greater personal crisis
 in the tuberculosis that eventually took her life.

6 "Journal of a Quaker Maid: From the Diary of Mary Haines
 Harker, May-December, 1853." <u>Virginia Quarterly Review</u> 11
 (1935):61-81.
 While on a visit to Lynchburg, Virginia, in 1853, **Mary
 Haines Harker** (Slaughter) (1836?-?) of Mount Holly, New Jersey,
 fell in love with the young man whom she married a few months
 later. Her diary became the repository of her joyous feelings as
 she chronicled the events of the courtship. The continual round
 of social calls and parties in Virginia appealed to Mary, who
 conceded that she was not much of a Quaker. Her favorable

impressions of southern society also hold interest as does the detailed record of her reading.

7 "A Journal of Our Trip to Texas Oct. 6, 1853," by Mary James Eubank. Edited by W.C. Nunn. Texana 10 (1972):30-44.
 Between October and December 1853, **Mary James Eubank** (1832-?), a young single woman, traveled with her family from Glasgow, Kentucky, to their new home in Williamson County, Texas. In her matter-of-fact journal account of the trip, Eubank commented on road conditions, the availability of water, and the terrain, and noted passing through Nashville, Memphis, Little Rock, and Dallas.

8 "The Journey to Oregon--A Pioneer Girl's Diary." Edited, and with an introduction by Claire Warner Churchill. Oregon Historical Quarterly 29 (1928):77-98.
 When her family decided to move to Oregon, **Agnes Stewart** (Warner) (1832-?), an upright young single woman, was reluctant to leave her best friend in Alleganey City, Pennsylvania. The journal Agnes kept during the trip to Oregon in 1853 testifies to her homesickness and her lack of real interest in the journey west.

9 Loving Warriors: Selected Letters of Lucy Stone and Henry B. Blackwell, 1853 to 1893. Edited and introduced by Leslie Wheeler. New York: Dial Press, 1981, 406 pp.
 Reluctant to relinquish the independence she valued so highly, feminist **Lucy Stone** (1818-93) ultimately was persuaded by Henry Blackwell to enter into a marriage of equals. The couple's courtship and the course of their unconventional marriage (Stone insisted on retaining her maiden name) is traced in this enlightening correspondence spanning the years 1853 to 1893. Stone's dedication to her career as a lecturer for the anti-slavery and women's rights movements delayed her marriage and became a source of stress after the birth of her daughter. Her letters to her husband, from whom she was frequently separated, disclose the inner conflict she experienced when she ceased her work so that she could fulfill her duties as a wife and mother. After the Civil War, Stone resumed her active role, touring the country to campaign for women's suffrage and editing the Woman's Journal, the organ of the American Woman Suffrage Association, from her home in Boston. Characteristically candid in her opinions on issues and persons, even when corresponding with her adversaries among feminist leaders, she assessed current politics and the split within the women's movement with the eye of a veteran. Stone frequently reminded her husband of her love for him and her appreciation for his longstanding devotion to the cause of women. See also 1846.8.

10 Maria Mitchell: Life, Letters, and Journals. Compiled by
 Phebe Mitchell Kendall. Boston: Lee & Shepard Publishers,
 1896, 293 pp.
 The compiler's failure to respect the integrity of the
documents limits the usefulness of this collection of the letters
and diary of astronomer **Maria Mitchell** (181?). Nevertheless,
this volume, which consists primarily of excerpts from Mitchell's
diary between 1853 and 1886, does enable the reader to get a
sense of the noted scientist's work habits, ideas, and person-
ality. A single self-supporting woman, Mitchell initially made
astronomical observations and mathematical calculations at her
home on Nantucket and later continued her career as a member of
the faculty of Vassar College. Mitchell's independence of mind
was well known, and she expressed controversial views on a
variety of issues, including women's intellectual development and
women's education, the value of scientific research, and the
merits of organized religion. Her diary also contains her
impressions of the slave South before the Civil War and her
record of two extended tours to Europe during which she met dis-
tinguished members of the scientific community.

11 "Plantation Experiences of a New York Woman." Edited by
 James C. Bonner. North Carolina Historical Review 33 (1956):
 384-412, 529-46.
 When **Sarah Frances Hicks Williams** (1827-1917) of New
Hartford, New York, moved to the North Carolina plantation of her
new husband in 1853, she encountered a world that was alien to
her. Her acclimation to southern culture can be traced in the
letters she wrote her family between 1853 and 1867. Initially
sensitive to differences in architecture, food, fashions, reli-
gious observances, and styles of entertaining, Sarah gradually
came to accept the way of life in North Carolina and later
Georgia. The best barometer of Sarah's adaptation to southern
mores is found in her changing perception of slaves and aboli-
tionists. These letters also cast light on Sarah's attitude
toward her husband and children as well as her strained rela-
tionship with her mother-in-law.

12 Prairie Schooner Lady: The Journal of Harriet Sherrill Ward,
 1853. As presented by Ward G. DeWitt and Florence Stark
 DeWitt. Los Angeles: Westernlore Press, 1959, 180 pp.
 Harriet Sherrill Ward (1803-65) felt distinctly out of
place in the wilderness as she traveled to California with her
family in 1853. A mature woman, Ward prized the values and
amenities of the civilized life and lamented their absence on the
trail. In her journal, she noted that she greatly missed the
domestic fireside, Episcopal church services, and newspapers.
The greed and profanity of the California immigrants also
aroused her ire, since her preference was for persons of

refinement. Ward was not impervious to the natural beauty of
the West, but as a rule her comments on the environment reflect
her literary tastes or her knowledge of eastern or European
scenery.

13 "Selections from the Plymouth Diary of Abigail Baldwin,
 1853-54." Vermont History 40 (1972):218-23.
 In 1853 **Abigail Pollard Baldwin** (1798?-1876) returned to
Plymouth, Vermont, after an extended stay in San Antonio, Texas,
where her husband preached in the Presbyterian church and she
visited her married daughter. The diary that Baldwin kept be-
tween June 1853 and November 1854 makes clear that she preferred
her home in Vermont to life in Texas. Terse descriptions of
routine domestic labors are coupled with accounts of visits to
relatives and neighbors and attendance at town meetings,
weddings, and funerals. A woman of strong religious faith,
Baldwin repeatedly expressed concern for her own and other
people's salvation. The frequency of illness and death in the
community prompted her to urge spiritual preparation for death.

14 "Through Nebraska before Any Settlement: Journal of a Journey
 to California in 1853." Transactions and Reports of the
 Nebraska State Historical Society 3 (1892):270-78.
 Reprinted here are excerpts from the travel diary of the
wife of a merchant, presumably named **MacMurphy**, who moved his
family from Wisconsin to California in 1853. Consisting pri-
marily of the portions of the diary recording the trip through
Iowa and Nebraska, this selection includes an account of the
activities of family members, particularly a young daughter, as
well as comments on the terrain and weather, settlements, other
migrants, and Indians.

1854

1 The Journal of Charlotte L. Forten: A Free Negro in the Slave
 Era. Edited, with an introduction and notes by Ray Allen
 Billington. New York: Dryden Press, 1953, 286 pp.
 The enslavement and oppression of black people in America,
aroused deep feelings of outrage in **Charlotte L. Forten** (Grimké)
(1837-1914), a young free black woman from a noted Philadelphia
family. Forten's determination to serve the cause of anti-
slavery as well as to further her own intellectual development are
evident in the journal she kept for most of the period from 1854
to 1864 as is her continuing recognition of her precarious posi-
tion as an educated black in a white world. During the years she
spent in Salem, Massachusetts, first as a student and then as a
teacher, Forten was able not only to quench her thirst for
knowledge through voluminous reading and regular attendance at
lectures, but to immerse herself in the abolitionist movement and

meet its leaders. Despite the rewards of her life in New England, Forten confided her dissatisfaction and frustration to her journal, belittling her own achievements and expressing her yearning for congenial companionship. In 1862, Forten seized the opportunity to teach recently freed blacks on St. Helena's Island, South Carolina. Her detailed account of her efforts in the schoolroom and on the abandoned plantations is useful for documenting the customs and music of the former slaves and their response to northern educators and administrators. The main value of Forten's South Carolina journal lies, however, in its revelation of her feelings as the dream of liberation for her people became a reality.

2 Leaves from an Old Washington Diary 1854-1863, by Elizabeth Lindsay Lomax Wood. Edited by Lindsay Lomax Wood. [New York]: Books Inc.; distributed by E.P. Dutton & Co., 1943, 256 pp.
 Widowed for many years, **Elizabeth Lindsay Lomax** (1804?-?) of Washington, D.C., was clearly able to live a full life on her own. In the brief matter-of-fact entries in her diary for the years 1854-63, she is found reading, shopping, collecting her pension, and making social calls. Her commitment to the Episcopal faith is also evident as is her interest in the activities of her grown children. Lomax regularly followed political news and made comments on current issues. The advent of the Civil War was a cause of great sorrow and anxiety for Lomax, who left her home in the capital and moved first to Virginia and then to Baltimore.

3 "Letter of Catherine Sager Pringle." Oregon Historical Quarterly 37 (1936):354-60.
 Orphaned as a child on the way to the Oregon Territory, **Catherine Sager Pringle** (1835-?), along with her six brothers and sisters, was taken in by Oregon missionaries Marcus and Narcissa Whitman. She survived the grisly Whitman massacre of 1847, married in 1851, and became the mother of an infant daughter. In this 1854 letter to an uncle, written from her farm near Salem, Oregon, Catherine recounted her tragic family history, supplying details of her parents' deaths on the trail and a graphic description of the Indian attack on the Whitman mission.

4 Life and Letters of Elizabeth L. Comstock. Compiled by her sister, C[atherine] Hare. London: Headley Brothers; Philadelphia: John C. Winston & Co., 1895, 511 pp.
 A native of England, **Elizabeth Leslie Rous** (Wright) **Comstock** (1815-91) embarked on her career as a Quaker minister in midlife, after settling in Rollin, Michigan, the home of her second husband. These selections from Comstock's letters

spanning the years 1854-91 provide a clear perspective on her life's work as a spiritual leader and an advocate of humanitarian reforms. Highly respected by members of the Society of Friends, Comstock traveled extensively, preaching the Gospel and participating in denominational meetings. Just as active in behalf of the unfortunate victims of society, Comstock was tireless in her efforts to ameliorate conditions in the prisons and hospitals she visited. Her letters also detail her involvement in a program to assist freedmen in Kansas after the Civil War.

5 Life and Letters of Mary Putnam Jacobi. Edited by Ruth
 Putnam. New York and London: G.P. Putnam's Sons, 1925,
 381 pp.
 Mary Putnam Jacobi (1842-1906) achieved eminence as
 physician at a time when women had little stature in the field
 of medicine. This biographical volume, which contains letters
 Jacobi wrote between 1854 and 1894--as well as letters written to
 her--is primarily devoted to the period of her medical training
 in Paris (1866-71). In addition to keeping her family
 apprised of her educational progress, she entertained them with
 keen observations on French society and politics. Jacobi's let-
 ters barely touch on her professional career in New York City or
 her relationship with her husband and children.

6 "Sarah Lyon Noteware's Letter." [Edited by] Peggy Trego.
 Nevada Historical Society Quarterly 2 (1959):17-21.
 In this 1854 letter to her cousin, written from Diamond
 Springs, California, **Sarah Lyon Noteware** (1834?-67), a recently
 married young woman, described life in the gold fields.

7 Through Some Eventful Years, by Susan Bradford Eppes (Mrs.
 Nicholas Ware Eppes). Macon, Ga.: Press of the J.W.Burke
 Co., 1926, 378 pp.
 This autobiographical work consists primarily of lengthy
 excerpts from the diary kept by **Susan Bradford** (Eppes) (1846-
 1942) from 1854 to 1866, the date of her wedding. Connective
 passages supplied by Mrs. Eppes in later life furnish additional
 background and provide an interpretive framework for the events
 depicted. Susan Bradford was the youngest daughter of a wealthy
 physician and planter who lived outside Tallahassee, Florida, and
 the initial portion of her diary documents her privileged
 upbringing in this slave society. Mounting sectional tension,
 followed by the Civil War and its aftermath, are all chronicled
 from the point of view of a committed southerner. The diary is
 of particular value for tracing the evolution of Susan Bradford's
 attitudes toward blacks.

1855

1 "The Diary of Eliza (Mrs. Albert Sidney) Johnston: The Second
 Cavalry Comes to Texas." Edited by Charles P. Roland and
 Richard C. Robbins. Southwestern Historical Quarterly 60
 (1957):463-500.
 Eliza Griffin Johnston accompanied her husband, the com-
 mander of the Second United States Cavalry, when he was ordered
 to the Texas frontier to control the Comanche Indians. The diary
 she kept between October 1855 and May 1856 chronicles her journey
 from Jefferson Barracks, Missouri, to Fort Mason, Texas, with the
 troops, her life at the fort, and the family's subsequent move to
 San Antonio, Texas. Mrs. Johnston's informative comments on the
 conditions of travel and the behavior of her three children are
 exceeded in interest by her keen observations on social relation-
 ships within army ranks.

2 "Letters of John and Sarah Everett, 1854-1864; Miami County
 Pioneers." Kansas Historical Quarterly 8 (1939):3-34,
 143-74, 279-310, 350-83.
 The preoccupations of a farm wife in the Kansas Territory
 between 1855 and 1863 are vividly conveyed in the three dozen
 letters of **Sarah Maria Colegrove Everett** (1830-64) in this col-
 lection of family correspondence. Transplanted from upstate New
 York to Osawatomie, Kansas, Sarah adapted readily to her altered
 circumstances and willingly shouldered the onerous burdens of
 frontier life. Her literate and at times humorous letters to
 members of her husband's family document her central role in the
 farm economy, as she made cheeses for sale in the market as well
 as performing housework and caring for her young children. Hard
 times plagued the Everetts, but Sarah's self-reliance and
 strength of purpose helped them to persevere. A frequent com-
 mentator on the turbulent political situation in Kansas, Sarah
 offered acute analyses of local developments and expounded on her
 strong antislavery views and their religious basis. Though
 wholeheartedly committed to her Kansas home, Saah had an abiding
 interest in eastern fashions and continually requested informa-
 tion on the latest styles from her relatives.

3 "Letters of Lucy Larcom to the Whittiers." [Edited by]
 Grace F. Shepard. New England Quarterly 3 (1930):501-18.
 Poet John Greenleaf Whittier was a treasured friend of **Lucy
 Larcom** (1824-93). This sample of her letters to him between 1855
 and 1892, most of them dating from the period when she was a
 teacher at the Wheaton Female Seminary in Norton, Massachusetts,
 is primarily concerned with the craft of writing. Larcom held
 Whittier's writing in high esteem and valued his critiques of her
 poems. That he played a role in facilitating the publication of
 Larcom's work is made clear in this correspondence. The letters

also constitute a useful source for ascertaining Larcom's poeti-
cal standards and her views on literature. See also 1846.6;
1849.8.

4 "Life on the Lower Columbia, 1853-1866." Edited by Helen
 Betsy Abbott. Oregon Historical Quarterly 83 (1982):248-87.
 In 1853 **Lydia Pollard Wright Plimpton** (1833-1903) traveled
 from her home in Massachusetts to Rainier in the Oregon Terri-
 tory to marry Silas Bullard Plimpton. Four letters written by
 Lydia to her mother and father between 1855 and 1861 are included
 in this collection of family correspondence. Filled for the most
 part with routine news, the young bride's letters paint a favor-
 able picture of farm life in pioneer Oregon. Of greatest inter-
 est is Lydia's poignant account of the death of her infant
 daughter in 1860.

5 "Private Journal of Mary Ann Owen Sims." Edited by Clifford
 Dale Whitman. Arkansas Historical Quarterly 35 (1976):
 142-87, 261-91.
 Widowed at an early age, **Mary Ann Owen Sims** (1830-?) of
 Dallas County, Arkansas, was forced to cope with her personal
 grief while caring for her three small children and addressing
 the practical and financial problems that formerly had been dealt
 with by her husband. The journal she kept from 1855 to 1861
 played a major role in her recovery, affording her the oppor-
 tunity to air her feelings of sorrow and register her complaints
 and frustrations. Sims grew in self-confidence over the years as
 she assumed responsibility for running the cotton plantation,
 supervising the slaves, and educating her youngsters. The jour-
 nal also provides evidence of the young widow's religious beliefs
 and intellectual interests.

6 "'A True Childe of Sorrow': Two Letters of Mary E. Surratt,"
 by Joseph George, Jr. Maryland Historical Magazine 80 (1985):
 402-5.
 Known to history for her alleged role in the conspiracy to
 assassinate President Abraham Lincoln, **Mary Eugenia Jenkins
 Surratt** (1823-65) was a woman whose life had been made miserable
 by her alcoholic husband. In these two letters of 1855, Surratt
 unburdened herself of her troubles to her former Catholic priest,
 explaining how her husband's behavior had multiplied her work and
 heightened her anxiety over her children's moral condition and
 educational progress.

1856

1 Dear Ellen: Two Mormon Women and Their Letters, by S. George
 Ellsworth. Salt Lake City: Tanner Trust Fund, University of
 Utah Library, 1974, 92 pp.

Ellen Curtis Spencer Clawson (1832-96) of Salt Lake City and **Ellen Sophronia Pratt McGary** (1832-95) of San Bernardino, California, had spent much of their youth together in successive Mormon settlements but had been separated for six years at the time they commenced this correspondence of 1856-57. The topic of marriage, and in particular the Mormon institution of plural marriage, dominated the letters of the two young women. McGary, a new bride, expressed her sympathy for Clawson when her husband brought home his third wife in 1856. Clawson's comments on her own situation highlight the conflict she felt between her religious beliefs and her emotions when faced with this sensitive issue. Additional insight into Mormon family life emerges from the correspondents' discussion of the behavior of their relatives and friends. Most of the letters printed in this book appeared previously in S. George Ellsworth, ed., "'Dear Ellen': A Utah-California Correspondence, 1856-1857," Western Humanities Review 13 (1959):201-19.

2 Diary of a San Diego Girl--1856, by Victoria Jacobs. Edited by Sylvia Arden. Santa Monica, Calif.: Norton B. Stern, Publisher, 1974, 75 pp.
 This diary holds special interest as one of the few published personal documents of a nineteenth-century American Jewish woman. **Victoria Jacobs** (1838-61), a young English-born Jew residing in San Diego, California, kept this diary during the period of her engagement to Maurice Franklin. Covering the months between June 1856 and February 1857, the diary chronicles the daily life of a privileged young lady, noting family and community events, visits, shopping expeditions, theater, balls, and occasionally, time spent sewing or cooking. Observance of the Sabbath as well as the Jewish holidays of Yom Kippur and Succoth is also recorded. Victoria's life, however, clearly revolved around her fiancé, Maurice, and the majority of diary entries concern him. She described their outings and dinners, reported on his business activities and travels, and expressed her yearning for him during his absences. At a few points, she expanded on her feelings toward him.

3 "Diary of Colonel Isaac N. and Mrs. Emily Ebey, 1856-1857." Pacific Northwest Quarterly 33 (1942):297-323.
 This joint diary, covering the period between October 1856 and January 1857, contains a number of entries made by **Emily Palmer Sconce Ebey** (?-1863[64?]), the second wife of Isaac Neff Ebey of Whidbey Island, Washington Territory. The entries written by Emily, designated as such, make clear the arduous nature of her household duties and record her anxiety at her husband's unexplained delay in returning home from a trip. See 1852.1 for the diary of Rebecca Whitby Davis Ebey, the first wife of Isaac Neff Ebey.

1856

4 "Letter from Mrs. James Steele of Anderson, 1856." [Con-
 tributed by George Wesley Clower.] <u>South Carolina Historical
 Magazine</u> 55 (1954):174-77.
 In this long letter of 1856, **Sarah Calhoun Davis Steele**
 (1805-86) of Anderson, South Carolina, supplied her brothers and
 sisters with news of her husband, son, and stepchildren as well
 as plantation affairs.

5 <u>Letters of Celia Thaxter</u>. Edited by A[nnie] F[ields] and
 R[ose] L[amb]. Boston and New York: Houghton, Mifflin &
 Co., 1895, 230 pp.
 The abiding love that poet **Celia Laighton Thaxter** (1835-94)
 had for her home on the Isles of Shoals (coastal islands off New
 Hampshire and Maine) shaped her life and work. The power of
 nature in both its benign and its malevolent aspects is a re-
 curring theme in this selection from her correspondence with
 friends and literary figures between 1856 and 1894. Vivid
 passages describing birds, flowers, the ocean, and shipwrecks in
 stormy weather alternate with philosophical and religious
 reflections and discussions of literary and aesthetic matters.
 Thaxter's troubled family life receives only passing attention
 in these letters, although her estrangement from her husband and
 her devotion to her sons and grandchildren is made clear. Ex-
 cerpts from Celia Thaxter's letters may also be found in the
 biography written by her granddaughter, Rosamond Thaxter,
 <u>Sandpiper: The Life & Letters of Celia Thaxter and Her Home on
 the Isles of Shoals, Her Family, Friends & Favorite Poems</u>,
 rev. ed. (Francestown, N.H.: Marshall Jones Co., 1963).

<u>1857</u>

1 "The Bryan Letters." [Foreword by Adelaide P. Bostick.]
 <u>Register of the Kentucky Historical Society</u> 53 (1955):76-85.
 Adelaide Vandeventer Thomas Bryan (?-1889) remained at
 home with her baby daughter in Brownsboro, Kentucky, when her
 husband, Dr. Stanton Pierce Bryan, traveled to Dublin, Ireland,
 in 1856-57 for advanced medical training. During their separa-
 tion, the young couple exchanged letters, and this article
 prints one representative sample of each partner's correspon-
 dence. Adelaide's letter to Stanton, dated January 8, 1857,
 is an affectionate communication to the man she loved and missed
 greatly. In addition to conveying news of the baby, family
 members, and household affairs, Adelaide expressed her feelings
 for her husband in intimate terms.

2 <u>Diary and Letters of Phebe M. Irish</u>. Philadelphia: Thomas
 William Stuckey, 1876 [1875], 219 pp.
 A young Quaker woman's ongoing search for spiritual per-
 fection is documented in these selections culled from the diary

and letters of **Phebe M. Hallock Irish** (1845-73) of Westchester County, New York, by her husband. The nineteen letters included in the volume are interspersed chronologically among the diary entries, which span the years 1857 to 1873. Deformed and in frail health from childhood, Phebe dedicated her life to serving God. She continually took the measure of her spiritual state, deploring her sins and praying for improvement. Attendance at Quaker meetings, dialogue with fellow Quakers, and religious reading played a vital role in her developnment as she strove to prepare herself for death. Phebe made relatively few comments on public issues, but she did take a strong position against slavery and war, and she expressed concern for the education of Quaker children. Near the end of her short life, Phebe experienced the joys of love and was married to David Irish, an equally devout member of the Society of Friends.

3 The Genteel Gentile: Letters of Elizabeth Cumming, 1857-1858.
 Edited by Ray R. Canning and Beverly Beeton. Salt Lake City:
 University of Utah Library, Tanner Trust Fund, 1977, 111 pp.
 At a time of mounting tension between the United States government and the Mormons, Alfred Cumming was appointed by President James Buchanan as the first non-Mormon governor of the Utah Territory. **Elizabeth Wells Randall Cumming** (1811-67), his wife, recorded her impressions of their adventurous trip to Utah, escorted by federal troops, and her stay in Salt Lake City in these eighteen letters written in 1857 and 1858. Her compelling account of life in a tent camp during the winter and her percep-tive comments on Indians and Mormons are of particular interest. Letters from this collection were previously published in A.R. Mortensen, ed., "The Governor's Lady: A Letter from Camp Scott, 1857," Utah Historical Quarterly 22 (1954):165-73, and Ray R. Canning, ed., "A Lady's View of Utah and the Mormons, 1858: A Letter from the Governor's Wife," Western Humanities Review 10 (1955-56):27-35.

4 Journal of Anna May. Edited by George W. Robinson.
 Cambridge, Mass.: Privately printed, 1941, 100 pp.
 This is the diary kept by a senior student at the New Hampton Institution in New Hampshire in 1857, although "Anna May" was not her real name. The brief entries recount daily experiences at school, social life, and attendance at church and prayer meetings. Although the diary contains an introspective dimension, the sentiments expressed by the author reflect fairly conventional views.

5 "A Letter from a Yankee Bride in Ante-Bellum Louisiana."
 Edited by John Q. Anderson. Louisiana History 1 (1960):
 245-50.

In 1857, directly following her marriage, **Emma Lay Lane**
(?-c.1867) moved with her husband to her father-in-law's cotton
plantation near Clinton, Louisiana. This letter to a female
friend in New England describes her new life in Louisiana.

6 Mollie: The Journal of Mollie Dorsey Sanford in Nebraska and
 Colorado Territories 1857-1866. [Edited by] Donald F. Danker.
 Lincoln and London: University of Nebraska Press, 1959,
 199 pp.
 Confiding her feelings to her journal enabled **Mollie Dorsey
 Sanford** (1838[39?]-1915) to reconcile her romantic dreams with
 the often-hard realities of her everyday existence. Between 1857
 and 1866, the years covered in the journal, Mollie faced a series
 of radical changes in her life--the economic downslide of her
 family and the resulting migration from Indianapolis to Nebraska
 City, the necessity of supporting herself, her engagement and
 marriage, the subsequent move to Colorado with her husband, and
 the birth of her children. Her efforts to understand herself
 throughout this period of maturation reveal a young woman who
 imagined a world of poetry and pathos but who also was grounded
 in a firm set of moral and religious convictions. Increasingly
 compelled to sacrifice her literary flights for the drudgery of
 household work, Mollie still managed to retain her penchant for
 sentiment and an abiding optimism. A portion of this journal was
 published in Albert B. Sanford, ed., "Life at Camp Weld and Fort
 Lyon in 1861-62: An Extract from the Diary of Mrs. Byron N.
 Sanford," Colorado Magazine 7 (1930):132-39.

 1858

1 "A Prairie Diary." Edited by Glenda Riley. Annals of Iowa,
 3rd ser. 44 (1977):103-17.
 The domestic labors of the women on a newly begun Iowa
 farm are detailed in this 1858 diary kept alternately by **Mary
 St. John** (Cutting) (1838?-69) and her sister **Esther St. John**
 (1836?-?), members of a family who had just moved from Walton,
 New York, to the vicinity of Saratoga, Iowa. Brief factual
 entries document the weekly cycle of work--a cycle broken only by
 attendance at meeting on the Sabbath and an occasional visit by
 neighbors.

2 The Welsh in America: Letters from the Immigrants. Edited by
 Alan Conway. Minneapolis: University of Minnesota Press,
 1961, 341 pp.
 Only a handful of these letters written by nineteenth-
 century Welsh immigrants in the United States were composed by
 women. There are, however, some examples of letters jointly
 written by husband and wife, such as the correspondence of

Humphrey and **Sarah Roberts** from Jackson County, Ohio, between
1858 and 1864.

1859

1 "The Diary of a Trip from Ione to Nevada in 1859," by Susan
 Mitchell Hall. California Historical Society Quarterly 17
 (1938):75-80.
 In September 1859, **Susan Mitchell Hall** (m. 1869) accom-
 panied her father on a brief journey from their home in Ione,
 Amador County, California, to Nevada. In her diary of the trip,
 Hall recorded her reactions to the spectacular mountain vistas
 and the dangerous conditions of travel. Among the places Hall
 visited in Nevada were Lake Bigler (Lake Tahoe), Steamboat
 Springs, Carson City, and Virginia City, where she descended into
 the mines and obtained specimens of the precious metals.

2 "Diary of Mrs. A.C. Hunt, 1859." With an introduction and
 notes by LeRoy Hafen. Colorado Magazine 21 (1944):161-70.
 This is the diary kept by **Ellen Elizabeth Kellogg Hunt**
 (1835-80) between April and September 1859 when she traveled
 overland to Colorado in a covered wagon with her husband and two
 small children. The major portion of the diary records the trip
 from Kansas City to Denver, noting her illness much of the way.
 One recurring theme is her distress at the fact that the Sabbath
 is not observed on the trail. When the family finally arrived in
 Denver, Elizabeth, as one of the few females in the settlement,
 was pressed into service cooking and baking for numerous
 boarders. Her displeasure at this unceasing and largely
 unrewarded labor is made clear in the diary.

3 Letters of a Family during the War for the Union 1861-1865.
 [By Georgeanna Woolsey Bacon and Eliza Woolsey Howland.]
 2 vols. N.p.: Privately printed, 1899, 723 pp.
 Female members of the well-to-do Woolsey family of New York
 City wrote most of the letters and journal entries that make up
 this sizable collection of Civil War materials spanning the years
 1859 to 1865. Each of the seven Woolsey sisters is represented
 in the book along with their widowed mother, **Jane Eliza Newton
 Woolsey** (1801-74), but the primary correspondents are **Abby
 Howland Woolsey** (1828-93), **Jane Stuart Woolsey** (1830-91),
 Georgeanna (Georgy) Muirson Woolsey (Bacon) (1833-1906), and
 Eliza Newton Woolsey Howland (1834-1917). Wholeheartedly
 dedicated to the Union cause, the Woolseys in New York spent
 the war years engaged in making, procuring, and distributing
 clothing, food, and other necessary articles to army personnel
 and in nursing sick and wounded soldiers. Georgy, accompanied
 at times by various sisters and her mother, served as a nurse
 on the hospital transport ships of the United States Sanitary

1859

Commission during the 1862 Peninsular campaign, and also at the
Gettysburg battlefield and at hospitals in Rhode Island,
Virginia, and New Jersey. The correspondence of the Woolsey
women documents their benevolent activities, conveys their views
on wartime issues, and makes plain the strong ties that cemented
the female and male members of this humanitarian family.

4 "A Young Woman in the Midwest: The Journal of Mary Sears,
 1859-1860." Edited by Daryl E. Jones and James H. Pickering.
 Ohio History 82 (1973):215-34.
 The emotional account of the excruciating death of her
 sister overshadows everything else in the journal of **Mary Sears**
 (1838-63) for 1859-60. Sears, a young single woman from Massa-
 chusetts, spent these years living with her married siblings
 first in Rochester, Ohio, where she taught school and then in
 Amboy, Illinois. Frail and lacking confidence in her own abili-
 ties, Sears continually beseeched God to sustain her amidst the
 hardships and crises of her life.

 1860

1 Cassatt and Her Circle: Selected Letters. Edited by Nancy
 Mowll Matthews. New York: Abbeville Press, 1984, 360 pp.
 Of the 208 letters of artist **Mary Stevenson Cassatt** (1844-
 1926), her family, and friends included in this volume, only 20
 were written in the United States. These letters by Cassatt,
 Eliza Haldeman (Figyelmessy) (1843-1910), a fellow art student in
 Philadelphia, and **Bertha Honoré Palmer** (1849-1918), the leader of
 late nineteenth-century Chicago society, enrich our understanding
 of the evolution of Mary Cassatt's career as well as shed light
 on the problems encountered by women artists in America. Letters
 written by Haldeman and Cassatt between 1860 and 1864 chronicle
 the experiences of the youthful student artists at the
 Pennsylvania Academy of the Fine Arts. Cassatt's 1871 corre-
 sponence with Emily Sartain, another young artist, documents her
 determination to return to Europe, the only place that she felt
 she could pursue her career as a painter. Bertha Palmer was in
 charge of the Women's Building at the Chicago Exposition of 1893,
 where Mary Cassatt's mural Modern Woman was displayed. Her
 letters of 1892-93 reveal her as a forceful advocate for women
 artists.

2 Chronicles from the Nineteenth Century: Family Letters of
 Blanche Butler and Adelbert Ames Married July 21st, 1870.
 Compiled by Blanche Butler Ames. 2 vols. N.p.: Privately
 printed, 1957, 719 pp., 689 pp.
 The letters of **Blanche Butler Ames** (1847-1939) in this
 massive collection of family correspondence constitute an espe-
 cially rich source for exploring the experiences of a young

upper-class wife and mother in the post-Civil War era. Though Blanche's letters span the years 1860 to 1899 and give a good sense of her life as a student and as a middle-aged woman, they are concentrated in the decade following her marriage to Adelbert Ames, the Republican senator and governor of Mississippi during Reconstruction. The affection that existed between Blanche and her husband comes across clearly in her writings as does the egalitarian character of their marriage. Blanche, whose father was a prominent public figure nationally as well as in her home state of Massachusetts, felt free to offer Adelbert advice on political and financial matters. She shared her feelings about her pregnancy with him and inundated him with minute details of the behavior of their children. Blanche was very close to her mother, **Sarah Jones Hildreth Butler** (1816-76), many of whose letters are included here. Mrs. Butler offered guidance to her daughter from the time she was a teenage girl until her own death in 1876.

3 "The Civil War Diaries of Anna M. Ferris." Edited by Harold
 B. Hancock. Delaware History 9 (1961):221-64.
 The thoughtful comments of a Quaker woman on the Civil War
 are presented in these selections from the diaries of **Anna M.
 Ferris** (1815-90) for the years 1860-65. Ferris, a middle-aged
 single woman from Wilmington, Delaware, followed the war news
 closely and interpreted political and military developments from
 a pro-Union, antislavery perspective. She regarded the war as a
 revolutionary period in world history and hoped for the triumph
 of justice and human rights.

4 "The Civil War Letters of Bethiah Pyatt McKown." Edited by
 James W. Goodrich. Missouri Historical Review 67 (1973):
 227-52, 351-70.
 An elderly St. Louis woman widowed during the course of the
 Civil War, **Bethiah Pyatt McKown** (1798-?) depended on the generos-
 ity of her children for her support. In letters written to her
 eldest son between 1860 and 1865, McKown presented finely
 embellished accounts of her financial and personal problems and
 appealed to his sympathies to elicit contributions from him.
 Conscious of both her precarious economic status and her
 deteriorating physical condition, McKown struggled courageously
 to maintain her self-respect. A highly religious woman, she
 placed the utmost value on preparing herself and her children for
 death.

5 A Civil War Marriage in Virginia: Reminiscences and Letters.
 Collected by Carrie Esther Spencer, Bernard Samuels, and
 Walter Berry Samuels, the three surviving children. Boyce,
 Va.: Carr Publishing Co., c.1956.

1860

 Kathleen Boone Samuels (1842-1925) of Front Royal,
Virginia, penned twenty-five letters to her mother when she was
a student at the Woodstock (Virginia) Female Academy in 1860.
Clothes formed the major preoccupation of this exuberant teen-
age girl, who, despite repeated protests to her parents that she
was concentrating on her lessons, filled her letters with dis-
cussions of the latest fashions and requests for various items of
apparel. Her correspondence also sheds light on the curriculum
of an antebellum female academy. In 1862, Kathleen became the
bride of Green Berry Samuels, a young Confederate officer. This
volume includes one letter from Kathleen to her husband, written
after the end of the Civil War in 1865, urging him to obtain his
release from prison and return home to his wife and baby
daughter.

6 "A Georgia Authoress Writes Her Editor: Mrs. Mary E. Bryan to
 W.W. Mann (1860)." Edited by James S. Patty. Georgia His-
 torical Quarterly 41 (1957):416-31.
 At the time she penned these four letters to William
 Wilberforce Mann, the editor of the weekly Southern Field and
 Fireside in 1860, **Mary Edwards Bryan** (1838?-1913) of Thomasville,
 Georgia, was just beginning a lengthy literary career. Con-
 scious of her youth and eager to improve her skills, Bryan ex-
 pressed her gratitude to Mann for his frank criticism of her
 contributions to the magazine and went on to discuss her back-
 ground and work. Elaborating on her own literary tastes and
 standards, she ventured thoughtful opinions on a number of
 contemporary authors. Bryan, who was separated from her husband
 and living with her parents, also commented on the difficulties
 she faced in pursuing a career as a writer while fulfilling the
 social obligations expected of a southern lady.

7 "A Girl in the Sixties: Excerpts from the Journal of Anna
 Ridgely (Mrs. James L. Hudson)." Edited by Octavia Roberts
 Corneau. Assisted by Georgia L. Osborne. Journal of the
 Illinois State Historical Society 22 (1929):401-46.
 These selections from the weekly entries in the diary of
 Anna Ridgely (Hudson) (1841-1926) of Springfield, Illinois, for
 1860 and the years 1863-65 give an idea of the activities and
 opinions of a single young woman from a well-to-do family during
 a turbulent era in American history. Shielded from the burdens
 of the war, Anna engaged in a full social life, tempered only by
 the self-restraint called for by her Presbyterian faith. A sup-
 porter of the Democratic party like others in her family, she was
 critical of President Lincoln and opposed the continuation of a
 war she felt served no purpose. Her diary contains a detailed
 account of Lincoln's funeral in Springfield.

8 "Journal of a Secesh Lady": The Diary of Catherine Ann
 Devereux Edmondston 1860-1866. Edited by Beth G. Crabtree and
 James W. Patton. Raleigh: North Carolina Division of
 Archives and History, 1979, 850 pp.
 An unquestioning belief in the righteousness of the south-
 ern cause permeates the account of the critical years between
 1860 and 1866 preserved in the voluminous diary of **Catherine
 Ann Devereux Edmondston** (1823-75) of Looking Glass plantation in
 Halifax County, North Carolina. Keenly aware of the political
 issues of the day, Edmondston voiced her partisan opinions of
 men and events in spirited terms. Although herself never exposed
 to the deeds of Federal troops, she continually vilified the
 Yankees and condemned their treatment of southern noncombatants.
 Firmly committed to the institution of slavery, she frequently
 discussed the characteristics of her own slaves and of Negroes in
 general. Edmondston, who was childless, was devoted to her hus-
 band, and her diary documents their harmonious marital relation-
 ship. Insulated from the pressures of the war which she
 chronicled in such detail, she enjoyed a tranquil domestic life,
 spending her time gardening, playing chess with her father, read-
 ing European literature and history, and indulging her taste for
 writing poetry. A faithful Episcopalian, Edmondston often quoted
 from the Bible in her diary. Excerpts from this diary were pub-
 lished in Catherine Edmondston, Journal, 1860-1866, ed. Margaret
 Mackay Jones (Mrs. George Lyle Jones) (N.p.: Privately printed,
 1954).

9 "The Journal of Mattie Wheeler: A Blue Grass Belle Reports on
 the Civil War." Edited by Frances L.S. Dugan. Filson Club
 History Quarterly 29 (1955):118-44.
 The journal that **Mattie Wheeler** (Hathaway) (1844-?) of
 Clark County, Kentucky, kept sporadically between 1860 and 1865
 chronicles her coming of age amidst the tumultuous circumstances
 of the Civil War. Accounts of her participation in the tradi-
 tional social activities of privileged young single people--
 visiting, hunting, attending parties and weddings--are
 interspersed with reports of the war and its impact on her
 relatives and on the nearby community of Winchester. Though her
 immediate family was divided in its loyalties, Mattie sympathized
 with the South and frequently expressed her concern for the fate
 of her brother in the Confederate army. Her deepest wish, how-
 ever, was for the restoration of peace.

10 "A Letter from Texas." [Edited by] Nath Winfield. South-
 western Historical Quarterly 71 (1968):425-29.
 In January 1860, **Sarah Morton Thompson**, a recently
 remarried widow, penned this letter to a female friend in her
 former home of Lowndes County, Mississippi. In it, she re-
 counted her experiences on the trip to Washington County, Texas,

where her family had resettled, and described the distinctive features of her new residence. Lonesome for the company of her companions in Mississippi, Mrs. Thompson encouraged them to come to Texas.

11 A Northern Daughter and a Southern Wife: The Civil War
 Reminiscences and Letters of Katharine H. Cumming 1860-1865.
 Edited by W. Kirk Wood. Augusta, Ga.: Richmond County
 Historical Society, 1976, 126 pp.
 Just prior to the outbreak of the Civil War, **Katharine Jane Hubbell Cumming** (1838-1921) married Joseph Bryan Cumming and moved from New York City to her husband's home in Augusta, Georgia. Separated from her family and placed amidst an alien society, Katharine struggled to deal with her conflicting feelings as war engulfed the nation. The seven letters to her husband and mother found in this collection of family correspondence reveal her longing to see her relatives as well as her loyalty to her husband in the Confederate army. Katharine's plight as "a northern daughter and a southern wife" elicited the strong sympathies of her mother, **Jane Maria Bostwick Hubbell** (1810-66), twenty-one of whose letters are printed here. Hubbell yearned to see her daughter and her new grandchildren and employed her considerable resources in fruitless efforts to arrange for Katharine to visit New York. Her frustration at being cut off from her daughter is evident in her emotion-laden letters. Although only thirty of the seventy letters in this volume were written by women, it nonetheless constitutes a valuable source for studying the human impact of political decisions.

12 The Private War of Lizzie Hardin: A Kentucky Confederate
 Girl's Diary of the Civil War in Kentucky, Virginia,
 Tennessee, Alabama, and Georgia. Edited by G. Glenn Clift.
 Frankfort: Kentucky Historical Society, 1963, 306 pp.
 Elizabeth (Lizzie) Pendleton Hardin (1839-95), a young single woman from a genteel family of Harrodsburg, Kentucky, rewrote the diary she kept on scraps of paper between 1860 and 1865. This edited version of her Civil War experiences makes plain that Lizzie was an ardent supporter of the Confederacy and as a result faced numerous difficulties living in a border state. Exiled from Kentucky, she traveled through the Confederacy with her mother and sister, reporting perceptively on wartime conditions and the attitude of the populace.

13 Sam Curd's Diary: The Diary of a True Woman, by Susan S.
 Arpad. Athens: Ohio University Press, 1984, 172 pp.
 The diary that **Mary Samuella (Sam) Hart Curd** (1834[35?]-1919) began on her wedding day in 1860 and concluded sorrowfully in June 1863, thirteen months after her husband's death, presents a picture of a young woman whose experience of marriage and

motherhood did not live up to the ideals of the day. Trans-
planted from Richmond, Virginia, to Fulton, Missouri, Curd worked
assiduously to establish social ties in her new home, but con-
fided repeatedly to her diary that she sorely missed her own
family. The outbreak of the Civil War only heightened the pain
of separation for Curd, whose secessionist sympathies had to be
concealed in a community controlled by Union forces. Curd's
troubles multiplied with the onset of her husband's fatal ill-
ness just after the birth of her baby, and her diary increasingly
became the repository of her feelings of distress. A devout
Presbyterian, she continued to seek release in her religion and
considered her husband's deathbed conversion to be of the utmost
importance.

14 Two Diaries: The Diary & Journal of Calvin Perry Clark Who
 Journeyed by Wagon Train from Plano, Illinois, to Denver and
 Vicinity over the Santa Fe Trail in the Year 1859 Together
 With the Diary of His Sister Helen E. Clark Who Made a Similar
 Journey by the Northern Route in the Year 1860. Denver:
 Denver Public Library, 1962, 91, 44 pp.
 In the spring of 1860, **Helen E. Clark**, a young single
 woman, traveled west from Plano, Illinois, with her mother to
 join her father and brother who had settled on a ranch near
 Denver. Helen kept a record of the wagon journey through
 Illinois, Iowa, and Nebraska to Colorado in her diary, commenting
 on scenery, towns, and gravestones along the road. Of particular
 interest are Helen's descriptions of encounters with various
 groups of Indians who sought to trade with the emigrants.

<div align="center">1861</div>

1 Brokenburn: The Journal of Kate Stone 1861-1868. Edited by
 John Q. Anderson. Baton Rouge: Louisiana State University
 Press, 1955. Reprint, with a new foreword. 1972, 400 pp.
 When the Civil War began, **Sarah Katherine (Kate) Stone**
 (Holmes) (1841-1907), a young single woman, was leading a priv-
 ileged existence at Brokenburn, her widowed mother's large cotton
 plantation in northeastern Louisiana. The first part of Stone's
 journal, which she kept regularly from 1861 to 1865 and supple-
 mented with summary sketches for 1867 and 1868, captures the
 pleasant routine of her life--reading, sewing, and socializing
 with family and friends--and also provides evidence of her strong
 support for the Confederacy. The appearance of Federal troops in
 the vicinity of Brokenburn precipitated Stone's flight to Texas
 with her family, where she spent the last two years of the war.
 Continuing to chronicle the events of the conflict, she expressed
 anxiety over the fate of her soldier-brothers and reiterated her
 firm belief in the southern cause. Initially dissatisfied with

her life in exile, she came to enjoy her residence in Tyler, Texas, where she met the man whom she eventually married.

2 "The Civil War Diary of Louisa Brown Pearl." Edited by James
 A. Hoobler. Tennessee Historical Quarterly 38 (1979):308-21.
 Determined to protect her family's property and be of
 service to her son who had enlisted in the Confederate army,
 Massachusetts-born **Louisa Brown Pearl** (1810-86) elected to
 remain in her Nashville, Tennessee, home during the Civil War
 while her husband and two daughters moved North. Her diary from
 September 1861 to March 1862, the period during which Nashville
 passed into the hands of Union troops, records her thoughts and
 emotions against the backdrop of wartime disorder and uncer-
 tainty. Faced for the first time at middle age with the neces-
 sity of making decisions for herself, Pearl kept boarders in her
 household and managed to see the crisis through. Lonely and
 depressed at the separation from her family, she sought comfort
 in religion.

3 "The Civil War Letters of Captain Andrew Lewis and His
 Daughter." Edited by Michael Barton. Western Pennsylvania
 Historical Magazine 60 (1977):371-90.
 This selection of correspondence contains five letters,
 dated 1861 and 1862, written by **Mary Lewis** (1844?-95), a girl of
 seventeen, to her father in the Union army. These letters report
 news of the family at home in Ebensburg, Pennsylvania, and pro-
 vide a lively account of the latest doings of Mary's little
 brother, Jackie. Mary expressed longing for her father's return
 as well as her hopes for the end of the war.

4 "The Colonel's Lady: Some Letters of Ellen Wilkins Tompkins,
 July-December 1861." Edited by Ellen Wilkins Tompkins.
 Virginia Magazine of History and Biography 69 (1961):387-419.
 Soon after her husband left to assume his duties as a
 colonel in the Confederate army, **Ellen Wilkins Tompkins** (1818-
 1901) found her estate, Gauley Mount in the Kanawha Valley of
 Virginia, occupied by Federal forces. Because of her husband's
 prior status in the United States Army and the great respect in
 which he was held by his peers, she was guaranteed protection
 for herself and her children by the commanders in the region.
 Tompkins elaborated on her anomalous situation in letters penned
 to her husband and sister between August and December 1861,
 always emphasizing the kind treatment she received from Union
 officers whom she considered her political enemies. Well aware
 of her strategic position between two opposing armies, Tompkins
 made clear her intention to preserve her own property and acted
 with courage in the face of recurrent impositions by soldiers.
 Continually anxious over her separation from her husband, she
 eventually was permitted to rejoin him in Richmond.

5 The Confederate Diary of Betty Herndon Maury, Daughter of
 Lieut. Commander M.F. Maury 1861-1863. Edited by Alice
 Maury Parmelee. Washington: Privately printed, 1938,
 102 pp.
 The outbreak of the Civil War shattered the hopes of
 domestic tranquility nurtured by **Betty Herndon Maury Maury**,
 a young wife and mother of genteel southern background. Up-
 rooted from Washington, D.C., with her husband and young
 daughter and forced to take up residence with her parents in
 Fredericksburg, Virginia, Maury struggled to maintain her
 equilibrium amidst the uncertainties of war. Her diary record
 of the period between June 1861 and February 1863, valuable as
 a source for following the military history of the war in
 Virginia, is noteworthy for documenting the toll the conflict
 took on family life. The strains her husband's intermittent
 unemployment placed on Maury's marital relationship are graphi-
 cally conveyed in her attempts to reconcile the reality of her
 experience with her vision of the ideal wife. Equally signifi-
 cant are the poignant entries that measure the impact of hos-
 tilities on her child's health and psychological state. Betty
 Maury's personal responses to the disruptions of war, oscillat-
 ing from patriotic effusions for the Confederacy to laments over
 the loss of accustomed material comforts and the insubordinate
 behavior of Negroes, are also captured vividly. The diary
 breaks off after Maury, resettled in Richmond and pregnant with
 her second child, finds her family peremptorily evicted from
 their boarding house.

6 Dear Ones at Home: Letters from Contraband Camps. Selected
 and edited by Henry L. Swint. Nashville, Tenn.: Vanderbilt
 University Press, 1966, 274 pp.
 When **Lucy Chase** (1822-1909) and her sister, **Sarah Chase**
 (1836-1911), single women from a well-to-do Quaker family of
 Worcester, Massachusetts, arrived at the contraband camp estab-
 lished on Craney Island near Norfolk, Virginia, in 1863, they
 found the needs of the newly freed slaves assembled there to be
 overwhelming. They commenced their work of dispensing material
 aid, establishing schools, and preparing black people to become
 self-sufficient, work they continued in other locations in the
 South for much of the decade. The correspondence of the Chase
 sisters, which spans the years 1861-70 and includes a number of
 letters from New England supporters and blacks whom the sisters
 had taught, constitutes a valuable source for examining the
 interaction of female humanitarians from the North with federal
 officials, ex-slaves, and white southerners. Lucy Chase's
 richly detailed accounts of the life histories of former slaves
 and the beliefs and religious practices of the black community
 are of unusual interest.

1861

7 "'Dear Sister Jennie--Dear Brother Jacob': The Correspondence between a Northern Soldier and His Sister in Mechanicsburg, Pennsylvania, 1861-1864." Edited by Florence C. McLaughlin. <u>Western Pennsylvania Historical Magazine</u> 60 (1977):109-43, 203-40.

 Despite the title of this article, virtually all the letters printed here were written by Jacob Heffelfinger, a soldier in the Union army, to his sister, **Jennie Heffelfinger** (1842-1908). Only two brief letters from Jennie, who was single and living at home in Mechanicsburg, Pennsylvania, are included.

8 <u>Diary of a Southern Refugee during the War</u>. New York: Arno Press, 1972, 360 pp. [Originally published in 1867.]

 Forced to flee her home in Alexandria, Virginia, at the outbreak of Civil War hostilities, **Judith White Brockenbrough McGuire**, a middle-aged woman, spent the remainder of the war in Richmond with her husband, an Episcopal minister, trying to secure adequate means of support. McGuire's diary of the years 1861 to 1865 captures the atmosphere in the Confederate capital as privation and competition for jobs caused both women and men to abandon the traditional niceties of behavior. McGuire herself felt lucky to obtain a job as a government clerk, though she continued to work as a volunteer at a local hospital and to manufacture soap for sale. An ardent supporter of the Confederacy, she was horrified by the tales she heard of Yankee inhumanity to her fellow Virginians and insisted on recording them in her diary for the sake of posterity. Critical of the pessimists around her, she maintained hope until the end of the war and refused to believe that Richmond would fall.

9 <u>Diary of a Union Lady 1861-1865</u>. Edited by Harold Earl Hammond. New York: Funk & Wagnalls Co., 1962, 396 pp.

 The daughter of wealthy and prominent New York Episcopalians, **Maria Lydig Daly** (1824-94) alienated her family by marrying Judge Charles Patrick Daly, a self-made Irish Catholic politician. Maria's allegiance to her husband shaped her attitude toward the personalities and events of the Civil War which she chronicled so vividly in her diary from 1861 to 1865. An intimate friend of leading New York City Democrats, Maria reviled Abraham Lincoln, had little sympathy for the abolitionists, and was partial to the cause of Catholics. Though she deplored the economic hardships imposed by the war, Maria nevertheless lived a life of leisure, spending much of her time at dinner parties, concerts, and the theater.

10 Diary of Lucy Rebecca Buck, 1861-1865. Edited by L. Neville
 Buck. N.p., c.1940, 240 pp.
 The emotional oscillations of a young single southern woman
over the years of the Civil War are captured in the diary kept by
Lucy Rebecca Buck (1842-1918) of Bel Air, a plantation near Front
Royal, Virginia, between 1861 and 1865. Lucy's passage to matur-
ity coincided with the dismantling of a cherished way of life and
her anguished outpourings convey not only the difficulties of
coming of age but the tragedies of a war-torn society. Nostalgia
for the tranquil round of domestic and community activity of
former days permeates her detailed record of wartime adaptations
in the Buck household as Union soldiers crisscrossed the area.
Lucy's passionate commitment to the Secessionist cause is evident
at all times, but nowhere more so than in her vitriolic charac-
terizations of Yankees and her diatribes against Lincoln and the
Union. The diary contains relatively few entries for 1864 and
1865.

11 The Diary of Miss Emma Holmes 1861-1866. Edited, with an
 introduction and notes by John F. Marszalek. Baton Rouge and
 London: Louisiana State University Press, 1979, 496 pp.
 Emma Edwards Holmes (1838-1910) viewed the events of the
Civil War from the perspective of the Charleston, South Carolina,
elite. Steadfastly loyal to the Confederate cause, Holmes
charted the progress of the prolonged struggle between the states
in the diary she kept from 1861 to 1866, while also making
copious notes on family affairs, churchgoing, and social activi-
ties. Compelled to move to Camden, South Carolina, after the
great fire of 1861 destroyed her widowed mother's home, she
eventually gained firsthand knowledge of the Union troops who
were the target of her venom. A woman with a strong intellectual
bent, Holmes spent much of her time reading. She consistently
sought a means of establishing her own independence and at times
was able to find employment as a teacher. Increasingly self-
conscious about being single, she made pointed comments about the
marriages of members of her social circle. Disheartened at the
outcome of the war, Holmes outlined the difficulties that leading
southern families had to face. As she elaborated on the altera-
tion in relations between masters and their former slaves, she
described her own initiation into the regime of household work.
A portion of this diary was published in John F. Marszalek, Jr.,
ed., "The Charleston Fire of 1861 as Described in the Emma E.
Holmes Diary," South Carolina Historical Magazine 76 (1975):
60-67.

1861

12 "An 1861 View of Wesleyan College, Macon, Georgia." Edited by
 Kenneth Coleman. <u>Georgia Historical Quarterly</u> 51 (1967):
 488-91.
 In January 1861, **Sallie Hudson** (probably Sarah E. Hudson of
 Jefferson County, Georgia), a student at Wesleyan Female College
 in Macon, Georgia, penned this letter to a former school friend.
 Sallie described conditions at the college in colorful terms,
 discoursing at length on the quality of the food and the behavior
 of the faculty.

13 <u>Frontier Mother: The Letters of Gro Svendsen</u>. Translated and
 edited by Pauline Farseth and Theodore C. Blegen. Northfield,
 Minn.: Norwegian-American Historical Association, 1950,
 153 pp.
 A Norwegian immigrant woman's gradual adaptation to Ameri-
 can ways is captured in the correspondence of **Gro Svendsen**
 (1841-78) spanning the years 1861 to 1877. Arriving in
 Estherville, Iowa, as a young bride from a privileged family
 background in Norway, Svendsen grew accustomed to working hard as
 a farmer's wife and the mother of a large brood of children. Her
 talent as a writer enabled her to distill the essence of her
 everyday experiences as well as to communicate her feelings about
 her husband and children in an unaffected manner. Svendsen's
 attitude toward the two cultures that shaped her life may also be
 traced in these letters. A woman who cherished her Norwegian
 heritage, she understood that her offspring had to be educated
 for their future as Americans. A selection of Svendsen's corre-
 spondence is printed in 1837.3.

14 <u>The Journal of a Milledgeville Girl 1861-1867</u>. Edited by
 James C. Bonner. Athens: University of Georgia Press, 1964,
 131 pp.
 The years 1861 to 1867, when **Anna Maria Green** (Cook)
 (1844-1936) of Milledgeville, Georgia, kept her journal, were a
 time of profound crisis and change for the South. Although Anna
 Maria was a loyal supporter of the Confederacy and made notations
 in her journal about the events of the Civil War and the initial
 phase of Reconstruction, it is clear that her central preoccupa-
 tion was her own emotional development. She scrutinized her
 behavior, monitored her feelings, and periodically resolved to
 correct her faults. A devout Methodist, she also reflected at
 length on her spiritual condition. As she matured, Anna Maria
 became increasingly anxious to find a proper husband, and she
 devoted more and more space to comments on the qualities of the
 men with whom she socialized. She also indulged in considerable
 gossip about the affairs of local young men and women. Anna
 Maria's journal also contains a valuable record of her voluminous
 reading.

15 The Journal of Eldress Nancy: Kept at the South Union,
 Kentucky, Shaker Colony August 15, 1861-September 4, 1864.
 Edited by Mary Julia Neal. Nashville, Tenn.: Parthenon
 Press, 1963, 256 pp.
 Because it was written to preserve a record of the expe-
 riences of the Shaker colony at South Union, Kentucky, during
 the Civil War crisis, the journal of Eldress **Nancy E. Moore**
 (1807-89), who served in the community's ministry, contains
 little of a personal nature. It focuses on the wartime tra-
 vails of the Shakers, who remained neutral because of their
 pacifist beliefs, yet were subjected to repeated demands for
 food, supplies, and shelter by both Confederate and Union troops
 in this border area. Nonetheless, a clear picture of the work,
 religious life, and recreations of Shaker women and men emerges
 from Eldress Nancy's journal. Moreover, infrequent, but reveal-
 ing, references to Nancy Moore's own views on the war and her
 spiritual state give the reader some idea of the individual who
 kept this unusual journal.

16 The Journal of Julia LeGrand, New Orleans 1862-1863. Edited
 by Kate Mason Rowland and Mrs. Morris L. Croxall. Richmond,
 [Va.]: Everett Waddey Co., 1911, 318 pp.
 The atmosphere of New Orleans under Federal occupation is
 captured vividly in the journal of **Julia Ellen LeGrand** (Waitz)
 (1829-81) from December 1861 to April 1863. A single woman whose
 family had lost its wealth, LeGrand proved a keen observer of the
 social scene, as she chronicled the uneasy relations between
 white residents of the city and the unwelcome representatives of
 the Union and assessed the changes in the behavior of blacks as a
 result of the new regime. A thoughtful and articulate exponent
 of the Confederate position, she used her diary to elucidate her
 reactions to the occupation, her opinion of the Federal authori-
 ties, and her views of wartime developments. LeGrand's comments
 on her household affairs, reading, and social engagements provide
 a glimpse of her private life. Throughout the diary, LeGrand ex-
 pressed her longing for the absent relatives whom she rejoined in
 Texas after the war.

17 "A Letter from Bleak Hall, 1861." South Carolina Historical
 Magazine 62 (1961):193-94.
 In this letter of May 3, 1861, **Phoebe Townshend** of Bleak
 Hall, Edisto, South Carolina, a young single woman who had been
 in Charleston while her father attended the convention, supplied
 Mrs. Mary Dawkins with a vivid description of the Battle of Fort
 Sumter.

18 <u>Letters from the Colonel's Lady: Correspondence of Mrs.
 (Col.) William Lamb written from Fort Fisher, N.C., C.S.A.,
 to her parents in Providence, R.I., U.S.A., December 1861 to
 January 1865</u>. Edited by Cornelius M. Dickinson Thomas.
 Winnabow, N.C.: Charles Towne Preservation Trust, 1965,
 97 pp.
 Though a native of New England, **Sarah Anne Chaffee Lamb**
 (1837-?) shifted her allegiance to the South after she married a
 man from Norfolk, Virginia. A partisan of the Confederacy, she
 insisted on accompanying her officer husband to his post at
 Fort Fisher, North Carolina, during the Civil War. In spite of
 the ever-present danger, Lamb managed to communicate at intervals
 with her parents in Rhode Island between 1861 and 1865. In her
 letters, she pictures her living arrangements and discusses
 menus, visits from military personnel and neighbors, the activ-
 ities of her children, and the events of the war. Her final
 letter, written during an attack on the fort, breaks off in the
 middle.

19 <u>Mason Smith Family Letters 1860-1868</u>. Edited by Daniel E.
 Huger Smith, Alice R. Huger Smith, and Arney R. Childs.
 Columbia: University of South Carolina Press, 1950, 292 pp.
 The family correspondence collected in this volume includes
 over fifty letters by **Eliza Carolina Middleton Huger Smith**
 (1824-1919), a widowed mother of six from Charleston, South
 Carolina, as well as letters of her two daughters, her mother-in-
 law, and other female relatives and friends of the Smiths.
 Eliza's letters, which date from 1861 to 1865, document her
 efforts to cope with the economic difficulties entailed by the
 Civil War and illustrate her loving concern for her children's
 spirits as the family was forced to move from home. In the midst
 of the crisis, Eliza remained committed to improving the educa-
 tion of her offspring and instilling the proper values in them.
 The most poignant letters in the collection, those Eliza penned
 from a Richmond, Virginia, hospital where she had gone to tend
 her mortally wounded son, testify to her strong religious faith
 in the face of tragedy.

20 "'On the Qui Vive For the Long Letter': Washington Letters
 from a Navy Wife, 1861." Edited by Virginia Jeans Laas.
 <u>Civil War History</u> 29 (1983):28-52.
 As the daughter of Francis Preston Blair, a powerful figure
 on the Washington scene, **Elizabeth Blair Lee** (1818-94?) had an
 intimate knowledge of political issues and personalities. The
 journal letters she wrote to her husband, a commander in the
 United States Navy, in January and February 1861 vividly re-
 create the tense atmosphere in the nation's capital on the eve of
 President Lincoln's inauguration. As she chronicled the move of
 the southern states toward secession and speculated on the

possibility of civil war, Lee unhesitatingly enunciated her own
Unionist sympathies. Though her letters are almost entirely
taken up with the discussion of political developments, Lee did
keep her husband apprised of the activities of their four-year-
old son.

21 The Private Mary Chesnut: The Unpublished Civil War Diaries,
 by C. Vann Woodward and Elisabeth Muhlenfeld. New York:
 Oxford University Press, 1984, 292 pp.
 During the 1880s, **Mary Boykin Miller Chesnut** (1823-86) of
 Camden, South Carolina, fashioned her now-classic account of the
 Civil War years out of diaries she had kept during the conflict.
 Chesnut's book was subsequently published in three versions
 (1905, 1949, 1981), the first two incorrectly labeling her work
 as a diary. The extant segments of Chesnut's actual wartime
 diary for the years 1861 and 1865 are published here for the
 first time. Chesnut's analysis of events and personalities is
 presented in a succinct but recognizable form. Her privileged
 position as the wife of a public figure allowed her to inspect
 the leaders of the Confederacy at close hand in Montgomery,
 Alabama, and to make acerbic comments on their frailties. Her
 equally telling remarks on her neighbors in the low country of
 South Carolina, slavery, and the position of women bear witness
 to the independence of mind that distinguished her from her
 contemporaries. Chesnut's candid revelations of her own
 temperament and behavior add to the singular value of the diary.

22 "Sarah Butler Wister's Civil War Diary." [Introduction by
 Fanny Kemble Wister.] Pennsylvania Magazine of History and
 Biography 102 (1978):271-327.
 Loyal to the Union but outspoken in her criticisms of inept
 leaders and misguided policies, **Sarah Butler Wister** (1835-?), the
 daughter of famed English actress Fanny Kemble, filled the diary
 she kept from April to September 1861 with trenchant observations
 on the conduct of the unfolding Civil War and fascinating
 vignettes of upper-class Philadelphians caught up in the frenzied
 atmosphere of the time. An accomplished woman who customarily
 devoted herself to supervising her household and servants, shop-
 ping, reading, practicing music, making calls, entertaining
 visitors, and spending time with her husband and infant son,
 Wister became increasingly preoccupied with following military
 and political developments. She was especially concerned over
 the fate of her father, whose southern sympathies caused his
 arrest.

1861

23 "Sue Sparks Keitt to a Northern Friend, March 4, 1861."
 Edited by Elmer Don Herd, Jr. South Carolina Historical
 Magazine 62 (1961):82-87.
 On the day Abraham Lincoln was inaugurated as president of
 the United States, March 4, 1861, **Sue Mandeville Sparks Keitt**
 (1834-1915), whose husband was a representative at the Provincial
 Congress of the Confederate States of America, penned this im-
 passioned defense of the southern cause to Mrs. Brown, a northern
 friend whom she had met in Europe. Writing from her father's
 plantation in the Marlborough District of South Carolina, Mrs.
 Keitt put forth a scathing critique of Lincoln and the Republi-
 cans and then enumerated the reasons southerners could no longer
 support the Union.

24 The Unknown Friends, A Civil War Romance: Letters of My
 Father and My Mother. Compiled by Charlotte Ingersoll Morse.
 Chicago: A. Kroch & Son, 1948, 110 pp.
 While serving in the Union army during the Civil War,
 Chalmers Ingersoll, at the urging of a comrade, initiated a
 correspondence with a daughter of the Rinewalt family of
 Williamsville, New York. **Lottie B. Rinewalt** (Ingersoll)
 (1842-1932) responded and thus began an interchange of letters
 that evolved into an epistolary courtship and eventuated in
 marriage. Seven of Lottie's letters to her "unknown friend" from
 1861 to 1863 are among the twenty-three letters printed in this
 volume. Written in a formal style and filled with the abstrac-
 tions common to literary discourse of the period, they paint a
 portrait of Lottie as a proper young lady eager for a taste of
 romance. The paucity of references to the mundane details of
 everyday life in a rural village and to the war itself suggests
 that Lottie preferred to dwell in the rarefied atmosphere of the
 mind. The increasingly affectionate tone of the letters, coupled
 with Lottie's greater willingness to disclose information about
 herself, anticipate the outcome of the relationship.

 1862

1 Civil War Nurse: The Diary and Letters of Hannah Ropes.
 Edited, with an introduction and commentary by John R.
 Brumgardt. Knoxville: University of Tennessee Press, 1980,
 149 pp.
 Deserted by her husband and left with two children to
 raise, **Hannah Anderson Chandler Ropes** (1809-63) of Bedford,
 Massachusetts, had become accustomed to contributing to society
 as an independent individual long before she volunteered to nurse
 Union soldiers during the Civil War. Author of two books relat-
 ing to her life as a free-soil emigrant to Kansas, Ropes recorded
 her experiences as matron of the Union Hotel Hospital in
 Georgetown, D.C., in her diary and in letters to her daughter

dating from June 1862 to January 1863. Ropes's primary concern
was to alleviate the suffering of the privates under her care,
and she wrote with feeling of their wounds, the treatment they
received, and the comforts she provided for them. Unwilling to
tolerate the corruption of hospital personnel because it affected
the condition of her patients, she challenged the military
bureaucracy by going to Secretary of War Edwin Stanton and
succeeded in having the hospital administration replaced. A
woman of broad humanitarian sympathies, Ropes demonstrated by her
example that women were capable of effective action in the world
outside the home.

2 "Civil War Wife: The Letters of Harriet Jane Thompson."
 Edited by Glenda Riley. <u>Annals of Iowa</u>, 3d ser. 44 (1978):
 214-31, 296-314.
 Harriet Jane Parsons Thompson (1836-97) of Marion, Iowa,
 could not overcome her feelings of loneliness after her husband
 went off to serve in the Union army in the Civil War. The
 petulant tone of the repeated requests for him to return home
 found in these 1862 letters, the majority of which were written
 during an extended stay with his family in Pennsylvania, suggests
 just how dependent this childless wife was on her husband. Ref-
 erences to her recurrent dreams of being with him coupled with a
 few explicit statements affirm the sexual nature of her longing.

3 <u>A Confederate Girl's Diary: Sarah Morgan Dawson</u>. Introduc-
 tion by Warrington Dawson. Boston and New York: Houghton
 Mifflin Co., 1913. Reprint, edited, with a foreword and notes
 by James I. Robertson, Jr. Bloomington: Indiana University
 Press, 1960, 473 pp.
 Though loyal to the South, **Sarah Ida Fowler Morgan** (Dawson)
 (1842-1909), a young single woman from a prominent Baton Rouge,
 Louisiana, family, exhibited an unusual independence of mind in
 her commentary on the course of the Civil War. Sarah used the
 diary she kept from March 1862 to June 1865 not only to preserve
 a detailed record of her wartime experiences--first in Baton
 Rouge with her widowed mother and her sister under the oversight
 of Union troops, then in exile in the Louisiana countryside, and
 finally in New Orleans under the protection of her Unionist
 brother--but as the repository of her candid opinions on the
 conduct of both southerners and northerners. Conscious of her
 social position and status as a lady, Sarah adhered to ingrained
 values of civility and charity and heaped scorn on the unthink-
 ing patriotism of southern women as well as the brutish behavior
 of the northern soldiers who sacked her family's home. Sur-
 prisingly resilient, Sarah was able to maintain her buoyant
 spirits in the face of property loss, physical injury, and social
 upheaval, succumbing to feelings of desperation only after

learning of the deaths of two of her brothers in the Confederate army in 1864.

4 Dear America: Some Letters of Orange Cicero and Mary America
 (Aikin) Connor. Edited by Seymour V. Connor. Austin and
 New York: Jenkins Publishing Co., Pemberton Press, 1971,
 132 pp.
 As a consequence of her husband's enlistment in the
 Confederate army, **Mary Ann America Aikin Connor** (1833-1912)
 learned to run the family's farm in east Texas and supervise the
 slave laborers. The down-to-earth letters that Connor wrote her
 husband between 1862 and 1864 supplied him with specific informa-
 tion on cotton, wheat, corn, hogs, and sheep as well as news of
 their young children, slaves, relatives, and neighboring men
 involved in the war. Unhappy over the prolonged separation from
 her husband and continually anxious over his condition, Connor
 nevertheless strove to make the best of her situation.

5 Diary of a Refugee. Edited by Frances Fearn. New York:
 Moffat, Yard & Co., 1910, 149 pp.
 Frances Fearn edited this diary kept by her mother, whose
 name is not disclosed, between 1862 and 1867. Although Fearn
 apparently altered the manuscript considerably, the diary is
 nonetheless useful for its account of the experiences of an
 extremely wealthy Louisiana planter's wife during the Civil War
 and the early stages of Reconstruction. Forced to flee the
 plantation in order to avoid invading Federal troops, Fearn's
 mother became a refugee, spending time in Texas, Mexico, Cuba,
 and England before settling in Paris for the duration of the war.
 Her chronicle of her adventures, presented in periodic diary
 entries without precise dates, recounts her husband's efforts to
 secure her safety and comfort, her sorrow at the death of two of
 her sons in the war, and her vicarious pleasure in the romances
 of her daughter and daughter-in-law. Returning to New Orleans
 during Reconstruction, Fearn's mother detailed the problems that
 faced her family with the loss of their property, including large
 slaveholdings. A woman who believed that slavery was a
 benevolent institution and that most slaves were loyal to their
 masters, she feared for the future because the Negroes were not
 prepared for freedom.

6 "Diary of a Young Girl: Grundy County to Correctionville,
 1862." Edited by Lida L. Greene. Annals of Iowa, 3d ser. 36
 (1962):437-57.
 In late 1862, young **Ellen Strang** left her family's farm in
 Grundy County, Iowa, for an extended visit with her married
 sister in Correctionville, Iowa. Initially, the diary Strang
 kept from November 1862 to April 1863 was taken up with reports
 of her household labors--sewing, washing, ironing, preparing

food, and listening to her niece recite her lessons--and family
news. In the latter part of the diary, Strang chronicled the
stages of the illness that ultimately took her sister's life.

7 A Diary with Reminiscences of the War and Refugee Life in the
 Shenandoah Valley 1860-1865, by Mrs. Cornelia McDonald.
 Annotated and supplemented by Hunter McDonald. Nashville,
 Tenn.: Cullom & Ghertner Co., 1934, 540 pp.
 This volume includes a diary kept by **Cornelia Peake
 McDonald** (1822-1909) from March 1862 to June 1863, the initial
 portion of which was largely reconstructed from memory. Left at
 home in Winchester, Virginia, with her seven children while her
 husband was serving in the Confederate army, McDonald strove to
 maintain a semblance of normal life for her family as the town
 shifted back and forth between Confederate and Union hands. A
 staunch supporter of the Confederacy, she recoiled at the in-
 dignities to which southern women were subjected by the Yankee
 occupiers but nevertheless manifested skill as well as courage
 in her own dealings with Union soldiers and officers. The death
 of her baby in the midst of the crisis caused her untold sorrow,
 and her diary was taken up more and more with recollections of
 happy days in the past. A woman of deep religious faith,
 McDonald frequently read the Bible as she sought to find meaning
 in the chaos around her.

8 "An Extract from the Journal of Mrs. Hugh H. Lee of
 Winchester, Va., May 23-31, 1862." Edited by C.A. Porter
 Hopkins. Maryland Historical Magazine 53 (1958):380-93.
 Mary Charlton Greenhow Lee (1819-1906), a middle-aged
 widow, could hardly contain her joy when Confederate forces under
 the command of General "Stonewall" Jackson recaptured Winchester,
 Virginia, from Federal troops in May 1862. Her journal furnishes
 a minutely detailed account of the arrival of the Confederates
 and their departure a few days later. Lee described the pleasure
 she felt in feeding and entertaining the southern soldiers and
 expressed her delight at the sight of so many Yankee prisoners.

9 "Frederick Diary: September 5-14, 1862." Edited by Virginia
 O. Bardsley. Maryland Historical Magazine 60 (1965):132-38.
 Catherine Susannah Thomas Markell (1828-1910), the wife of
 a prominent Frederick, Maryland, merchant, sided with the South
 during the Civil War. These brief excerpts from her diary reveal
 that Mrs. Markell entertained top Confederate officers while they
 were in Frederick in September 1862. See also 1892.3.

10 "Iowa to California in 1862: The Journal of Jane Holbrook
 Gould." Edited by Philip K. Lack. Annals of Iowa, 3d ser.
 37, no. 6 (Fall 1964):460-76; no. 7 (Winter 1965):544-59;
 no. 8 (Spring 1965):623-40; 38, no. 1 (Summer 1965):68-75.

1862

As she traveled from Mitchell County, Iowa, to California by covered wagon in 1862, **Jane Augusta Holbrook Gould** (1833-?) only occasionally confided to her journal that she yearned to see the folks at home. For the most part, her record of the journey west with her husband and two young sons concentrates on outward events--the mechanics of transportation, the changing features of the landscape, and the activities of members of the wagon train. Encounters with the natives initially elicited mild expressions of distaste from Gould, but after Indians began to attack the migrants in the Far West, her attitude toward them altered to one of outright detestation. The sight of graves along the trail unfailingly moved Gould to reflect on the deaths of westward travelers.

11 "Journal Kept While Crossing the Plains By Ada Millington." Edited by Charles G. Clarke. <u>Southern California Quarterly</u> 59 (1977):13-48, 139-84, 251-69.
 Ada Millington (Jones) (1849-1930) was twelve years old when her family left Iowa for California in 1862. A curious and observant girl, Ada kept a faithful record of the uneventful trip in her journal, which she revised in 1868. Her account includes the customary material on covered wagon travel through the West, but is of particular interest for its candid relation of amusing incidents involving the men of the party, its objective depiction of Indians, and its unemotional narrative of the death and burial of Ada's baby brother. In addition, Ada's journal offers a glimpse of the activities of children on the trail.

12 "The Journal of Miss Susan Walker, March 3rd to June 6th, 1862." Edited by Henry Noble Sherwood. <u>Quarterly Publication of the Historical and Philosophical Society of Ohio</u> 7 (1912): 1-48.
 Susan Walker (1811-87), a mature single woman living in Washington, D.C., was among the first group of northern volunteers to travel to Port Royal, South Carolina, in March 1862 to aid the newly freed slaves. Walker's record of her three-month stay in the Sea Islands is distinguished for its unsentimental analysis of the behavior and values of both the whites and the blacks involved in this unprecedented venture in social engineering. An educated woman who realized that her task of distributing clothes to the former slaves did not make adequate use of her talents, Walker nonetheless was deeply committed to protecting the rights of the blacks and levied harsh criticism at those northern administrators who abused the power entrusted to them.

13 Kate: The Journal of a Confederate Nurse, by Kate Cumming.
 Edited by Richard Barksdale Harwell. Baton Rouge:
 Louisiana State University Press, 1959, 321 pp.
 Over the opposition of her family, Scottish-born **Kate**
 Cumming (1835?-1909), a young single woman, volunteered to leave
 her comfortable home in Mobile, Alabama, to nurse wounded and
 sick Confederate soldiers at the front. The journal she kept
 from April 1862 to May 1865 preserves a minutely detailed record
 of her experiences as a hospital matron in the Confederate army
 of Tennessee as she moved among hospitals in Mississippi,
 Tennessee, and Georgia. Dedicated to her work and to the south-
 ern cause, Cumming persevered under adverse conditions, aiding
 and comforting countless men. Her account of events and per-
 sonalities is, for the most part, factual in nature, though she
 did offer her opinions on issues as they arose. Cumming's
 journal was originally published in 1866 under the title A
 Journal of Hospital Life in the Confederate Army of Tennessee
 from the Battle of Shiloh to the End of the War: With Sketches
 of Life and Character, and Brief Notices of Current Events
 During That Period (Louisville: J.P. Morton & Co.; New Orleans:
 W. Evelyn, 1866).

14 Letters and Diary of Laura M. Towne Written from the Sea
 Islands of South Carolina 1862-1884. Edited by Rupert
 Sargent Holland. Cambridge, Mass.: Riverside Press, 1912,
 310 pp.
 In 1862, **Laura Matilda Towne** (1825-1901), a single woman
 from Philadelphia, volunteered to help the newly freed slaves on
 the Sea Islands of South Carolina. As these selections from her
 diary and letters between 1862 and 1884 show, Towne found her
 vocation in teaching and dispensing medical care to the freedmen
 on St. Helena Island and stayed there for the remainder of her
 life. Financial support from Philadelphia philanthropists
 enabled her to found the Penn School, which she ran for many
 years with her close friend Ellen Murray. Towne's commitment to
 her work, her uncompromising attitude toward the whites who
 attempted to thwart the efforts of northern reformers in South
 Carolina, and her respect for the black people of her community
 are evident in her writings.

15 "Letters from Nashville, 1862, II: 'Dear Master.'" [Edited
 by] Randall M. Miller. Tennessee Historical Quarterly 33
 (1974):85-92.
 Susanna, a household slave on the Belle Meade plantation
 near Nashville, Tennessee, wrote these two letters to her master,
 Gen. William G. Harding, in the summer of 1862 when he was de-
 tained in a federal prison for refusing to take the loyalty oath
 to the Union. As the personal maid of General Harding's wife,
 Susanna occupied a privileged status on the plantation, and her

communications, containing news of the master's family, other
slaves, and livestock, as well as her expressions of solicitude
for Harding's welfare, reflect the affection and trust that bound
her to him. Although both of these letters were dictated, the
first one more accurately conveys Susanna's own language.

16 Letters from Port Royal 1862-1868. Edited by Elizabeth Ware
 Pearson. New York: New York Times Co., Arno Press, 1969,
 345 pp. [Originally published in 1906.]
 Among the letters of New England missionaries to the newly
 freed Negroes on Port Royal Island, South Carolina, included in
 this volume are a sizable number by **Harriet Ware** of Boston. The
 format of the book detracts from its usefulness, since Ware's
 letters are interspersed with those of her colleagues according
 to date of composition. Nevertheless, Ware's correspondence,
 which spans the years 1862 to 1868, constitutes a valuable source
 for documenting the experiences of a teacher of the freedmen.
 She paints a vivid picture of the unusual milieu in which she
 worked and offers thoughtful comments on the personalities that
 shaped this idealistic social experiment. Of particular interest
 is the account she gives of the local celebration of the
 Emancipation Proclamation. The 1906 edition of this book
 referred to the correspondents only by initials.

17 Lucy Breckinridge of Grove Hill: The Journal of a Virginia
 Girl 1862-1864. Edited by Mary D. Robertson. [Kent, Ohio]:
 Kent State University Press, 1979, 235 pp.
 From August 1862 to December 1864, the time she kept this
 journal, **Lucy Gilmer Breckinridge** (Bassett) (1843-65), the
 daughter of a wealthy slaveholding planter of Botetourt County,
 Virginia, was primarily concerned with preparing herself for
 marriage. Though she grieved excessively over the death of her
 favorite brother in the Civil War and worried about the fate of
 her other brothers in the Confederate army, Lucy was not directly
 exposed to the dangers of the fighting and spent these years
 engaged in the customary rounds of visiting and entertaining. As
 she considered the merits of a series of young men, ultimately
 selecting the man she would marry, she pondered the differences
 between the sexes and attempted to reconcile herself to the loss
 of freedom she would experience as a wife. A faithful member of
 the Episcopal church, Lucy was an avid reader of the Bible and
 religious tracts, as well as contemporary novels. A portion of
 this journal was published in Mary D. Robertson, ed., "The Dusky
 Wings of War: The Journal of Lucy G. Breckinridge, 1862-1864,"
 Civil War History 23 (1977):26-51.

18 Michigan Women in the Civil War. Lansing: Michigan Civil War
 Observance Commission, 1963, 144 pp.
 This book contains two sources that are useful for docu-
 menting the lives of Michigan farm women during the Civil War.
 "Letters from Home," edited by Virginia Everham, prints the
 correspondence of **Lydia Watkins** (1819-1909) and her son, Benton
 Lewis, a member of the Eighth Michigan Cavalry, for the years
 1863-65. Mrs. Watkins's letters primarily describe family and
 local activities. "Mary Austin Wallace: Her Diary; A Michigan
 Soldier's Wife Runs Their Farm," edited by Julia McCune, is the
 1862 diary of **Mary Austin Wallace** (1837[38?]-1921), a young wife
 and mother who was left to run the family farm when her husband
 enlisted in the army. The diary recounts her experiences during
 the period of their separation.

19 "Notes from the Diary of Susan E. Foreman." [Edited by]
 Linda Finley. Chronicles of Oklahoma 47 (1969-70):388-97.
 After studying at the Fayetteville (Arkansas) Female
 Seminary, **Susan E. Foreman**, a young single woman, taught the
 Cherokee neighborhood school at Webber's Falls in the Cherokee
 Nation, Oklahoma. The entries in her diary from 1862 and 1863,
 most of them extremely brief, convey her distaste for school-
 teaching and her homesickness. Returning home to Park Hill,
 Oklahoma, she expressed great fear for herself and her father as
 the town experienced the turmoil engendered by the Civil War.

20 The Other Side of War With the Army of the Potomac: Letters
 From the Headquarters of the United States Sanitary Commission
 During the Peninsular Campaign in Virginia in 1862, by
 Katharine Prescott Wormeley. Boston: Ticknor & Co., 1889,
 210 pp.
 A native of England, **Katharine Prescott Wormeley** (1830-
 1908) played a significant role in caring for sick and wounded
 soldiers of the Union army during the Civil War. Her letters to
 her mother and a few unidentified friends present a compelling
 picture of the experiences of a female nurse on the hospital
 ships of the United States Sanitary Commission during the
 Peninsular campaign of 1862. Totally committed to her work
 despite its distasteful aspects, Wormeley explained her duties in
 illuminating fashion, incorporating concrete details of individ-
 ual cases as she discussed washing, feeding, reading to, writing
 letters for, and conversing with soldiers. The praiseworthy
 qualities of the soldiers elicited her admiration as did the
 dedication and skill of the surgeons and her female colleagues
 on the ships. Wormeley's letters are also of interest for her
 dispassionate assessment of the military situation and her
 evocative comments on the historic landscape she traversed.

21 "Pioneer Migration: The Diary of Mary Alice Shutes." Edited
by Glenda Riley. <u>Annals of Iowa</u>, 3d ser., 43 (1977):487-514,
567-92.
 A thirteen-year-old girl's account of her family's migra-
tion from Ohio to a farm in Carroll County, Iowa, by covered
wagon is preserved in the 1862 diary of **Mary Alice Shutes**
(Mallory) (1849-1939). Not hiding her enthusiasm about moving to
"Ioway," Mary narrated the group's experiences each day in great
detail, paying particular attention to the opinions voiced by her
father and uncle on the conduct of the trip. For Mary, the high
point of her family's uneventful journey through settled terri-
tory was crossing the Mississippi River.

22 "'Strangers and Pilgrims': The Diary of Margaret Tilloston
Kemble Nourse, 4 April-11 November 1862." Edited by Edward
D.C. Campbell, Jr. <u>Virginia Magazine of History and
Biography</u> 91 (1983):440-508.
 Born in New York and loyal to the Union, **Margaret Tilloston
Kemble Nourse** (1830?-83) had misgivings when she and her husband
moved from Washington, D.C., to his family's farm near Warrenton,
Virginia, in April 1862. The diary she kept for the next seven
months reveals not only the fluctuations in her political views
as northern and southern troops vied for control of the area but
her growing discontent with life on the farm. Though sympathetic
to the plight of Virginians, Nourse anguished over the deleteri-
ous impact of the isolated rural existence on her husband and
especially on her son and was deeply concerned about the lack of
church services in the neighborhood. Nourse's detailed record of
everyday life during a period of upheaval also documents her
relations with slaves, the overseer's family, and Union soldiers
and officers.

23 "A Volunteer Nurse in the Civil War: The Diary of Harriet
Douglas Whetten." Edited by Paul H. Hass. <u>Wisconsin Magazine
of History</u> 48, no. 3 (Spring 1965):205-21.
 The diary that **Harriet Douglas Whetten** (Gamble) kept in
July and August 1862 provides a record of her experiences as a
volunteer nurse on a hospital transport ship off the coast of
Virginia. In addition to outlining her part in treating the
casualties resulting from General McClellan's unsuccessful
Peninsular campaign, Whetten recounted her efforts to teach
recently freed black slaves and set forth her assessments of the
motives and behavior of her fellow volunteers. See also 1862.24.

24 "A Volunteer Nurse in the Civil War: The Letters of Harriet
Douglas Whetten." Edited by Paul H. Hass. <u>Wisconsin Magazine
of History</u> 48, no. 2 (Winter 1964-65):131-51.
 Harriet Douglas Whetten (Gamble), a single woman from
Staten Island, New York, served as a volunteer nurse on the

hospital transport ships of the United States Sanitary Commission during General McClellan's campaign in Virginia in the early part of the Civil War. These letters, written between May and July 1862, furnish a detailed picture of Whetten's work caring for wounded and sick Union soldiers on their way to hospitals in northern cities. They also make clear her sympathetic response to her charges. See also 1862.23.

25 Window on the War: Frances Dallam Peter's Lexington Civil
 War Diary. Edited by John David Smith and William Cooper, Jr.
 Lexington, Ky.: Lexington-Fayette County Historic Commission,
 1976, 53 pp.
 Pro-Union sympathies color this diary kept by **Frances
 Dallam Peter** (1843-64), a member of a well-to-do Lexington,
 Kentucky, family, between 1862 and 1864. A talented writer,
 Frances described wartime conditions in Lexington with acuity,
 intermittently venting her antipathy toward the area's Seces-
 sionists. Although the editors have excluded virtually all
 material of a personal nature from this edition, the diary none-
 theless possesses great interest for Miss Peter's views on Civil
 War politics in Kentucky and on slavery and blacks.

1863

1 "An Army Wife Comes West: Letters of Catharine Wever Collins
 (1863-1864)." Colorado Magazine 3 (1954):241-73.
 Catharine Wever Collins (1818?-1911) traveled to Fort
 Laramie, Wyoming, in 1863-64 to visit her husband and son. In
 this series of letters to her fifteen-year-old daughter Josephine
 at home in Ohio, she chronicled her journey west, described
 social life among the officers and their wives at the fort, and
 characterized the Indians of the area in vivid terms. Mrs.
 Collins also furnished her daughter with detailed advice on
 proper behavior.

2 "A Confederate Girl Visits Pennsylvania, July-September 1863."
 Edited by Ernest M. Lander, Jr. Western Pennsylvania Histori-
 cal Magazine 49 (1966):111-26, 197-211.
 In the summer of 1863, **Floride Clemson** (Lee) (1842-71),
 whose family members were strong partisans of the Confederacy in
 the Civil War, traveled from her home in Bladensburg, Maryland,
 to Altoona, Pennsylvania, to visit with relatives. Floride's
 letters to her mother are primarily taken up with characteriza-
 tions of her cousins, expressions of gratitude for their con-
 siderate treatment of her despite her southern sympathies, and
 elaborate narratives of her sightseeing excursions. Of greater
 interest is Floride's detailed explanation of her decision to be
 baptized in the Episcopal church while in Pennsylvania. The

editor provides summaries of Floride's mother's replies to her
daughter's letters. See also 1863.11.

3 Ebb Tide as Seen through the Diary of Josephine Clay Habersham
 1863. [Edited by] Spencer Bidwell King, Jr. Athens: Univer-
 sity of Georgia Press, 1958, 129 pp.
 The diary of **Josephine Clay Habersham Habersham** (1821-93),
 the middle-aged wife of a wealthy rice merchant, offers a vivid
 portrait of the life of a privileged Georgia woman during the
 summer of 1863. While staying at the family's summer home a
 short distance from Savannah, Habersham spent her days reading,
 playing the piano, singing, instructing her children, church-
 going, and visiting with relatives and friends. Although her
 leisured life-style was disrupted only minimally by the exigen-
 cies of war, her detailed reports of battles and other war news
 make clear that her innermost thoughts centered on the fate of
 the Confederacy and in particular on the welfare of her eldest
 son who was in the Confederate army. Determined to maintain the
 outward appearance of normal social life, Habersham continually
 struggled to master her deep felt anxiety over the potential
 impact of the war on her family. This diary also constitutes a
 valuable record of the literary tastes of a well-educated
 nineteenth-century woman since Habersham noted all her readings
 and her particular fondness for Shakespeare. See 1864.5 for the
 diary of Anna Wylly Habersham, the daughter of Josephine Clay
 Habersham.

4 Faint Clews & Indirections: Manuscripts of Walt Whitman and
 His Family. Edited by Clarence Gohdes and Rollo G. Silver.
 Durham, N.C.: Duke University Press, 1949, 250 pp.
 The sixteen letters of **Louisa Van Velsor Whitman** (1795-
 1873) printed in this volume afford a fascinating glimpse of the
 life of the elderly widowed mother of poet Walt Whitman between
 1863 and 1873. In her communications to her famous son from her
 Brooklyn, New York, home, Louisa chronicled the successive
 physical and mental afflictions of members of her family in
 straightforward but never unfeeling terms and ventured her own
 ideas on problems as they arose. Well aware of her financial
 dependence on her offspring, she nonetheless remained a person of
 independent mind and managed to resist until shortly before her
 death her children's well-intentioned efforts to break up her
 household. Louisa's interests were not confined to the domestic
 circle, and she expressed her own opinions on literature and on
 the impeachment of President Andrew Johnson. This book also
 contains a few letters written by two of Louisa's daughters,
 Mary Elizabeth Whitman Van Nostrand (1821-99) and **Hannah Louisa
 Whitman Heyde** (1823-1908). See 1863.8 for letters of her
 daughter-in-law Martha Emma Mitchell Whitman.

5 Glencoe Diary: The War-Time Journal of Elizabeth Curtis
 Wallace. Edited by Eleanor P. Cross and Charles B. Cross,
 Jr. N.p.: Norfolk County Historical Society of Chesapeake,
 Va., 1968, 157 pp.
 Unaccustomed to performing the drudgery of housework,
 Elizabeth Curtis Wallace (1816-66) found herself forced to
 shoulder many onerous tasks when the slaves departed from her
 family's plantation in Norfolk County, Virginia, after Union
 troops established control over the surrounding area. Wallace,
 a middle-aged wife and mother, used the diary she kept from April
 1863 to December 1864 to record the various stratagems she de-
 vised to cope with the increased burdens of housekeeping and the
 generally unstable conditions. A loyal southerner, Wallace in-
 cluded capsule summaries of war news in her diary as well as
 criticisms of Yankee policies, but her primary concern through-
 out was the welfare of her three sons in the Confederate army.
 The wounding of one son and the death of another caused her
 untold anguish and tested her strong religious faith. Pre-
 occupied with the condition of an epileptic daughter, she none-
 theless carefully followed the activities of her husband, her
 other two daughters, and her small grandchildren. Wallace's
 diary also contains notations on her reading.

6 A Governor's Wife on the Mining Frontier: The Letters of
 Mary Edgerton from Montana, 1863-1865. Edited by James L.
 Thane, Jr. Salt Lake City: University of Utah Library,
 Tanner Trust Fund, 1976, 148 pp.
 Mary Wright Edgerton (1827-84) accompanied her husband,
 Sidney Edgerton, to the mining frontier when he became chief
 justice of the Idaho Territory and later, governor of the newly
 created Montana Territory. These letters were written to Mrs.
 Edgerton's mother and sisters in Ohio between 1863 and 1865 and
 describe the journey west and the problems of daily life in
 Bannack, Montana. Raised in genteel society, Mrs. Edgerton
 struggled to maintain her values in the rough society of the
 mining camp. Her correspondence reflects the inner turmoil of
 a woman who yearned for the refinements of the civilized East,
 not to mention her family and friends, yet felt strongly that she
 had no choice but to fulfill her duties as wife and mother un-
 complainingly wherever her husband chose to live. Some of these
 letters were published in James L. Thane, Jr., "Love from All to
 All: The Governor's Lady Writes Home to Ohio," Montana: The
 Magazine of Western History 24 (1974):12-25.

7 "Life in Confederate Arkansas: The Diary of Virginia Davis
 Gray, 1863-1865." Edited by Carl H. Moneyhon. Arkansas
 Historical Quarterly 42 (1983):47-85, 134-69.

1863

Though born in Maine, **Virginia Davis Gray** (1834-86) was as devoted a supporter of the Confederacy as her neighbors in Princeton, Arkansas. Residing at a hotel in town during the war years while her husband served in the Confederate army, Gray kept a diary from 1863 to 1866 in which she recorded her activities and expressed her sympathy for the southern cause. Notes on reading, writing, churchgoing, visiting, entertaining, and sewing for the soldiers are punctuated by accounts of Confederate skirmishes with Federal troops in the vicinity of Princeton and reports of battles elsewhere.

8 Mattie: The Letters of Martha Mitchell Whitman. Edited by Randall H. Waldron. [New York]: New York University Press, 1977, 101 pp.
 Because **Martha Emma (Mattie) Mitchell Whitman** (1836-73) was married to the brother of poet Walt Whitman, these letters, all but one of which were directed to Walt or to his mother, Louisa Van Velsor Whitman, are of particular interest for the light they cast on the inner workings of the Whitman family between 1863 and 1870. In addition to furnishing evidence of her warm relations with members of the Whitman clan, Mattie's letters, most of which were written from Brooklyn, New York, and St. Louis where she lived after 1868, paint a picture of a happy young woman with a devoted husband and two lovely daughters who was struck by tragedy. Mattie's occasional references to the lingering illness that ultimately took her life only hint at the bravery with which she bore her suffering. See 1863.4 for letters of Louisa Van Velsor Whitman.

9 Miss Waring's Journal: 1863 and 1865. Being the Diary of Miss Mary Waring of Mobile, during the Final Days of the War between the States. Edited by Thad Holt, Jr. Chicago: Wyvern Press of S.F.E. [1964], 17 pp.
 When **Mary Douglass Waring** (Harrison) (1845-?), a young single woman of Mobile, Alabama, first began her journal in the summer of 1863, the Civil War was not uppermost in her mind. She wrote primarily of socializing with female friends, shopping, music lessons, and family matters. By 1865, when Waring resumed her journal, her attention was focused on the bombardment of the fort, the evacuation of Confederate troops from Mobile, and the occupation of the city by Federal forces. Waring tended to view events in personal terms, expressing regret at the departure of all her male friends with the army and deprecating the appearance of the Yankee soldiers whom she detested.

10 "Mrs. Cooke's Civil War Diary for 1863-1864." Vermont History, n.s. 25 (1957):56-65.
 A considerable amount of editorial comment links these selected entries from the diary kept by **Mrs. George Cooke**

(1808-?), a farmer's wife of Corinth, Vermont, during 1863 and
1864. Mrs. Cooke's brief jottings note her everyday work, the
rampant illness and death in the community, and the activities of
her sons. She expressed a negative attitude toward President
Lincoln's reelection in 1864.

11 A Rebel Came Home: The Diary of Floride Clemson Tells of Her
 Wartime Adventures in Yankeeland, 1863-1864, Her Trip Home to
 South Carolina, and Life in the South during the Last Few
 Months of the Civil War and the Year Following. Edited by
 Ohailcd H. HoOos, Jr., and Drnast H. Landur, Jr. Columbia:
 University of South Carolina Press, 1961, 153 pp.
 The granddaughter of famed South Carolinian John C.
 Calhoun, **Floride Clemson** (Lee) (1842-71) supported the Con-
 federacy during the Civil War but nonetheless cherished her ties
 with friends and relatives in the North. Between 1863 and 1866,
 the time she kept this diary, Floride lived with her mother, at
 first in Bladensburg and then in Beltsville, Maryland, made an
 extended visit to family members in Pennsylvania, and finally
 went to her grandmother Calhoun's home in Pendleton, South
 Carolina. Floride repeatedly expressed concern over the course
 of the war and especially the fate of her brother, a Confederate
 officer taken prisoner by Union forces. She wrote sympatheti-
 cally of the hardships and anxieties of white southerners in the
 aftermath of the conflict and chronicled in excruciating detail
 her grandmother's final illness. Floride's diary is of interest
 also for its account of her emergence into young womanhood.
 Plagued by chronic illness, she was not deterred from leading an
 active social life and was flattered by receiving the attentions
 of young men. Religion played an increasingly important part in
 Floride's life during this period, and she noted with pride her
 baptism and confirmation in the Episcopal church. See also
 1863.2.

12 South after Gettysburg: Letters of Cornelia Hancock 1863-
 1868. Edited by Henrietta Stratton Jaquette. New York:
 Thomas Y. Crowell Co., 1956, 288 pp.
 Serving the powerless members of society was the work to
 which **Cornelia Hancock** (1840-1926), a young single Quaker woman
 from New Jersey, dedicated her life. Between 1863 and 1868, the
 period from which this correspondence dates, Hancock pursued her
 career in two separate arenas, first as a volunteer nurse for the
 Union army in Virginia during the Civil War and then as a teacher
 of freed slaves in South Carolina. Her unbounded sympathy for
 the ordinary soldiers she cared for is evident in her unsenti-
 mental letters to her family, letters that discuss the realities
 of wartime politics with unflinching honesty, while making clear
 her own strong anti-Secessionist bias. Hancock's commitment to
 the education of blacks in the postwar South was equally

unswerving. The progress and enthusiasm of the students in her
Mount Pleasant, South Carolina, school were highlighted in many
letters to her family and to the Philadelphia Quaker association
which funded her work. Outspoken in her criticism of Reconstruc-
tion officials, Hancock made recommendations that were meant to
benefit the poor blacks of the South. Though primarily concerned
with Hancock's work, this correspondence also sheds light on the
nature of her personal relationships. An earlier edition of this
book contains only Hancock's wartime letters. See Henrietta
Stratton Jaquette, ed., South after Gettysburg: Letters of
Cornelia Hancock from the Army of the Potomac, 1863-1865
(Philadelphia: University of Pennsylvania Press, 1937).

13 "To Pike's Peak by Ox-Wagon: The Harriet A. Smith Day-Book."
 Edited by Fleming Fraker, Jr. Annals of Iowa, 3d ser. 35
 (1959):112-48.
 In the summer of 1863, **Harriet Amelia Smith** (1841?-1923), a
 young single woman, traveled from Iowa to the newly settled
 territory of Colorado with her uncle and his family, who were
 moving to their new homestead in Boulder County. As the only
 woman in the party besides her aunt, Harriet performed a large
 share of the essential domestic tasks on the trail. Her day-book
 (or diary) contains a detailed record of these labors as well as
 routine observations of people and places. Harriet Smith's diary
 holds greatest interest for its dispassionate account of
 encounters with Indians in western Nebraska. Harriet subse-
 quently returned home to Iowa.

14 "The Vicksburg Diary of Mrs. Alfred Ingraham (May 2-June 13,
 1863). Edited by W. Maury Darst. Journal of Mississippi
 History 44 (1982):148-79.
 Born in Philadelphia and the sister of a general in the
 Union army, **Elizabeth Mary Meade Ingraham** (1806-?) was a long-
 time resident of Mississippi and a staunch supporter of the
 Confederate cause. In the spring of 1863, when Union troops
 were besieging Vicksburg, Ingraham recorded her feelings and
 those of her husband at the wanton destruction of their prop-
 erty by Yankee soldiers. Her diary is of particular interest
 for its candid comments on the behavior of her slaves after they
 had learned of their freedom.

1864

1 "The Correspondence of David Olando McRaven and Amanda Nantz
 McRaven, 1864-1865." Edited by Louis A. Brown. North
 Carolina Historical Review 26 (1949):41-98.
 Though largely taken up with matters pertaining to the
 operation of the family's small plantation in Mecklenburg County,
 North Carolina, the letters **Amanda Nantz McRaven** (1820-87) wrote
 her husband between September 1864 and April 1865 offer

considerable evidence of this middle-aged woman's loving
relationship with her spouse. Amanda did not conceal her
feelings of disappointment that her husband could not leave his
post as a guard at the Salisbury (North Carolina) Confederate
Military Prison to be with her when she gave birth to a baby nor
did she disguise her longing for him during subsequent months.
She sought his advice on farming and hiring slaves and made sure
to keep him supplied with provisions. She also sent news of
their children and of kin and neighbors.

2 "The Diary of Anna Hasell Thomas (July 1864-May 1865)."
 Edited by Charles E. Thomas. South Carolina Historical
 Magazine 74 (1973):128-43.
 On account of her sister's poor health, South Carolina-born
 Anna Hasell Thomas (1828-1908), a single woman, received permis-
 sion to travel with her mother and sister from New York to her
 native state in the final year of the Civil War. Her diary for
 the period following the death of her sister, December 1864 to
 May 1865, chronicles a lengthy visit to an aunt living near
 Ridgeway, South Carolina, during which she witnessed the ransack-
 ing of the plantation by Union soldiers.

3 "Fanny Cohen's Journal of Sherman's Occupation of Savannah."
 Edited by Spencer B. King, Jr. Georgia Historical Quarterly
 41 (1957):407-16.
 When the Union army entered Savannah, Georgia, toward the
 end of the Civil War, **Fanny Yates Cohen** (Taylor) (1840-1938), a
 young single woman from a well-to-do family, commenced a journal.
 This brief record of her life during the occupation of Savannah,
 dating from December 21, 1864, to January 3, 1865, reveals
 Fanny's sadness at the turn of events as well as her unrestrained
 antipathy for Yankees.

4 "A Georgia Woman's Civil War Diary: The Journal of Minerva
 Leah Rowles McClatchey, 1864-1865." Edited by T. Conn Bryan.
 Georgia Historical Quarterly 51 (1967):197-216.
 The horrors of the Civil War were literally brought home to
 Minerva Leah Rowles McClatchey (1820-80) soon after her husband
 fled from their plantation near Marietta, Georgia, with the
 family's slaves. Between January 1864 and September 1865, the
 period when McClatchey kept this journal, her home was overrun by
 Union troops and she and a disabled son were forced to endure
 fighting, ransacking of their property, food shortages, and
 harassment from Union soldiers. McClatchey's suffering was com-
 pounded when she learned of the death of her eldest son who was
 serving in the Confederate army. Throughout her ordeal,
 McClatchey drew strength from her religious faith.

1864

5 The Journal of Anna Wylly Habersham. Darien, Ga.: Ashantilly
 Press, 1961, 23 pp.
 The journal fifteen-year-old **Anna Wylly Habersham** (Jones)
 (1849-?) kept between August and October 1864 while her family
 summered at their home near Savannah, Georgia, centers on her
 romantic involvement with a midshipman in the Confederate navy.
 The most striking passage in Anna's journal, however, is her
 lengthy remembrance of good times spent with her two brothers,
 whom she had just learned had been killed in the Civil War. See
 1863.3 for the diary of Josephine Clay Habersham, the mother of
 Anna Wylly Habersham.

6 "Letters from an Illinois Farm 1864-1865," by Louisa Jane
 Phifer. Introduction and notes by Carol Benson Pye. Journal
 of the Illinois State Historical Society 66 (1973):387-403.
 When her forty-one-year-old husband was drafted into the
 Union army during the final stages of the Civil War, **Louisa Jane
 Heisler Phifer** (1825-1904), the mother of seven children, was
 left to run the family farm near Vandalia, Illinois. In these
 nine letters written to her husband between December 1864 and
 August 1865, Louisa repeatedly voiced her concern for his health
 and safety and urged him to find a means to return home. In
 addition, she and the children reported their progress in farming
 and related news of family members and neighbors.

7 "Maggie!" Maggie Lindsley's Journal, Nashville, Tennessee,
 1864, Washington, D.C., 1865, Including Letters Written to Her
 in 1862 from Professor Benjamin Silliman of Yale College.
 Southbury, Conn.: Privately printed, 1977, 129 pp.
 The journal **Margaret Lawrence Lindsley** (Ramsey) (1840-
 1922), a young single woman, kept between October 1864 and May
 1865 mixed comments on family affairs, social life, and litera-
 ture with discussions of politics and the events of the Civil
 War. Her family's strong support of the Union made them
 extremely unpopular in their Nashville, Tennessee, home, a
 situation that was alleviated to some extent by the Federal occu-
 pation of the city. A portion of Lindsley's journal chronicles
 a lengthy trip to Washington, D.C., and includes an account of
 her activities there and a description of President Lincoln's
 second inauguration.

8 The Montana Gold Rush Diary of Kate Dunlap. Edited and anno-
 tated by S. Lyman Tyler. Denver: Fred A. Rosenstock Old West
 Publishing Co.; Salt Lake City: University of Utah Press,
 1969, [73] pp.
 In 1864, shortly after her marriage, **Catherine (Kate)
 Cruickshank Dunlap** (1837-1901) and her husband set off from
 Keokuk, Iowa, for the mining country of Montana Territory.
 Kate's diary of the trip, which she transcribed for her friends

at home, furnishes an informative account of her experiences camping out on the plains and in the mountains, notes the prevailing concern about attacks from Indians, and paints romantic descriptions of the scenery. Though Kate's outlook on the migration west was generally positive, her repeated melancholy references to the gravestones of migrants along the route suggest that she recognized the dark side of the adventure.

9 Postmarked Hudson: The Letters of Sarah A. [sic, E.] Andrews
 to Her Brother, James A. Andrews, 1864-65. With a Genealogy
 of the Andrews Family. Edited by Willis Harry Miller.
 Hudson, Wisc.: Star-Observer Publishing Co., 1955, 76 pp.
 Motherly advice permeates the over fifty letters Sarah E.
Andrews (1835-98) of Hudson, Wisconsin, wrote to her younger
brother, Jimmie, while he was serving in the Union army between
1864 and 1866. Sarah, a single woman, devoted her life to her
family, and this correspondence reveals just how important her
brother's physical and spiritual welfare was to her. She filled
her letters to him with suggestions on how to assure his comfort
and health and counseled him to avoid danger and moral tempta-
tion. The letters also include news of the family and the
Baptist church as well as notes on her participation in social
gatherings and the town literary club. Sarah's pro-Union senti-
ments are evident from her reactions to events of the Civil War
and Lincoln's assassination.

10 The War-Time Journal of a Georgia Girl 1864-1865, by Eliza
 Frances Andrews. New York: D. Appleton & Co., 1908,
 387 pp.
 The journal kept by Eliza Frances Andrews (1840-1931)
between December 1864 and August 1865, though carefully edited
by the author in later life, preserves the partisan sentiments
of a bright young southern woman as she faced the defeat of the
Confederacy and the imposition of rule by the Yankees she
detested. Though written in the wake of Sherman's march to the
sea and the chaos of the final weeks of the war, much of the
journal is taken up with Andrews's notes on her social life,
first during a visit to her sister in Albany, Georgia, and then
at home in Washington, Georgia. The issues raised by the ter-
mination of the war and the commencement of Reconstruction
elicited spirited comments from Andrews. Her difference of opin-
ion with her father over loyalty to the Union, her derogatory
assessment of freed blacks, and her candid reaction to her ini-
tiation into housework are of particular interest.

1864

11 When the World Ended: The Diary of Emma LeConte. Edited by
 Earl Schenck Miers. New York: Oxford University Press, 1957,
 124 pp.
 The intensity of her commitment to the Confederate cause
 made the final months of the Civil War especially difficult for
 Emma Florence LeConte (Furman) (1847-?), a seventeen-year-old
 girl of Columbia, South Carolina. LeConte's diary of the period
 from December 1864 to August 1865 constitutes a sensitive
 barometer of her emotional state as the Union army burned and
 pillaged her town and the Confederacy went down to defeat. Fre-
 quently overwhelmed by sadness, she expressed her disbelief at
 the course of events, made clear her detestation of the Yankees,
 and penned several evocative descriptions of Columbia in ruins.
 As the daughter of a college professor, LeConte placed a high
 value on her own education and registered her consternation that
 the excitement of the war's waning days prevented her from pur-
 suing her studies. See also 1918.1.

12 "The Yankees in New Albany: Letter of Elizabeth Jane Beach,
 July 29, 1864." Edited by Mrs. W.F. Smith. Journal of
 Mississippi History 2 (1940):42-48.
 On two separate occasions during the summer of 1864, Union
 soldiers searched and ransacked the house of **Elizabeth Jane
 Renfroe Beach** (1833-70), a young wife and mother of New Albany,
 Mississippi, and made off with food, clothing, and household
 goods. In this letter to her parents in Georgia, Mrs. Beach
 re-created these painful scenes in minute detail and recalled her
 dismay when the Yankees discovered the family's secret hiding
 place.

 1865

1 The Diary of Clarissa Adger Bowen, Ashtabula Plantation, 1865,
 with Excerpts from Other Family Diaries and Comments by Her
 Granddaughter, Clarissa Walton Taylor, and Many Other Accounts
 of the Pendleton Clemson Area, South Carolina 1776-1889. Com-
 piled by Mary Stevenson. Pendleton, S.C.: Foundation for
 Historic Restoration in Pendleton Area, 1973, 128 pp.
 The distress and anxieties of white southerners during the
 months following the Civil War were compounded for **Clarissa
 Walton Adger Bowen** (1837-1915) by the loss of a baby in child-
 birth. Clarissa, a young wife and mother residing on a planta-
 tion near Pendleton, South Carolina, used her diary to bear
 witness to her personal sufferings as well as those of her com-
 munity. Her record of the period between May and November 1865
 captures the mood of Confederate sympathizers faced with the
 imposition of Yankee rule, the emancipation of their slaves, and
 the economic uncertainties of the future. Clarissa's religious

faith was a source of strength as she sought comfort in this
troubled time.

2 "Freedmen's Farm Letters of Samuel and Louisa Mallory to 'our
 absent but ever remembered boy' in McHenry County, Illinois."
 [Edited by] Carol N. Wenzel. <u>Journal of the Illinois State
 Historical Society</u> 73 (1980):162-76.
 When her husband, a captain in the Union army, became the
 superintendent of the Freedmen's Home Farm in Pine Bluff,
 Arkansas, during the Civil War, **Louisa Andrus Mallory** (?-1867)
 and her two young daughters joined him there, leaving her son
 Leroy behind with his grandparents in Nunda, Illinois. Seven of
 Mrs. Mallory's letters to her ten-year-old son in 1865 are
 printed here. Written in simple language, they chronicle the
 activities of Leroy's father and sisters and tell of the freed
 slaves, teachers, and army personnel on the farm. Mrs. Mallory
 evinced great interest in her son's schooling and counseled him
 to abide by moral and religious precepts.

3 <u>From a New England Woman's Diary in Dixie in 1865</u>, by Mary
 Ames. Springfield, Mass.: Plimpton Press, 1906. Reprint.
 New York: Negro Universities Press, 1969, 125 pp.
 Mary Ames (1831-1903) of Springfield, Massachusetts,
 traveled to Edisto Island, South Carolina, under the auspices of
 the Freedman's Bureau to serve as a teacher of recently emanci-
 pated slaves. She kept this diary during her stay in South
 Carolina from May 1865 to September 1866, although the latter
 part of the diary appears to have been composed retrospectively.
 The entries furnish a lively account of the experiences of Ames
 and her friend Emily Bliss as teachers, documenting the problems
 they coped with, such as primitive living conditions, oppressive
 heat, and illness. But it is Ames's acute insights into the
 attitudes of the freedmen that distinguish her diary. Sensitive
 to the profound impact of slavery on these people, Ames under-
 stood why they prized their freedom so highly. Despite the
 patronizing tone of her writing, Ames makes clear that she
 sympathized with the ex-slaves as they struggled to realize their
 freedom in concrete ways. Her praise for their vigorous efforts
 to improve their condition coupled with her understanding por-
 trayal of their behavior toward their former masters leaves no
 doubt that she was their advocate.

4 <u>The Letters of Mrs. Henry Adams 1865-1883</u>. Edited by Ward
 Thoron. Boston: Little, Brown, & Co., 1936, 587 pp.
 Whenever **Marian (Clover) Hooper Adams** (1843-85) left Boston
 for any extended period of time, she regaled her father with
 elaborate accounts of her interesting life with her husband,
 historian Henry Adams. This book consists of letters Marian
 penned during trips to Europe in 1872-73 and 1879 and from her

Washington, D.C., home between 1880 and 1883 along with an 1865
letter describing the review of Grant's and Sherman's armies at
the end of the Civil War. Her critical observations on European
society and art make Marian's early letters noteworthy, but her
letters from Washington are outstanding. Marian's familiarity
with the Washington scene enabled her not only to comment
astutely on current political issues but to satirize the foibles
of the denizens of the capital city. As a purveyor of gossip,
Marian was unequaled and her pen portraits of the politicians,
diplomats, literary figures, and historians whom she entertained
in her Washington home are sharp-edged and witty. The corre-
spondence suggests that Marian had a very satisfactory marital
relationship and leaves one unprepared for the fact that she took
her own life in 1885, shortly after her father's death.

5 Love Lies Bleeding. Compiled by Helen Smith Jordan. N.p.:
 Privately printed, 1979, 502 pp.
 Mary Abigail Chaffee Abell (1846-75) labored devotedly for
 her husband and five children in the face of grinding poverty and
 failing health until she died at the age of twenty-nine. Her
 letters, dating almost exclusively from the years 1865 to 1875,
 present a poignant picture of this loving family's struggle for
 existence on the farm near Manhattan, Kansas, to which they moved
 after living in New York and Illinois. In addition to performing
 arduous housekeeping chores and caring for her children, Mary
 supplemented her husband's income as a Free Methodist minister
 and schoolteacher by giving music lessons and sewing for
 neighbors. Her persistent medical problems are detailed in these
 letters, which also contain a good deal of information on her
 experiences of pregnancy and childbirth.

6 "The Personal Journal and Arizona Letters of Margaret Hunt
 McCormick." Edited by Norm Tessman. Journal of Arizona
 History 26 (1985):41-52.
 Margaret Griffiths Hunt McCormick (1843-67) traveled from
 her home in New Jersey to Prescott, Arizona Territory, with her
 new husband, the secretary of Arizona Territory, in the fall of
 1865. Her journal, containing brief notes on her trip, high-
 lights the hospitality the couple received en route. In two
 letters written to her brother in 1866 after her husband had
 become governor of Arizona Territory, McCormick related how she
 had entertained a large number of guests and expressed her fear
 of Indians in the area.

7 "Reconstruction in Orange County, Virginia: A Letter from
 Hannah Garlick Rawlings to Her Sister, Clarissa Lawrence
 Rawlings, August 9, 1865." Edited by Andrew Buni. Virginia
 Magazine of History and Biography 75 (1967):459-65.

Writing to her sister in Pennsylvania in August 1865, Virginian **Hannah Garlick Rawlings** (1837-1901) poured out her bitter feelings at the outcome of the Civil War. Still certain of the justness of the southern cause, she asserted her pride in the soldiers of the Confederacy, cataloged the sufferings of local families, and articulated her undying hatred for Yankees. Curious about hints of her sister's engagement, Rawlings admitted that it was likely she herself would remain single.

8 "Sherman's Occupation of Savannah: Two Letters." <u>Georgia Historical Quarterly</u> 50 (1966):109-15.
 Maria Monroe Barney Postell (1821-?) of Savannah, Georgia, was a diehard supporter of the Confederate cause. In the first of these letters from 1865, she related how she appealed the decision of Union army officers ordering her out of the lines for writing letters enunciating her prosouthern sentiments. In the second letter, she expressed her anguish at her son's death in the war and informed her husband that she wished to leave the country rather than continue to live in the South.

9 <u>Two Diaries from Middle St. John's, Berkeley, South Carolina, February-May 1865: Journals Kept by Miss Susan R. Jervey and Miss Charlotte St. J. Ravenel, at Northampton and Pooshee Plantations, and Reminiscences of Mrs. (Waring) Henagan. With Two Contemporary Reports from Federal Officials</u>. [Pinopolis, S.C.]: St. John's Hunting Club, 1921, 56 pp.
 These brief journals of **Susan R. Jervey** and **Charlotte St. J. Ravenel** give an account of the events of the final months of the Civil War in Middle St. John's, Berkeley, South Carolina, from the perspective of women of upper-class families. The depredations of the invading Yankees were at the forefront of the minds of these young women as they continually expressed their fears of the enemy soldiers, particularly those whom they called the "black Yankees." The diarists also revealed their anxiety about the rebellious behavior of the slaves belonging to the planters of their neighborhood.

<u>1866</u>

1 "An Army Wife on the Upper Missouri: The Diary of Sarah E. Canfield, 1866-1868." Edited by Ray H. Mattison. <u>North Dakota History</u> 20 (1953):191-220.
 Sarah Elizabeth Haas Canfield (1840-1932) began this diary on her wedding day in April 1866 and continued it intermittently until June 1868. During much of this time, she lived with her officer husband at army posts on the northern plains. Her detailed and relatively objective portrayal of life in the Indian village near Fort Berthold, Dakota Territory, is of more than

ordinary interest as is her account of a massive Indian attack on Camp Cooke, Montana Territory.

2 A Bride on the Bozeman Trail: The Letters and Diary of Ellen Gordon Fletcher 1866. Edited by Francis D. Haines, Jr. Medford, Oreg.: Gandee Printing Center, 1970, 139 pp.

Directly following her marriage in 1866, **Ellen Gordon Fletcher** (1841-?) set out from Cuba, New York, with her husband, William Asbury Fletcher, a widower with one daughter, and a small party of relatives and friends for the gold fields of Montana. In letters to her family and in her diary, she recorded the high-lights of the trip from Bellevue, Nebraska, to Montana and related her experiences during the first few months of her stay in Summit City, the mining community where her husband had previously established himself. Ellen's account of the journey, filled with her favorable impressions of scenery and fellow migrants, reflects the positive attitude of a happy young bride, even though she did express misgivings over the failure to observe the Sabbath on the trail. Her descriptions of the Indians encountered along the way are noteworthy for their objective tone. In keeping with her optimistic outlook, Ellen glossed over the primitive aspects of life in the small mining community of Summit City, making clear that she enjoyed her exalted status as one of the few ladies in a society of men.

3 Cavalry Wife: The Diary of Eveline M. Alexander, 1866-1867, Being a Record of Her Journey from New York to Fort Smith to Join Her Cavalry-Officer Husband, Andrew J. Alexander, and Her Experiences with Him on Active Duty among the Indian Nations and in Texas, New Mexico and Colorado. Edited, with an intro-duction by Sandra L. Myres. College Station and London: Texas A&M University Press, 1977, 175 pp.

The prospect of being stationed in the American West stirred the imagination of **Eveline Throop Martin Alexander** (1843-1922), the New York-born wife of a cavalry officer in the United States Army. Alexander's diary record of her trip across the plains and her sojourns at army posts in New Mexico and Colorado during 1866-67 conveys not only her warm affection for her hus-band but the enthusiasm with which she approached new expe-riences. Alexander wrote with equal facility of scenery, camp life, buffalo herds, Indians, and her encounters with Gen. William T. Sherman and Kit Carson. Her derogatory comments on the Negro regiments with which she traveled are revealing of con-temporary attitudes. Extracts from letters Alexander wrote from Fort McDowell, Arizona Territory, in 1868-69 are printed in Sandra L. Myres, "Evy Alexander: The Colonel's Lady at McDowell," Montana: The Magazine of Western History 24 (1974): 26-38.

4 "An 1866 Letter on the War and Reconstruction." Edited by
 James T. Bratcher. <u>Tennessee Historical Quarterly</u> 22 (1963):
 83-86.
 This barely literate letter, probably dictated by **Nancy
 Lawley Cox** (1793-?), an elderly widow of Readyville, Tennessee,
 provided her two children in Kansas with an account of her fate
 during and after the Civil War. In it, Cox commented on her
 health, the death of her husband, wartime casualties, and
 problems relating to the family property, and she specified
 exactly what the Yankees had taken from her.

5 <u>Green Mount after the War: The Correspondence of Maria
 Louisa Wacker Fleet and Her Family 1865-1900</u>. Edited by Betsy
 Fleet. Charlottesville: University Press of Virginia, 1978,
 287 pp.
 Against the backdrop of hard times in Virginia following
 the Civil War, **Maria Louisa Wacker Fleet** (1822-1900), a widow
 who lived at Green Mount in King and Queen County, courageously
 shouldered the burden of supporting her six children. Fleet's
 letters from 1866 to 1899, which form the centerpiece of this
 volume of family correspondence, make plain her determination
 to give her sons and daughters an education and to instill in
 them the moral and religious values that formed the basis of
 character. Fleet always coupled her advice to her children with
 praise for their efforts, expressions of affection, and asser-
 tions of her faith that God would take care of them. To combat
 the financial problems that plagued the family, Fleet opened a
 boarding school for girls in her home. Her correspondence
 chronicles the success of this enterprise as well as her con-
 tinuing efforts to pay off her debts. This book also contains
 letters written by Fleet's daughters--**Maria Louisa Fleet**
 (1849-1917), **Florence Fleet** (1852-1903), and **Betsy Pollard Fleet**
 (1854-1904)--all of whom remained single and pursued careers as
 teachers.

6 "Mrs. General Custer at Fort Riley, 1866." Edited by Minnie
 Dubbs Millbrook. <u>Kansas Historical Quarterly</u> 40 (1974):63-71.
 In 1866, **Elizabeth Bacon Custer** (1842-1933) moved to Fort
 Riley, Kansas, with her husband, Gen. George Armstrong Custer.
 In this letter to her cousin, Rebecca Richmond, Mrs. Custer
 expressed her delight at her new home and described the main
 features of the military post. See 1868.5 for the diary of
 Rebecca Richmond.

7 <u>The Saga of "Auntie" Stone and Her Cabin: Elizabeth Hickok
 Robbins Stone (1801-1895) . . . With the Overland Diary of
 Elizabeth Parke Keays</u>, by Nolie Mumey. Centenary ed.
 Boulder, Colo.: Johnson Publishing Co., 1964, 128 pp.

In the spring of 1866, **Elizabeth L. Parke Keays** (Stratton) (1830-1922), a widow, traveled with her young son to Fort Collins, Colorado, to live with her aunt, Elizabeth Stone. Her diary of the journey from Bloomington, Illinois, across the plains by covered wagon contains her observations on scenery, fellow travelers, and opportunities for settlement. After her arrival, she noted her satisfaction with her new home. Portions of this diary were published in "Across the Plains in a Prairie Schooner: From the Diary of Elizabeth Keyes," <u>Colorado Magazine</u> 10 (1933):71-78.

<u>1867</u>

1 "Dear Sister": Letters Written on Hilton Head Island 1867. Edited by Josephine W. Martin. Beaufort, S.C.: Beaufort Book Co., 1977, 133 pp.
 For six months in 1867, **Eliza Ann Summers** (Hitchcock) (1844-1900) of Woodbury, Connecticut, taught freed Negroes at the Lawton plantation on Hilton Head Island, South Carolina, under the sponsorship of the American Missionary Association. The letters she penned to her sister during this time focus on every-day life, inside and out of the classroom. Summers described the progress of her pupils, the hardships they faced, and her own social activities with white northerners in the vicinity.

2 "A Lady Novelist Views the Reconstruction: An Augusta Jane Evans Letter." Edited by Ben W. Griffith, Jr. <u>Georgia Historical Quarterly</u> 43 (1959):103-9.
 Augusta Jane Evans (Wilson) (1835-1909), one of the most popular novelists of the nineteenth century, wrote Gen. P.G.T. Beauregard from Mobile, Alabama, in 1867 to express her vehement opposition to the Reconstruction program of the Radical Republicans. In a letter filled with biblical, historical, and mythological references, Evans excoriated the northern politicians who had victimized the South and predicted their eventual downfall.

3 "A Letter from Mother to Daughter--Los Angeles to New York, 1867," by Rosa Newmark. <u>Western States Jewish Historical Quarterly</u> 5 (1973):274-84.
 The wedding of her youngest daughter was the subject of this joyful letter written by **Rosa Levy Newmark** (1808-75) of Los Angeles on November 21, 1867, to another daughter living in New York City. In it, Mrs. Newmark, a member of a prominent Jewish family of Los Angeles, recounted the day's celebration and de-scribed in detail the attire of the bride and female relatives, and the furnishings of the couple's new home. The letter also included the names of the bridesmaids, groomsmen, and guests as well as a list of the wedding presents.

4 Life in Custer's Cavalry: Diaries and Letters of Albert and
 Jennie Barnitz, 1867-1868. Edited by Robert M. Utley. New
 Haven and London: Yale University Press, 1977, 302 pp.
 The life of an army officer's wife appealed to **Jennie Platt
 Barnitz** (1841?-1927) who, as a new bride, accompanied her hus-
 band, Albert, a captain in the United States Cavalry, to Kansas.
 The excerpts from Jennie's journal and letters included in this
 volume, dating from 1867 to 1869--the period of Albert's service
 on the Indian frontier--convey Jennie's delight with the
 luxurious life-style at Fort Leavenworth and other military posts
 and record her impressions of officers, ladies, and enlisted
 men. Jennie was devoted to her husband and reluctant to be
 separated from him when he was away fighting Indians. Her
 account of her onerous journey from her family home in East
 Cleveland, Ohio, to Kansas to be with him after he was seriously
 wounded offers poignant testimony of the depth of her feelings.

5 "A Literate Woman in the Mines: The Diary of Rachel Haskell."
 Edited by Richard G. Lillard. Mississippi Valley Historical
 Review 31 (1944-45):81-98.
 The rewards as well as the petty annoyances of domestic
 life in a silver mining town are made clear in the diary kept by
 Rachel Mitchell Clark Haskell (1829-1900) of Aurora, Nevada, in
 March and April 1867. The diary documents both her routine
 labors and the amusements that filled the gaps in her day.
 Music, playing games with the children, conversation with
 visitors, and especially reading broke the monotony of hours
 spent cooking, cleaning, sewing, washing, and ironing. Haskell
 duly noted the titles of all the books and magazines that she
 read. Though fond of her husband and appreciative of his assis-
 tance in the household work, Haskell repeatedly expressed her
 displeasure at his frequent trips to town in the evening to spend
 time with his male friends.

6 "A Trip to Florida, 1867: Three Letters of Mary R. Birchard."
 Edited by Watt. P. Marchman. Florida Historical Quarterly 32
 (1954):142-52.
 Shortly after the Civil War, invalids from the northern
 states began flocking to Florida for its beneficent climate.
 Mary Roxana Birchard (1827-76), a single woman from Vermont who
 traveled there in 1867 as the companion of a health seeker
 extolled Florida's natural beauty in her letters to family
 members but was highly critical of the people and their social
 habits. Birchard's antipathy toward southerners, heightened
 as a result of her brother's death in the war, was expressed
 most forcefully in her argument that the lack of northern
 industriousness accounted for Florida's failure to develop its
 resources.

<u>1868</u>

1 "The Journal of Ada A. Vogdes, 1868-71." Edited by Donald K.
 Adams. <u>Montana, The Magazine of Western History</u> 13 (1963):
 2-17.
 Alternately fascinated and repelled by the Indians she
 encountered at Fort Laramie and Fort Fetterman, **Ada Adams Vogdes**
 (?-1919?) filled the journal she kept between 1868 and 1871 with
 lengthy descriptions of the appearance and customs of the Sioux
 and Cheyenne. As the new bride of an army lieutenant, Ada had
 been transplanted from New York to a series of frontier military
 posts. Her record of garrison life, in addition to revealing her
 attitude toward the Indians, offers a glimpse of the social
 activities of officers' families on an army post.

2 "The Journal of Sallie D. Smith." Edited by Mrs. Dana O.
 Jensen. <u>Bulletin of the Missouri Historical Society</u> 20
 (1964):124-45.
 In 1868, **Sallie Diana Smith** (Kingsbury) (1849?-71), a
 single woman of about nineteen, embarked from her home in
 Missouri on an extended visit to her numerous relatives in
 Kentucky. The account of the trip preserved in her journal re-
 veals Sallie to have been an observant traveler. Vivid descrip-
 tions of shipboard accommodations, sights in St. Louis and
 Louisville, the Mammoth Cave, a fair, a political celebration,
 and a series of religious meetings highlight the record of
 Sallie's stay among her kinfolk. Appended to Sallie's journal
 is a letter written by her sister, **Alice Smith**, in 1871 describ-
 ing Sallie's agonizing death in childbirth.

3 <u>Letters of a New England Coaster 1868-1872</u>, by Ralph H.
 Griffin, Jr. N.p.: Privately printed, 1968, 284 pp.
 The letters **Abbie Avery Griffin** (1843?-1918?) of Stockton,
 Maine, wrote to her sea-captain husband, Joseph, between 1868 and
 1872 form a major part of this collection of family correspon-
 dence. Undistinguished in terms of literary merit, Abbie's com-
 munications are of interest for their un-self-conscious recital
 of the everyday pleasures and burdens of a young wife and mother
 and for their openness in referring to sexual needs and preg-
 nancy. Abbie's lonesomeness and her consternation at her
 husband's prolonged absences made her wish to sail with him.
 During the one voyage on which she did accompany Joseph, however,
 he was falsely arrested and placed in prison in Cuba, where she
 wrote him letters expressing her anxiety and anger over his
 plight. This volume also contains a number of letters by other
 female family members.

4 "The Letters of Emma Lazarus 1868-1885 to R.W. Emerson, T.W.
 Higginson, E.C. Stedman, Dr. Gustav Gottheil, Philip Cowen,
 and Others." Edited by Morris U. Schappes. Bulletin of the
 New York Public Library 53 (1949):315-34, 367-86, 419-46.
 Celebrated today as the author of the sonnet inscribed on
 the Statue of Liberty, **Emma Lazarus** (1849-87) was known to her
 contemporaries as a poet, translator, and advocate of Jewish
 causes. A single woman, raised in an affluent New York Jewish
 family, Lazarus corresponded with prominent literary and
 religious figures including Ralph Waldo Emerson, Rabbi Gustav
 Gottheil, and editor Philip Cowen. These seventy-six letters,
 spanning the years 1868-85, touch on a number of matters of
 deep concern to Lazarus--the publication and critical reception
 of her poems and other writings, the merits of American litera-
 ture, the differing perspectives of Reform and Orthodox Jews,
 and charitable efforts in behalf of Russian Jewish refugees.
 These letters were also published in book form: Morris U.
 Schappes, ed., The Letters of Emma Lazarus 1868-1885 (New York:
 New York Public Library, 1949).

5 "Rebecca Visits Kansas and the Custers: The Diary of Rebecca
 Richmond." Edited by Minnie Dubbs Millbrook. Kansas
 Historical Quarterly 42 (1976):366-402.
 Rebecca Richmond (1840-1925) of Grand Rapids, Michigan,
 enjoyed a busy social life when she visited relatives in Fort
 Leavenworth, Wamego, and Topeka, Kansas, in 1868 and again in
 1870. Her diary leaves no doubt that her stays with her cousin
 Elizabeth Custer, the wife of Gen. George Armstrong Custer, at
 Fort Leavenworth gave her the greatest pleasure. There she
 participated in a continual round of visiting, churchgoing, din-
 ners, parties, and dances and indulged her fondness for singing
 and playing euchre. She clearly relished the attention bestowed
 on her by the young army officers at the military post. See
 1866.6 for a letter of Elizabeth Custer to Rebecca Richmond.

1869

1 Julia Newberry's Diary. With an introduction by Margaret Ayer
 Barnes and Janet Ayer Fairbank. New York: W.W. Norton & Co.,
 1933, 176 pp.
 Between 1869 and 1871, as she kept this diary, **Julia Rosa
 Newberry** (1853-76) edged toward maturity, growing in self-
 awareness and becoming skilled in analyzing the behavior of
 others. A member of a prominent Chicago family, she lived in
 luxury and moved in a select social circle, indulging her tastes
 for reading, music, drawing and painting, and participating in
 the customary round of visiting and entertaining. Like other
 girls in their mid-teens, Julia evinced a lively interest in boys
 and mused endlessly on the attributes of her male companions.

One of the prerogatives of great wealth in the late nineteenth century was the opportunity it afforded for extended travel, yet Julia entertained mixed feelings about her frequent sojourns away from home. She dutifully accompanied her widowed mother and older sister on their peregrinations to New York, Florida, and Europe, savoring many of her experiences, but nonetheless cherishing her time in Chicago and looking forward to returning there. Her horror upon learning of the city's destruction by fire in 1871 and the loss of all the family treasures was expressed in an emotional reminiscence of her father and the house he had built.

2 Letters of Mrs. James G. Blaine. Edited by Harriet S. Blaine Beale. 2 vols. New York: Duffield & Co., 1908, 1:319 pp.; 2:326 pp.
 These letters of **Harriet Bailey Stanwood Blaine** (1828-1903) from the years 1869 to 1889 constitute a valuable source for documenting the existence of a privileged middle-aged woman in the post-Civil War era. Married to James G. Blaine, congressman from Maine, speaker of the House of Representatives, and secretary of state in the Garfield administration, Harriet Blaine relished her social life as the wife of a nationally prominent political figure. Nevertheless, she also derived a great deal of pleasure from her domestic role. The letters published here, most of which were written to her children from Augusta, Maine, Washington, D.C., and places in Europe, are filled with intimate details of family life and provide ample evidence for assessing the nature of Harriet Blaine's marital relationship, her duties and feelings as a mother, and her management of household affairs. This correspondence also illuminates Mrs. Blaine's perspective on public events of the period, such as the assassination of President Garfield and the trial of his attacker, Charles Guiteau.

3 Life and Letters of Laura Askew Haygood, by Oswald Eugene Brown and Anna Muse Brown. Nashville, Tenn. and Dallas, Texas: Publishing House of the M.E. Church, South, 1904, 522 pp.
 In 1884, at the age of thirty-nine, **Laura Askew Haygood** (1845-1900), a single woman, embarked on a distinguished career as a missionary educator in China for the Methodist Episcopal church, South. Most of the correspondence assembled in this volume comes from the period of her work in China, but a small group of letters dates from the years between 1869 and 1883 when she was a teacher in Atlanta. In these letters, she offered advice on life and education to a young boy who had been her pupil. The letters Haygood wrote during a trip home between 1894 and 1896 deal primarily with missionary affairs and her travels in the South.

4 Sarah Orne Jewett Letters. Enl. and rev. ed. With an intro-
 duction and notes by Richard Cary. Waterville, Maine: Colby
 College Press, 1967, 186 pp.
 Business and private communications are intermixed in this
 collection of 142 letters written by author **Sarah Orne Jewett**
 (1849-1909) between 1869 and 1908. Jewett's correspondence with
 editors and publishers touched on matters such as the placement
 of her stories in magazines and the content and style of her
 writing. In other letters, Jewett offered encouragement and
 practical suggestions to beginning authors, praised the
 accomplishments of fellow writers, and expressed gratitude for
 compliments on her own stories and novels. The sensitive and
 thoughtful letters Jewett wrote to friends and family members
 provide evidence of the importance she attached to her personal
 relationships. See also 1877.2; 1880.1; 1894.2.

1870

1 "Letters of the Rev. and Mrs. Olof Olsson, 1869-1873,
 Pioneer Founders of Lindsborg." Translated and edited by
 Emory Lindquist. Kansas Historical Quarterly 21 (1955):
 497-512.
 Anna Olsson (1842?-87), the wife of a minister of the
 Swedish Evangelical Lutheran church, had mixed feelings about
 her new home in Lindsborg, Kansas. In five letters written to a
 close friend in Sweden between 1870 and 1873, she expressed
 gratitude for the bountiful harvests and good living conditions
 in Kansas, yet at the same time she made clear her nostalgia for
 her former way of life in Sweden. A devout woman, Anna placed
 herself in God's hands, even when she suffered the loss of an
 infant son. Her letters also contain an interesting description
 of the weaning of her young daughter.

2 The Making of a Feminist: Early Journals and Letters of
 M. Carey Thomas. Edited by Marjorie Housepian Dobkin. With
 a foreword by Millicent Carey McIntosh. [Kent, Ohio]: Kent
 State University Press, 1979, 314 pp.
 Martha Carey Thomas (1857-1935) left her mark on women's
 higher education in America as the president of Bryn Mawr Col-
 lege. These excerpts from her journal and letters, all but a few
 dating from the years 1870 to 1883, document the origins of
 Thomas's zealous commitment to the ideal of equal education for
 women in her Quaker family upbringing and her drive to excel as a
 student, first at boarding school, then at Cornell and Johns
 Hopkins, and finally while working for her Ph.D. at universities
 in Germany and Switzerland. Thomas's writings also provide in-
 sights into her dominating personality, her close relationships
 with young women, and her views on men and marriage.

1870

3 "Roughing It on Her Kansas Claim: The Diary of Abbie Bright,
 1870-1871." Edited by Joseph W. Snell. Kansas Historical
 Quarterly 37 (1971):233-68, 394-428.
 Abbie Bright (Achenbach) (1848-1926), a young single
schoolteacher from Danville, Pennsylvania, long dreamed of making
a trip to the West. Her goal was realized between September 1870
and December 1871, when, after visiting relatives in Indiana and
Illinois, she traveled to Sedgwick County, Kansas, to homestead
with her brother. The pleasure Abbie took in the simple frontier
life as well as her willingness to forgo familiar comforts are
made clear in her diary. Her ongoing record of performing house-
hold tasks, nursing her brother during recurrent bouts of ill-
ness, and socializing with neighbors is enlivened by colorful
descriptions of a buffalo hunt and a prairie fire.

1871

1 Autobiography and Diary of Elizabeth Parsons Channing:
 Gleanings of a Thoughtful Life. Boston: American Unitarian
 Association, 1907, 304 pp.
 Prior to her death, **Elizabeth Parsons Channing** (1818-1906)
of Milton, Massachusetts, a member of a prominent Unitarian
family, edited her diaries for publication. These self-selected
excerpts, which span the years 1871-1903 but are relatively com-
plete only after 1891, trace the work and thought of a single
woman whose life was devoted to the cause of Unitarianism.
Channing, in addition to being a regular churchgoer, taught
Sunday school, lectured, wrote for religious publications, and
participated in several organizations of her church. Notes on
these activities are juxtaposed in the diary with philosophical
meditations and comments on her reading. As she aged, Channing
became increasingly disenchanted with the trends she observed in
modern society and manifested a critical attitude toward a number
of contemporary innovations. She expressed the belief that the
love of money was responsible for the decline of spirituality in
the modern world.

2 "The Diary of Luna E. Warner, a Kansas Teenager of the Early
 1870's." Edited by Venola Lewis Bivans. Kansas Historical
 Quarterly 35 (1969):276-311, 411-41.
 In 1871, fifteen-year-old **Luna E. Warner** (Lewis)
(1855-?) of Barre, Massachusetts, accompanied her parents,
brothers, and a large circle of kinfolk as they journeyed to
Kansas to establish a homestead along the Solomon River. The
brief entries in the diary Luna kept between 1871 and 1874
chronicle her activities and those of other family members as
they carved out a new way of life on their farm. Luna was im-
pressed with the novel features of the prairie landscape and
regularly recorded her observations of flowers and animals.

Although lacking an introspective dimension, this long diary
constitutes a valuable source for re-creating the everyday life
of an adolescent girl in rural Kansas in the post-Civil War era.

3 Grandmother's Letters: Being for the Most Part Selections
 from the Letters of Betsey Shipman Gates to Her Daughter
 Betsey Gates Mills. [Prepared by Mary Dawes Beach.] Chicago:
 Privately printed, 1926, 177 pp.
 Betsey Shipman Gates (1816-?), of Marietta, Ohio, embraced
 the role of grandmother with enthusiasm, actively involving her-
 self in the daily lives of her daughter Mary's seven children.
 These excerpts from letters she wrote to another daughter between
 1871 and 1892 are filled with affectionate descriptions of her
 grandchildren--their distinctive characteristics, accomplish-
 ments, and development over time--as well as praise for the
 patience and efficiency of their mother. Although Gates's life
 was clearly centered on her family, the correspondence also gives
 some sense of her as an individual. A woman of comfortable
 means, secure in the Presbyterian faith, Gates participated in
 community clubs, traveled, and admired poetry and sculpture.
 She also exhibited a strong interest in politics, no doubt en-
 hanced by her son-in-law's election to Congress. Seemingly con-
 tent just to enunciate her own preferences in candidates, she
 hinted occasionally that women had a role to play in governing
 the country.

4 "Mrs. Alcott of Concord to Mrs. Adams of Dubuque." [Edited
 by] Madeleine B. Stern. New England Quarterly 50 (1977):
 331-40.
 Customarily overshadowed by her philosopher-husband,
 Bronson Alcott, and her author-daughter, Louisa May Alcott,
 Abigail May Alcott (1800-77) assumes center stage in this
 compilation of letters she wrote to Mary Newbury Adams of
 Dubuque, Iowa, between 1871 and 1873. Mrs. Adams, a cultural
 leader of her community, entertained Bronson Alcott in Dubuque
 and later visited the Alcotts in Concord, Massachusetts. Abby
 May Alcott's friendship and correspondence with Mrs. Adams
 developed as a result of these encounters. In these letters,
 composed when she was in her seventies, Mrs. Alcott articulated
 her philosophical and religious beliefs and related her opinions
 on literature. She also presented a singular characterization of
 her husband and made critical comments on eastern society. The
 letters are of interest, as well, for their references to her
 daughters. See 1843.4 for the journals and letters of Louisa
 May Alcott.

1872

1 Letters of Louise Imogen Guiney. Edited by Grace Guiney.
 With a preface by Agnes Reppelier. 2 vols. New York and
 London: Harper & Brothers Publishers, 1926, 259 pp., 270 pp.
 Louise Imogen Guiney (1861-1920) pursued a literary career
 in late nineteenth-century Boston with considerable success, even
 though she lacked the financial resources that would have enabled
 her to devote herself full time to writing. As a single self-
 supporting woman, Guiney was forced to hold jobs as the post-
 mistress of Auburndale, Massachusetts, and as a cataloger at the
 Boston Public Library. Guiney's correspondence, spanning the
 years 1872-1920, is primarily concerned with literary matters and
 provides copious evidence of her interests and opinions. As a
 Roman Catholic, Guiney expressed views that distinguished her
 from other New England female authors of this era. Guiney's
 affinity for British literature eventually prompted her to settle
 in England, and all her letters after 1901 (nearly half of the
 correspondence in this collection) were written from there.

1873

1 Life and Letters of Mary Emma Woolley, by Jeannette Marks.
 Washington, D.C.: Public Affairs Press, 1955, 300 pp.
 Excerpts from letters written by college president **Mary
 Emma Woolley** (1863-1947) between 1873 and 1946 are incorporated
 in this laudatory biography prepared by her longtime companion.
 Woolley's writings shed light on her career at Mount Holyoke
 College, her advocacy of women's equality, and her work for the
 cause of peace.

1874

1 An Army Doctor's Wife on the Frontier: Letters from Alaska
 and the Far West, 1874-1878. Edited by Abe Laufe. Prelim-
 inary editing by the late Russell J. Ferguson. Pittsburgh,
 Pa.: University of Pittsburgh Press, 1962, 352 pp.
 In the letters **Emily McCorkle FitzGerald** (1850-1912) penned
 her mother from army posts in Sitka, Alaska, and Idaho Territory
 between 1874 and 1878, the familiar concerns of a young mother
 and housewife are combined with the observations of a curious
 visitor to alien surroundings. FitzGerald, the wife of an army
 surgeons, had much to say about life on army posts, her husband's
 medical work, and especially Indian affairs. She voiced her
 hostility toward Indians most bitterly after moving to Fort
 Lapwai, Idaho Territory, on the eve of the conflict with the Nez
 Percés. That FitzGerald would have preferred a more conventional
 setting for raising her children is evident from the obvious
 pleasure she took in recording everyday occurrences on the

domestic scene. She wrote at length of the devoted attentions of her husband, gave intimate details of her health and her pregnancy and childbirth, and even made an intriguing reference to birth control. The actions of her little daughter and son elicited her most enthusiastic comments, but she also spent an inordinate amount of time discussing the faults of her servants, particularly a Negro nursemaid and a Chinese cook.

2 "Etta's Journal January 2, 1874-July 25, 1875." Edited by
 Ellen Payne Paullin. <u>Kansas History: A Journal of the Great
 Plains</u> 3 (1980):201-19, 255-78.
 Physically deformed and convinced that she was morally
deficient by the strict standards of her evangelical Protestant
faith, **Julia Etta Parkerson** (Reynolds) (1853-89) of Manhattan,
Kansas, was frequently overcome by feelings of inadequacy and
self-doubt. From January 1874 to July 1875, a period during
which she studied at the Kansas State Agricultural College and
then worked as a housekeeper for her uncle, Etta kept a journal
in which she poured out her feelings in the course of recording
the events of her daily life. Exhausted from the drudgery she
was forced to perform, unable to obtain the teaching position to
which she aspired, and uncertain what to do about the attentions
of Alvin Reynolds, a persistent suitor thirty years her senior,
Etta consistently turned to her religion for answers. Even after
acknowledging her love for Alvin, she was still reluctant to
marry, fearing the dangers of childbirth for a person of her
condition, but her desire to have her own home finally made her
consent to the marriage.

3 "Letters of Caroline Frey Winne from Sidney Barracks and Fort
 McPherson, Nebraska, 1874-1878." Edited by Thomas R. Buecker.
 <u>Nebraska History</u> 62 (1981):1-46.
 Caroline Frey Giddings Winne (1841-1922) found little
worthy of praise at Sidney Barracks, Nebraska, the post where she
and her new husband, an army surgeon, were stationed. In the
letters she wrote to her family in New York between 1874 and
1878, Winne painted a bleak picture of frontier life, highlight-
ing the lack of congenial people, church services, and fruits,
vegetables, flowers, and plants, and deploring the proximity of
a vice-ridden town. She characterized her daily routine as
monotonous, broken only by recurrent problems with domestic
servants. Winne expressed her disgust for the Indians whom she
encountered at the outset of her stay and colored her reports of
military expeditions with anti-Indian comments. In November
1877, soon after the birth of a son, the Winnes were transferred
to Fort McPherson, Nebraska, where they remained for a few months
prior to returning to the East on leave. See also 1879.3.

1874

4 <u>Letters of Sarah Wyman Whitman</u>. Cambridge, Mass.: Printed at
 the Riverside Press, 1907, 255 pp.
 In this volume are assembled excerpts from letters written
 by **Sarah Wyman Whitman** (1842-1904), an artist from Boston,
 between 1874 and 1904 to a number of correspondents, including
 Sarah Orne Jewett and William James. Whitman's letters, which
 are grouped by recipient rather than arranged chronologically,
 are most useful for recovering her views on philosophical ques-
 tions, particularly in the areas of aesthetics and religion.
 Whitman also referred to her artistic endeavors in her letters--
 her painting and her work as a creator of stained-glass windows--
 and offered her reactions to the paintings of the Old Masters she
 saw in Europe. These letters shed virtually no light on Mrs.
 Whitman's family or domestic life. Appended to the correspon-
 dence are passages from a notebook kept by Whitman in 1885 and
 also a series of undated notes.

5 "A Woman's View of the Texas Frontier, 1874: The Diary of
 Emily K. Andrews." Edited and annotated by Sandra L. Myres.
 <u>Southwestern Historical Quarterly</u> 86 (1982):49-80.
 In the summer of 1874, **Emily Kemble (Oliver) Brown Andrews**,
 accompanied by her young daughter, traveled by wagon from Austin,
 Texas, to Fort Davis, Texas, with her new husband, a colonel in
 the United States Army. Andrews's pleasure in camping out and in
 military life is evident in the diary of the journey that she
 kept for her father. She commented on the distinctive features
 of the landscape, plants and animals, the people encountered on
 the trail, and the reactions of her daughter to the unusual
 situation.

<div align="center">1875</div>

1 "By Wagon from Kansas to Arizona in 1875--The Travel Diary of
 Lydia E. English." Edited by Joseph W. Snell. <u>Kansas His-
 torical Quarterly</u> 36 (1970):369-89.
 There is little doubt that **Lydia E. English** regretted
 leaving her home in Concordia, Kansas, and migrating with her
 husband and three youngest sons to Prescott, Arizona, in 1875.
 Her diary of the family's wagon journey, subsequently published
 in a Concordia newspaper, includes realistic reports of the
 landscape, vegetation, and historic sites but is sharply critical
 of the inhabitants of Dodge City, the Mexicans of Albuquerque,
 and the Indians.

1876

1 Letters of Lydia Jane Clark 1858-1936. Boston: [Thomas Todd
 Co. Printers], 1939, 152 pp.
 A rich portrait of the life-style of an upper-class woman
 emerges from the correspondence of **Lydia Jane Newhall Clark**
 (1858-1936) spanning the years 1876-1936. Residing initially in
 Germantown and then on an estate in Chestnut Hill, Pennsylvania,
 Lydia devoted her time to family and friends. Descriptions of
 her husband's cricket matches, dinners, parties, balls, yachting,
 and travel occupy a prominent place in her letters, which also
 include notes on her wardrobe and news of her children and other
 relatives. Tragedy struck Mrs. Clark in 1906, with the illness
 and death of her eldest son, a student at Harvard. Her subse-
 quent correspondence with his college friends, dealing in large
 part with her efforts to build a chapel in his memory at the
 Pomfret School, strikes a poignant note in an otherwise un-
 remarkable volume.

1877

1 "Times Hard but Grit Good; Lydia Moxley's 1877 Diary." Edited
 by James Sanders. Annals of Iowa 47 (1984):270-90.
 The terse entries in the diary **Lydia Dart Moxley** (1851?-
 1948) kept during the year 1877 synopsize her daily activities as
 a farm wife in Hickory Grove Township, near Grinnell, Iowa.
 Lydia's routine included household chores such as cooking, clean-
 ing, and washing, as well as churning butter, taking care of the
 chickens, and helping her husband with farm work. Attendance at
 the United Brethren church, visits to neighbors, and occasional
 social activities punctuated a life dominated by hard work.

2 "'Yours Always Lovingly': Sarah Orne Jewett to John Greenleaf
 Whittier." Edited by Richard Cary. Essex Institute Histori-
 cal Collections 107 (1971):412-50.
 Sarah Orne Jewett (1849-1909) cherished her friendship with
 the poet John Greenleaf Whittier, and her correspondence with
 him, spanning the years 1877-90, reflects their shared appre-
 ciation of literature and New England. The twenty-eight letters
 published here, the majority of which date from 1882 and 1883,
 are especially valuable for documenting Jewett's deepening
 affection for the recently widowed Annie Fields, who became
 Jewett's close companion for the remainder of her life. See also
 1869.4; 1880.1; 1894.2.

1878

1 "Mrs. Lucy A. Ide's Diary, 'In a Prairie Schooner, 1878.'"
 [Edited by J. Orin Oliphant.] Washington Historical
 Quarterly 18 (1927):122-31, 191-98, 277-88.
 The conditions of overland travel had improved substan-
 tially by the time Lucy A. Ide (1838-1903) and her party
 journeyed from Mondovi, Wisconsin, to Dayton, Washington
 Territory, in 1878. Ide's diary of the trip west gives evidence
 of numerous populated settlements and the ready availability of
 supplies and services along the way. Ide, a wife and mother,
 made routine observations on scenery and offered critical com-
 ments on the Mormons.

1879

1 A Girl of the Eighties at College and at Home from the Family
 Letters of Charlotte Howard Conant and from Other Records, by
 Martha Pike Conant and others. Boston and New York:
 Houghton Mifflin Co., 1931, 261 pp.
 A colorful picture of what it was like to be a student at
 Wellesley College during its early years emerges from letters
 penned by Charlotte Howard Conant (1861-1925) of Greenfield,
 Massachusetts, between 1879 and 1890. Conant kept her mother,
 father, and sister informed of both the intellectual and the
 social sides of college life, reporting on the subjects she was
 taking and her reading as well as on campus activities and
 personalities. She also commented on current political issues.
 Excessively solicitous of the needs of other members of her
 family, she regularly discussed their interests and concerns.
 In letters written after graduation, Conant recounted her
 experiences as a teacher in Northfield, Massachusetts, and
 Rutland, Vermont. Conant later built a reputation as the head
 of a private school for girls, which she founded with her college
 roommate.

2 Letters and Memories of Susan and Anna Bartlett Warner, by
 Olivia Egleston Phelps Stokes. New York and London:
 G.P. Putnam's Sons, 1925, 229 pp.
 This biographical volume memorializing Susan Bogert Warner
 (1819-85), an immensely popular novelist, and her sister, Anna
 Bartlett Warner (1827-1915), the author of children's books,
 contains a selection of their correspondence for the years 1879
 to 1914. All but a few of these letters were penned by Anna from
 her house on Constitution Island in the Hudson River, opposite
 West Point, New York, or from nearby places. Though primarily
 messages of friendship, the letters do refer to Anna's efforts to
 support herself through writing, her Bible class, and her love of
 flowers.

3 "Letters from a Post Surgeon's Wife: The Fort Washakie
 Correspondence of Caroline Frey Winne, May 1879-May 1880."
 Edited by Thomas R. Buecker. Annals of Wyoming 53 (1981):
 44-63.
 Indian customs and artifacts formed a major topic of
 discussion in the letters Caroline Frey Giddings Winne (1841-
 1922), the wife of an army surgeon, wrote to her family from Fort
 Washakie, Wyoming Territory, in 1879-80. Though her abhorrence
 of Indians had not lessened since her residence at military posts
 in Nebraska, she was curious enough to acquire a fund of
 knowledge about them, and she did acknowledge some sympathy for
 their plight. Far from enchanted with army life on the frontier,
 Winne managed to enjoy her year at Fort Washakie, largely because
 of the pleasure she derived from the actions of her little son.
 See also 1874.3.

4 Reminiscences and Letters of Caroline C. Briggs. Edited by
 George S. Merriam. Boston and New York: Houghton, Mifflin
 & Co., 1897, 445 pp.
 A sensitive woman's responses to the problems and oppor-
 tunities of old age is documented in the letters written by
 Caroline Clapp Briggs (1822-95) of Springfield, Massachusetts,
 between 1879 and 1895. Widowed in 1881 and afflicted by blind-
 ness as well as other ailments, Briggs was able nevertheless to
 shape a meaningful life for herself by developing friendships
 with younger men and women. The pleasure she received from her
 new companions is evident in her descriptions of visits, outings,
 and reading aloud. As advancing age and accumulated infirmities
 captured more of her attention, Briggs tended to write in a
 philosophical vein. Reflections on her disabilities were coupled
 with reminiscences of her childhood and marriage. Perennially in
 search of truth, Briggs revised her religious views in late life,
 rejecting her Unitarian beliefs as insufficient and adopting a
 more pantheistic outlook.

 1880

1 Letters of Sarah Orne Jewett. Edited by Annie Fields. Boston
 and New York: Houghton Mifflin Co., 1911, 259 pp.
 Literary matters predominate in this selection of the
 correspondence of Sarah Orne Jewett (1849-1909), noted for her
 perceptive stories and novels of New England life. In letters
 composed between 1880 and 1909, many of them written to her close
 friend, Annie Fields, Jewett set forth her judgments on a variety
 of authors, discussed her current reading, and shared her
 thoughts on the creative process. Of particular interest are two
 letters Jewett wrote to Willa Cather in 1908, offering advice on
 Cather's writing and her career as a writer. Casual comments on
 family members, visitors, and village affairs give a sense of the

flow of everyday life in Jewett's beloved hometown of South
Berwick, Maine. See also 1869.4; 1877.2; 1894.2.

1881

1 "The Diary of Anna Webber: Early Day Teacher of Mitchell
 County." Edited by Lila Gravatt Scrimsher. Kansas Historical
 Quarterly 38 (1972):320-37.
 When **Anna Webber** (Gravatt) (1860-1948) undertook to teach
 her first district school in Mitchell County, Kansas, in 1881,
 she had in mind not only the instruction of her young pupils but
 her own education. The diary she kept during her three-month
 school term between May and July 1881 records her diligent
 efforts at self-improvement through study as well as her con-
 tinuing frustration at the primitive conditions of her school-
 room. Anna's diary was primarily a vehicle for self-examination,
 and she used it to analyze the course of her life and to reflect
 on her own limitations.

2 Dissipations at Uffington House: The Letters of Emmy Hughes,
 Rugby, Tennessee, 1881-1887. Edited by John DeBruyn.
 Memphis, Tenn.: Memphis State University Press, 1976, 80 pp.
 This book contains thirty-five letters written by **Emily
 Margaret Anna (Emmy) Hughes** (1863-1934), a young English immi-
 grant, to her best friend in England, Lucy Taylor, between 1881
 and 1887. Emmy lived with her grandmother in Rugby, a colony of
 upper-class English immigrants established by her uncle in
 Tennessee in 1880. Her letters detail the varied activities in
 which she engaged at Rugby: managing her grandmother's house-
 hold, teaching a Sunday school class, playing the piano, taking
 photographs, and raising silkworms. Emmy's delight and interest
 in her new surroundings are evident, but the letters also reveal
 her loneliness and her nostalgia for the stimulating life of
 London.

3 Letters and Diaries of Margaret Cabot Lee: Extracts Selected
 by Her Sisters, Marian C. Putnam and Amy W. Cabot, with a
 Biographical Sketch by Her Husband Joseph Lee. N.p.:
 Privately printed, 1923, 401 pp.
 The idyllic youth, blissful marriage, and gratifying expe-
 rience of motherhood of an upper-class Bostonian are chronicled
 in the diary entries and letters of **Margaret Copley Cabot Lee**
 (1866-1920) spanning the years 1881 to 1920. As she grew up,
 days spent at the seashore and in the Adirondack Mountains with
 young men and women of her social set were happily filled with
 tennis, sailing, horseback riding, games, singing, telling ghost
 stories, and dances. Lee's years as a single woman were taken up
 with friends and family, teaching kindergarten, and travel to
 Europe. Her engagement and marriage to a man she loved dearly

opened the next stage of her life. Her joys were multiplied by
the birth of four children, whose appearance and behavior she
described fondly in her letters. In her later years, Lee
expressed her views on World War I and discussed her involvement
in community work.

4 Maud. Edited and arranged for publication by Richard Lee
 Strout. New York: Macmillan Co., 1939, 593 pp.
 From the time she was a sixteen-year-old high school
student in 1881 to the eve of her marriage at the age of thirty
in 1895, **Isabella Maud Rittenhouse** (Mayne) (1864-?), the
daughter of a well-to-do Cairo, Illinois, family, engaged in a
continual process of self-examination in her diary. Maud's
privileged social world comes to life in her minutely detailed
accounts of incidents involving the adolescent boys and girls
who were her friends at school and at play. Determined to make
a good impression on people, Maud attempted to mold herself into
her image of the ideal young woman. A large part of Maud's
diary over the years is taken up with her search for a suitable
mate, and she speculated endlessly on the merits of various young
men and the progress of her relationships. After graduation from
high school, Maud studied at the St. Louis School of Fine Arts
and then returned to Cairo where she worked as a teacher and
wrote fiction.

1882

1 Austin and Mabel: The Amherst Affair & Love Letters of Austin
 Dickinson and Mabel Loomis Todd, by Polly Longsworth. New
 York: Farrar Straus & Giroux, 1984, 449 pp.
 Mabel Loomis Todd (1856-1932) of Amherst, Massachusetts, is
best known for her role in editing and publishing the first edi-
tions of Emily Dickinson's poetry and letters. Another dimension
of Mabel's life is exposed in the passionate love letters she
wrote to Emily's brother, Austin Dickinson, between 1882 and
1895. Mabel carried on her affair with Austin with her husband's
knowledge, but the strong disapproval of Austin's wife forced the
couple to engage in continual subterfuge. Nonetheless, their
letters give abundant evidence of their intimate union. A
talented woman, gifted as a painter, musician, writer, actress,
lecturer, fashion designer, and interior decorator, Mabel kept
Austin informed of her accomplishments as she traveled in the
United States and abroad. Her ardent outpourings continued for
thirteen years until Austin's death.

1882

2 "Levancia Bent's Diary of a Sheep Drive, Evanston, Wyoming,
to Kearney, Nebraska, 1882." Edited by George Squires
Herrington. <u>Annals of Wyoming</u> 24 (1952):24-51.
 This unusual diary of a single middle-aged woman's expe-
riences on a sheep drive was kept by **Levancia Bent**, who accom-
panied her sister's family and other relatives on the journey
from Evanston, Wyoming, to Kearney, Nebraska, in 1882. While the
males in the party were responsible for herding the sheep, the
women occupied themselves in cooking and housekeeping chores.
Levancia appreciated the natural beauty of the territory and
spent some of her time painting and collecting rock specimens.
Although troubled by a residual fear of Indians, she relished the
simplicity of camp life and regretted the completion of the trip.

3 "The Picnic: From the Diary of Clara Mitchell, age 15.
12 June 1882, Glendale, Missouri." <u>Bulletin of the Missouri
Historical Society</u> 9 (1953):155-60.
 On a late spring weekend in 1882, a group of friends of
Clara Mitchell (Macbeth) (1867-1903) came to her house in
Glendale, Missouri, for a picnic. The lengthy retrospective
account of the weekend's activities found in Clara's diary
affords a glimpse of the relations between teenage girls and boys
in this era as well as a record of contemporary amusements. See
also 1882.4; 1887.2.

4 "School Days in the Kirkwood Seminary: From the Diary of
Clara Mitchell." <u>Bulletin of the Missouri Historical Society</u>
10 (1953):78-85.
 Clara Mitchell (Macbeth) (1867-1903), an irrepressible
fifteen-year-old girl from Glendale, Missouri, filled her diary
between February and May 1882 with amusing tales of her bad
conduct while a student at the Kirkwood Seminary. No matter how
frequently they were disciplined by teachers and the principal,
Clara and her fellow "day scholars" seemed incapable of main-
taining a ladylike demeanor either in the classroom or on the way
to school. See also 1882.3; 1887.2.

<u>1883</u>

1 "California in the Eighties As Pictured in the Letters of Anna
Seward." <u>California Historical Society Quarterly</u> 16 (1937):
291-303; 17 (1938):28-40.
 Before **Anna Seward** (Pruitt) (1862-?) entered on her life-
long career as a missionary in China, she spent a few years in
California as a schoolteacher. These selections from the young
single woman's letters of the years 1883-87 offer a witty commen-
tary on her journey west from Ohio by emigrant train, her expe-
riences as a teacher in Ventura and Ojai, and her travels in

California. They also shed light on her decision to become a missionary.

2 "Diary of Kena Fries." Edited by Jean Yothers and Paul W.
 Wehr. Translated by Margareta Miller. Florida Historical
 Quarterly 62 (1984):339-52.
 The major portion of this diary was written in 1883 when
 Christina (Kena) Fries (1867-1945), a Swedish immigrant, was a
 teenager living on a farm in central Florida. It presents a
 picture of a girl who loved her parents, quarreled with her
 sister, was fond of animals, and enjoyed observing a number of
 Swedish customs. Kena taught school for a brief period and never
 married. The few scattered subsequent entries in the diary, the
 last in 1937, disclose Kena's dissatisfaction with the course her
 life had taken.

3 "Elizabeth Fedde's Diary, 1883-88." Translated and edited by
 Beulah Folkedahl. Norwegian-American Studies and Records 20
 (1959):170-96.
 The plight of needy and sick Norwegian immigrants in
 Brooklyn, New York, prompted the migration of **Elisabeth Fedde**
 (Slettebo) (1850-1921) to the United States in 1883. Fedde, who
 had been a Lutheran deaconess in Norway, immediately began nurs-
 ing the ill in their homes, dispensing food, clothing, and money
 to the poor, and offering spiritual counsel to transplanted
 Norwegians. In 1885, she participated in founding what became
 the Norwegian Lutheran Deaconesses' Home and Hospital in
 Brooklyn. Fedde's diary, translated from the Norwegian, suc-
 cinctly reports the work she did for the immigrants and casts
 light on her tribulations in administering the home and hospital
 and dealing with its board of managers. Brief passages in the
 diary reveal Fedde's deep religious convictions.

4 The Priceless Gift: The Love Letters of Woodrow Wilson and
 Ellen Axson Wilson. Edited by Eleanor Wilson McAdoo. With a
 foreword by Raymond B. Fosdick. New York: McGraw-Hill Book
 Co., 1962, 324 pp.
 The mutual attraction and admiration that brought **Ellen
 Louise Axson Wilson** (1860-1914) and Woodrow Wilson together is
 vividly illustrated in their correspondence between 1883, the
 date of their meeting, and 1913, the year before her death.
 Letters written during the two-year period of their courtship,
 first from her home in Rome, Georgia, and then from New York
 City where she was studying at the Art Students' League, make
 plain her deepening love for Woodrow and attest to her concern
 to be a useful wife to a man with such extraordinary powers of
 mind and sterling character. Her strong Presbyterian faith and
 her affinity for literature and art come through in these early
 writings. Ellen's affection for Woodrow did not diminish after

their marriage and the birth of their three daughters, but flour-
ished. As her husband moved determinedly along the path that
ultimately took him to the White House, Ellen stood by him, re-
affirming her belief in the importance of his work and nourishing
him with assurances of her love.

1884

1 The Checkered Years: Excerpts from the Diary of Mary Dodge
 Woodward Written While Living on a Bonanza Farm in Dakota
 Territory during the Years 1884 to 1889. Edited by Mary
 Boynton Cowdrey. Caldwell, Idaho: Caxton Printers, 1937,
 265 pp.
 Mary Dodge Woodward (1826-90), a widow with grown children,
was transplanted from Wisconsin to the Dakota Territory when her
son became the manager of a cousin's wheat farm near Fargo. Her
diary, covering the years 1884 to 1889, documents her adaptation
to this unfamiliar isolated existence. Mrs. Woodward described
the ongoing work of the farm, spoke with pride of the labors of
her son and daughter, and noted her own contributions to the
household in the form of cooking, washing, and housecleaning. A
keen observer of nature, she spent a good deal of time depicting
the landscape and the weather and vividly conveyed the pleasure
she derived from the flowers and animals. Despite Mrs. Wood-
ward's successful adjustment to her new environment, a sense of
loss pervades her diary. Periodic references to her late husband
and her former way of life, coupled with comments on her advanc-
ing age, indicate that Mrs. Woodward was acutely conscious of her
limitations as an older widow.

1885

1 "'I Think I Will Like Kansas': The Letters of Flora Moorman
 Heston, 1885-1886." Kansas History 6 (1983):70-95.
 Flora Moorman Heston (1859-86) was enthusiastic about the
prospect of leaving Indiana and starting a farm in Kansas, as
her letters of 1885-86 show. When her husband went to file a
land claim there, she sent him words of encouragement and ex-
pressed her willingness to work by his side under difficult
conditions so that they might have a more secure future. Flora's
optimism did not diminish after she had joined her husband in
Clark County, Kansas, with their three children. Her letters to
her family in Indiana registered her satisfaction with her new
home and emphasized the appealing features of the Kansas environ-
ment. Flora kept her relatives informed of the continual
progress on the farm and fondly recounted the development of
her children. Her final letter discussed her pregnancy and the
imminent birth of her fourth child, after which she soon died.

1885

2 "Pioneering Near Steamboat Springs--1885-1886--As Shown in the
 Letters of Alice Denison." Colorado Magazine 28 (1951):81-94.
 Alice Denison (1838-1904), a middle-aged single woman, came
 to Steamboat Springs, Colorado, from her home in Washington,
 D.C., in order to give support to her nephew Willy, who was
 suffering from tuberculosis. In seven letters to her sister in
 Illinois written in 1885 and 1886, Alice discussed Willy's health
 and his mental outlook and made clear her deep concern for him.
 The letters also document Alice's reactions to the rugged
 mountain country, her interest in art, and her taste in reading.

3 Testament of Happiness: Letters of Annie Oakes Huntington.
 Edited by Nancy Byrd Turner. Portland, Maine: Anthoensen
 Press, 1947, 235 pp.
 The correspondence of **Annie Oakes Huntington** (1875-1940),
 an upper-class New England woman with an abiding interest in
 nature and a talent for writing, illuminates the life of a single
 woman whose primary personal relationships were with other women.
 Spanning the years 1885 to 1940, with some gaps, these finely
 crafted letters, all but one written to female friends, provide a
 detailed record of Annie's work and social life and disclose her
 views on a variety of subjects including literature and politics.
 Successful as a writer and lecturer on trees and plants as well
 as a designer of gardens until deteriorating health curtailed
 these activities, Annie made her home on a farm in Waterford,
 Maine, with a companion, Jeanette Payson. She also enjoyed
 periodic stays in Boston and trips through New England and the
 South. Although frequently troubled by illness and, in fact,
 forced to live as an invalid for much of her final decade, Annie
 consistently exhibited an optimistic tone in her letters, re-
 tained a genuine interest in her friends' activities, and never
 lost her joyful appreciation of life. The correspondence of the
 1930s is of particular interest for Annie's comments on the
 ominous political developments in Europe.

4 "'This Worry I have': Mary Herren Journal." [Edited by]
 Brenda Hood. Oregon Historical Quarterly 80 (1979):229-57.
 Mary E. Lacey Herren (1858-86), a young wife and mother
 suffering from tuberculosis, traveled with her family by wagon
 from her farm in Hopewell, Yamhill County, Oregon, to Pasadena,
 California, in hopes of restoring her health. The brief entries
 in the journal she kept from September 1885 to May 1886 record
 her observations on the places she visited in California and note
 changes in her condition. Though the journal is of interest for
 the light it sheds on Herren's relationship with her husband and
 small children, its major value lies in the insight it provides
 into the consciousness of a seriously ill woman.

<u>1886</u>

1 <u>An Academic Courtship: Letters of Alice Freeman and George</u>
 <u>Herbert Palmer 1886-1887</u>. With an introduction by Caroline
 Hazard. Cambridge, Mass.: Harvard University Press, 1940,
 259 pp.
 Alice Elvira Freeman (Palmer) (1855-1902) resigned the
 presidency of Wellesley College to marry George Herbert Palmer, a
 professor at Harvard University. Freeman's letters to Palmer
 during the period of their courtship, 1886-87, printed in this
 volume, provide the necessary background for understanding this
 momentous decision. Faced with the prospect of marriage at a
 relatively late age, Freeman pondered the question of whether she
 could fulfill her responsibilities to Wellesley at the same time
 as she devoted her love to Palmer. These letters, although writ-
 ten in a formal style, shed light on the inner conflict expe-
 rienced by this noted educator forced to confront the issue of
 career versus marriage just when she had reached the peak of her
 career.

2 <u>Alice Weston Smith 1868-1908: Letters to Her Friends and</u>
 <u>Selections from Her Note-books</u>. With an introduction by Rt.
 Rev. C.H. Brent, D.D. Boston: Addison C. Getchell & Son,
 privately printed, 1908?, 480 pp.
 Confined to the life of an invalid for most of her adult
 years, **Alice Weston Smith** (1868-1908), a member of a well-to-do
 Boston family, refused to withdraw from active social life.
 Despite her chronic illness, she kept close ties with her circle
 of female friends in eastern Massachusetts through their visits
 to her sickroom and through her correspondence. Alice's letters,
 covering the years 1886 to 1906, demonstrate how she was able to
 live vicariously through her friends, immersing herself in their
 joys and sorrows. The letters also disclose Alice's intellectual
 side. Written in a literary style, they chronicle her reading of
 both religious works and current books. Alice also remained
 abreast of contemporary issues, at one point offering a negative
 assessment of feminist Charlotte Perkins Stetson (Gilman).

3 "The Daughter of the Confederacy." [Edited by] Leah A.
 Strong. <u>Mississippi Quarterly</u> 20 (1967):234-39.
 The correspondence of **Varina Anne (Winnie) Davis** (1864-98)
 and **Varina Anne Howell Davis** (1826-1906), the daughter and wife,
 respectively, of Jefferson Davis, the president of the Con-
 federacy, with New England author Charles Dudley Warner between
 1886 and 1899 is printed here. Winnie Davis aspired to a lit-
 erary career and her four brief notes to Warner express her
 gratitude for his friendship. Of Varina Howell Davis's five
 letters to Warner, the two written immediately following Winnie's

premature death in 1898 illuminate a mother's response to the tragic loss of her daughter. See 1845.3 for other letters by Varina Anne Howell Davis and Varina Anne (Winnie) Davis.

4 Marion T. Brown: Letters from Fort Sill 1886-1887. Edited by
 C. Richard King. Austin, Texas: Encino Press, 1970, 80 pp.
 Between November 1886 and February 1887, **Marion Taylor Brown** (1857-1939), a single woman from Dallas, Texas, made an extended visit to a female friend at Fort Sill, Indian Territory, purportedly to improve her health. Although her letters to her family did report encouraging signs of weight gain as well as her participation in invigorating outdoor activities, their main focus was on the busy social life she was enjoying at the army post. Brown attended hops, card parties, and dinners with various officers, and she made special note of the dresses she wore and the appearance and behavior of her male escorts. During her stay at Fort Sill, Brown also conducted historical research on Indians for her father and for an elderly doctor on the post.

5 "Our Western Journey: Journal of Martha Wilson McGregor
 Aber." Edited by Clifford P. Westermeier. Annals of
 Wyoming 22 (1950):91-100.
 In June 1886, **Martha Wilson McGregor Aber** (1861-1932), with her husband, young son, and other family members, set out by wagon from Aurora, Nebraska, where they had lived for a year since moving from Pennsylvania, for the Territory of Wyoming. Aber's journal of their three-month trip to Wyoming, where they established a cattle ranch in the Wolf Creek country, consists of brief entries noting the terrain the party passed through and the conditions of travel. Unlike many other migrants, the Abers stopped for the Sabbath.

1887

1 Henrietta Szold: Life and Letters, by Marvin Lowenthal.
 New York: Viking Press, 1942, 350 pp.
 Judaism formed the central preoccupation of **Henrietta Szold** (1860-1945) throughout her life, although she did not embark on her pioneering work in behalf of Zionism until she was past forty years of age. These selections from Szold's correspondence, spanning the years 1887 to 1941, serve to document her career and the evolution of her thought. Virtually all of her letters written after 1920 emanated from Jerusalem. Szold's intellectual powers were applied successively to writing for the Jewish press; teaching English to immigrant Jews from Russia; lecturing; and translating, writing, and editing for the Jewish Publication Society of America. Szold, who never married, shared her developing enthusiasm for the Zionist cause with a circle of

1887

close female friends, explaining her ideas and detailing both the
joys and the frustrations that fell to the lot of a missionary.
Just prior to World War I, she became the president of Hadassah,
a new female Zionist organization, and she continued to play a
leadership role in Zionist endeavors for the remainder of her
life.

2 "'In Society,'" by Clara Mitchell. Bulletin of the Missouri
 Historical Society 21 (1965):115-32.
 The social world of a privileged single woman of St. Louis
 is recaptured in the diary kept by **Clara Mitchell** (Macbeth)
 (1867-1903) in 1887. Clara's talent for description brings to
 life the parties, receptions, balls, promenades, and theatrical
 entertainments that formed the focus of activity for her elite
 circle of young women and men. See also 1882.3-4.

3 "The Problem of Professional Careers for Women: Letters of
 Juanita Breckenridge, 1872-1893." Edited by Carol Kammen.
 New York History 55 (1974):280-300.
 The title of this article is misleading since the eighteen
 letters printed here cover only the years from 1887 to 1893.
 More important, only four of these letters were written by
 Juanita Breckenridge (Bates) (1860-1946) herself. The remaining
 correspondence consists of letters addressed to her by both men
 and women. Nevertheless, the eight female-composed letters in-
 cluded here are of particular interest because they shed light on
 the career experiences of one of the first female Congregational
 ministers in the United States. One friend, **Pansy Blaine**, was
 highly critical of Breckenridge's decision to enter the ministry,
 and her letter deliberately extolled the virtues of domesticity.
 Most fascinating is an 1891 letter from **Antoinette Brown
 Blackwell**, the noted minister and reformer, requesting informa-
 tion on the treatment of female students in the Department of
 Theology at Oberlin College, where Breckenridge was studying,
 for a paper on women in the ministry. See 1846.8 for letters of
 Antoinette Brown (Blackwell).

1888

1 Alice Hamilton: A Life in Letters, by Barbara Sicherman.
 Cambridge, Mass. and London, England: Harvard University
 Press, 1984, 460 pp.
 Despite early uncertainty regarding her own abilities and
 a prolonged period of job experimentation, physician **Alice
 Hamilton** (1869-1970), left an indelible mark on American society
 as a pioneer in the field of industrial toxicology. Hamilton's
 approach to her work, her social and political views, her abiding
 concern for her family and friends, and the distinctive flavor of
 her personality are all readily discernible in the 131 letters,

spanning the years 1888 to 1965, that form an integral part of
this biographical study. The letters offer insight into her
experiences as a medical student, her connection with Hull
House, her appointment as a professor at Harvard University, and
her other professional activities. They also cast light on her
investigations of industrial poisons and her dealings with
business and government in her continuing efforts to safeguard
the health of workers. Hamilton made her voice heard on current
issues, and she wrote with spirit of her involvement in the
pacifist cause during World War I, her support of Sacco and
Vanzetti, and her antipathy toward Nazism and McCarthyism. As
a single woman, she structured her personal life around her
sisters and close female friends, and her letters provide evi-
dence of the strength of these ties. Hamilton's unusual longev-
ity gave her ample opportunity to communicate her reflections
on the condition of old age.

2 "North Central Kansas in 1887-1889: From the Letters of
 Leslie and Susan Snow of Junction City." Edited by Lela
 Barnes. Kansas Historical Quarterly 29 (1963):267-323,
 372-428.
 Susan Eliza Currier Snow (?-1892) came to Junction City,
Kansas, as the young bride of an examiner for the U.S. Bureau of
Pensions. Her letters to her family in New Hampshire of 1888 and
1889 convey her impressions of her new home and document her
reception in local society. Self-conscious about her appearance,
she devoted considerable time to discussing her dress for various
occasions. Snow also disclosed her feelings about her pregnancy
in her letters home.

1890

1 "Rowe Creek, 1890-91: Mary L. Fitzmaurice Diary." Edited by
 Eileen Hickson Donnell. Oregon Historical Quarterly 83
 (1982):171-94, 288-310.
 Mary L. Fitzmaurice (?-1892), a recent Irish immigrant,
homesteaded with her son's family at Rowe Creek in Wheeler
County, Oregon. The brief entries in her diary between April
1890 and May 1891 convey a sense of the contributions she made to
the extended family in which she lived. In addition to aiding in
household chores and gardening, Fitzmaurice, who was presumably a
widow, assisted her grandchildren in their lessons and led
prayers on Sundays.

1890

2 Vinegar Pie and Chicken Bread: A Woman's Diary of Life in the
 Rural South, 1890-1891. Edited, with an introduction by
 Margaret Jones Bolsterli. Fayetteville: University of
 Arkansas Press, 1982, 108 pp.
 The multiplicity of tasks that composed the daily routine
of a small farmer's wife in Watson, Arkansas, come into sharp
focus in the diary kept by **Nannie Hudson Stillwell Jackson** (1854-
1908) from June 1890 to April 1891. Prosaic in nature, the diary
centers around Jackson's household work, her family, and her
social relations with the women of the town, both white and
black. Although Jackson rarely expanded on her feelings, her
chronicling of everyday events makes clear her troubled relation-
ship with her second husband and her reliance on female friends
for emotional sustenance. The diary also documents her concern
for the welfare of her young daughters from her first marriage
and her seemingly indifferent attitude toward the birth of a son.

1891

1 Diary and Letters of Josephine Preston Peabody. Selected and
 edited by Christina Hopkinson Baker. Boston and New York:
 Houghton Mifflin Co., 1925, 346 pp.
 Writing poems gave meaning to the life of **Josephine Preston
Peabody** (Marks) (1874-1922), who began publishing her work while
still in her teens and went on to establish a substantial reputa-
tion as a poet and author of plays in verse. These selections
from her diary and letters between 1891 and 1922 furnish an inti-
mate view of Peabody as she refined her ideas and matured as a
creative artist. Peabody's marriage to a Harvard professor,
quickly followed by the birth of two children, added immeasurably
to her happiness and dispelled the economic uncertainty that had
marred her early career. Yet the new demands on her necessitated
concessions in her schedule that prompted her to lament the loss
of writing time. New interests in social problems, pacifism, and
women's suffrage were similarly curtailed by household obliga-
tions and, more important, debilitating illness. Her personal
writings reveal the undaunted spirit with which she faced physi-
cal pain in her later years. Additional letters by Peabody may
be found in "Abbie Farwell Brown and Josephine Preston Peabody:
The Intimate Letters of Youth," Poetry Review 22 (1931):117-26,
219-22, 298-304, 387-90, 457-62.

2 "The Private Journals of Florence Crawford and Arthur Capper,
 1891-1892." Edited by Homer E. Socolofsky. Kansas Historical
 Quarterly 30 (1964):15-61, 163-208.
 The juxtaposition of the daily journal entries of **Florence
Crawford** (Capper) (1868-1926) between June 1891 and February 1892
with those of her fiancé during the same period, offers a reveal-
ing perspective on female and male roles in the late Victorian

era. Forced to endure a lengthy separation from Arthur Capper
while he pursued his journalistic career in New York and
Washington, D.C., Florence continued to engage in the customary
activities of a privileged young woman amidst a large circle of
female and male friends at home in Topeka, Kansas, and on a
family vacation trip to Nantucket, Massachusetts. In contrast to
Arthur's notations of reportorial assignments and business
appointments, Florence's jottings recorded social calls, parties,
shopping, club meetings, and music lessons. Periodically,
Florence wallowed in self-pity at her loneliness and admitted
that her happiness depended on Arthur.

3 "The Ranch Letters of Emma Robertson, 1891-1892." Edited by
 James E. Potter. <u>Nebraska History</u> 56 (1975):221-29.
 Emma Bent Robertson's husband managed the Hershey Stock
 Ranch near North Bend, Nebraska. These four letters written by
 Emma to her aunt in Iowa between September 1891 and September
 1892 describe the Robertsons' life on this large ranch and give
 a picture of Emma's responsibilities, which included supervising
 household workers and weighing corn. Emma spent a considerable
 amount of time relating the experiences of her only daughter and
 discussing the girl's reactions to her new environment. Emma's
 satisfaction with her life on the ranch is evident from these
 letters.

4 <u>The Tarbells of Yankton: A Family and a Community 1891-1932</u>
 <u>Presented in Letters</u>. Edited by Egbert S. Oliver. Portland,
 Oreg.: HaPi Press, 1978, 514 pp.
 This collection of family correspondence includes over
 eighty letters of **Alice Tarbell Brown** (1858-1934), a dozen let-
 ters of her daughter, **Beth Brown Masten** (1891-1929), and a few
 letters by other women of the Tarbell family in Oregon. Alice
 Brown's letters to her sister-in-law and brother and to a close
 female friend, spanning the years 1891-1932, document an extended
 period in the life of a wife and mother who was transplanted from
 Maine to the newly settled area around Yankton, Oregon. In addi-
 tion to conveying routine news of children, farm, church,
 school, and community, Alice reported regularly on her personal
 life, including detailed accounts of her health problems, work
 habits, and relationships with other members of her family.
 Letter writing also presented Alice with an opportunity to
 discourse on nature, good literature, her enjoyment of female
 friendships, and above all, her religious beliefs. Alice, a
 devoted Baptist, felt that spiritual concerns transcended all
 other matters. Alice Brown's introspective letters also contain
 her reflections on the female role.

1892

1 "Diary of an Iowa Farm Girl: Josephine Edith Brown, 1892-
 1901." Edited by Vivian C. Hopkins. <u>Annals of Iowa</u>, 3d ser.,
 42 (1973):126-46.
 Reproduced here are extracts from diaries kept between 1892
 and 1901 by **Josephine Edith Brown** (1878-1964), a young girl whose
 family lived on a farm near Shelby, Iowa. The diary entries
 chronicle her high school studies and activities, her busy social
 life in the community of young people, and her interest in
 clothes, as well as family events such as the death and funeral
 of her uncle. Josephine's diary touches briefly on her expe-
 riences as a teacher in a local school and as a student at Iowa
 State College. Religion was an important concern of Josephine's.
 In addition to recording her regular attendance at the Methodist
 church and the Epworth League, her diary documents her attempts
 to order her life according to religious principles.

2 "A Philadelphia Medical Student of the 1890's: The Diary of
 Mary Theodora McGavran." Edited by Robert M. Kaiser, Sandra
 L. Chaff, and Steven J. Peitzman. <u>Pennsylvania Magazine of
 History and Biography</u> 108 (1984):217-36.
 By the late nineteenth century, American women were no
 longer denied the opportunity to receive a professional medical
 education. These excerpts from the diary kept by **Mary Theodora
 McGavran** (1869-1923) between 1892 and 1896 furnish an illuminat-
 ing picture of the experiences of a student at the Woman's
 Medical College of Philadelphia. McGavran's undisguised pleasure
 in her work is evident throughout her account of lectures,
 laboratories, dissections, clinical observations, and examina-
 tions. Vivid characterizations of the faculty and fellow
 students as well as descriptions of her social activities add a
 personal dimension to this record of McGavran's medical training.

3 "A Visit to Savannah, 1892." [Contributed by Virginia O.
 Bardsley.] <u>Georgia Historical Quarterly</u> 50 (1966):100-4.
 Toward the end of an extended tour of the South, **Catharine
 Susannah Thomas Markell** (1828-1910), an elderly widow of
 Frederick, Maryland, visited her uncle and his family in
 Savannah, Georgia, in the winter of 1892. This excerpt from
 Markell's diary, recounting her activities during her stay, is
 noteworthy for its descriptions of Savannah's churches and
 cemeteries. See also 1862.9.

1893

1 "The Diary of Mrs. Anna S. Wood: Trip to the Opening of the
 Cherokee Outlet in 1893." [Edited by] H.D. Ragland.
 Chronicles of Oklahoma 50 (1972):307-25.
 The opportunity to acquire newly available Indian land
 lured **Anna S. Prouty Wood** (1844-1926) and her son from Denver to
 the opening of the Cherokee Outlet in Oklahoma Territory in 1893.
 In her diary, Wood, a middle-aged widow and former schoolteacher,
 noted their experiences while traveling to the "Strip" by covered
 wagon and their eventual success in locating land claims.

2 "Katharine Brackenbury's Letters to Her Mother." Compiled by
 Richard Brackenbury. Colorado Magazine 28 (1951):185-97.
 Transplanted from her family's comfortable home in England
 to her husband's cattle and sheep ranch near Carbon, Wyoming,
 shortly after her marriage in 1893, **Katharine Gibbs Brackenbury**
 (1862?-1950) set about acclimating herself to the strange
 environment. Excerpts from letters Katharine wrote to her mother
 between 1893 and 1895 document the young English immigrant's
 rapid adjustment to the role of rancher's wife. Pungent obser-
 vations on the differences between Wyoming and England color
 Katharine's account of her active new life.

3 "Our Trip to Mount Hood, 1893," by Marion B. Russell.
 Oregon Historical Quarterly 79 (1978):203-10.
 This is the diary **Marion B. Russell** kept on a group
 sightseeing trip to Mount Hood in the summer of 1893.

1894

1 On the Way Home: The Diary of a Trip from South Dakota to
 Mansfield, Missouri, in 1894, by Laura Ingalls Wilder. With
 a setting by Rose Wilder Lane. New York: Harper & Row,
 1962, 101 pp.
 Laura Ingalls Wilder (1867-1957), who later achieved fame
 as the author of the Little House series of children's books,
 moved with her husband and young daughter from De Smet, South
 Dakota, to Mansfield, Missouri, in the summer of 1894 in search
 of a better farm. In this brief travel diary, Wilder recorded
 the highlights of that journey--the scenery, the towns, the
 condition of the land and the crops, and the people she en-
 countered. See also 1915.5. See 1946.1 for the letters of Rose
 Wilder Lane, the daughter of Laura Ingalls Wilder.

2 "'We New Englanders . . .': Letters of Sarah Orne Jewett to
 Louise Imogen Guiney." [Edited by] William L. Lucey, S.J.
 Records of the American Catholic Historical Society of
 Philadelphia 70 (1959):58-64.

1894

Sarah Orne Jewett (1849-1909) took a proprietary interest
in the work of the young New England writer Louise Imogen Guiney.
This group of seven letters written to Guiney between 1894 and
1899 contains ample evidence of Jewett's high opinion of Guiney's
poetry and literary scholarship. The correspondence also docu-
ments Jewett's role in securing employment for Guiney at the
Boston Public Library. See also 1869.4; 1877.2; 1880.1.

1896

1 Amy Lowell: A Chronicle with Extracts from Her Correspon-
 dence, by S. Foster Damon. Boston and New York: Houghton
 Mifflin Co., 1935, 773 pp.
 This massive biography of poet Amy Lowell (1874-1925)
 includes copious extracts from letters she wrote between 1896 and
 1925. Inserted into the text in essentially chronological order,
 these letters provide evidence of her views on poetry, her in-
 volvements in the literary world, and the nature of her relations
 with her publishers as well as casting light on her personal
 life. See also 1904.1; 1915.1; 1917.2.

2 "A Nebraska High School Teacher in the 1890's: The Letters of
 Sadie B. Smith." Edited by Rosalie Trail Fuller. Nebraska
 History 58 (1977):447-73.
 Sadie B. Smith (Trail) (1873-1942) was enthusiastic about
 her job as a high school teacher in North Bend, Nebraska. These
 fifteen letters written between 1896 and 1899 to Rollin A. Trail,
 the man she eventually married, make clear how much satisfaction
 she derived from her profession and how ambitious she was to
 climb even further on the career ladder. In addition to depict-
 ing the school and community activities of a young high school
 teacher in a small western town, Sadie's correspondence also
 documents her slowly evolving relationship with Rollin. See also
 1900.1.

1897

1 "Agent and Author: Ellen Glasgow's Letters to Paul Revere
 Reynolds," by James B. Colvert. In Studies in Bibliography.
 Papers of the Bibliographical Society of the University of
 Virginia. Edited by Fredson Bowers. Charlottesville:
 Bibliographical Society of the University of Virginia, 1961,
 14:177-96.
 Ellen Anderson Gholson Glasgow (1873-1945) corresponded
 with her literary agent from 1897 to 1930, but the majority of
 these letters were written prior to 1901. In discussing arrange-
 ments for the publication of her novels and short stories,

Glasgow made clear that she judged success from an aesthetic
rather than a monetary standpoint. See also 1897.2.

2 Letters of Ellen Glasgow. Compiled and edited, with an intro-
 duction and commentary by Blair Rouse. New York: Harcourt,
 Brace & Co., 1958, 384 pp.
 Though the correspondence in this volume spans the years
 1897-1945, the majority of these letters were written after
 novelist **Ellen Anderson Gholson Glasgow** (1873-1945) was fifty and
 provide minimal information on her early development as a writer.
 The letters' primary value lies in their elucidation of Glasgow's
 conception of her own fiction and her relationship with her pub-
 lisher. They are also useful for documenting Glasgow's strong
 opinions of contemporary authors and books. Despite occasional
 comments on family and health matters, this correspondence
 reveals little about the enigmatic personal life of the writer
 from Richmond, Virginia. See also 1897.1.

1898

1 A Seafaring Legacy: The Photographs, Diaries, Letters and
 Memorabilia of a Maine Sea Captain and His Wife 1859-1908, by
 Julianna FreeHand. New York: Random House, 1981, 210 pp.
 Two sides of the life of a sea captain's wife are captured
 in the diary and letters of **Alice Gray Drinkwater** (1861-1915),
 which are included in this volume. Accompanying her husband on a
 lengthy voyage around the Cape of Good Hope in 1898-99, Drink-
 water kept a diary in which she recounted her daily routine
 aboard the sailing ship and offered her impressions of such
 exotic places as Singapore. Settled at home in Yarmouth, Maine,
 in 1908 while her husband was away at sea, she wrote him of the
 death and funeral of his father and commented on affairs in the
 community.

1900

1 "A Holdrege High School Teacher, 1900-1905: The Letters of
 Sadie B. Smith." Edited by Rosalie Trail Fuller. Nebraska
 History 60 (1979):372-400.
 This selection from the correspondence of **Sadie B. Smith**
 (Trail) (1873-1942) with Rollin A. Trail, whom she married in
 1906, continues from the point where the previous collection left
 off. These twenty-eight letters date from 1900 to 1904, when
 Sadie was the principal of the high school in Holdrege, Nebraska.
 Sadie's writing remains concerned with her work as a teacher and
 now administrator, with discussions of overcrowding in the
 school, yearly salary negotiations, professional meetings, and

1900

the social life of teachers occupying most of her attention.
Sadie also shared her aspirations with Rollin, detailing her
efforts to secure a better position and her plans to attend the
state university at Lincoln. See also 1896.2.

2 Letters of Edna St. Vincent Millay. Edited by Allan Ross
 Macdougall. New York: Harper & Brothers, 1952, 384 pp.
 Recognition for her poetic talent came early to **Edna St.
Vincent Millay (Boissevain) (1892-1950). These 281 letters
spanning the years 1900-50, many of them written to her mother
and sisters, provide a fund of information on Millay's writing
career and also reveal much about her personal life. A spirited
woman, Millay enthusiastically related her experiences as a
student at Vassar College, a fledgling poet in Greenwich Village,
and a traveler in Europe. Her correspondence is enlightening
with respect to her own work as well as that of other authors and
critics. The enduring satisfaction Millay found in her love for
her husband is evident in the joyous letters she penned from
their farm in Austerlitz, New York.

3 May Lansfield Keller: Life and Letters 1877-1964. Written
 and edited by Pauline Turnbull. [Verona, Va.]: McClure
 Press, 1975, 399 pp.
 The two discrete groups of letters in this volume repre-
sent different sides of the life of **May Lansfield Keller** (1877-
1964), long-time dean of Westhampton College of the University
of Richmond in Virginia. A sizable selection of letters written
by Keller to her parents between 1900 and 1904 relates her expe-
riences while pursuing her doctorate in Germanic philology at the
University of Heidelberg. This correspondence emphasizes
Keller's intellectual achievements and her reactions to European
society and culture. The second set of letters is of a com-
pletely different order. Dating from the year 1909 to 1912, when
Keller was a professor at Goucher College in Baltimore, these
highly personal letters trace the course of an intimate relation-
ship that culminated tragically in the suicide of the man Keller
loved. In them, Keller acknowledged the emotional impulses that
she had previously suppressed in her quest for professional suc-
cess. As she deliberated on how to reconcile her strong feelings
for a man with her career aspirations, Keller formulated her own
views on love, marriage, and the role of woman in the modern
world.

4 "September 8, 1900: An Account by a Mother to Her Daughters."
 Edited by W. Maury Darst. Southwestern Historical Quarterly
 73 (1969):56-82.
 On September 8, 1900, a devastating hurricane struck
Galveston, Texas. In these two letters, **Anna Marckmann Focke**, a

native of Germany who had married a wealthy Galveston cotton
factor, described this catastrophic event and its aftermath to
her two daughters who were spending the summer in Germany. The
letters were originally written in German.

1 "End of an Era: The Travel Journal of Mary Mahoney." Edited
 by Donald Mahoney. Nebraska History 47 (1966):329-38.
 In 1901, **Mary Mahoney** (1874-1964), a poorly educated young
 woman, traveled with her husband and a group of other people from
 Alliance, Nebraska, to Colorado in search of better land. This
 journal records the events of that short trip.

1 Love, Eleanor: Eleanor Roosevelt and Her Friends, by Joseph
 P. Lash. Garden City, N.Y.: Doubleday & Co., 1982, 534 pp.
 An inveterate letter writer all her life, **Anna Eleanor
 Roosevelt** (1884-1962) drew emotional sustenance from her corre-
 spondence with a diverse circle of female and male friends. This
 book contains copious extracts from Eleanor's letters dating from
 1903 to 1943 woven together by a continuous narrative. A
 sampling of Eleanor's letters to Franklin D. Roosevelt and other
 family members is also included. As she began to forge her own
 identity in the 1920s, Eleanor wrote frequently to women such as
 Nancy Cook, Marion Dickerman, and Elinor Morgenthau who shared
 her interest in politics and served to educate her in reform
 causes. In the early 1930s, Eleanor began an intense relation-
 ship with Associated Press reporter Lorena Hickok, which
 generated a flood of effusive letters that distilled the events
 of the day and pledged unswerving affection. Hickok was super-
 seded as the object of Eleanor's devotion by Joseph P. Lash, a
 young radical whom she showered with advice, gifts, and invita-
 tions. Eleanor fostered Lash's romance with Trude Pratt, the
 woman whom he eventually married. In addition to illuminating
 the nature of Eleanor's personal life, this correspondence also
 documents the evolution of her public career. See also 1916.4;
 1943.2.

1 Literary America 1903-1934: The Mary Austin Letters.
 Selected and edited by T.M. Pearce. Westport, Conn.:
 Greenwood Press, 1979, 296 pp.
 Most of the 115 letters printed in this volume were
 addressed to author **Mary Hunter Austin** (1868-1934); only 8 were
 written by Austin herself. In these letters, Austin touched on a
 variety of subjects, including the death of her retarded

1904

daughter, her belief in psychic power, American public opinion
regarding World War I, and a proposed collaboration with Sinclair
Lewis on a novel about water and the American West. Austin's
correspondents were a host of prominent literary and political
figures of the early twentieth century, among them distinguished
women such as **Ina Donna Coolbrith** (1841-1928), **Amy Lowell** (1874-
1925), **Marianne Craig Moore** (1887-1972), **Lou Henry Hoover** (Mrs.
Herbert Hoover) (1874-1944), and **Mabel Dodge Luhan** (1879-1962).
The female-composed letters in this book span the years 1904
to 1933. See 1896.1, 1915.1, and 1917.2 for letters by Amy
Lowell.

1905

1 Letters from Dr. Anna Howard Shaw to Dr. Aletta Jacobs.
 Edited by Jane de Iongh. Leiden: E.J. Brill, 1938,
 pp. 71-134.
 Between 1905 and 1918, **Anna Howard Shaw** (1847-1919), a
 single woman who was a principal figure in the cause of women's
 rights in America, corresponded with Dr. Aletta Jacobs, a leader
 of the Dutch women's suffrage movement. As president of the
 National American Woman Suffrage Association from 1904 to 1915,
 Shaw was in a unique position to comment on the issues, tactics,
 personalities, and politics of women's suffrage, both in the
 United States and internationally, and her letters are a valuable
 source of information on the movement during this critical
 period. They also shed light on Shaw as an individual and her
 perception of her role in the movement. Some of these letters
 were written as Shaw traveled in connection with her work, but
 the majority were dated from her home in Moylan, Pennsylvania.
 Originally published in International Archief Voor De Vrouwen-
 beweging, Jaarboek 2 (Leiden, E.J. Brill, 1938).

2 "My Trip to the Fair," by Oelo McClay. Oregon Historical
 Quarterly 80 (1979):51-65.
 This diary kept by **Pauline Oelo McClay** (1864-1950), a
 single woman, contains an account of her trip to the Lewis and
 Clark Exposition in Portland, Oregon, in 1905.

3 New Hampshire's Child: The Derry Journals of Lesley Frost.
 With notes and index by Lawrence Thompson and Arnold Grade.
 Albany: State University of New York Press, 1969, n.p.
 This book consists of photographic reproductions of the
 handwritten childhood journals kept by **Lesley Frost** (1899-),
 daughter of poet Robert Frost, between February 1905 and August
 1909. Lesley's journals are not strictly diaries since the
 dated entries were actually intended as imaginative composi-
 tions. Nevertheless, the contents of the journals illuminate
 the everyday life of an exceptional young girl in a way in which
 a more conventional record might not. Growing up on a farm in

Derry, New Hampshire, Lesley became a dedicated student of the
natural world around her. The remarkable observations of ani-
mals, birds, insects, flowers, and trees which fill these pages
tell us much about the developing worldview of a sensitive girl.
The journals are also a matchless source of information on
relationships within Robert Frost's family. See 1917.1 for the
letters of Elinor Frost, the mother of Lesley Frost.

<u>1908</u>

1 "Diary, Jeanne Eliz. Wier (1908)." <u>Nevada Historical Society</u>
 <u>Quarterly</u> 4 (1961):5-21.
 Historian **Jeanne Elizabeth Wier** (1870-1950), who taught at
 the University of Nevada in Reno, is remembered for her tireless
 efforts in behalf of the Nevada State Historical Society. Dr.
 Wier's enterprise in assembling materials to document Nevada's
 early years is illustrated by her 1908 diary, which contains
 notes on her travels around the state interviewing pioneer
 settlers, photographing significant sites, and collecting old
 newspapers and manuscripts.

2 <u>Growing Pains: Diaries and Drawings for the Years 1908-1917</u>,
 by Wanda Gag. New York: Coward McCann, 1940, 479 pp.
 The formative years of a creative artist are captured un-
 forgettably in the illustrated diary **Wanda Hazel Gag** (Humphreys)
 (1893-1946) kept faithfully between 1908 and 1917. As the eldest
 daughter of a Bohemian immigrant family in New Ulm, Minnesota,
 Gag employed her talent for drawing and story writing to help
 support her widowed mother and younger siblings while still going
 to school. Her diary became the repository of her intimate
 thoughts and emotions as she chronicled first the simple plea-
 sures and disappointments of her family life and then the stimu-
 lating experiences of work and friendship during her years at art
 school in St. Paul and Minneapolis. Gag, who became famous as an
 artist and as the author and illustrator of children's books,
 edited her voluminous diaries in later life.

3 <u>Letters and Journal of Edith Forbes Perkins 1908-1925</u>. Edited
 by Edith Perkins Cunningham. 4 vols. [Cambridge, Mass.]:
 Privately printed, 1931, 273 pp., 281 pp., 253 pp., 281 pp.
 The widowhood of **Edith Forbes Perkins** (1843-1925), as
 documented in this assemblage of selections from her journal and
 letters spanning the years 1908-25, was spent in great luxury.
 The elderly Perkins, whose husband had been president of a rail-
 road, was attended by servants as she toured the western United
 States and circulated among four family residences in Iowa,
 Massachusetts, and California, visiting, entertaining, and enjoy-
 ing the company of her children and grandchildren. At times,
 Perkins indulged in reminiscences about the old days and

1908

expatiated on her philosophy of life. She also communicated her reactions to World War I. Family documents pertaining to Edith Perkins's earlier life are found in Edith Perkins Cunningham, ed., <u>Charles Elliott Perkins and Edith Forbes Perkins: Family Letters and Reminiscences 1865-1907</u>, 2 vols. (Portland, Maine: Privately printed, 1949). See 1910.2 for the letters of Alice Forbes Perkins Hooper, the daughter of Edith Forbes Perkins.

<u>1909</u>

1 "They Had a Wonderful Time: The Homesteading Letters of Anna and Ethel Erickson." Edited by Enid Bern. <u>North Dakota History</u> 45 (1978):4-31.
 For **Anna Erickson** (?-1944) and her sister **Ethel Erickson** (1887?-1976?), young single women from Marshalltown, Iowa, living on their own homestead in Hettinger County, North Dakota, was a great source of satisfaction. The pleasure the sisters derived from working on their farm and participating in the social life of the neighboring community is evident in the letters they wrote to their parents between 1909 and 1911. This correspondence also sheds light on Ethel's term as a schoolteacher and Anna's experience of proving the claim to their land.

<u>1910</u>

1 <u>Beloved Prophet: The Love Letters of Kahlil Gibran and Mary Haskell and Her Private Journal</u>. Edited and arranged by Virginia Hilu. New York: Alfred A. Knopf, 1972, 450 pp.
 Mary Elizabeth Haskell (Minis) (1873-1964) played a major, but largely unknown, role in the career and private life of Kahlil Gibran, the celebrated Lebanese-born poet and artist. These selections from Haskell's journal and correspondence between 1910 and 1927 focus exclusively on her relationship with Gibran. Haskell, who taught in a girl's school in Boston, took an interest in Gibran immediately after meeting him in 1904 and offered him support and encouragement for the remainder of his life. She fostered his work by assisting him financially, editing his writing--in particular, The Prophet--and continually affirming her belief in the importance of his teachings. Haskell and Gibran were intimate friends and loved each other but agreed mutually to keep their relationship on a spiritual plane. Haskell's journal summarizes conversations during their meetings and frequently includes verbatim transcripts of Gibran's remarks.

2 <u>"Dear Lady": The Letters of Frederick Jackson Turner and Alice Forbes Perkins Hooper 1910-1932</u>. Edited by Ray Allen Billington with the collaboration of Walter Muir Whitehill. San Marino, Calif.: Huntington Library, 1970, 487 pp.

178

A mutual interest in the American West sparked the friend-
ship of **Alice Forbes Perkins Hooper** (1867-?), an upper-class
woman from Manchester, Massachusetts, with an intellectual bent,
and famed historian Frederick Jackson Turner, recently appointed
to a professorship at Harvard University. Their correspondence,
which spans the years 1910 to 1932, was initially concerned with
the Harvard Commission on Western History, an agency that was
established through Hooper's beneficence for the purpose of
collecting books and manuscripts relating to the history of the
American West. But when the commission became defunct in 1920,
the letters took on a more personal cast, with Hooper setting
forth her views on national and international politics, the his-
torical profession, and the diverse books and articles she read.
Married to an older man and childless, Hooper sponsored a number
of humanitarian community projects and frequently entertained
people of note, whose most recent accomplishments she described
in detail to Turner. Confident of Turner's sympathetic under-
standing, Hooper grew philosophical at times, reflecting on the
experiences of her prominent family, the responsibilities of
great wealth, and the attributes of women. See 1908.3 for the
letters and journal of Edith Forbes Perkins, the mother of Alice
Forbes Perkins Hooper.

3 Letters and Verses of Clara Boardman Peck. [Edited by
 Laurence F. Peck.] New York: Dodd, Mead, & Co., 1951,
 432 pp.
 A full-bodied portrait of a witty and creative upper-class
woman emerges from the correspondence of **Clara Temple Boardman
Peck** (1885-1950) spanning the years 1910-50. Married to an
architect and the mother of two children, Clara divided her time
between New York City, a country home in Connecticut, and Europe.
Sheltered from the pressures of the world, Clara freely culti-
vated her own interests. An avid reader and gardener, she also
enjoyed the social life of the sophisticated urban elite. Yet
what distinguished Clara from her peers was her mastery of the
craft of bookbinding and her talent for writing. These letters,
and the poems that are interspersed among them, demonstrate her
literary gift as well as illuminate her intellectual and emo-
tional development over a long period of time. They are valuable
for documenting the texture of her personal relationships--with
her mother, husband, and children--and for reconstructing her
social and political views. The correspondence dating from the
World War II years is of particular interest for its candid
revelations of the alterations in the upper-class life-style
necessitated by the crisis.

1910

4 The Maimie Papers. Historical editor: Ruth Rosen. Textual
 editor: Sue Davidson. With an introduction by Ruth Rosen.
 [Old Westbury, N.Y.]: Feminist Press, 1977, 439 pp.
 Separated by a seemingly unbridgeable gulf, **Maimie Pinzer**
 (Jones) (Benjamin) (pseud.) (1885-?) a poor Jewish working woman,
 and Fanny Quincy Howe, a member of a prominent Boston family,
 carried on an extraordinary correspondence between 1910 and 1922.
 This ample selection of Maimie's letters to the sympathetic Mrs.
 Howe gives a revealing self-portrait of a young woman struggling
 to reclaim her dignity after engaging in prostitution and
 succumbing to morphine addiction. Maimie's trust in Mrs. Howe
 enabled her to speak freely about her troubled past as well as
 her current activities. Her letters shed light on her uneasy
 relations with her family, her health problems, her efforts to
 earn a living, her attitudes toward men, and her two marriages.
 A gifted writer, Maimie was able to bring to life the world of
 poor immigrants in her lengthy narrations of events. With the
 financial assistance of the reformers who had befriended her,
 Maimie set up a program in Montreal to help prostitutes. Her
 discussion of the approach she took in her work with these women
 substantiates her distrust of the charitable endeavors of the
 middle class.

1911

1 Sharlot Hall on the Arizona Strip: A Diary of a Journey
 through Northern Arizona in 1911. Edited by C. Gregory
 Crampton. [Flagstaff]: Northland Press, 1975, 97 pp.
 This is a newly edited version of a series of articles in
 the form of a travel diary that was originally published in
 Arizona, the New State Magazine between October 1911 and April
 1913. **Sharlot Mabridth Hall** (1870-1943), a successful writer of
 poetry, essays, and historical pieces, was appointed terri-
 torial historian of Arizona in 1909. In 1911, she made a trip
 through the northern part of the territory with a guide in order
 to collect information on the people, historic places, and
 natural resources of the area. Her travel diary constitutes a
 record of her findings.

1912

1 "The Last Eden: The Diary of Alice Moore at the XX Ranch."
 Edited by Austin L. Moore. Annals of Wyoming 41 (1969):
 63-81.
 Reading aloud around the fire was just one of the pleasures
 Alice Moore (Sawyer) (1896[97?]-?) experienced during her fam-
 ily's vacation on a ranch in southeastern Wyoming in the summer
 of 1912. The delight this fifteen-year-old girl took in camping
 out is apparent in her diary record of a month spent hiking in

the mountains, observing animals, gazing at the stars, gathering
and pressing flowers, singing favorite songs, and taking pic-
tures.

1913

1 "Life Anew for Czech Immigrants: The Letters of Marie and
 Vavřín Střítecký, 1913-1934." Edited by Marilee Richards.
 South Dakota History 11 (1981):253-304.
 For many years after she and her husband had settled on a
 farm in Colome, South Dakota, **Marie Spacil Střítecký** (?-1944)
 craved news of her family and friends in Saratice, Czecho-
 slovakia. These letters from the years 1913-34, virtually all
 of them written by Marie, give concrete evidence of her enduring
 emotional ties to her homeland, but they also trace her gradual
 Americanization. Grateful for the superior economic opportuni-
 ties that had enabled the Stříteckýs to establish a successful
 farm in South Dakota, Marie managed to sustain her optimism even
 during the troublesome times of the depression. She recognized
 that her daughters' future lay in America and consequently
 abandoned her hope of returning to Czechoslovakia, but she never
 surrendered her pride in her heritage.

1914

1 Letters of Elizabeth Keats McClelland 1914-1936. 2 vols.
 N.p.: Privately printed, 1941.
 Though she never achieved recognition for her scholarship,
 Elizabeth Keats McClelland (1890-1936) devoted her life to study,
 teaching, and research. Intellectual references abound in the
 letters she wrote from Boston, New York, and Oxford, England,
 between 1914 and 1936 as she pursued her work. A single woman,
 McClelland had close ties to her friends, and in addition to
 furnishing them with lucid descriptions of the places and people
 she visited, she conveyed her strong feelings for them.

1915

1 "The Correspondence of Amy Lowell and Barrett Wendell, 1915-
 1919." [Edited by] Robert T. Self. New England Quarterly
 47 (1974):65-86.
 Though leagues apart in critical standards, **Amy Lowell**
 (1874-1925) and Harvard professor Barrett Wendell engaged in a
 mutually rewarding interchange of letters between 1915 and 1919.
 Lowell, whose poetry radically challenged the old literary canons
 with which Wendell identified, esteemed the aging scholar's
 friendship and valued his criticism of her work. In responding
 to his comments, she articulated her views on poetry, the

creative process, New England writers, and the Salem "witches" of the seventeenth century. See also 1896.1; 1904.1; 1917.2.

2 Lella Secor: A Diary in Letters 1915-1922. Edited by Barbara Moench Florence. New York: Burt Franklin & Co., 1978, 295 pp.
 In 1915, **Lella Faye Secor** (Florence) (1887-1966), a young journalist from the state of Washington, seized the opportunity to become a reporter on Henry Ford's peace ship, which was traveling to Europe for the purpose of promoting a negotiated settlement to World War I. Secor's letters to her mother and sisters between 1915 and 1923 trace her rapid conversion to the cause of pacifism during her association with the Ford venture, her subsequent career as a magazine writer and political activist in New York City, and her transition to a very different life as a wife and mother of two infant sons. Ambitious and energetic, Secor poured herself into her work for the American Neutral Conference Committee and its successor, the Emergency Peace Federation, taking time out to inform her family of her increasingly radical political views and her countless social engagements. Reluctant to sacrifice her independence but drawn irresistibly by feelings of love, Secor married a young Englishman who shared her sympathies. She chronicled her happiness in her marital union, her difficult pregnancies, and the problems she encountered in trying to raise children and keep house with inadequate servants. The letters also shed light on Secor's ambivalent relationship with her mother, whom she supported.

3 The Letters of Ruth Draper 1920-1956: A Self-Portrait of a Great Actress. Edited, with narrative notes by Neilla Warren. New York: Charles Scribner's Sons, 1979, 362 pp.
 Famed for her monologues, actress **Ruth Draper** (1884-1956), a single woman, traveled around the globe performing before appreciative audiences. The majority of these letters, which span the years 1915-56, were written from Europe and countries elsewhere, but a small number were composed during Draper's periodic stays in the United States. Draper furnished her correspondents with lively accounts of her theatrical tours, conveying her delight in the places she visited and the people she met, and regularly offered her opinions on art, music, and literature. The letters also document her close ties to her family and friends and shed light on her romantic relationship with an Italian man.

4 A President in Love: The Courtship Letters of Woodrow Wilson and Edith Bolling Galt. Edited by Edwin Tribble. Boston: Houghton Mifflin Co., 1981, 225 pp.
 Edith Bolling Galt (Wilson) (1872-1961) was a well-to-do middle-aged Washington, D.C., widow when President Woodrow

Wilson, recently widowed himself, fell in love with her in 1915. Against a backdrop of concern over World War I, Wilson pursued her with passion and persistence, and she soon responded to his overtures by agreeing to marry him. These letters, dating from April to December 1915, trace the course of their courtship, providing evidence of Galt's ripening feelings for Wilson, her self-deprecation before his superior intellect, and her commitment to support and serve him as his partner. Galt's comments on the political matters that Wilson was grappling with are of particular interest.

5 West from Home: Letters of Laura Ingalls Wilder to Almanzo Wilder, San Francisco 1915. Edited by Roger Lea MacBride. Historical setting by Margot Patterson Doss. New York: Harper & Row, 1974, 124 pp.
 In 1915, **Laura Ingalls Wilder** (1867-1957), later the author of the Little House series of children's books, traveled to San Francisco to see her daughter, Rose Wilder Lane, a feature writer for the San Francisco Bulletin, and to visit the Panama-Pacific International Exposition. Her letters to her husband, Almanzo, who remained at home on the couple's farm in Mansfield, Missouri, give a detailed record of her sightseeing at the exposition and in San Francisco and the surrounding area. These letters also offer insight into the role played by Laura's daughter in fostering her mother's career as a writer. See also 1894.1. See 1946.1 for the letters of Rose Wilder Lane, the daughter of Laura Ingalls Wilder.

<div align="center">1916</div>

1 Letters from Amelia 1901-1937, by Jean L. Backus. Boston: Beacon Press, 1982, 253 pp.
 Famed aviator **Amelia Mary Earhart** (Putnam) (1897-1937) spent much of her life in the glare of publicity, but she never neglected to keep her mother informed of her adventures as a flyer, her speaking engagements, her travels, and her contacts with celebrities. The letters she wrote her mother between 1916 and 1937, which constitute the bulk of the correspondence in this biographical volume, are most valuable for the light they cast on Earhart as a private person. Perennially concerned about her mother's welfare, she deluged her with advice on serious as well as trivial matters and provided her with money and clothing so that she could avoid hard work and make a good appearance. Convinced that her sister's marriage was unsatisfactory, she included suggestions as to how her sister should act. Earhart also supplied her mother with gossip about family members, including her father, from whom her mother was divorced. Fiercely independent, Earhart married George Palmer Putnam in

1931 but wrote him on the eve of their wedding that she did not expect to abide by conventional notions of fidelity.

2 <u>Letters of Hart Crane and His Family</u>. Edited by Thomas S.W. Lewis. New York and London: Columbia University Press, 1974, 675 pp.
 The family correspondence of poet Hart Crane assembled in this volume includes more than seventy letters by his divorced mother, **Grace Edna Hart Crane** (?-1947) and over twenty letters by his maternal grandmother, **Elizabeth Belden Hart** (1839-1928), a widow. The letters Grace Crane wrote Hart between 1916 and 1930, primarily from her home in Cleveland, shed light on her personal beliefs as well as her feelings toward her ex-husband. Their primary interest lies, however, in their delineation of her relationship with her son, whose career as a writer engendered conflict between his parents. Elizabeth Belden Hart's letters to her grandson, spanning the years 1918-27, hold value not only for their revealing comments on her daughter Grace, with whom she lived, but for the temperate advice she offered Hart during his troubled life.

3 "Life at the Pebble Quarry, Nye County, Nevada, 1916-1919," by Cora Maris. Introduction and epilogue by Faith Maris. <u>Nevada Historical Society Quarterly</u> 25 (1982):53-64.
 Her husband's decision to operate a pebble mine in the mountains of southern Nevada meant that **Cora Maris** (1868?-1920), a middle-aged woman with grown children and grandchildren, had to live in extreme isolation. Cora's diary for early 1916 captures the monotony of her difficult existence at the quarry and also reveals her feelings about her writing talent and her appearance. Diary entries from January 1918, written at her home in Manhattan, Nevada, disclose Cora's involvement in Red Cross work during World War I.

4 <u>Mother and Daughter: The Letters of Eleanor and Anna Roosevelt</u>. Edited by Bernard Asbell. New York: Coward, McCann, & Geoghegan, 1982, 366 pp.
 From 1916 to 1962, **Anna Eleanor Roosevelt** (1884-1962) carried on a voluminous correspondence with her only daughter **Anna Roosevelt** (Dall) (Boettiger) **Halsted** (1906-1975). Though these letters undoubtedly contribute to knowledge of the career of President Franklin D. Roosevelt, their primary value lies in the light they shed on the work and personal life of Eleanor and Anna and on the nature of their relationship. Eleanor's active participation in public life, begun long before the White House years, continued through most of her widowhood. She provided her daughter with a running account of her travels, political activities, speaking engagements, radio talks, and writings as well as commenting on the doings of family members. Married three times,

Anna had emotional, physical, and financial problems, and Eleanor supported her through all these adversities. In response to her mother's queries, Anna sketched her daily routine and provided additional information on her health, social activities, love life, and children, as well as her work as a journalist. Even though there were occasions of mistrust between them, Eleanor and Anna were devoted to each other. See 1903.1 and 1943.2 for letters of Eleanor Roosevelt.

1917

1 <u>Family Letters of Robert and Elinor Frost</u>. Edited by Arnold Grade. Foreword by Lesley Frost. Albany: State University of New York Press, 1972, 293 pp.
 This engrossing collection of family correspondence contains fifty letters written by **Elinor Frost** (1873-1938) between the years of 1917 and 1937. Virtually all these letters were written to her daughter, Lesley, and the majority were composed in three places: Franconia, New Hampshire, Arlington, Vermont, and Amherst, Massachusetts. Focusing on down-to-earth family matters and news of the community, these personal letters offer an insight into the ideas and attitudes of the wife of the famous poet, Robert Frost, as well as exposing the internal dynamics of the Frost family. These letters are of particular value for an examination of the mother-daughter relationship in the early twentieth century. See 1905.3 for the childhood journals of Lesley Frost, the daughter of Elinor Frost.

2 <u>Florence Ayscough & Amy Lowell: Correspondence of a Friendship</u>. Edited, with a preface by Harley Farnsworth MacNair. Chicago: University of Chicago Press, 1945, 289 pp.
 Convinced that the beauty of Chinese lyric poetry should be made known to Western readers, **Amy Lowell** (1874-1925) and her childhood friend **Florence Wheelock Ayscough** (MacNair) (1878-1942), a student of Chinese culture, embarked on a translation project that resulted in the publication of <u>Fir-Flower Tablets</u> in 1921. The collaboration, which was primarily conducted by mail with Lowell in Brookline, Massachusetts, and Ayscough in China or New Brunswick, Canada, is documented in these letters spanning the years 1917 to 1925. For the most part, the correspondence is taken up with discussions of the technical aspects of rendering the poems into English, the merits of Chinese literature, the work of persons perceived to be competitors in their field, the process of publication, and the reception of the book. Lowell and Ayscough touched on personal matters whenever they wrote each other, but it was their joint literary venture that captured most of their attention. See 1896.1, 1904.1, and 1915.1 for letters of Amy Lowell.

1917

3 "The Letters of Effie Hanson, 1917-1923: Farm Life in
 Troubled Times." Compiled and edited by Frances M. Wold.
 North Dakota History 48 (1981):20-43.
 The down-to-earth letters **Effie Kimbrell Hanson** (1892-1923)
 of Burleigh County, North Dakota, penned to a female friend
 between 1917 and 1923 make it simple to comprehend the tedious
 and often frustrating work of a farm wife during an era of
 adversity. At the time she was writing, Hanson was in the midst
 of a cycle of pregnancy and childbearing that ultimately cost
 her her life, and the letters reveal much about this strong
 woman's attitude toward motherhood.

 1918

1 "A Righteous Aim: Emma LeConte Furman's 1918 Diary." Edited
 by Lester D. Stephens. Georgia Historical Quarterly 62
 (1978):213-24.
 The opinions of an elderly widow on the events and issues
 of World War I are found in this diary kept by **Emma Florence
 LeConte Furman** (1847-?) of Macon, Georgia, in 1918. Furman
 digested the war news and assessed the progress of Allied
 efforts, described privations on the home front, and noted her
 own participation in local patriotic activities such as Red Cross
 work. A devout Episcopalian, Furman sought to define the reli-
 gious purpose of the war. The diary also documents Furman's
 support of women's suffrage as well as her political views. See
 also 1864.11.

2 Selected Letters of Marjorie Kinnan Rawlings. Edited by
 Gordon E. Bigelow and Laura V. Monti. Gainesville: Univer-
 sity Presses of Florida, 1983, 414 pp.
 Marjorie Kinnan Rawlings (Baskin) (1896-1953) earned
 immense popularity as the author of novels and stories depicting
 the denizens of rural north central Florida. These 191 letters,
 spanning the years 1918-53, constitute a rich source for tracing
 the evolution of her career as a writer as well as examining her
 personal life and beliefs. In her correspondence with her
 editor, Maxwell Perkins, Rawlings explained the research process
 that underlay her fictional creations, elaborated on her plots
 and characters, and offered her opinions of authors such as
 Fitzgerald, Hemingway, and Wolfe. The disruptive impact on
 Rawling's work of a protracted legal case in which she was sued
 for invasion of privacy is made clear in letters to her lawyer
 and to friends. Rawlings did not disguise the anguish that
 resulted from her ongoing struggle to reconcile her desire for
 both independence and companionship, and she reflected on the
 limitations of both her marriages with unusual candor. These
 letters are also valuable for evaluating Rawlings's views on
 blacks.

 186

3 The Stump Farm: A Chronicle of Pioneering, by Hilda Rose.
 Boston: Little, Brown & Co., 1928, 178 pp.
 The title of this book gives no indication of the adverse
 conditions under which **Hilda Rose** (1880?-?), a schoolteacher who
 had gone west because of the threat of tuberculosis, labored to
 survive on an isolated farm in the hills of Montana. In these
 letters written to unnamed friends and benefactors between 1918
 and 1927 and originally published in the Atlantic Monthly, Mrs.
 Rose painted a picture of her life with a frail husband twenty-
 eight years her senior, and a young son. Devoted to her family,
 she improvised ways to feed them and keep up their spirits. Yet
 it is her personal struggle to preserve her values amidst primi-
 tive surroundings that provides the thread of continuity in
 these letters. Mrs. Rose's yearning for female friends was
 gratified by her successful effort to establish a local woman's
 club. Her ambition to write was ultimately realized when these
 letters were accepted for publication. The latter half of this
 volume contains Hilda Rose's letters from the new homestead near
 Fort Vermilion, Alberta, Canada, to which the family moved in
 1926.

 1919

1 Abby Aldrich Rockefeller's Letters to Her Sister Lucy. New
 York: Privately printed, 1957, 328 pp.
 As the wife of John D. Rockefeller, Jr., one of the
 world's wealthiest men, **Abby Greene Aldrich Rockefeller** (1874-
 1948) enjoyed a host of privileges that set her apart from most
 women of her generation. This extensive collection of her
 correspondence with her unmarried sister, Lucy Truman Aldrich,
 spanning the years 1919-48, offers ample evidence of the upper-
 class life-style to which she was accustomed. Managing the
 Rockefeller family's residences staffed with servants, enter-
 taining on a grand scale, participating in appropriate philan-
 thropic and civic activities, and extensive traveling were all
 regular activities. Mrs. Rockefeller also had time to indulge
 her own interests in art collecting, interior decorating, and
 ordering clothing from Paris and London. Her comments on her
 husband's work and her detailed accounts of the health, educa-
 tion, and social life of her six children also reveal her to have
 been a loyal wife and concerned mother. Although detached in
 tone and rarely introspective, Abby Rockefeller's letters make
 clear her viewpoint on a variety of social and political issues
 and offer a unique perspective on the domestic life of an excep-
 tional family.

1920

1 Frances Newman's Letters. Edited by Hansell Baugh. With a
 prefatory note by James Branch Cabell. New York: Horace
 Liveright, 1929, 372 pp.
 Frances Newman (1883-1928) of Atlanta, Georgia, who
 achieved fame as a literary critic and novelist in the 1920s, is
 best known for her novel The Hard Boiled Virgin (1926). This
 collection of her correspondence, most of which dates from 1920
 to 1928, is invaluable for tracing her development as a writer.
 In articulate and witty letters to authors, editors, publishers,
 family members, and friends, Newman discussed her work, ini-
 tially as a librarian and book reviewer, and later as an essayist
 and novelist. She revealed her artistic standards and tastes,
 the sources of her inspiration, and her method of writing, and in
 the process, she shed light on the literary world of the day. As
 a single self-supporting woman, Newman could not ignore economic
 considerations, and her correspondence documents her efforts to
 become financially independent. Although these letters offer
 glimpses into Frances Newman's personal life, their significance
 lies in their delineation of her career.

2 What the Woman Lived: Selected Letters of Louise Bogan
 1920-1970. Edited, with an introduction by Ruth Limmer.
 New York: Harcourt Brace Jovanovich, 1973, 401 pp.
 The exacting standard to which poet and critic **Louise Bogan**
 (Alexander) (Holden) (1897-1970) held members of her craft is
 readily apparent in this selection from her correspondence over
 the years 1920 to 1970. Bogan's conception of artistic merit is
 evident not only in her dispassionate assessment of her own verse
 and in the advice she proffered to younger poets, such as close
 friends Theodore Roethke and May Sarton, but in her candid reac-
 tions to the hundreds of works she read in the course of her
 career as a reviewer for the New Yorker. Steeped in the literary
 culture of the modern era, Bogan wrote with enthusiasm and wit of
 art and ideas, often spicing her commentaries with anecdotes
 displaying the eccentricities of some of the twentieth century's
 best-known writers. Bogan's correspondence also affords tanta-
 lizing glimpses of the personal struggle of a woman writer de-
 termined to preserve her own independence. The more mundane
 aspects of her life as a self-supporting professional become
 clear in her references to stints as a college teacher, lecturer,
 and judge of literary awards. Of greater interest are her
 allusions to her Irish Catholic heritage, her marriages and love
 affairs, her relationship with her daughter, and her periodic
 nervous breakdowns.

1921

1 "Faithfully Yours, Ellen C. Sabin: Correspondence between
 Ellen C. Sabin and Lucia R. Briggs from January, 1921, to
 August, 1921." Edited by Virginia A. Palmer. Wisconsin
 Magazine of History 67 (1983):17-41.
 The retirement of **Ellen Clara Sabin** (1850-1949) from the
 presidency of Milwaukee-Downer College prompted this enlighten-
 ing interchange of letters between Sabin and **Lucia Russell
 Briggs** (1887?-?) in 1921. Briggs, a young professor of English
 at Simmons College in Boston, was the prime candidate for the
 position as head of the Wisconsin college, and this correspon-
 dence traces the process by which she was selected to replace
 Sabin. The letters are filled with valuable information on the
 administration of a woman's college in the post-World War I
 era, ranging from faculty appointments and salaries to resi-
 dential arrangements and racial attitudes. But the queries of
 Briggs and the replies of Sabin do more than document institu-
 tional policy and practice. They illuminate the values and
 methods of two notable professional women, both single and both
 dedicated to the cause of female higher education.

2 Give Us Each Day: The Diary of Alice Dunbar-Nelson. Edited,
 with a critical introduction and notes by Gloria T. Hull.
 New York and London: W.W. Norton & Co., 1984, 480 pp.
 The rarity of diaries by black women lends added signifi-
 cance to the diary **Alice Ruth Moore Dunbar-Nelson** (1875-1935)
 kept in 1921 and from 1926 to 1931. The range of this remarkable
 woman's interests and the level of her aspirations are suggested
 by her multifaceted career as a teacher, poet, columnist,
 lecturer, club woman, and political activist committed to
 ameliorating the condition of blacks and women in early
 twentieth-century American society. Her diary constitutes not
 only a chronicle of her endeavors but a barometer of her feelings
 as she struggled for recognition of her talents. Dunbar-Nelson's
 mixed record of success in the public arena was paralleled by an
 equally uneven personal life starting with her early marriage to
 poet Paul Laurence Dunbar. The diary casts valuable light on her
 relationships with both men and women and also provides a view of
 the all-important circle of black women who sustained her.

3 Ingenue among the Lions: The Letters of Emily Clark to Joseph
 Hergesheimer. Edited by Gerald Langford. Austin: University
 of Texas Press, 1965, 221 pp.
 As editor of the Reviewer, a fledgling literary magazine
 based in Richmond, **Emily Tapscott Clark** (Balch) (1893-1953), a
 young single woman from a well-known Virginia family, sought to
 attract the attention of established authors. Her introduction
 to novelist Joseph Hergesheimer sparked a correspondence that ran

1921

between 1921 and 1924 and ranged over a variety of topics related to the magazine's contents, financial condition, readership, and reputation. Clark's animated letters are filled with intriguing vignettes of literary figures of the 1920s as well as shrewd observations on Virginians and Virginia. They also reveal a great deal about Clark herself--her pride in her own writing and her opinions of other people's work.

4 "Our Automobile Trip to the West, 1921." Edited by Edith Rohrbough Slate and Geri Ellen Howard. Oregon Historical Quarterly 85 (1984):253-77.
 Cross-country automobile travel was still a novelty in May 1921 when **Edith Dell Rohrbough Slate** (1888?-?), her husband, Thomas, and their two young children set out from Washington, D.C., for Portland, Oregon, in a "housecar" Thomas, an inventor, had built. Edith's diary of the trip, which ended in August 1921 when an accident near North Platte, Nebraska, forced the family to complete their journey home by train, recounts sightseeing at Gettysburg, Philadelphia, and Niagara Falls and visiting relatives in Elvaston, Illinois, as well as her husband's efforts to promote his inventions at the Ford Motor Company in Detroit.

1922

1 Bring Me a Unicorn: Diaries and Letters of Anne Morrow Lindbergh 1922-1928. New York: Harcourt Brace Jovanovich, 1972, 259 pp.
 The intense public exposure that confronted **Anne Morrow Lindbergh** (1906-) after her marriage to famed aviator Charles Lindbergh contrasted markedly with the sheltered life she had led as the daughter of an affluent Englewood, New Jersey, family. The character of Anne's privileged upbringing as well as the distinguishing features of her personality are brought to light in the first of five volumes of selections from her diaries and letters, covering the years 1922 to 1928. Excessively shy and strongly attached to her parents, sisters, and brother, Anne nonetheless welcomed the opportunity to attend Smith College and further her aspirations toward a literary career. Her letters from college chart her intellectual maturation as well as her struggles with examinations. On a vacation trip to Mexico, where her father was the American ambassador, Anne met Charles Lindbergh. Her diary and letters record in detail how she found herself drawn to the popular hero and his alien way of life. See also 1929.2; 1933.4; 1936.1; 1939.2.

2 "Letters from Authors." [Edited by] Levette Jay Davidson. Colorado Magazine 19 (1942):122-126.
 This article contains two lengthy letters written by author **Mary Anna Hallock Foote** (1847-1938) to Thomas F. Dawson, curator

of the State Historical Society of Colorado, in October 1922.
The letters supply information on Foote's experiences in
Leadville, Colorado, in the late 1870s, her writings set in
Colorado, and her meeting with Helen Hunt Jackson.

3 Letters Written to Winifred Comstock Bowman 1923-1963, by
 Abbie Findlay Potts. London and New York: Regency Press,
 1975, 225 pp.
 College professor **Abbie Findlay Potts** (1884-1964), a single
woman, offered counsel and friendship to Winifred Comstock Bowman
from the time she was a student at Vassar College, through her
years as a wife, mother, and grandmother, to her stint as a
career woman. The letters Potts wrote Bowman between 1922 and
1963 attest to the strong ties between the two women and hint at
just how important Potts's former students were to her. The
correspondence also furnishes a history of Potts's professional
life as a teacher of English literature and theater at Rockford
College in Illinois. Her lively comments on her work reveal the
pleasure she derived from producing plays, writing poetry, and
engaging in scholarly research and publication. The concern
Potts felt for her mother, brother, and other relatives emerges
most clearly from the letters she penned from her family home in
Troy, New York. Potts's love of the life of the mind and her
pursuit of excellence as a scholar continued into her retirement
years.

4 To Remember Forever: The Journal of a College Girl 1922-1923,
 by Gladys Hasty Carroll. Boston and Toronto: Little, Brown
 & Co., 1963, 306 pp.
 From the vantage point of a successful author looking back
after forty years, **Gladys Hasty Carroll** (1904-) edited this jour-
nal she kept as a sophomore at Bates College in Lewiston, Maine.
Comprised of ten lengthy entries written retrospectively at
intervals between August 1922 and June 1923, the journal, notable
for its professional literary quality, weaves excerpts from
letters to her mother into a narrative that combines self-
analysis with the chronicling of events. What emerges is a
compelling picture of Gladys Hasty's family life on a farm in
South Berwick, Maine, and her college experiences during a year
marked by the recognition of her literary talent and the flower-
ing of romantic love. Although lacking in spontaneity, the
journal nonetheless captures the state of mind of a bright and
articulate young woman on the brink of adulthood.

1925

1 My Other Loneliness: Letters of Thomas Wolfe and Aline
 Bernstein. Edited by Suzanne Stutman. Chapel Hill and
 London: University of North Carolina Press, 1983, 390 pp.
 The joys and disappointments of her prolonged love affair
with novelist Thomas Wolfe are reflected in the letters **Aline
Frankau Bernstein** (1881-1955) wrote Wolfe between 1925 and 1936.
Bernstein, a middle-aged wife and mother of Jewish background,
was passionately attached to the much younger and Christian
Wolfe, and her letters to him are filled with expressions of
affection and concern for his work and well-being. Though the
letters center around her intense feelings for Wolfe, they also
reveal much about Bernstein's career as a stage and costume
designer for the theater in New York City, her relations with
family and friends, and her own efforts at writing.

2 The Southern Mandarins: Letters of Caroline Gordon to Sally
 Wood, 1924-1937. Edited by Sally Wood. Baton Rouge and
 London: Louisiana State University Press, 1984, 218 pp.
 Novelist **Caroline Gordon** (Tate) (1895-1981) perennially
strove to carve out time for her writing while still fulfilling
her obligations as a wife, mother, and worthy southern hostess.
The flavor and tempo of Gordon's life with her husband, poet
Allen Tate, at their home near Clarksville, Tennessee, and else-
where are captured indelibly in the letters she wrote to her
close friend, Sally Wood, between 1925 and 1937. These absorbing
letters reveal how Gordon managed to produce novels and short
stories at the same time as she cared for her daughter, main-
tained friendly relations with a large circle of kin and neigh-
bors, and catered to the needs of a steady stream of visitors
from the world of letters.

1926

1 Letters from Jenny. Edited and interpreted by Gordon W.
 Allport. New York: Harcourt, Brace & World, 1965, 223 pp.
 Psychologist Gordon Allport describes the letters of **Jenny
Gove Masterson** (pseud.) (1868-1937) as a rich source for the
study of human personality. Whether viewed as the raw material
for psychological analysis or simply as the testament of a
deeply troubled elderly widow living in New York City, Jennie's
correspondence with her son's college roommate and his wife from
1926 to 1937 is indisputably fascinating. As she wrote, Jennie
revealed herself. Her definition of herself as both Irish and
Protestant, her love of art and literature, her determination to
remain independent at all costs, her perpetual problems in
relating to family and friends, and her pessimistic philosophy
of life all come into sharp focus in letters filled with accounts

of extraordinary incidents. But the center of Jennie's existence was her only son, and it was his errant behavior that prompted her most heated effusions. After his death in 1929, Jennie became preoccupied with the pain of aging and loneliness. Her last years were spent in a home for aged women, and she communicated her harsh perceptions of this experience with candor.

1927

1 Dust Bowl Diary, by Ann Marie Low. Lincoln and London: University of Nebraska Press, 1904, 100 pp.
 Drought, dust storms, and depression form the backdrop for the diary kept by North Dakotan **Ann Marie Low** (1912-) between 1927 and 1937. Low has edited and shaped her youthful diary for publication, adding a connecting narrative that furnishes details regarding family and community events. The portrait that emerges from the selected entries is of a highly competent and resilient young woman who faced the successive crises of the era with fortitude. Accustomed to arduous labor on the family farm in southeastern North Dakota, Ann worked to put herself through Jamestown College and then took a series of teaching positions in the state. Compelled by financial hardship to contribute to the support of family members, Ann dreamed ultimately of setting her own life course. The diary reveals her reluctance to marry despite a number of suitors. Initially determined to remain in the Stony Brook country she loved, Ann altered her plans following the federal government's intrusion into the region. Her passionate criticism of New Deal programs such as the wildlife refuge and Civilian Conservation Corps (CCC) camp that consumed the local land bears witness to her unusual independence of spirit in a difficult time.

1929

1 Diry [sic] of Sylvia McNeely. New York: Longmans, Green & Co., 1931, 121 pp.
 Sylvia McNeely (1919-?) was nine years old when she commenced this diary for the year 1929. Her brief daily entries discussing family, friends, church, school, and play suggest what it was like to be a child growing up in comfortable circumstances in an Iowa town. With its idiosyncratic spellings and occasional poems, Sylvia's diary captures the enthusiasms, prejudices, and abiding curiosity about life of a spirited young girl.

1929

2 Hour of Gold, Hour of Lead: Diaries and Letters of Anne
 Morrow Lindbergh 1929-1932. New York and London: Harcourt
 Brace Jovanovich, 1973, 340 pp.
 Following her marriage to Charles Lindbergh in 1929, **Anne
 Morrow Lindbergh** (1906-) was introduced to the world of flying
 and responded with enthusiasm and courage. The second volume of
 her diaries and letters, which deals with the period 1929 to
 1932, preserves her accounts of adventurous survey flights with
 her husband and her impressions of the diverse places they
 visited. Her happiness at the birth of a son and her delight in
 chronicling his development were abruptly terminated by the
 child's kidnapping and murder. Because of the celebrity of the
 case, Anne's version of the Lindberghs' ordeal is of exceptional
 interest. But it is the disclosure of how she faced the tragedy
 and later felt a sense of renewal after the birth of a second son
 that places the episode in its human context. See also 1922.1;
 1933.4; 1936.1; 1939.2.

1930

1 The Letters of Elizabeth Sherman Lindsay 1911-1954. Edited by
 Olivia James. New York: Privately printed, 1960, 246 pp.
 Elizabeth Sherman Hoyt Lindsay (1885-1954), a member of a
 well-to-do New York family, spent much of her adult life outside
 the United States, and the majority of these letters to her
 friend Olivia James were written from Europe. Lindsay married a
 British diplomat in 1924, and his career took her back to America
 in the 1930s. Her letters from the British embassy in Washing-
 ton, D.C., and from vacation spots in Florida and Arizona during
 this decade provide a sophisticated commentary on the rituals of
 upper-class society and the diplomatic corps and also give evi-
 dence of her concern for her own health and that of her pet dog.

1931

1 Silent Hattie Speaks: The Personal Journal of Senator Hattie
 Caraway. Edited by Diane D. Kincaid. Westport, Conn.:
 Greenwood Press, 1979, 151 pp.
 Appointed to fill her husband's Senate seat after his death
 in 1931, **Hattie Ophelia Wyatt Caraway** (1878-1950) subsequently
 was elected to office on her own and served as Democratic senator
 from Arkansas for a total of thirteen years. The journal she
 kept regularly from December 1931 to June 1932, and then resumed
 briefly in early 1934, traces her development from a political
 novice to an assured public figure committed to discharging her
 obligations to her constituents as effectively as possible. Ini-
 tially captivated by the attire, mannerisms, and oratorical
 styles of her colleagues, she gradually shifted her attention to
 the substance of the issues being debated and formulated her own

opinions on them. Strongly critical of President Hoover, she later became a loyal supporter of Franklin Roosevelt's New Deal. Painfully aware of her anomalous position as a female senator, Caraway cataloged the slights she experienced and became increasingly determined to prove that women were capable of playing a meaningful role in politics. Though occupied by her work throughout this period, Senator Caraway was still a grieving widow and looked to her three sons for comfort and support.

1932

1 Leaves from a Doctor's Diary, by Edith E. Johnson. Palo Alto, Calif.: Pacific Books, 1954, 279 pp.
 Late in life, **Dr. Edith E. Johnson**, a single woman, decided to publish portions of the voluminous diary she had kept since 1927. The entries she selected for her book, spanning the years 1932 to 1953, disclose little of her personal life, focusing instead on her practice as an obstetrician in Palo Alto, California. Dr. Johnson detailed the medical and personal problems of her patients, who were primarily poor people from minority ethnic groups, and explained how she treated them. It is evident that she held a sympathetic, yet somewhat condescending attitude toward her patients. The diary also includes anecdotes and accounts of significant public events.

1933

1 Beyond Love and Loyalty: The Letters of Thomas Wolfe and Elizabeth Nowell. Together with "No More Rivers," a Story by Thomas Wolfe. Edited by Richard S. Kennedy. Chapel Hill and London: University of North Carolina Press, 1983, 164 pp.
 Literary agent **Elizabeth Howland Nowell** (Perkins) (1904-1959) played a vital role in editing and marketing the writings of Thomas Wolfe. Nowell's unshakable belief in the talent of her volatile client as well as her genuine affection for him as a person are evident in her correspondence with him over the years 1933-38. A single career woman, Nowell was willing to put in an inordinate amount of time pruning Wolfe's manuscripts to make them salable to magazines. The letters bring to light her consummate editorial skills, her knowledge of the New York City publishing business, and most of all, the integrity that was her hallmark.

2 "The Diary of Edith K.O. Clark." Annals of Wyoming 39 (1967): 217-44.
 The enthusiasm with which **Edith K.O. Clark** (?-1936) approached homesteading in Johnson County, Wyoming, radiates from her diary record of the summers of 1933 and 1934. A single woman in her early fifties, Clark savored her primitive outdoor life

and wrote with passion and wit of her adventures in building a
log cabin, the spectacular mountain sunsets, and the efforts of
her friends to combat a raging forest fire.

3 Eleanor Roosevelt, an Eager Spirit: The Letters of Dorothy
 Dow 1933-1945. Edited by Ruth K. McClure. New York and
 London: W.W. Norton & Co., 1984, 252 pp.
 As a secretary in the White House Social Bureau assigned to
 work for Eleanor Roosevelt both in Washington and at Val-Kill,
 Mrs. Roosevelt's cottage on the family estate in Hyde Park, New
 York, **Dorothy Dow** (Butturff) (1904-) was in a unique position to
 observe the First Lady. Her correspondence with her mother,
 sister, and husband between 1933 and 1945 provides an intimate
 view of Mrs. Roosevelt's family and social life as well as her
 work and public activities. More than half of the letters in-
 cluded in this volume were written in the critical year 1945 and
 cast light on the early stages of Eleanor Roosevelt's widowhood.
 Although the editor of this book has shaped Dow's correspondence
 to focus on Mrs. Roosevelt by deleting most personal material,
 these letters nonetheless paint a portrait of an efficient and
 level-headed young working woman who, for all her curiosity about
 the life-style of the wealthy and famous, never lost sight of her
 own identity. Despite her fondness for Mrs. Roosevelt, Dorothy
 persistently marked the distance that separated them. Dorothy
 Dow married in 1934 and became a mother in 1941, and these let-
 ters contain clues to the nature of her marital relationship and
 her abiding concern for her handicapped young daughter.

4 Locked Rooms and Open Doors: Diaries and Letters of Anne
 Morrow Lindbergh 1933-1935. New York and London: Harcourt
 Brace Jovanovich, 1974, 352 pp.
 From 1933 to 1935, the years covered in the third volume of
 her diaries and letters, **Anne Morrow Lindbergh** (1906-) worked to
 rebuild her life after the loss of her first son. Continuing her
 expeditions with her husband, Anne traveled to the far corners of
 the globe and wrote of the rigors of flying in primitive air-
 craft, the fears that gnawed at her, and the newness of her
 experiences. Taking a major step toward fulfilling her own
 personal dreams, she completed her first book, North to the
 Orient, and recorded her excitement when it was accepted for
 publication. Anne wrote lovingly of her small son, but her life
 was shadowed by the kidnap and murder trial, the unrelenting
 publicity, and her ever-present concern for her child's safety.
 The death of her sister brought her additional pain in this
 already troubled period. See also 1922.1; 1929.2; 1936.1;
 1939.2.

1936

1 The Flower and the Nettle: Diaries and Letters of Anne
 Morrow Lindbergh 1936-1939. New York and London: Harcourt
 Brace Jovanovich, 1976, 605 pp.
 Europe provides the setting for the fourth volume of the
 diaries and letters of **Anne Morrow Lindbergh** (1906-) spanning
 the years 1936 to 1939. Desperate for privacy in which to
 nurture their marriage and raise their son, the Lindberghs moved
 to England and then France just as the European situation was
 becoming more critical. Pleased with her secluded life, Anne
 wrote at length of domestic details, social events, the birth of
 a third son, and her work on another book. Travel added spice to
 her life, as the still celebrated couple visited India, Russia,
 and Germany. Involvement in contemporary political debates was
 unavoidable in such a turbulent time, and Anne's writings shed
 considerable light on the Lindberghs' controversial views. Of
 particular interest is her account of her husband's activities in
 Nazi Germany. See also 1922.1; 1929.2; 1933.4; 1939.2.

2 Helen Keller's Journal 1936-1937. Garden City, N.Y.:
 Doubleday, Doran & Co., 1938, 313 pp.
 The death of Anne Sullivan Macy, her beloved "Teacher" and
 companion for almost fifty years, in October 1936 was a traumatic
 event in the life of **Helen Adams Keller** (1880-1968). World-
 famous not only for surmounting her handicaps but as a writer,
 lecturer, and advocate for the blind, Keller forced herself to go
 on with her work in the face of overwhelming grief. This jour-
 nal, kept from November 1936 to April 1937, a period during which
 she visited England and Scotland, returned briefly to her home in
 Forest Hills, New York, and then embarked on a trip to Japan,
 constitutes a moving testament of her adjustment to an existence
 without "Teacher." The journal holds interest not only as an
 account of Keller's activities but as a record of her emotions,
 beliefs, and aspirations. A stimulating mixture of personal
 reflections, reactions to current events and books, and recol-
 lections of famous personages, it reveals Keller as a person of
 wide-ranging knowledge and deep sensitivity.

3 Margaret Mitchell's "Gone with the Wind" Letters 1936-1949.
 Edited by Richard Harwell. New York: Macmillan Publishing
 Co., 1976, 441 pp.
 The perils of instant celebrity are vividly illustrated in
 the correspondence of **Margaret Munnerlyn Mitchell** (Marsh) (1900-
 1949) from the time her best-selling novel Gone with the Wind was
 published in 1936 to her death in 1949. An Atlanta housewife
 with a background in journalism, Mitchell struggled valiantly to
 maintain her privacy as she was inundated with innumerable re-
 quests for information, advice, personal appearances, and favors

in connection with the book at first and then with the movie.
The hundreds of letters printed here, although not of a private
nature, provide valuable clues to Mitchell's personality as well
as offering insights into her method of historical research, her
conception of the book, and her strong identification with the
South. The correspondence also sheds light on her attitude
toward Hollywood and her handling of business and legal matters.

1939

1 Dear Me: Leaves from the Diary of Agnes Sligh Turnbull. New
 York: Macmillan Co., 1941, 170 pp.
 After creating countless imaginary characters over the
 years, novelist **Agnes Sligh Turnbull** (1888-1982) decided in her
 early fifties to begin a diary in order to examine her own life.
 The diary, which covers the period from September 1939 to March
 1941, conveys Turnbull's contentment in her multiple roles of
 wife, mother, hostess, community worker, writer, and lecturer.
 Interspersed among the often-humorous descriptions of daily
 happenings are Turnbull's reflections on the status of women and
 men, the critical situation in England at the onset of World
 War II, and the differences between the past and the present.

2 War Within and Without: Diaries and Letters of Anne Morrow
 Lindbergh 1939-1944. New York: Harcourt Brace Jovanovich,
 1980, 471 pp.
 When her husband was subjected to massive abuse for his
 isolationist views on the eve of World War II, **Anne Morrow
 Lindbergh** (1906-) came to his defense. In addition to disclosing
 her feelings during this traumatic period, the fifth volume of
 her diaries and letters, spanning the years 1939-44, treats
 Anne's own involvement in the politics of the period and the pub-
 lication of her widely criticized book defending the pacifist
 position. Against the backdrop of public criticism and the
 shadows of war, Anne also continued to explore the unresolved
 tension between her need to write and her dedication to her grow-
 ing family. See also 1922.1; 1929.2; 1933.4; 1936.1.

1942

1 "Portland Assembly Center: Diary of Saku Tomita." Translated
 by Zuigaku Kodachi and Jan Heikkala. Edited by Janet Cormack.
 Oregon Historical Quarterly 81 (1980):149-71.
 After the bombing of Pearl Harbor, the federal government
 ordered the relocation of Japanese-Americans living on the West
 Coast. **Mrs. Saku Tomita**, a middle-aged Issei (a member of the
 immigrant generation of Japanese Americans), along with her
 family, was placed in the Portland (Oregon) Assembly Center
 before being relocated. Her diary, recounting her experiences

between May and August 1942, is strictly reportorial in tone, the brief entries supplying concrete details on everyday activities in the detention center. In a dispassionate tone, Mrs. Tomita comments on the discomforts caused by conditions in the camp, arbitrary regulations, food shortages, and illness, betraying little emotion at the disruption of her family's life. Students of Japanese-American women will find Mrs. Tomita's diary of exceptional interest.

1943

1 Ladies in Pants: A Home Front Diary, by Mable R. Gerken. New York: Exposition Press, 1949, 96 pp.
 During the Second World War, thousands of American women labored in defense plants to aid the war effort. **Mable R. Gerken**, a middle-aged wife and mother of two grown sons, felt it was her patriotic duty to take a job at an aircraft factory near her home in southern California. A woman with a background in writing, she deliberately kept a diary during her period of employment--January 1943 to August 1945--in order to preserve a record of the contributions of the housewives who formed the backbone of these war industries. Focused almost exclusively on the internal life of the plant, the diary is a storehouse of information on the nature of the work performed by women, the interaction between employees, and the social relationships fostered by working together in a common endeavor. Initially self-conscious because of her age and appearance, Gerken soon blended into the work force, rising from stockroom clerk to supervisor. Her rehearsal of everyday incidents in the factory coupled with her profiles of co-workers brings to life the unique experience of a generation of women.

2 A World of Love: Eleanor Roosevelt and Her Friends 1943-1962, by Joseph P. Lash. Garden City, N.Y.: Doubleday & Co., 1984, 610 pp.
 This volume, the sequel to Love, Eleanor: Eleanor Roosevelt and Her Friends, prints extracts from the correspondence of **Anna Eleanor Roosevelt** (1884-1962) from 1943 to her death in 1962. Although a substantial number of letters to Franklin D. Roosevelt and to her children are included here, the emphasis continues to be on Eleanor's letters to her friends. Still deeply attached to Joseph P. Lash and Trude Pratt, his wife as of 1944, Eleanor kept up her inspiriting communications to them, buoying their confidence during a difficult time. After Franklin Roosevelt's death in 1945, Eleanor embarked on an independent career as a delegate to the first United Nations General Assembly, and her ensuing correspondence reflects the satisfaction she derived from her work on the international scene. Eleanor's lifelong quest for affection and intimacy was now

1943

requited by Dr. David Gurewitsch, who became the recipient of
scores of letters that attest to her concern and generosity. In
her correspondence with old and new friends as well as family
members, Eleanor Roosevelt proved an acute observer of people and
events in the postwar world. See also 1903.1; 1916.4.

1946

1 The Lady and the Tycoon: Letters of Rose Wilder Lane and
 Jasper Crane. Edited by Roger Lea MacBride. Caldwell, Idaho:
 Caxton Printers, 1973, 401 pp.
 Between 1946 and 1967, journalist and author **Rose Wilder
 Lane** (1886-1968) carried on an extensive correspondence with
 Jasper Crane, vice president of the Du Pont Company, a man who
 shared her strong belief in the merits of individualism and
 Americanism. Lane's letters to Crane, consisting primarily of an
 exposition of her ideological position, contain her views on cur-
 rent issues, critiques of various books and articles, and
 analyses of political developments. Among the few personal items
 found in the correspondence are Lane's comments on the life and
 work of her mother, Laura Ingalls Wilder, the author of the
 Little House series of children's books. See 1894.1 for the
 diary of Laura Ingalls Wilder and 1915.5 for the letters of Laura
 Ingalls Wilder.

2 "'The Unconfined Role of the Human Imagination': A Selection
 of Letters; Richard Chase and Ruth Benedict, 1945-46."
 [Edited by] Judith Modell. American Studies 23 (1982):49-65.
 Ruth Fulton Benedict (1887-1948), a professor of anthro-
 pology at Columbia University, served as a reader on the disser-
 tation committee of Richard Chase, later to become a well-known
 literary scholar. In the two letters of hers printed here, both
 written from Washington, D.C., in early 1946, she presented her
 critique of Chase's study of myth and culture and responded to
 his objections to her analysis.

1947

1 The Diaries of Judith Malina 1947-1957. New York: Grove
 Press, 1984, 485 pp.
 A person of enormous creative energy, German-born **Judith
 Malina** (Beck) (1926-) is known for her pioneering work in experi-
 mental theater. The selections she has culled from her diaries
 of 1947-57 illuminate all facets of her life--her efforts to
 establish the Living Theatre, her intellectual pursuits, her
 feelings about her Judaism, her political activism, and her inti-
 mate relationships. Producing plays dominated Malina's thoughts,
 and her friends were drawn mainly from the New York theatrical
 world. The daughter of a rabbi, she struggled to reconcile her

unconventional life-style with the religious truths she held
dear. Despite her advanced social attitudes, she was devoted to
her husband, who helped stage her plays, and to her young son and
her mother. As a result of her deep-felt opposition to the
nuclear bomb, Malina was incarcerated for a time in jail and in a
mental hospital.

1948

1 Anne Sexton: A Self-Portrait in Letters. Edited by Linda
 Gray Sexton and Lois Ames. Boston: Houghton Mifflin Co.,
 1977, 390 pp.
 The troubled life of poet **Anne Gray Harvey Sexton** (1928-74)
 is opened to view in this compelling selection from her corre-
 spondence that begins with her elopement in 1948 and follows her
 through marriage, the birth of two daughters, the unfolding of
 her literary career, and divorce to the eve of her suicide in
 1974. Revelations of Sexton's personal struggle for identity
 abound in the letters. In often graphic detail, she described
 the burdens placed on her by her parents, husband, and children,
 the guilt and self-doubt that plagued her, her erratic mood
 swings, her dependence on drugs and alcohol, her suicide
 attempts, and her continuing treatment by psychiatrists. Writ-
 ing poetry, she believed, gave her a means of channeling her
 emotions and saving herself. Her communications with an array of
 writers, editors, agents, and publishers attest to her whole-
 hearted commitment to her craft, despite her chaotic private
 existence. Sexton wrote at length about the content of her
 poems, stories, and plays, her work habits, her public readings,
 her teaching, the awards she received, and her conception of
 appropriate remuneration.

2 The Habit of Being, by Flannery O'Connor. Letters edited and
 with an introduction by Sally Fitzgerald. New York: Farrar,
 Straus & Giroux, 1979, 617 pp.
 The courageous spirit and exceptional writing talent of
 Flannery O'Connor (1925-64) shines through this extensive and
 rich collection of her letters spanning the years 1948-64.
 Stricken with lupus erythematosus in her mid-twenties and
 restricted to a circumscribed life on her mother's farm near
 Milledgeville, Georgia, she carried on a voluminous correspon-
 dence that nourished friendships with ordinary people as well as
 persons of note. O'Connor's letters enable us to appreciate her
 intellectual powers as well as her spiritual fiber. She evalu-
 ated her own work critically, offered substantive help to other
 writers, and enunciated her literary preferences in no uncertain
 terms. She had a penchant for discussing theology and illumi-
 nated the roots of her Catholic belief. A single woman, fre-
 quently denied the companionship of others with similar

interests, she regaled her correspondents with amusing stories, practical advice, and serious reflections.

1950

1 Death House Letters of Ethel and Julius Rosenberg. New York: Jero Publishing Co., 1953, 168 pp.
 Arrested, convicted, and sentenced to die for "conspiracy to commit treason," **Ethel Greenglass Rosenberg** (1915-53) was housed separately from her husband, Julius, during their long imprisonment at Sing Sing and allowed only periodic supervised visits with him. From 1950 to 1953, Ethel communicated with Julius by letter, and this private correspondence, which also includes several letters to their lawyer, Emanuel Bloch, was published for the purpose of raising funds for the support of their two young sons. As their case proceeded through its various stages, Ethel voiced her feelings at the injustice being done to them and pondered their future. Suffering greatly from loneliness, she wrote of her deep desire to be reunited with husband and children. She declared her undying love for Julius and shared with him her enormous concern for the welfare of their children. Faced with the prospect of execution, Ethel Rosenberg maintained her spirit by force of will and left these moving letters as a testament of her courage.

2 The Journals of Sylvia Plath. Foreword by Ted Hughes. Ted Hughes, consulting editor, and Frances McCullough, editor. New York: Dial Press, 1982, 370 pp.
 The suicide of poet and novelist **Sylvia Plath** (Hughes) (1932-63) at the age of thirty heightened interest in her life and work. This selection from her journals, though marred by numerous deletions and covering only the period from 1950 to 1959, provides myriad clues to the inner world of a woman whose powerful drive to succeed as a writer conflicted with her equally strong desire to fulfill the traditional feminine role. A scrupulous recorder of her experiences, Plath filled her journal with the minutiae of her days at Smith College and Cambridge University and later in Boston. Academic and literary triumphs, her relationships with men, her illnesses, her therapy, and her romance and marriage to the English poet Ted Hughes are all chronicled in lavish detail. But the extraordinary intensity of the journals derives from Plath's relentless self-analysis. As she probed her feelings, argued with herself, and rehearsed her goals, she exposed to view the tortuous path of her emotional life. See also 1950.3.

3 Letters Home: Correspondence 1950-1963, by Sylvia Plath.
 Selected and edited with commentary by Aurelia Schober Plath.
 New York: Harper & Row, 1975, 502 pp.
 From the time she entered Smith College in 1950 until the
 week before she took her own life in 1963, poet and novelist
 Sylvia Plath (Hughes) (1932-63) wrote faithfully to her mother
 and brother. A portion of this correspondence, with excisions by
 her mother, is printed here. These letters, which cover much of
 the same ground as Plath's journals, form a fascinating variant
 on the material found there. They convey a picture of an ambi-
 tious young woman with exceptional talent whose aggressive pur-
 suit of a career as a writer and hunger for experience did not
 diminish her loyalty to her mother. The emotional turmoil that
 provided the raw material for her creative work is downplayed in
 her communications to loved ones at home. Because Plath's jour-
 nal entries after 1959 were destroyed, the letters from her last
 years dealing with her domestic life, the birth and growth of her
 children, the collapse of her marriage, her deepening despera-
 tion, and her final outburst of creativity are of unusual inter-
 est. See also 1950.2.

1953

1 Dear Deedee: From the Diaries of Dori Schaffer. Edited by
 Anne Schaffer. Secaucus, N.J.: Lyle Stuart, 1978, 222 pp.
 This is the highly introspective journal of **Dori Schaffer**
 (1938-63), a young woman from southern California who committed
 suicide at the age of twenty-five. Begun in 1953, when she was
 in high school, this well-written diary follows her through col-
 lege and graduate school in New York City, and ends with her
 death in 1963. Dori Schaffer was an extremely bright young
 Jewish woman with strong intellectual interests and liberal
 views. She was an activist in the civil rights movement and was
 enlightened in her notion of sexuality. The basic conflict in
 her life involved her need for a career versus her equally strong
 need for a loving male partner. The diary, despite its gaps,
 graphically details the series of problems that eventually led
 Dori to take her own life, including a brief and unhappy marriage
 to a man who turned out to be a homosexual, and the death of her
 lover in an automobile accident that left her partially disabled.
 Those seeking insight into the inner lives of women who came of
 age in the 1950s and early 1960s will find this haunting diary
 especially rewarding.

1953

2 Touchstones: Letters between Two Women, 1953-1964, by
 Patricia Frazer Lamb and Kathryn Joyce Hohlwein. Edited and
 with additional material by Patricia Frazer Lamb. New York:
 Harper & Row, 1983, 330 pp.
 Brought together while students at the University of Utah
 by their mutual appreciation of literature and music, **Patricia
 Frazer Lamb** (1931-) and **Kathryn Joyce Hohlwein** (1930-) sustained
 their friendship through correspondence from 1953 to 1964. Al-
 though intellectually gifted, both women stifled their own ambi-
 tions and married early, channeling their energy into forwarding
 their husbands' careers and raising children. Both having Euro-
 pean husbands, the women traveled around the globe, Pat settling
 in Tanganyika and Joyce returning to the American Midwest by
 1957. They sketched pictures of the different settings in which
 they lived, discussed their health problems, exchanged views on
 current books and politics, and encouraged each other to continue
 writing poetry. As the years passed, the letters became more
 intimate in nature, as the women analyzed the shortcomings of
 their marriages and offered each other comfort.

1954

1 A Woman's Diary, by Alice Bingle. New York: Vantage Press,
 1958, 91 pp.
 Keeping a diary for her sister and three other close
 friends was just one of the self-assigned tasks of **Alice Bingle**
 (1879-?), a retired nurse who had been in charge of the infirmary
 at Antioch College in Yellow Springs, Ohio. This portion of
 Alice's diary, covering the period between September 1954 and
 January 1955, charts the active life of a single woman in her
 mid-seventies. Firmly rooted in an extensive social network,
 Alice enjoyed a continual round of visiting, shopping, and
 attending church, concerts, movies, lectures, club meetings, and
 special events at the college. In addition, she derived much
 pleasure from solitary pursuits--listening to classical music on
 the radio, observing nature, reading, and most of all, writing.
 At this juncture in her life, Alice was composing her auto-
 biography and the process of reminiscence is also evident in her
 diary, which contains nostalgic vignettes of her childhood in
 England as well as other remembrances. Alice's simple, opti-
 mistic philosophy of life, expressed in her reflections on a
 variety of issues, unifies the diverse materials found in the
 diary.

1956

1 "'But we are not at all distant in sympathy!'--Letters of
 Dorothy Canfield Fisher and Lillian Smith." Edited by Anne C.
 Loveland. Vermont History 52 (1984):17-32.

The racial turmoil in the American South following the Supreme Court's 1954 desegregation decision precipitated this enlightening interchange of seven letters between authors **Dorothy Canfield Fisher** (1879-1958) and **Lillian Smith** (1897-1966) in 1956. Writing for a concerned Arlington, Vermont, Quaker group, Fisher, already advanced in years, sought Smith's guidance on how best to further the cause of equal rights for Negroes. In her forthright responses to Fisher's letters, Lillian Smith offered an incisive analysis of southern views on race relations, clarified her own position as a southern liberal, and ventured an explanation for the exclusion of her writings from the northern popular press. Her devastating critique of William Faulkner is also of considerable interest.

1959

1 The Diary of a Widow, by Frances Beck. Boston: Beacon Press, 1965, 142 pp.
 When her thirty-five-year-old husband died suddenly in 1959, **Frances Beck**, the mother of three young children, turned to diary keeping as a means of coping with the crisis. Covering the period between 1959 and 1962, her diary traces the stages of Frances's adjustment to widowhood, moving from her initial grief and despair to acceptance, planning for the future, and ultimately, remarrying. Matter-of-fact discussions of finances and child care alternate with soul-searching passages that bare the spiritual cornerstones of Frances's life. Recurrent meditations in the form of "conversations" with her deceased husband reveal the loneliness and sexual longing of a young woman caught in an unexpected situation.

1968

1 Members of the Class Will Keep Daily Journals: The Barnard College Journals of Tobi Gillian Sanders and Joan Frances Bennett, Spring 1968. New York: Winter House, 1970, 153 pp.
 This book contains two journals written for a 1968 Barnard College class which required students to keep daily journals and then work up the material in finished papers. "Hard G, Soft G" by **Tobi Gillian Sanders**, a young Jewish woman from Philadelphia, covers the period February-May 1968, when Sanders was a junior at Barnard, and also includes three entries from February 1969. **Joan Frances Bennett**, a young black woman from Taylors, South Carolina, was a freshman at Barnard when she wrote "Back There, Down There" between February and April 1968. These journals record an important stage in the development of two intelligent and articulate college women. Although both journals are introspective, Sanders's journal tends to be concrete, whereas Bennett's is more abstract in nature.

1970

1 Journal of a Solitude, by May Sarton. New York: W.W.
 Norton & Co., 1973, 208 pp.
 During the year 1970-71, when she kept this journal, poet
 and novelist **May Sarton** (1912-) believed that being alone in
 her Nelson, New Hampshire, home was the best remedy for the anger
 and depression that was tormenting her. She wrote in it largely
 to explore her feelings, as she sought to come to terms with her
 identity as a creative artist and the disintegration of an inti-
 mate relationship. But Sarton's journal is also a testament of
 her unflagging interest in ideas, her love of nature, and her
 high regard for friendship. See also 1974.2; 1978.1; 1982.1.

1972

1 Being Seventy: The Measure of a Year, by Elizabeth Gray
 Vining. New York: Viking Press, 1978, 194 pp.
 The advent of old age inspired author **Elizabeth Gray Vining**
 (1902-) to keep a journal of her seventieth year, 1972-73. Well
 educated, successful, and financially independent, Vining enjoyed
 advantages not shared by many of her peers. Nevertheless, she
 still was compelled to grapple with the problems that confront
 older women in modern American society. Widowed at an early age
 and accustomed to being on her own, Vining agonized over whether
 to maintain her apartment or move into an attractive retirement
 community. The element of finality represented in her decision
 to break up her home emerged in other guises during this crucial
 year as she reflected on the loss of an audience for her writ-
 ings, the signs of her physical and mental deterioration, and the
 passing of old friends. In her carefully crafted journal,
 Elizabeth Gray Vining articulates the concerns of an aging woman
 preparing for death with sensitivity and grace.

1974

1 Daybook: The Journal of an Artist, by Anne Truitt. New York:
 Pantheon Books, 1982, 225 pp.
 For **Anne Truitt** (1921-), her journal was the key to unlock-
 ing the secrets of her inner self and establishing her identity
 as an artist. A self-supporting divorced mother of three, Truitt
 kept her journal consistently from June 1974 to 1975 and inter-
 mittently in 1978, 1979, and 1980. Much more than a record of
 outward events, the journal incorporates recollections of her
 family and her early years into a beautifully written meditation
 on the meaning of her life. Truitt's writing is rich in in-
 sights into her work as a sculptor, painter, and professor of art
 as well as the special quality of her relationships with her
 children.

2 The House by the Sea: A Journal, by May Sarton. New York:
W.W. Norton & Co., 1977, 287 pp.
 Following a year of painful inner struggle, poet and
novelist **May Sarton** (1912-) uprooted herself from her home in
Nelson, New Hampshire, and moved to a house by the sea in York,
Maine. This journal, kept from November 1974 to August 1976,
records the meditations of a more serene period in Sarton's life,
one marked by a renewal of her work, the feelings of joy aroused
by her new environment, and the pleasure she took in her new dog.
Yet Sarton's happiness was tempered by the growing senility of
her longtime companion who was now in a nursing home, the deaths
of close friends, and her own bout of illness. See also 1970.1;
1978.1; 1982.1.

1975

1 That Time of Year: A Chronicle of Life in a Nursing Home, by
Joyce Horner. [Amherst]: University of Massachusetts Press,
1982, 207 pp.
 Mentally acute as ever, but increasingly restricted by
physical infirmities, **Joyce Mary Horner** (1903-80), a retired pro-
fessor of English at Mount Holyoke College, entered a nursing
home in western Massachusetts voluntarily. Accustomed to writ-
ing, Horner kept a journal from March 1975 to June 1977 in which
she recorded her own occupations (reading, listening to classical
music, observing birds, and struggling to compose poetry), penned
probing character sketches of nursing home residents and staff
members, and analyzed her feelings. A single woman, Horner
relished occasional visits to her former home and friends but
came to realize the irreversibility of her situation. The
insight the journal affords into her thought processes as she
faced the degeneration of old age and the prospect of death make
it a singularly rewarding document.

1976

1 Nan, Sarah and Clare: Letters between Friends, by Nan Bishop,
Sarah Hamilton, and Clare Bowman. New York: Avon Books,
1980, 300 pp.
 The impact of feminist values on the personal lives of
women in the 1970s is graphically conveyed in this interchange of
letters between three close friends from college years, who were
then in their early thirties--**Nan Bishop** of Sperry Corners, New
York, **Sarah Hamilton** of Indianapolis, and **Clare Bowman** of
Portland, Oregon. Separately struggling to cope with the dis-
solution of their troubled marriages, the responsibilities of
single parenthood, financial difficulties, and the search for
meaningful work, the women rediscovered their affinity for one
another and initiated an intense, self-revealing, three-way

1976

correspondence between December 1976 and June 1977. The letters
became a means to examine their innermost feelings as they re-
defined their needs and goals. Buoyed by the support and en-
couragement of their confidants, Bishop, Hamilton, and Bowman
wrote in great detail of their relationships with their husbands,
sons, and families, their sexual experiences, their jobs, and
their reading. In the process, they came to understand their
disillusionment with traditional female roles and realized their
desire for work that would use their creative potential. During
the cycle of letter writing, the notion of publishing a book
together surfaced, eventuating in this edited version of their
correspondence.

1978

1 Recovering: A Journal, by May Sarton. New York: W.W. Norton
 & Co., 1980, 246 pp.
 In the year spanned by this journal, 1978-79, poet and
 novelist **May Sarton** (1912-) had to combat both professional and
 personal crises--the distress caused by a highly critical review
 of her most recent novel in the New York Times, a mastectomy, and
 her unfulfilled yearning for love. A remarkably resilient indi-
 vidual, Sarton drew on her inner resources as she moved to regain
 her equilibrium. Much more than a chronicle of recovering, her
 journal is a storehouse of mature reflections on literature,
 world events, lesbianism, and senility. See also 1970.1; 1974.2;
 1982.1.

1980

1 Winter Season: A Dancer's Journal, by Toni Bentley. New
 York: Random House, 1982, 150 pp.
 Australian-born ballet dancer **Toni Bentley** (1958-), a young
 single woman, kept a journal during the 1980-81 season of the New
 York City Ballet in order to assess the progress of her career.
 Bentley's journal illuminates many facets of the life of a ballet
 company member--the grueling practice routines, the meticulous
 attention paid to ballet slippers, cosmetics, work clothes, and
 diet, and the camaraderie between dancers--as well as charting
 her own personal responses to the world of ballet.

1982

1 At Seventy: A Journal, by May Sarton. New York: W.W. Norton
 & Co., 1984, 334 pp.
 The attainment of the age of seventy was the occasion for
 poet and novelist **May Sarton** (1912-) to begin another journal,
 one that covers the year 1982-83. In it, she squarely confronted
 the fact of her advancing age and pondered the essence of the

time remaining to her. Sarton's zest for living had not abated, and she still relished her seacoast home in York, Maine, her dog and cat, and the birds and the flowers. The journal captures the rhythm of her existence--reading and writing, composing letters, gardening, travel, periodic poetry readings, and the enriching visits of friends. See also 1970.1; 1974.2; 1978.1.

Author Index

Abell, Mary Abigail Chaffee,
 1865.5
Aber, Martha Wilson McGregor,
 1886.5
Adams, Abigail Smith, 1762.1;
 1785.1; 1788.2; 1808.1
Adams, Cecelia McMillen, 1845.1
Adams, Marian (Clover) Hooper,
 1865.4
Alcott, Abigail May, 1871.4
Alcott, Louisa May, 1843.4
Alexander, Eveline Throop
 Martin, 1866.3
Allen, Ann Isabella Barry McCue,
 1835.1
Almy, Mary Gould, 1778.3
Alston, Theodosia Burr, 1803.1
Ambler, Mary Cary, 1770.1
Ames, Blanche Butler, 1860.2
Ames, Mary, 1865.3
Andrews, Eliza Frances, 1864.10
Andrews, Emily Kemble (Oliver)
 Brown, 1874.5
Andrews, Sarah E., 1864.9
Anthony, Susan Brownell, 1852.2
Anthony, Susanna, 1740.1
Assheton, Susan, 1801.3
Austin, Mary Hunter, 1904.1
Ayer, Sarah Newman Connell,
 1805.2
Ayscough, Florence Wheelock
 (McNair), 1917.2

Bacon, Lydia B. Stetson, 1811.2
Bacon, Mary Ann, 1796.1
Bailey, Mary Stuart, 1849.4
Baker, Jean Rio Griffiths
 (Pearce), 1845.1
Baker, Kate Stuart, 1849.10
Baker, Mary Elizabeth Stuart
 Turner, 1849.10
Baldwin, Abigail Pollard, 1853.13
Ballard, Martha Moore, 1785.2

Barbour, Martha Isabella Hopkins
 (Bunch), 1846.4
Barnitz, Jennie Platt, 1867.4
Bartlett, Mary, 1775.1
Bascom, Ruth Henshaw. See
 Henshaw, Ruth (Miles)
 (Bascom)
Bayley, Elizabeth (Betsey)
 Munson, 1845.1
Beach, Elizabeth Jane Renfroe,
 1864.12
Beck, Frances, 1959.1
Belknap, Kitturah (or Keturah)
 Penton, 1839.2; 1845.1
Belshaw, Maria Parsons, 1853.2
Benedict, Ruth Fulton, 1946.2
Bennett, Joan Frances, 1968.1
Bent, Levancia, 1882.2
Bentley, Anna Briggs, 1826.1
Bentley, Toni, 1980.1
Bernstein, Aline Frankau, 1925.1
Bigelow, Ellen, 1835.3
Bingle, Alice, 1954.1
Birchard, Mary Roxana, 1867.6
Bishop, Nan, 1976.1
Black, Elizabeth Gundaker Dale
 (Mrs. William M. Black),
 1852.8
Blackwell, Antoinette Brown. See
 Brown, Antoinette (Blackwell)
Blaine, Catherine Paine, 1852.6
Blaine, Harriet Bailey Stanwood,
 1869.2
Blaine, Pansy, 1887.3
Blanchard, Elizabeth Howell,
 1844.1
Blank, Parthenia McMillen,
 1845.1
Bogan, Louise (Alexander)
 (Holden), 1920.2
Boggs, Mary Jane (Holladay),
 1851.7
Bond, Catherine, 1846.2
Botta, Anne Charlotte Lynch,
 1835.5

Coon, Polly Lavinia Crandall
(Price), 1845.1
Cooper, Mary Wright, 1768.1
Cox, Nancy Lawley, 1866.4
Cowles, Julia, 1796.1; 1797.1
Cranch, Elizabeth (Norton),
1785.3
Crane, Grace Edna Hart, 1916.2
Cranston, Susan Amelia Marsh,
1845.1
Crawford, Florence (Capper), 1891.2
Crowninshield, Mary Boardman,
1814.4; 1815.3
Cumming, Elizabeth Wells Randall,
1857.3
Cumming, Kate, 1862.13
Cumming, Katharine Jane Hubbell,
1860.11
Cummings, Mariett Foster, 1845.1
Curd, Mary Samuella (Sam) Hart,
1860.13
Custer, Elizabeth Bacon, 1866.6

Daly, Maria Lydig, 1861.9
Dart, Eliza Catlin, 1835.2
Davidson, Margaret Miller, 1833.2
Davis, Sarah Green, 1845.1
Davis, Margaret Howell, 1845.3
Davis, Varina Anne Howell, 1845.3;
1886.3
Davis, Varina Anne (Winnie),
1845.3; 1886.3
Dawson, Sarah Ida Fowler Morgan.
See Morgan, Sarah Ida
Fowler (Dawson)
De Lancey, Margaret Munro
(Rochester), 1849.2
Denison, Alice, 1885.2
Dewees, Mary Coburn, 1788.1
Dickinson, Emily, 1842.1; 1847.3
Dickinson, Lavinia Norcross,
1847.3
Dix, Dorothea Lynde, 1850.3
Dodge, Mary Abigail (Gail
Hamilton), 1845.2
Donner, Tamsen Eustis, 1845.1
Donovan, Minerva Padden, 1846.3
Dow, Dorothy (Butturff), 1933.3
Draper, Ruth, 1915.3
Drinker, Elizabeth Sandwith,
1758.1
Drinkwater, Alice Gray, 1898.1

Dunbar-Nelson, Alice Ruth Moore,
1921.2
Duncan, Elizabeth Caldwell Smith,
1824.2
Duniway, Abigail Jane Scott. See
Scott, Abigail Jane
(Duniway)
Dunlap, Catherine (Kate)
Cruickshank, 1864.8
Dwight, Margaret Van Horn (Bell),
1810.1
Dwight, Mary Ann (or Marianne)
(Orvis), 1844.2

Earhart, Amelia Mary (Putnam),
1916.1
Ebey, Emily Palmer Sconce, 1856.3
Ebey, Rebecca Whitby Davis, 1852.1
Edgerton, Mary Wright, 1863.6
Edmondston, Catherine Ann
Devereux, 1860.8
Eells, Myra Fairbanks, 1836.1
Emerson, Ellen Tucker, 1846.5
Endressen, Guri, 1837.3
English, Lydia E., 1875.1
Enos, Salome Paddock, 1815.1
Eppes, Susan Bradford. See
Bradford, Susan (Eppes)
Erickson, Anna, 1909.1
Erickson, Ethel, 1909.1
Espy, Harriett Newell (Vance),
1851.6
Eubank, Mary James, 1853.7
Evans, Augusta Jane (Wilson),
1867.2
Eve, Sarah, 1772.1
Everett, Sarah Maria Colegrove,
1855.2

Fairfax, Sally Cary, 1771.1
Farmar, Eliza, 1774.1
Farnham, Jerusha Brewster Loomis,
1837.4
Fearn, Frances (Mother of),
1862.5
Fedde, Elizabeth (Slettebo),
1883.3
Ferris, Anna M., 1860.3
Few, Frances (Chrystie), 1808.2
Fisher, Dorothy Canfield, 1956.1
Fisher, Rachel Joy (Mills), 1845.1
Fisher, Sally (Corbit), 1779.1

Rockefeller, Abby Greene Aldrich,
1919.1
Roos, Rosalie, 1851.4
Roosevelt, Anna (Dall)
(Boettiger) Halsted. See
Halsted, Anna Roosevelt
(Dall) (Boettiger)
Roosevelt, Anna Eleanor, 1903.1;
1916.4; 1943.2
Ropes, Hannah Anderson Chandler,
1862.1
Rose, Hilda, 1918.3
Rosenberg, Ethel Greenglass,
1950.1
Russell, Marion B., 1893.3
Rutledge, Harriott Horry
(Ravenel), 1841.1

St.John, Esther, 1858.1
St. John, Mary (Cutting), 1858.1
Sabin, Ellen Clara, 1921.1
Saehle, Jannicke, 1837.3
Salisbury, Harriet Hutchinson.
See Hutchinson, Harriet
(Salisbury)
Samuels, Kathleen Boone, 1860.5
Sanders, Tobi Gillian, 1968.1
Sanford, Mollie Dorsey, 1857.6
Sarton, May, 1970.1; 1974.2;
1978.1; 1982.1
Savage, Pamela (Moore), 1825.3
Sawyer, Francis, 1845.1
Schaffer, Dori, 1953.1
Scott, Abigail Jane (Duniway),
1845.1
Sears, Mary, 1859.4
Secor, Lella Faye (Florence),
1915.2
Sedgwick, Catharine Maria, 1800.3
Sessions, Patty Bartlett (Parry),
1845.1
Seton, Elizabeth Ann Bayley,
1796.2; 1798.1
Seward, Anna (Pruitt), 1883.1
Sexton, Anne Gray Harvey, 1948.1
Sharp, Cornelia A., 1853.4
Shaw, Anna Howard, 1905.1
Sheldon, Charlotte, 1796.1
Sheldon, Lucy, 1796.1
Sherwood, Laura Bostwick,
1814.3

Shipman, Joanna (Bosworth),
1834.2
Shippen, Nancy. See Livingston,
Anne (Nancy) Home Shippen
Shrode, Maria Hargrave, 1849.4
Shutes, Mary Alice (Mallory),
1862.21
Sims, Mary Ann Owen, 1855.5
Slate, Edith Dell Rohrbough,
1921.4
Smith, Alice, 1868.2
Smith, Alice Weston, 1886.2
Smith, Eliza Carolina Middleton
Huger, 1861.19
Smith, Elizabeth Dixon (Geer),
1845.1; 1847.2
Smith, Harriet Amelia, 1863.13
Smith, Lillian, 1956.1
Smith, Margaret Bayard, 1800.2
Smith, Sadie B. (Trail), 1896.2;
1900.1
Smith, Sallie Diana (Kingsbury),
1868.2
Smith, Sarah Gilbert White, 1836.1
Snow, Susan Eliza Currier, 1888.2
Spalding, Eliza Hart, 1836.1
Spaulding, Anna Brown, 1794.1
Spencer, Caroline (Benton), 1835.6
Spencer, Cornelia Phillips, 1844.4
Sprague, Achsa W., 1849.9
Stafford, Mary, 1711.1
Stanton, Elizabeth Cady, 1839.1;
1852.2
Stanton, Phoebe Fail, 1845.1
Stebbins, Sarah Ames, 1839.4
Steele, Sarah Calhoun Davis,
1856.4
Stephenson, Mary, 1851.4
Stewart, Agnes (Warner), 1853.8
Stone, Lucy, 1846.8; 1853.9
Stone, Sarah Katherine (Kate)
(Holmes), 1861.1
Storrow, Ann Gillam, 1820.2
Stowe, Harriet Elizabeth Beecher,
1827.2; 1828.2
Strang, Ellen, 1862.6
Strenzel, Louisiana Erwin, 1845.1
Stritecky, Marie Spacil, 1913.1
Strong, Julia Barnard, 1836.5
Stuart, Elizabeth Emma Sullivan,
1849.10

Subject Index

Abolitionists, 1811.1; 1817.2;
1819.1; 1836.3; 1843.4;
1846.8; 1849.7; 1853.9;
1854.1. See also Blacks;
Slaves
Actress, 1915.3
Adolescents. See Children and
adolescents
American Indians
-attacks by, 1854.3; 1866.1
-attitudes toward, 1811.2; 1849.3;
1852.6; 1853.14; 1857.3;
1862.10-11; 1863.1; 1864.8;
1865.6; 1866.1; 1868.1;
1874.1, 3; 1875.1; 1879.3;
1882.2
-encounters with, 1851.2; 1852.1,
7; 1860.14; 1863.13; 1866.2-3
-missionaries to, 1836.1, 4; 1840.1;
1842.2; 1845.4
-teachers of, 1850.2; 1862.19
American Revolution. See
Revolutionary war
Army wives, posts, 1811.2; 1843.1;
1846.4; 1855.1; 1861.4, 18;
1863.1; 1866.1, 3, 6; 1867.4;
1868.1; 1874.1, 3, 5; 1879.3;
1886.4
Artists, 1848.2; 1860.1; 1874.4;
1908.2; 1974.1
Astronomer, 1853.10
Aviator, 1916.1

Birth control, reference to,
1874.1
Blacks, 1770.2; 1772.2, 4;
1843.2; 1854.1; 1921.2;
1968.1. See also
Abolitionists; Slaves
-attitudes toward, 1852.9; 1854.7;
1866.3; 1918.2
-civil rights of, 1956.1
Bohemians, 1908.2

Botany, 1852.10. See also
Gardening
Business enterprises, family,
1680.1; 1725.1; 1814.4

Childbirth. See Pregnancy,
childbirth
Child rearing, 1758.1; 1760.1;
1761.1; 1791.1; 1798.1;
1803.1; 1804.1; 1805.2;
1808.4; 1809.2; 1811.1;
1815.3; 1824.1-2; 1825.2;
1826.1; 1827.1-2; 1831.1;
1832.3; 1835.2; 1837.1;
1838.3; 1840.1, 7; 1845.4;
1848.1; 1850.1; 1851.3, 8;
1860.2; 1861.5, 19; 1863.1;
1865.2; 1866.5; 1869.2;
1870.1; 1874.1; 1885.1;
1890.2; 1891.3; 1915.2;
1919.1; 1933.3; 1959.1;
1976.1. See also Mothers,
relationships with grown
children
Children and adolescents,
1771.1-2; 1772.3; 1778.1;
1790.1; 1797.1; 1800.4;
1805.2; 1824.2; 1833.2;
1838.2; 1841.1; 1852.4, 9;
1860.5; 1861.3, 14; 1862.11,
21; 1864.5; 1869.1; 1871.2;
1881.4; 1882.3-4; 1883.2;
1892.1; 1905.3; 1912.1;
1929.1
Church. See Piety, personal;
Religions, denominations
Cities. See Localities
Civil rights, 1956.1
Civil War
-northern women, 1817.2; 1831.2;
1844.3; 1852.9; 1860.3, 7;
1861.3, 7, 9, 20, 22; 1862.2,
12, 14, 16, 18; 1863.10;
1864.6, 9
--living in South, 1847.1; 1851.10;
1853.5, 11; 1860.11; 1861.2,

18; 1862.22; 1863.7, 14;
1865.2
-nurses, 1811.1; 1843.4; 1859.3;
1862.1, 13, 20, 23-24;
1863.12
-Shakers during, 1861.15
-southern women, 1844.4; 1845.3;
1854.2, 7; 1860.8-9, 12-13;
1861.1, 4-5, 8, 10-11, 14,
16-17, 19, 21, 23; 1862.3-5,
7-9, 17, 25; 1863.2-3, 5, 9,
11; 1864.2-5, 7, 10-12;
1865.1, 7-9; 1866.4; 1886.3
Colleges. See Educators (school
founders, administrators);
Students; Teachers, professors
Courtship. See Marriage,
courtship
Czech women, 1913.1

Dancer, 1980.1
Death, 1739.1; 1760.1; 1772.2-3,
1776.2; 1785.1; 1791.1;
1794.1; 1797.1; 1798.1;
1807.2; 1811.1; 1823.1;
1824.1-2; 1831.1; 1836.6;
1837.1; 1839.2; 1840.2, 5, 7;
1844.3; 1846.2; 1847.2;
1849.3; 1850.4; 1851.10;
1852.1, 3; 1854.3; 1855.4;
1859.4; 1860.13; 1861.19;
1862.3, 5, 7, 11, 17; 1863.5,
10-11; 1864.4-5; 1865.4, 8;
1866.4; 1868.2; 1876.1;
1886.3; 1892.1; 1898.1;
1904.1; 1929.2; 1936.2;
1950.1; 1953.1; 1959.1;
1974.2
Divorce, separation, 1783.1;
1835.2; 1840.1-2; 1849.1;
1856.5; 1860.6; 1916.2;
1948.1; 1950.3; 1976.1
Domestic life, 1754.1-2; 1758.1;
1760.1; 1761.1; 1762.1;
1771.2; 1785.2; 1790.1;
1797.2; 1800.1; 1801.2;
1805.3; 1808.4; 1809.1;
1818.4; 1821.1; 1825.2;
1826.1; 1827.1; 1828.1;
1830.1; 1831.1; 1832.1-2;
1833.1; 1837.1; 1839.2;
1840.1; 1845.5; 1846.5;

1848.1; 1851.8; 1852.3, 6;
1853.5, 13; 1855.2; 1856.2-3;
1857.6; 1858.1; 1860.8;
1861.13; 1862.6, 18, 22;
1863.3; 1865.5; 1867.5;
1868.3; 1869.2; 1870.3;
1871.2-3; 1877.1; 1881.2;
1884.1; 1890.1-2; 1891.3-4;
1916.3; 1917.3
Dutch women, 1669.1; 1680.1

Eastern women. See Localities
Editors, 1817.1; 1846.6; 1853.9;
1882.1; 1910.1; 1921.3; 1933.1
Educators (school founders,
administrators), 1796.1;
1818.2; 1820.3; 1844.4;
1870.2; 1873.1; 1879.1;
1886.1; 1900.1, 3; 1921.1.
See also Teachers, professors
English women, 1711.1; 1739.1;
1774.1; 1846.2; 1854.4;
1856.2; 1862.20; 1881.2;
1893.2; 1954.1
Entertainment. See Social life,
entertainment
Ethnic groups. See specific
groups

Factory workers, 1830.3; 1838.1;
1851.1; 1943.1
Farm women, 1884.1; 1892.1;
1927.1. See also Pioneers,
frontier life; Ranch women
-hired workers, 1838.1; 1846.2
-wives, 1768.1; 1775.1; 1826.1;
1830.3; 1832.1; 1837.1;
1846.3; 1848.1; 1851.5;
1861.13; 1862.4, 18, 22;
1864.6; 1865.5; 1877.1;
1885.1; 1890.2; 1913.1;
1917.3
Fashions, 1761.1; 1771.2; 1772.1;
1782.2; 1787.1; 1800.2;
1814.3-4; 1815.3; 1855.2;
1860.5; 1888.2; 1892.1
Feminism, 1817.2; 1819.1; 1836.3;
1839.1; 1843.4; 1846.8;
1852.2; 1853.9; 1870.2;
1873.1; 1891.1; 1905.1;
1918.1

French women, 1809.2; 1840.4;
 1841.2; 1852.10
Friendships, women's, 1740.1;
 1778.1; 1779.1-2; 1796.1;
 1802.1; 1805.2-3; 1818.4;
 1820.1; 1821.1; 1837.4;
 1843.2; 1849.5; 1856.1;
 1870.2; 1871.4; 1877.2;
 1880.1; 1885.3; 1887.1;
 1888.1; 1890.2; 1891.4;
 1903.1; 1914.1; 1917.2;
 1918.3; 1921.2; 1922.3;
 1943.2; 1953.2; 1970.1;
 1978.1; 1982.1
Frontier life. See Pioneers,
 frontier life

Gardening, 1760.2; 1837.1;
 1885.3; 1890.1; 1982.1. See
 also Botany
German women, 1765.1; 1900.4;
 1947.1

Historians, 1908.1; 1910.2; 1911.1
Homesteaders. See Farm women;
 Pioneers, frontier life;
 Westward migration
Humanitarians, 1811.1; 1849.9;
 1850.3; 1854.4; 1861.6;
 1910.2

Illness, invalidism, 1754.1;
 1760.1; 1772.3; 1788.2;
 1795.1; 1797.3; 1807.2;
 1818.3; 1821.2; 1826.2;
 1839.4-5; 1844.3; 1849.9;
 1853.3, 5, 13; 1857.2;
 1859.2; 1862.6; 1863.4-5,
 8, 10-11; 1865.5; 1870.3;
 1879.4; 1885.2-4; 1886.2;
 1891.1, 4; 1948.1-2;
 1950.2-3; 1970.1; 1974.2;
 1978.1
Immigrants, 1711.1; 1725.1; 1739.1;
 1774.1; 1837.3; 1840.4;
 1841.2; 1845.5; 1846.2-3;
 1850.4; 1851.3-4; 1853.1;
 1858.2; 1861.13; 1870.1;
 1881.2; 1883.2-3; 1890.1;
 1893.2; 1908.2; 1910.4;
 1913.1. See specific

nationalities for countries
 of origin
Imprisonment, 1811.2; 1950.1
Inoculation, 1770.1
Internment, of Japanese
 Americans, 1942.1
Invalids. See Illness,
 invalidism
Irish women, 1846.3; 1850.4;
 1890.1; 1926.1

Japanese-American women, 1942.1

Localities (residences of
 writers are listed below as
 well as places described in
 travel accounts; territories
 are listed under modern names
-Alabama, 1861.21; 1863.9; 1867.2
-Alaska, 1874.1
-Arizona, 1865.6; 1911.1; 1930.1
-Arkansas, 1846.2; 1855.5;
 1863.7; 1865.2; 1890.2
-Boston, 1758.2; 1771.2; 1804.1;
 1808.4; 1814.1; 1820.3; 1825.2;
 1844.3; 1845.2; 1872.1; 1874.4;
 1881.3; 1886.2; 1894.2; 1910.1;
 1914.1; 1921.1. See also
 Massachusetts
-California, 1849.1, 3; 1851.8;
 1852.7; 1854.6; 1856.1-2;
 1867.3; 1883.1; 1885.4;
 1908.3; 1915.5; 1932.1; 1943.1
-Colorado, 1857.6; 1866.3, 7;
 1885.2; 1901.1; 1922.2
-Connecticut, 1688.1; 1761.1;
 1796.1; 1797.1; 1816.2;
 1818.1; 1831.1; 1838.1; 1846.2;
 1910.3
-Delaware, 1832.3; 1860.3
-Florida, 1854.7; 1867.6; 1883.2;
 1930.1
-Georgia, 1847.1; 1851.10;
 1853.11; 1860.6; 1861.12, 14;
 1862.13; 1863.3; 1864.3-5,
 10; 1865.8; 1869.3; 1883.4;
 1892.3; 1918.1; 1920.1;
 1936.3; 1948.2; 1956.1
-Idaho, 1874.1

Poverty, financial straits, women
in, 1669.1; 1711.1; 1742.1;
1758.2; 1772.1; 1776.1; 1778.2;
1795.1; 1817.2; 1821.2;
1823.1; 1828.1; 1832.2;
1835.1-2; 1840.4-5; 1843.4;
1846.3; 1851.10; 1855.2;
1857.6; 1860.4; 1861.2, 5, 8,
11, 19; 1862.5; 1865.1, 5;
1866.5; 1910.4; 1917.3;
1918.3; 1927.1
Pregnancy, childbirth, 1758.1;
1760.1; 1762.1; 1782.2;
1788.2; 1797.3; 1798.1;
1809.2; 1821.1; 1824.2;
1825.2; 1828.4; 1836.4;
1839.1-2; 1840.1; 1845.5;
1850.4; 1852.5; 1853.3;
1860.2; 1865.1, 5; 1868.2-3;
1874.1; 1885.1; 1888.2;
1890.2; 1915.2; 1917.3;
1948.1; 1950.3
Prostitution, 1910.4
Public affairs, political events,
1755.1; 1758.1-2; 1762.1;
1774.1; 1775.1; 1776.1-3;
1778.3; 1782.1; 1785.1;
1788.2; 1800.2; 1801.1;
1803.1; 1804.2-3; 1807.1;
1808.1-3; 1811.1; 1814.2-4;
1816.1; 1817.2; 1824.1;
1825.2; 1828.2; 1835.4;
1838.2; 1839.1, 5; 1840.5;
1845.2-3; 1850.4; 1851.3;
1854.2; 1855.2; 1861.20-23;
1862.25; 1863.4, 12; 1864.7;
1865.4; 1867.2; 1869.2;
1871.3; 1881.3; 1885.3;
1886.2; 1887.1; 1903.1;
1910.3; 1915.2; 1916.4;
1931.1; 1932.1; 1943.2;
1946.1. See also
Abolitionists; Feminism;
Reformers; specific wars

Ranch women, 1882.2; 1891.3;
1893.2. See also Farm
women; Pioneers, frontier
life
Reading, 1688.1; 1758.2; 1787.1;
1791.1; 1797.1-2; 1800.3;

(Reading)
1801.2; 1808.2-3; 1815.2;
1816.1; 1820.2; 1824.1-2;
1836.6; 1838.2; 1839.1, 5;
1840.3; 1851.3, 8; 1854.1-2;
1860.8; 1861.11, 14, 16;
1862.17; 1863.3-5, 7; 1864.7;
1867.5; 1871.1, 4; 1879.1, 4;
1880.1; 1885.2; 1886.2; 1891.4;
1910.2; 1946.1; 1975.1; 1976.1
Reformers, 1811.1; 1817.1-2; 1819.1;
1820.3; 1836.3; 1839.1;
1844.2; 1846.8; 1849.7;
1850.3; 1852.2; 1853.9;
1854.4; 1910.4. See also
Abolitionists; Feminism
Regions of the United States. See
Localities
Religions, denominations. See
also Piety, personal
-Baptists, 1768.1; 1801.3;
1840.7; 1864.9; 1891.4
-Congregationalists, 1839.5;
1846.6, 8; 1852.9; 1887.3
-Episcopalians, 1832.2-3; 1838.3;
1846.6; 1854.2; 1860.8;
1861.8-9; 1862.17; 1863.2,
11; 1918.1
-Jews, 1808.3; 1815.2; 1856.2;
1867.3; 1868.4; 1887.1;
1910.4; 1925.1; 1947.1;
1953.1; 1968.1
-Lutherans, 1845.5; 1851.3;
1853.1; 1870.1; 1883.3
-Methodists, 1818.3; 1836.4;
1838.1; 1840.1; 1846.1;
1847.1; 1861.14; 1865.5;
1892.1
-Methodist Episcopalians, 1852.6;
1869.3
-Moravians, 1757.1
-Mormons, 1850.4; 1856.1
--comments on, 1857.3; 1878.1
-Presbyterians, 1772.3; 1824.2;
1825.3; 1836.5; 1844.4;
1849.10; 1851.6; 1852.8;
1853.13; 1860.7, 13; 1871.3;
1883.4
-Quakers, 1757.1; 1758.1;
1776.1-3; 1777.2; 1778.1;
1779.1; 1781.1; 1799.1;